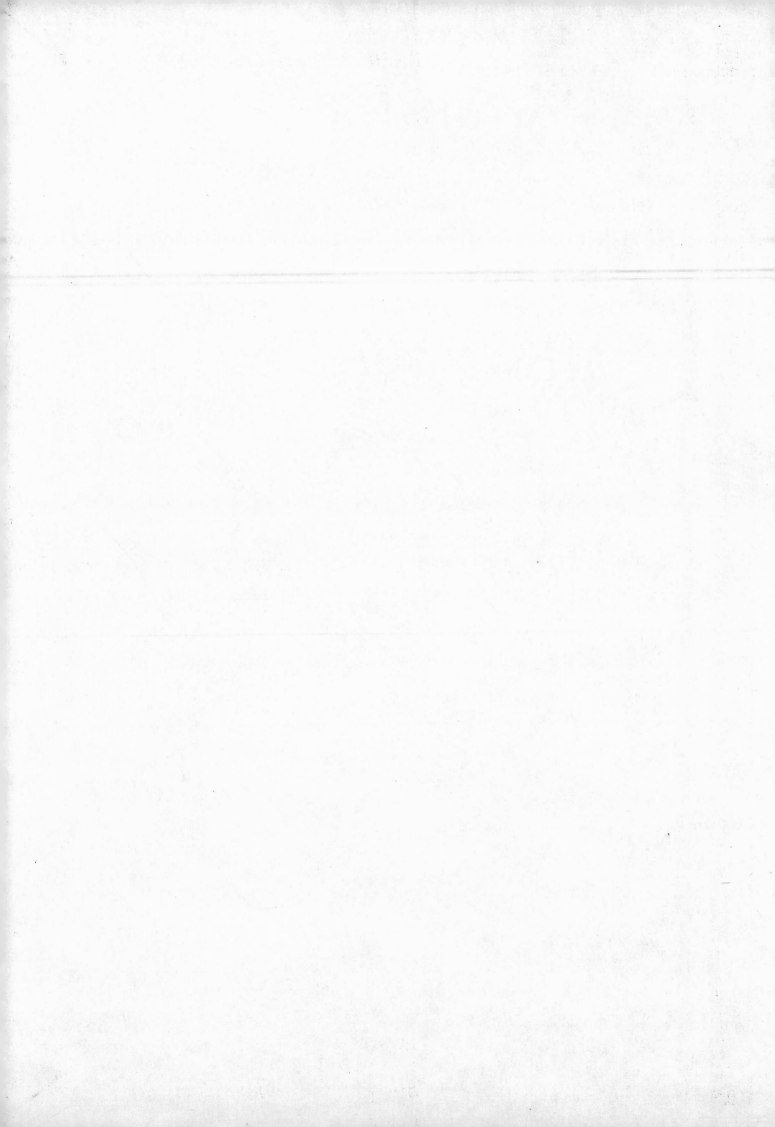

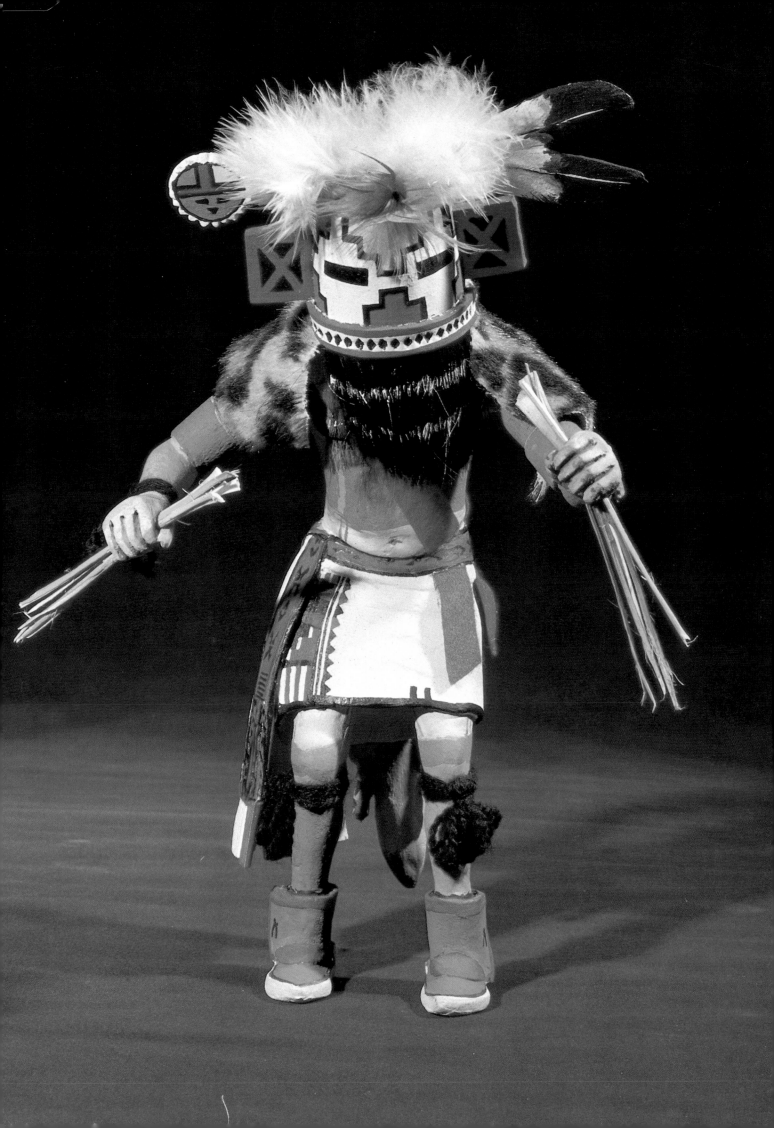

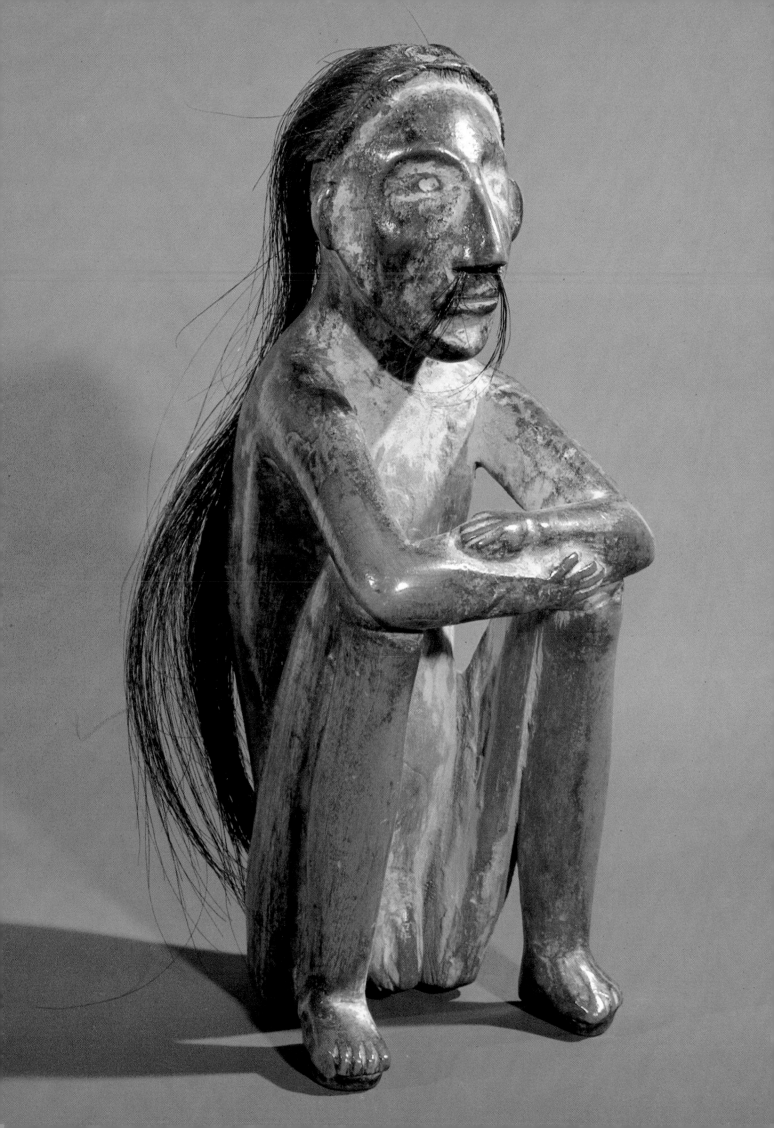

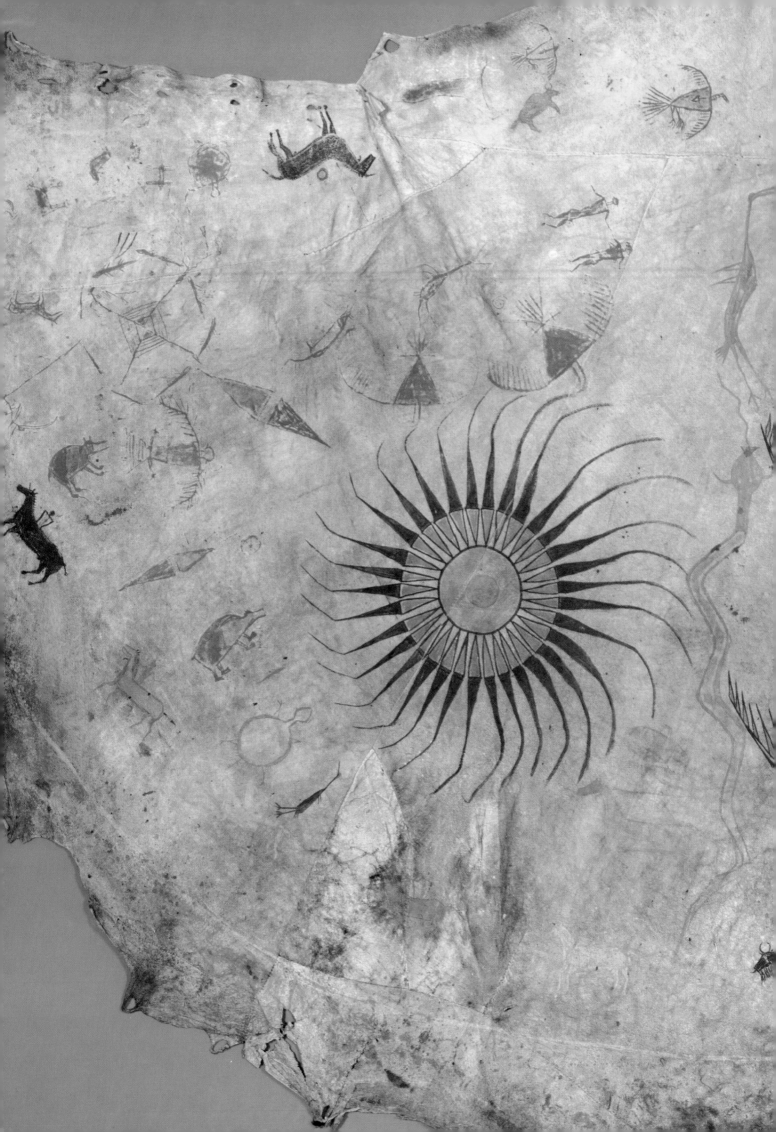

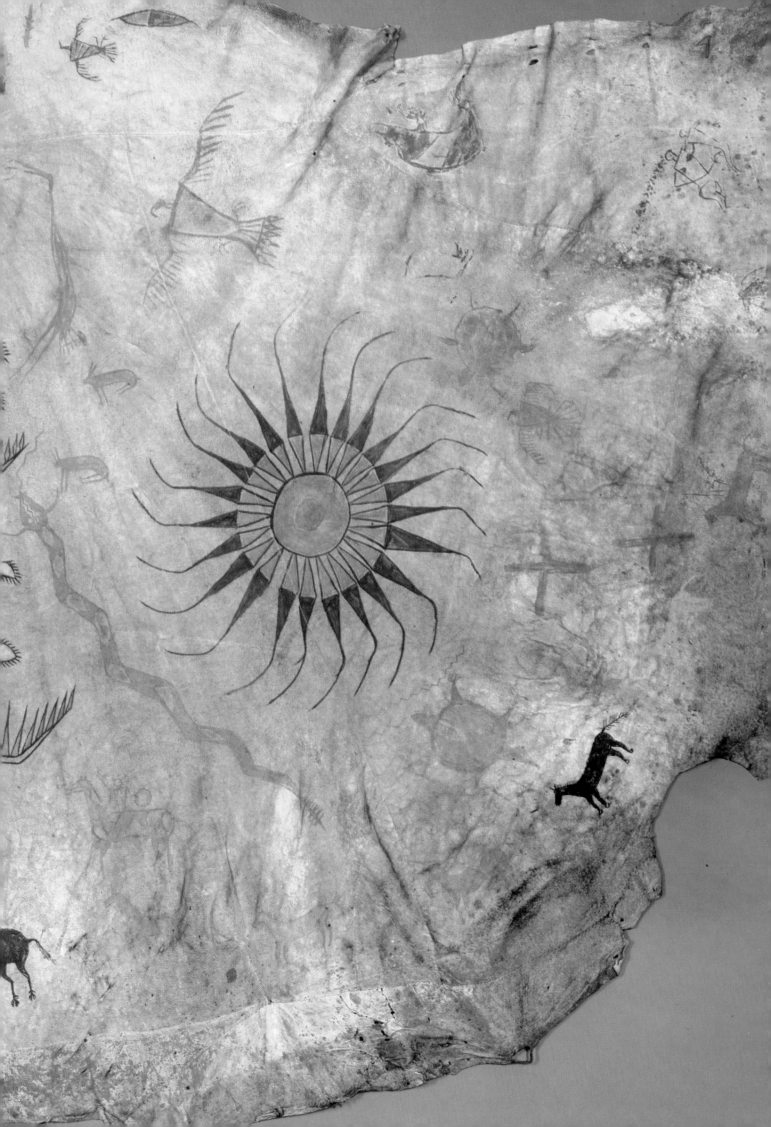

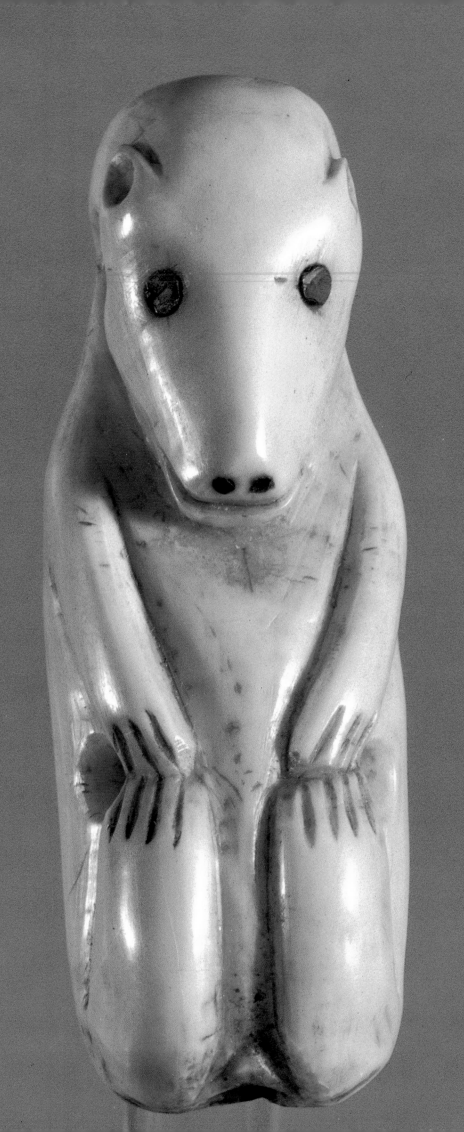

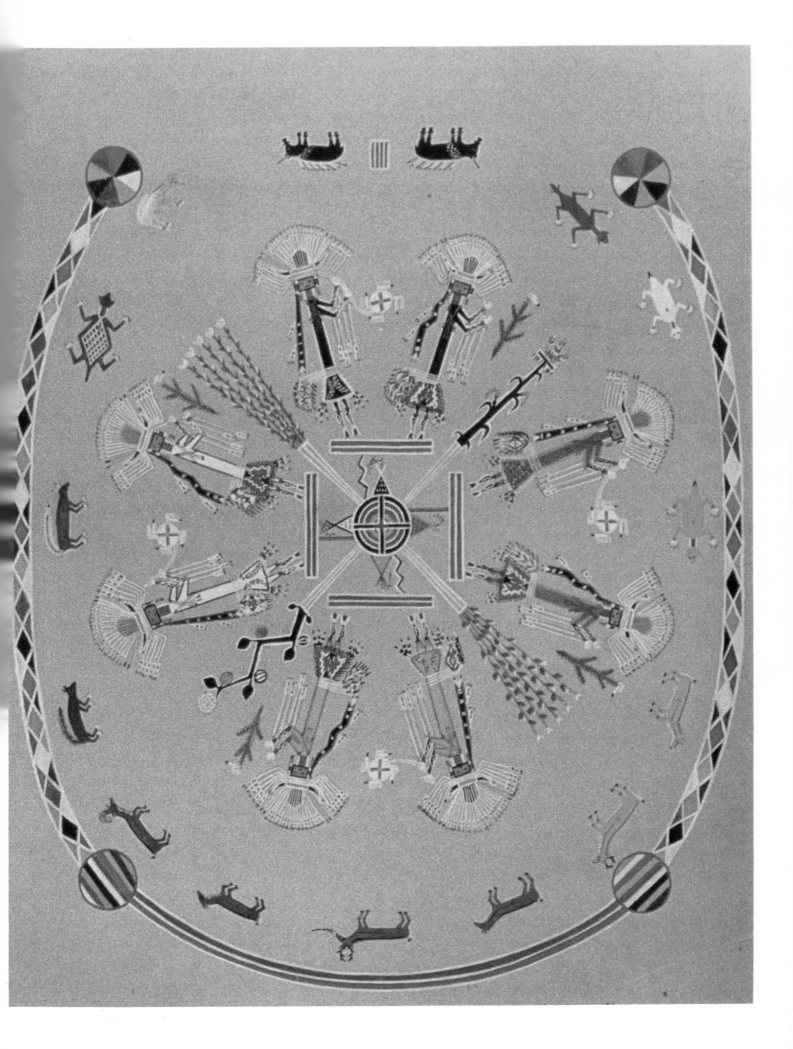

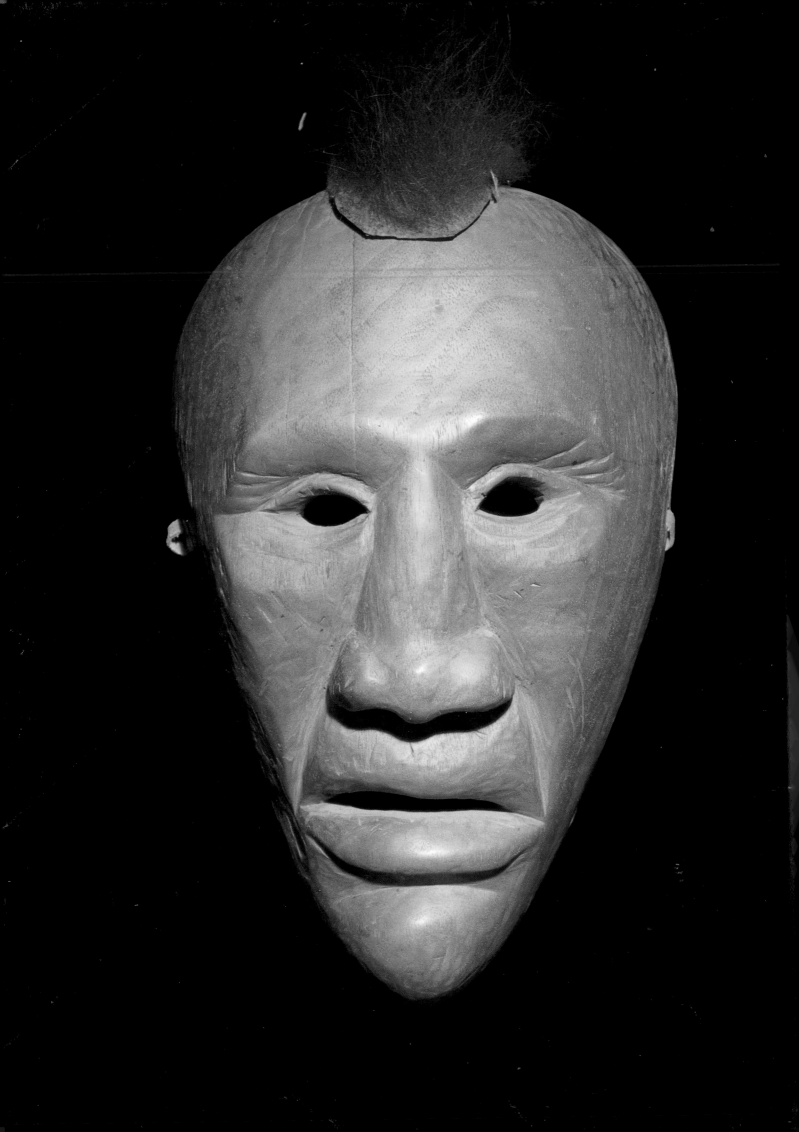

Peter T. Furst
Jill L. Furst

# North American Indian Art

RIZZOLI
NEW YORK

*An Artpress Book*

Artpress Books is the imprint of
Annellen Publications, Inc.
122 East 42nd Street
New York, NY 10022

Chairman: Milton Esterow
President and Editor-in-Chief: John L. Hochmann
Managing Editor: Ray F. Patient
Designer: Kornelia Kurbjuhn

Composition by Dix Type Co., Syracuse, NY
Printed and bound by Mandarin Offset International, Ltd.,
Hong Kong

© 1982 by Peter T. and Jill Leslie Furst

Published in the United States of America by
Rizzoli International Publications, Inc.
712 Fifth Avenue
New York, N.Y. 10019

Library of Congress Cataloging in Publication Data
Furst, Peter T.
  North American Indian art.

  Bibliography: p.
  1. Indians of North America—Art.
I. Furst, Jill Leslie. II. Title.
E98.A7F87   1982    704'.0397    82-40343
ISBN 0-8478-0461-5

Plate 1. Spirited Hopi kachina doll representing Hilili, a guard or warrior kachina who protects the other kachina spirits and also the initiates into the kachina cult. (12" high. Carved in 1979 by William Quotskuyva of New Oraibi, Arizona. Private Collection.)

Plate 2. Wooden sculpture of a long-haired shaman or holy man, attributed to the Caddo, an agricultural people that once inhabited portions of Texas, Arkansas, and Louisiana, in the extreme southeastern Plains. (6½" high. Eighteenth century. Smithsonian Institution.)

Plate 3. Dagger of native copper and mountain sheep horn from Klukwan, a Chilkat-Tlingit citadel near Chilkat Pass in southern Alaska, which preserved its cultural heritage until the Gold Rush of 1898. From their village the Chilkat controlled both the source of copper and the copper trade route. The weapon, dating from about 1800, bears the marks of stone saw cutting on the back. Daggers of this type were given names and passed down from generation to generation. (22⅜" long. Private Collection.)

Plate 4. With its feathered pipe centerpiece flanked by sun symbols and numerous pictographs, this magnificent buffalo-hide Plains tipi liner almost certainly decorated the interior of a sacred lodge, probably one that contained an important ceremonial pipe. It may have been seen by only the select few privileged to enter the sacred tipi. Painted between 1820 and 1830, probably Dakota Sioux, it was acquired shortly afterwards by a German traveler. (97" wide. Museum für Völkerkunde, Berlin-Dahlem.)

Plate 5. Ivory dog-sled drag handle in form of polar bear cub, carved by Bering Sea Eskimo, 1870–80. (2⅞" high. Peabody Museum of Natural History, Yale University.)

Plate 6. In a sacred dry painting from the Navajo Shootingway curing chant, Holy People and animals circle the mountain of the center of the world. Four plants representing blue corn, beans, squash, and tobacco, the last symbolizing all the medicine plants, radiate from the center in four directions (Copy by Mrs. Franc J. Newcomb, 1936. Photo courtesy Wheelwright Museum of the American Indian, Santa Fe, New Mexico.)

Plate 7. Attributed to Will West Long (1869–1946), a famous carver, shaman, and ritual specialist of the Eastern Cherokee band at Big Cove, North Carolina, this mask was made about 1940. It represents a character in the Booger Dance usually called Angry or Apprehensive Indian. The principal aim of the dance is to neutralize the negative influence of Europeans and other strangers through satire and ridicule. But, like the False Face drama of the Iroquois, it is also held to cure the sick or to drive out evil spirits. Some Booger masks depict Indians and game, others are caricatures of whites. The term "booger," like bogey, boogie-woogie, and bug, derives from the West African words baga (Mandingo) and bugal (Wolof), meaning to annoy, harm, or worry; it was introduced into American English by black slaves. (12½" high. Private Collection.)

# Table of Contents

# "...To Beautify the World"

The Navajos have a saying that the purpose of art is "to beautify the world." On the face of it, this does not sound so different from the function of art in the West. Yet, pleasure for the senses is only one dimension, and by no means the most important, of what Navajos understand by making the world beautiful. Beauty, rather, means balance, the proper order of things. Its affirmation or its restoration implies that society, the natural and supernatural environment, and the individual are in the normal state of health and harmony.

What we call art has a different meaning for a Navajo, and for Native Americans generally. Because art was functional, serving social and religious purposes, and was never "art for art's sake" as it became in the West, Indian languages generally lack even a discrete term for art as a category apart from its function as communication of specific ideas and values. Still, the stylistic canons and subject matter of Native American art are not so different and mysterious that non-Indians are unable to enjoy them purely in terms of aesthetics and general standards of good craftsmanship. A Pomo feather basket like those shown in Chapter Three is beautiful and superbly crafted by any measure, whether or not one knows why this or that color feather was chosen by the weaver, or how shell beads fit into the social, economic, and ideological systems of Native Californians. Few carvers in the world could do with wood what the artists of the Northwest Coast achieved even before they had metal tools. To appreciate as art alone their soaring sculptured totem poles or splendid masks does not necessarily require an understanding of their religious ideology, their social organization, or the ways in which the right to commission or carve these works passed from the ancestors to their living descendants.

Yet much of American Indian art does require a suspension of bias toward the European tradition, an opening of the mind to new experiences in forms, materials, and subject matter, and a willingness even to be jolted and mystified by unfamiliar beauty and power. For many works of the First Americans express and convey magic and mystery as much as beauty. This special spiritual dimension propels us into another world, beyond aesthetics, which may or may not be universal, into the particular social and ideological settings that gave rise to many of the works from the Indian Southwest, California, the Northwest Coast, the Arctic, the Plains, and the eastern Woodlands in these pages.

But if Native American art cannot be understood apart from ideology and religion, it is also true that there is no such thing as "*the* American Indian religion." The social and ideological settings varied considerably from region to region and society to society. And the subtle interplay of environment, historical experience, cultural contact and diffusion, forms of subsistence, social organization, and other factors, natural and manmade, led to an enormous variety of localized religious forms, almost as many as there were Native languages and dialects and peoples with shared group values and a sense of their own identity. To appreciate this historical heterogeneity, one need recall only that linguists have identified more than fifty different Native language families, each containing numerous member languages that, though related, were mutually unintelligible. Most European languages, in contrast, belong to just two families: German and Romance.

Nonetheless, whatever their ways of dealing with their environments, and whatever factors contributed to the organic growth of their particular religions and art forms, the Native peoples of North America did share certain basic assumptions about the structure of the cosmos, the natural environment, and the place of human beings within it. However different in emphases, the religions and rituals of the Native peoples—from Arctic sea hunters to seed collectors and cultiva-

tors of the soil—clearly grew from common ideological roots, in what might best be called a shamanic transformational world view that valued above all the personal pathway to the supernatural in the ecstatic spirit vision and that recognized no essential qualitative difference between humans and other life forms. This world view accounted for the origin of the world and natural phenomena in terms of transformation of matter rather than creation out of nothing. The central figure in this religious system was the shaman, who was the specialist in the sacred and mediator between the society and the world of spirits.

In the Native view, human beings were not superior to animals; if anything, animals by their very nature were already in possession of sacred powers which humans sought to acquire. The relationship of people to their environments, to plants and animals, to the dead, to the spirit powers great and small, as to one another, was one of reciprocity: to receive benefits one had to give. What was taken from the earth had to be compensated for by gifts of like worth so as not to anger the spirits and deplete the natural resources. Whatever their specific local forms, American Indian religions were profoundly ecological in origin as well as in their philosophical assumptions.

Archaeological evidence suggests that in a few cases there may have been animal kills greater than were justified by need, but by and large the spiritual-ecological orientation seems to have protected game against overhunting and man-made extinction, at least until traditional values began to break down in the north under the pressures and temptations of the fur trade. It is well known that only a sudden change in fashion in men's top hats saved the beaver from extinction. On the Northwest Coast, the playful otter, an appealing animal that everywhere enjoyed a special status in myth and symbolism and that was also a powerful source of supernatural power for the shaman, was virtually wiped out before its gleaming pelt lost its economic allure. Its near-extinction, though, left a curious mythological residue among the Tlingit. Like all animals, the otter had its human aspect, and it could transform itself merely by taking off its animal skin, revealing the human essence beneath. While shamans might seek out the otter in their initiatory power quests, to take its tongue and preserve it as a magical amulet, ordinary folk feared it as a magical and merciless adversary of human beings that lurked beneath the surface of lakes to kidnap and drown unsuspecting people, especially children. The inoffensive and entertaining otter

seems a curious choice as a dangerous enemy, but the Tlingit had a logical explanation. The otters were only taking revenge because so many of their number had been killed for profit. With their power as transformers, the Otter People inducted their human victims into their own tribe, to replace those otters that had been killed.

Of course, this represents an extreme consequence of the breakdown of the rules of life. Ordinarily, if an animal had voluntarily given up its life to human beings, it was incumbent on the people to see to its regeneration by the strict observance of taboos and rituals of propitiation. Among the Eskimos, for example, the slain animal was not simply butchered but addressed with respect and gratitude and offered its favorite foods. Considering the precariousness of Eskimo life, it is not surprising that hunting taboos and rites for the rebirth of game were most elaborated in the Arctic. Indeed, much of Eskimo art was functionally related to the constant need to placate the spirits of the game and the greater powers who watched over the animals on whom Eskimos depended for virtually everything that made life possible in the frozen North. The Eskimos shared in the general Native American belief that animals were reborn from their bones. To make certain that game was regenerated true to species, the bones of land and sea animals had to be disposed of separately. So complete was this separation that a hunter could not even wear the same clothing or use the same weapons for hunting on land as on sea. Seal were returned to life by uniting the bones with the bladder, which is where Eskimos located the soul or life force of human beings and animals.

To Native Americans, not just animals but all other phenomena were alive and inhabited by an animating spirit. A rock, a tree, a blade of grass, or a deer was no less potentially capable of thought, speech, and action than a human being. In fact, there was no such thing as dead or inanimate matter, although natural objects and phenomena did not manifest their potential for conscious interaction at all times. Thus, the builders of the Northwest Coast communal houses, when they took planks from a cedar, or the Iroquois mask carvers, when they cut the outlines of a mask on the trunk of a basswood tree, begged the tree to excuse them for hurting it.

Every entity was given its outward appearance by a "form soul." The shaggy bark of the cedar gave the tree its appearance, just as the pelt gave form to the otter. Beneath this outer form, however, the spiritual essences of the different phenomena were qualitatively equivalent. When the form soul was removed, natural phenomena re-

vealed their inner identities, and Native American mythology and art, especially in the Pacific Northwest, are replete with themes of supernatural beings who transformed themselves into snakes or trees, bags of paint, or even men to accomplish their tasks. On the Northwest Coast, some peoples graphically expressed this qualitative equivalence in complex hinged masks that represented a spirit being on the outside but, at a given moment in a dance, could be instantaneously opened by the wearer to reveal another face and identity within. If the animals could lay aside their skins and appear as men, so too could a man put on an animal skin and become the animal, at least during a ceremony or while he was hunting.

When the form soul was forcibly removed, the plant or animal might die in its present form, but its spirit continued to exist and could return and avenge itself, as did the Otter People in Northwest Coast legend. Therefore a hunter accorded respect to a slain animal and propitiated its spirit, often thanking it for giving up its life to sustain the man and his family, and the hunter's wife further honored the game by decorating its skin with paintings or embroidery. Plants harvested or collected were believed to be just as sentient, and to ensure that the plant spirits would not be offended, agricultural peoples celebrated ceremonies of thanksgiving at the different stages of plant growth and maturation. The Algonquian and Iroquoian peoples of the northern and eastern Woodlands held plant life in such high regard and were so firmly convinced of the beneficent effect of the living vegetation on human life that plant and floral motifs literally dominated their sacred and decorative arts.

Many Native Americans believed that, in addition to the spirits animating individual plants and animals, there also existed Masters or Mistresses of the species, conceived as supernatural guardians more spiritually potent than the beings under their care. These guardians took offense if their charges were mistreated, overexploited, or not properly honored in ritual and in the observation of the taboos. In the tradition of Southwestern Pueblos, for example, corn was in the charge of the Corn Maidens, each representing corn of a different color. To this day Zuni tradition tells of a time when food was so wantonly wasted that the Corn Maidens grew angry and withdrew from the pueblo, taking refuge by the sacred lake in the center of the underworld and leaving misery and famine among the irreverent people. Similarly, the Iroquois addressed their principal cultivated staples—corn, beans, and squash—as a trio of female deities known as the

Three Sisters and paid them reverent respect.

Still, much American Indian art falls into the category of "animal art," in the sense that even among people who relied heavily on the vegetable kingdom, animals and their perceived social and symbolic functions constituted major themes in the oral as well as the visual arts. The animals selected for special attention were not necessarily especially important for physical survival or particularly fearsome or respected for physical prowess as predators. These factors, while certainly important, seem not to have been the principal attractions. Rather, people were fascinated by species that mirrored the predominant themes of the general world view, especially the overarching concept of transformation, or species that, like the shaman, the mediator between the natural and supernatural worlds, were not strictly bound to a specific ecological niche or cosmic level but transcended the normal boundaries restricting most species to one environment. Thus, creatures that occur over and over in art and myth are those that undergo dramatic transformations, or while not changing form do equally well in radically different settings: toad or frog, for example, which metamorphoses from aquatic, vegetarian, gill-breathing and fishlike tadpole to terrestrial, four-footed carnivore, or diving birds that seem equally at home in the sky, on the water, and under the water. No wonder, then, that in the Northwest Coast art, the frog is often represented as the direct source of magical power, transferring his or her spirit qualities to the shaman through the tongue. Birds in general were symbols of the celestial journey of the shaman, and water birds, in particular, of the shaman's ability to descend into the watery depths as well as rise into the heavenly realm. This kind of symbolism is well-nigh universal: the prominence of the duck in Native American myth and art all over the continent, for example, stems not from its contribution to the Indian diet but from its uncanny sense of navigation over enormous distances, its ability as a swimmer, and its capacity to remain under water for a long time. On the other hand, economic importance hardly disqualifies an animal from a spiritual role. No species was more essential to the survival of the Plains Indians than the buffalo, and none was more sacred.

Animals that share certain characteristics with humans, such as an omnivorous diet or care for their young, were generally selected for special attention. However, the qualities that made some animals stand out over other species were not necessarily obvious: Native peoples were superb observers of the natural environment, experts in

the ecology and behavior of every creature or plant, from insect to tree, ever alert for characteristics in some way perceived as analogous to their own thinking. It is this constant interplay between close and accurate observation of the natural world and ideology that accounts for the origins of many metaphors and symbols that to us at first glance appear arbitrary, illogical, or the invention of overactive imaginations. If certain animals were credited with special spirit powers useful to the shaman and others were not, the reason might lie buried deep in very old mythologies, reaching back perhaps as far as the ultimate Asiatic origins of American Indians. But it is at least as likely that some special observed characteristic of the species was responsible. On the Northwest Coast, for example, the killer whale was considered a great "shaman-maker." It is a beautiful animal, graceful, intelligent, and "anomalous"—a warm-blooded mammal that acts like a fish, a fact well known to people dependent on ocean life. Perhaps its strikingly contrasting black and white coloration contributed to its mediating role in shamanic cosmology, but no doubt the coastal hunters of the Northwest Coast observed other behaviors that linked this species with the transformational powers of their shamans. Otters, bears, wolves, octopus, and mountain goats were likewise credited with shaman-making powers that unquestionably had their origin in particular observable characteristics in form, life cycle, social organization, food preferences, habitat, even sound, characteristics that associated them with one or another of such dominant themes in the shamanic world view as metamorphosis, simultaneity of different forms inherent in one and the same phenomenon, or physical and spiritual breakthrough from one cosmic plane to another.

If many of the phenomena in the Native universe were capable of change and transformation, people nevertheless had a clear conception of the structure of the cosmos and their place within it. Most peoples divided the world into four sacred quarters, marked the cardinal points, and sometimes added the zenith and the nadir as a fifth and sixth direction, and believed themselves to live at the sacred center, the navel of the world, as the true human beings. Hence, many called themselves in their own languages simply *The People,* while the names by which we know them today are frequently no more than European inventions or versions of the often unflattering names traders or settlers heard from their neighbors. Thus, the proper name of the Navajos (thought to derive from the Tewa *Navá-hu'u,* "arroyo with cultivated fields") is *Diné,* Peo-

ple. Small local groups of Eskimos generally named themselves after the place in which they lived, but as a whole they are *Inuit,* People, "*Esquimaux*" being a French transliteration of an Athabascan word meaning, roughly, "eaters of raw meat."

The idea of an underworld—the Nadir—as the home of the generative Earth as Mother Goddess and of various fertility and germination deities was naturally best developed among such agricultural peoples as the Southwestern Pueblo Indians. Yet there was a comparable conception even among the Eskimos, who, in the absence of agriculture and significant plant resources, replaced the agricultural earth goddess with an ambivalent, half-terrible, half-beneficent Mother Goddess who ruled over all the animals of the sea from her house beneath the ocean. Northwest Coast peoples had a rather terrifying but also sometimes nurturing female spirit of the forested interior, source of berries and other plant foods and materials; curiously, the Northwest Coast peoples also shared with the ancient Mexicans the idea of a female earth spirit in the form of a transforming toad, a frequent motif in Northwest Pacific art. Like other Native Americans, the Kwakiutl and their neighbors on the Northwest Coast also conceived of a multilayered cosmos, with an underworld peopled by the human dead and by the ruling spirits of fish and other sea animals.

Above the four-quartered earth was the sky world, usually conceived as a dome, sometimes with several levels, where Sun and Moon and other sky beings lived. The Sun was usually male and the Moon female, except among the Eskimos, who reversed the sexes. Stars were sometimes thought of as souls of the dead who traveled through the heavens. Most peoples also marked constellations, often quite different from our zodiac, and observed the motions of certain planets, particularly Venus. The Plains Indians and many agricultural peoples believed that rain was brought by the Thunderbirds, large, eagle-like birds whose wings made the sound of the thunder and who used lightning and hail against terrestrial snakes that lived beneath the earth in caves and springs or other bodies of water. Thunderbirds and their cosmic struggles against terrestrial adversaries are prominent in the symbolism of peoples as far apart as the Navajos of Arizona and New Mexico, the Kwakiutl of British Columbia, and the Woodlands peoples of northeastern North America.

Many peoples not only shared in the worldwide tradition of a great primordial flood but visualized the earth itself as an island floating in a

cosmic ocean. Common in art and myth was the motif of the turtle as support for the earth. The origin myths of the Iroquois, for example, credit Turtle with having been the original "Earth Diver," who descended to the bottom of the cosmic sea to bring up the mud that became the first dry land. Other peoples assigned this seminal role to different animals, but the idea of a primordial Earth Diver is well-nigh universal in Native American cosmology. With a turtle supporting the earth on its back, the sky vault, in turn, was widely thought to be held up by a great cosmic tree, its roots in the underworld, its trunk piercing the earth as *axis mundi,* the world axis, and its spreading crown reaching into and supporting the heavens. The Iroquois carried this symbolism of the cosmic or world tree so far as to identify their chiefs as pine trees that were uprooted with their death and replanted with the installation of their successors, in symbolic re-enactment of the uprooting and replanting of the original cosmic tree when the present world came into being. In one form or another the world tree as *axis mundi* was, in fact, universal among Native Americans, a basic concept they shared with most of the peoples of the world. In the Plains Indian ritual of the sacred pipe, the human being himself became one with the world axis as he raised the pipe, mouthpiece uppermost, to the heavens so that the superior powers might partake of his gift of the fragrant smoke.

In this conception of the universe, with its *axis mundi* in the center, earth and sky meet at the horizon, with the meeting place often envisioned as a paradoxical or dangerous passage, a rapidly opening and closing mouth or gateway where brave heroes and shamans in ancient times dared to pass into the celestial realm to retrieve souls or obtain knowledge, spirit power, or some other benefit for humankind. The clashing gateway as dangerous passage between the worlds is also a universal theme in shamanic, funerary, and heroic mythology the world over, often with such specific similarities that they might be accounted for by common historical origins in humankind's earliest past or, more probably, by the very similar deep structures of the common human psyche and the universal human experience. In Native American myth and art, as in the ancient art of Asia and other places, this universal motif of the dangerous passage (the Symplegades of Greek mythology) was often expressed as a fanged monster mouth or cosmic *vagina dentata*—the toothed or fanged vagina—from which only those who had assumed the qualities of spirit could escape unharmed. Northwest Coast symbolism is full of this motif. But regardless of the

specific conceptions of the relationship between the worlds or its levels, the basic complementary division seems generally to have been between a male sky and a female earth, or, as the Navajos expressed it, "Mother Earth and Father Sky." This cosmic pair was also frequently conceived as the divine progenitors of the first human couple and, among such peoples as the Navajos and their Puebloan neighbors, of the Hero Twins, who did battle against the enemies of the Holy People and put the present world in order.

Many peoples organized themselves into two complementary halves which anthropologists call moieties. Each moiety acted in the other's behalf in matters of the sacred, in the great communal ceremonies, in marriage arrangements, condolence rites, ritual games, and other social activities. This dual organization generally reflected the complementary dichotomy ascribed to the greater cosmos. Some peoples specifically associated their two moieties with war and peace, winter and summer, sky and earth, or male and female. Together they symbolized social unity and, in the larger sense, cosmic unity. The cosmic unity, in turn, was embodied in the male and female pantheons, which consisted of deities of greater or lesser spirit power who, though capable of affecting individual lives, generally acted for the society and the world as a whole.

It is clear, then, that for the first Americans, the whole universe, social, natural, and "supernatural," was permeated with generalized spirit power. But there was also a universal perception of an individualized spirit protection that could be obtained by people in the vision quest. Indeed, so pervasive was the seeking of the vision and of a personal guardian spirit that it is virtually *the* unifying hallmark of Native American spirituality. As a religious phenomenon the vision quest had its most intensive development on the Plains and prairies, but it existed everywhere in one form or another, regardless of environment, social organization, or forms of subsistence. Usually the spirit manifested itself to the supplicant in the form of a bird or an animal, whatever its actual nature. Individuals were not limited to a single vision quest or guardian spirit. Biographers of the great Oglala Sioux chief Crazy Horse note that among the guardian spirits who came to him in visions were not only the dancing horse from which he took his name but also such supernaturals as Shadow, Badger, Day, Spotted Eagle, and Spirit Rock, the last a major Dakota deity.

Guardian spirits sometimes came unbidden in dreams, but as a rule the vision had to be actively sought in isolation after a period of sleeplessness,

fasting, prayer, ritual smoking, and sometimes self-torture. Especially among the peoples of the Plains, the actual quest was preceded by purification in the sweat lodge and by instruction in the meaning of the sacred rite by a holy man of the supplicant's choice. The Sioux called the ritual "crying" or "lamenting" for a vision, for the supplicant's suffering was meant to move the superior powers to such pity that they had to fulfill his wish. Among the Sioux the lamenter had two assistants who accompanied him on horseback to a lonely hill, on whose summit they erected five long poles, one for each of the cardinal points and one in the center as *axis mundi*. On one level this was a model of the ceremonial lodge; on another, it was the model of the cosmos itself. Each of the poles had offerings tied to the top for the spirits; those on the center pole were intended for *Wakan Tanka,* the Great Mystery. During the day and also at night the lamenter prayed to the spirits, especially the birds, while following a sacred path back and forth between the poles. At last, exhausted and tortured by thirst, hunger, and sleeplessness, he came to rest against the sacred center pole to await his vision. Later the assistants returned to help him home, where he was counseled on the meaning of the experience by the holy man and purified once more in the sweat lodge. In all these rites the sacred pipe played a crucial role. It was in this way that the young man obtained his personal guardian spirit, although among some peoples individual visions were also sought for guidance in war and hunting, mourning, or the naming of offspring. It was from these sublime spiritual experiences that many of the symbols of Plains art first arose. Some became part of the repertoire of the civil, military, and medicine societies; some were used by the owner for his own protection as symbols painted on his lodge, his clothing, and his war shields.

Boys as young as seven or eight could seek a vision, and they could do so again and again throughout their lives. In fact, access to the supernatural through the personal vision quest was open to everyone, and in many cases women as well as men embarked upon this powerful personal encounter with the spirits, especially if they intended to become doctors. If more men than women sought the vision and personal supernatural guardians, it was perhaps in part because women by their very nature as creators and givers of life already possessed some of those sacred and magical qualities which men had to acquire through repeated ordeals. Like Mother Earth, women created life and sustained it: they, in a sense, were the original transforming shamans.

The recruitment by shamans of spirit helpers— or the spirits' recruitment of the shamans—does bear some resemblance to the vision quest: both arose out of the ecstatic-shamanistic substratum that underlies Native American religions and that has its ultimate origins in Asia. Almost universally, the future shaman first learned of his or her destiny when a mysterious illness struck whose supernatural cause was divined by an experienced shaman and whose cure required assent to the supernatural vocation. Preparation for the enlistment of spirit helpers, following rigorous training, resembled in many respects preparation for the personal vision quest. The novice secluded himself and observed food and sexual prohibitions, isolation, and sensory deprivation until at last he fell into an ecstatic trance in which the first of his spirit helpers manifested itself. Most dramatically, the young novice experienced separation of body and spirit, feeling himself rising into the celestial realms, where he was joined by bird spirits, and descending into the underworld, where marine animals and other subterranean spirits became his tutelaries. Sometimes the spirit helpers came unbidden in the shaman's dream or trance and possessed him so as to act through him; many shamans even had spirit wives who visited them at night. The principal difference between the recruitment of personal guardian spirits in the ordinary vision quest and the shaman's acquisition of tutelaries or spirit helpers lay in the spirits' function: guardian spirits protected and guided the individual, whereas the shaman's tutelaries assisted him in his exertions in behalf of patients or the community in which he functioned as diviner and curer of physical and emotional ills, magician and transformer, mediator between the worlds, religious philosopher and guardian of the traditions, and, often, artist and poet *par excellence.*

As a corollary of the universal availability of some kind of immediate spiritual experience in the vision quest, Native American spirituality in general was characterized by a great respect for the validity of everyone's personal pathway to the supernatural. To our knowledge, there is no evidence in North or South America that any Native peoples, even those who were otherwise militaristic and expansionist (the Aztecs, for one), ever tried to impose their particular religious philosophy on anyone else, friend or foe. To the contrary, the Aztecs commonly adopted the gods and rites of peoples they had conquered and added them to their own. All over North America, in fact, individuals and whole societies readily took from others those deities, ceremonies, and sacred objects that seemed particularly

efficacious in curing, bringing the rains, ensuring abundant game or harvests, and generally attracting to themselves the good things to be expected from the superior powers in exchange for the gifts and respect human beings gave to them. It took the white man to bring into the New World the idea of one exclusionist religious truth before which all others had to give way. Historically, the Native Americans themselves followed their own traditional pathways of spirituality and artistic expression but periodically enriched their spiritual knowledge and their symbols by borrowing from their neighbors.

The six areas whose religious and decorative arts are illustrated in these pages—from the semiarid Southwest, with its cultural mix of long-time sedentary, corn-growing villagers and sheepherders, through nonagricultural California and the Pacific Northwest to the Arctic shore, and across the Plains to the eastern Woodlands, with its Iroquois and Algonquian farmers—were selected because they represent most of the principal environments and lifeways of the first inhabitants. They also give a representative cross-section of most of the major styles, materials, and functions of the Native American arts during the past two centuries, from the purely spiritual to decorative but still extraordinarily high-quality art made for the white market. Of course, selection means frustration: lasting reminders of imagination, taste, and skill were produced beyond the environmental and cultural boundaries of these areas that could not be included—the Subarctic, the Plateau, the coast between California and British Columbia, for example, or the Southeast with its remarkably sophisticated tradition of archaeological art reminiscent, in some respects, of ancient Mexico, and its historic cultures that were uprooted and driven west by the relentless advance of white colonization before there was any interest at all in preserving the Native arts for posterity.

But selection, often arbitrary, there had to be, for so great and universal was the compulsion "to beautify the world" among all the aboriginal peoples that for almost every object, big or small, shown in this book there are many others of equal beauty. For the Northwest Coast alone, to mention one case, there are an estimated 220,000 catalogued objects in the world's public and private collections, from halibut hooks transformed by a skilled carver into scuplture in the round to masks and totem poles. The Southwest Museum in Los Angeles alone has more than ten thousand baskets, many of them from California and a majority of them masterpieces of this woman's art by any standard of aesthetics and craftsmanship. The great Datsolalee was the most famous and most accomplished of Washoe basket-weavers (Plate 72), but not every fine basket ascribed to her necessarily came from her hands: there were a few others nearly as accomplished as she whose work she sold to get them higher prices. Shelf after shelf filled with old Pueblo pots, each rivaling those accompanying Chapter Two, line the walls of the Smithsonian's extensive storage facilities. In a sense, all these peoples were societies of artists, for almost everyone participated to some degree in the making of what we now call "Indian art." Thus, to be a woman admired in Plains society, one had to be adept at embellishing buckskin and rawhide, sharing in the accepted canons of beauty and symbol and in the common standards of good craftsmanship, while still expressing one's individual taste and temperament. Girls learned the creative as well as utilitarian arts from their mothers and other female relatives, boys theirs from their fathers. And good design and execution were virtually universal, not exceptions to the rule.

Still, there were everywhere recognized masters of their crafts, men and women whose work was in demand beyond their own needs and those of their own families. The idea of the anonymous tribal artist is in any event largely false, even if their names have failed to come down to us, for they and their works were certainly well known to their contemporaries and often remembered well beyond their death. What is true is that few, if any, Native artists were ever full-time professionals. Even on the Northwest Coast with its great art tradition that often kept master carvers busy for months and years at a time, most artists, like shamans, hunted and fished for their main support. Nor were they "primitive artists," in the sense of a self-taught Grandma Moses; they learned their craft over many years under the tutelage of master carvers.

There are other major differences between "art" in the Western sense and Native American art, or, for that matter, any traditional or "tribal arts." For one thing, frequently the act of making the object, or its use in a specific context, was far more important than the work of art itself. The work might even be destroyed or abandoned to the elements once its purpose had been accomplished, no matter how much effort and expense had gone into its creation. By supernatural sanction, Navajo sandpainting, an ephemeral art form requiring years to learn, had to be obliterated and its materials returned to the natural environment after the curing ceremony of which it was part. In other cases, the art was not even meant to be seen by anyone but the artist himself or the spirits

with whom he was in communication. So, for example, California Indians painted their supernatural visions in hidden caves and rock shelters as far removed as possible from places frequented by other people.

But that was the exception. In its broadest sense and purpose, Native American art was a system of public communication, a means of sharing symbols and meanings, of confirming and reinforcing the traditional system and its values and, by adding the visible dimension of beauty and spirit to even the most mundane of objects, of affirming their animate nature and the bond of reciprocity among human beings, their works, and the natural and supernatural environment.

*Plate 8. Leather case mask of Kokopelli, the Hopi sexual clown, transformer, and guardian of seeds. One of the most powerful fertility figures among all the kachina spirits, Kokopelli is also among the oldest. As a hump-backed flute player, he appears on prehistoric Hohokam pottery of the tenth century and earlier, and in virtually his modern form he is depicted in pre-Hispanic sacred Pueblo murals. (11" high. Private Collection.)*

*Plate 9 (overleaf). Most painted images covering the walls of the sacred rock art site known as Painted Cave, near Santa Barbara, California, are geometric or abstract, but this winged figure seems to represent a flying spirit, part bird, part lizard, part human—perhaps the shaman-artist himself, experiencing his own transformation in an ecstatic trance.*

*Plate 10 (page 23). Northwest Coast transformation mask of a woman with a labret in her movable lower lip conveys an anguished intensity depicting the interplay between life and death. The mask's appearance by firelight in a costumed ritual drama must have been a gripping experience. Masks like this seemed to come alive when worn by a dancer, perhaps a shaman representing his spirit helper, who gave movement to the hinged lip while speaking or singing through its open mouth. (9¼" high. Tsimshian or Haida, British Columbia, 1830–50. Private Collection.)*

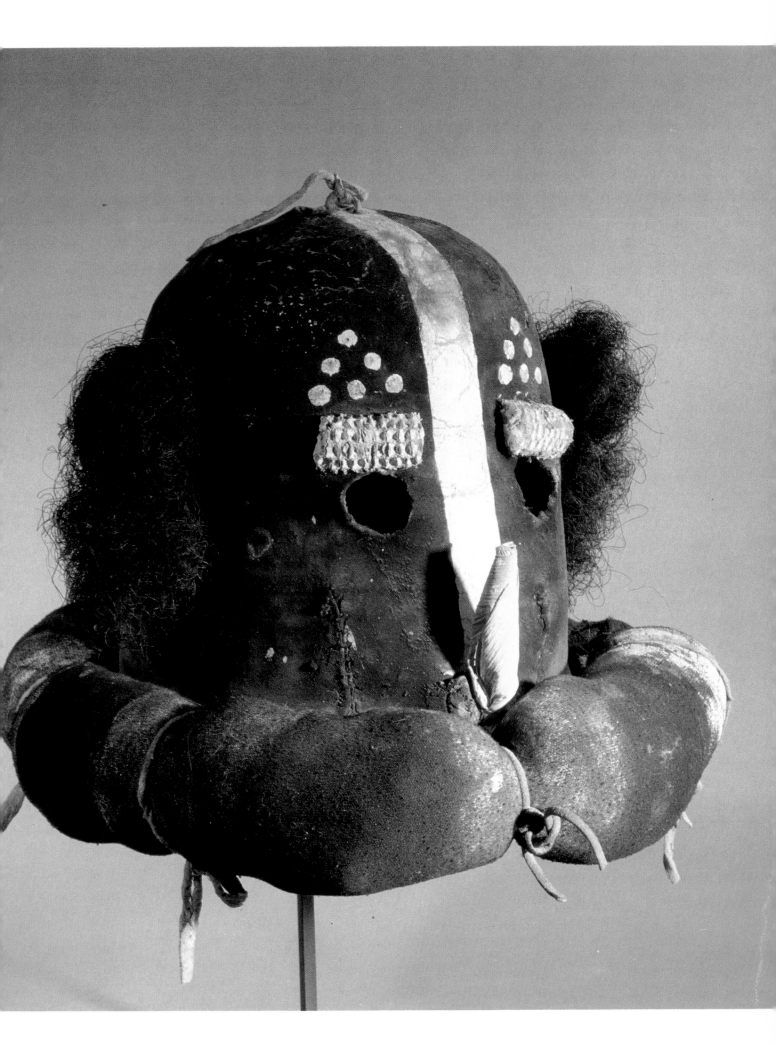

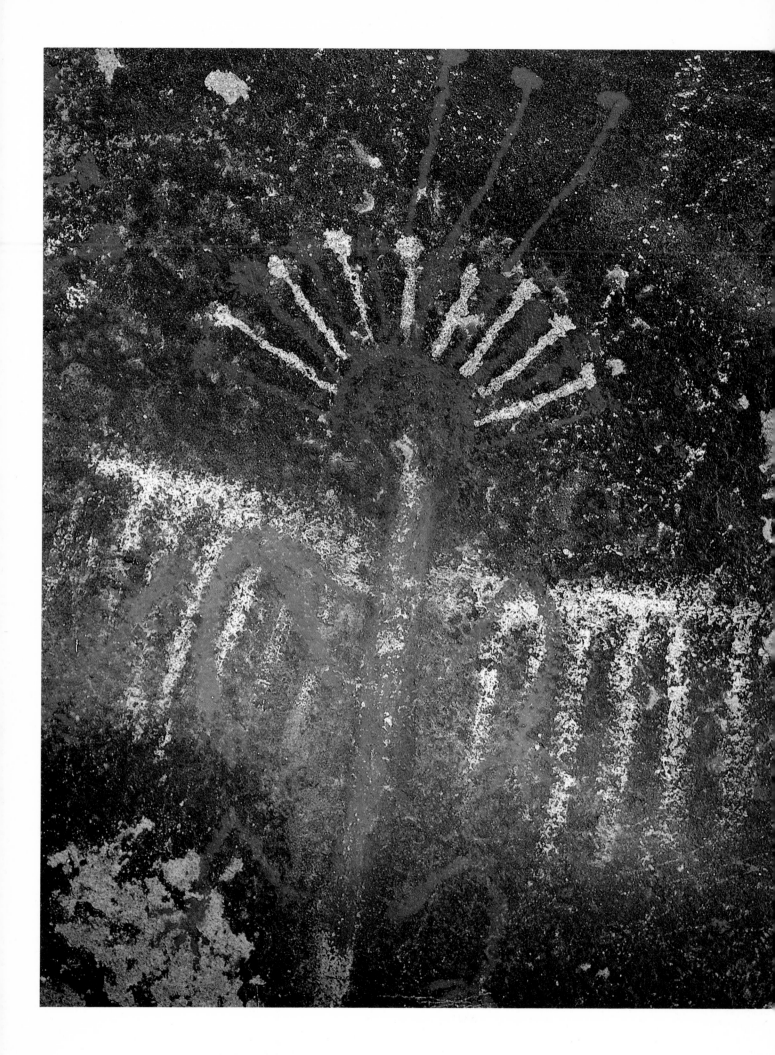

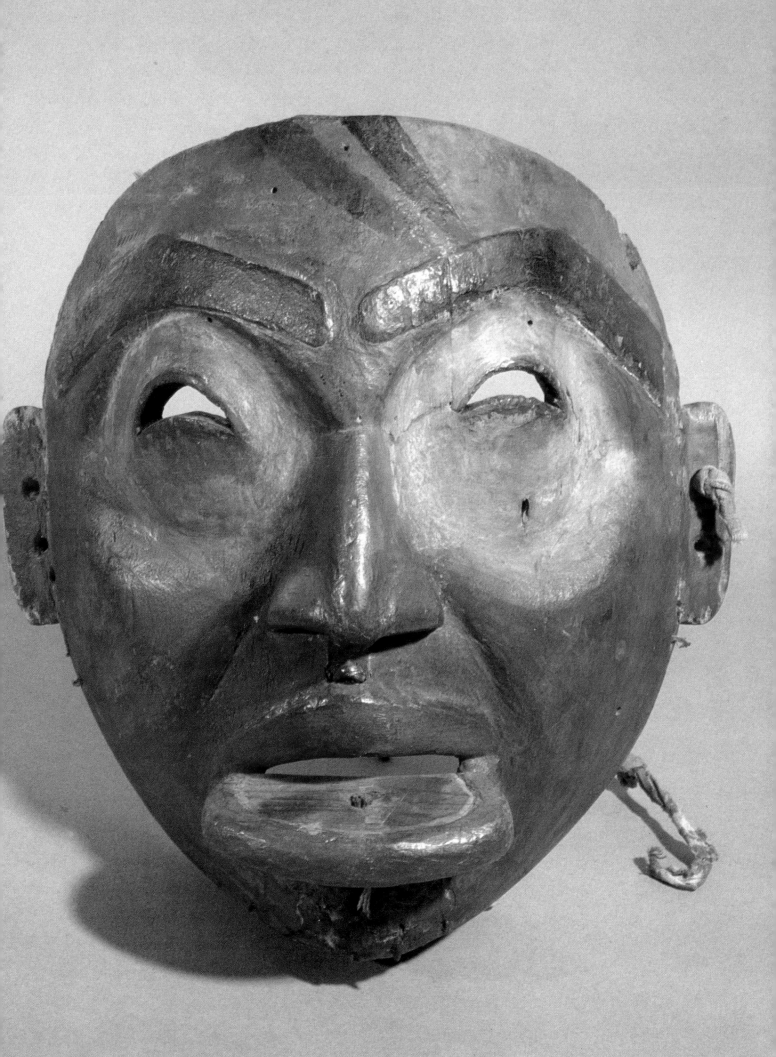

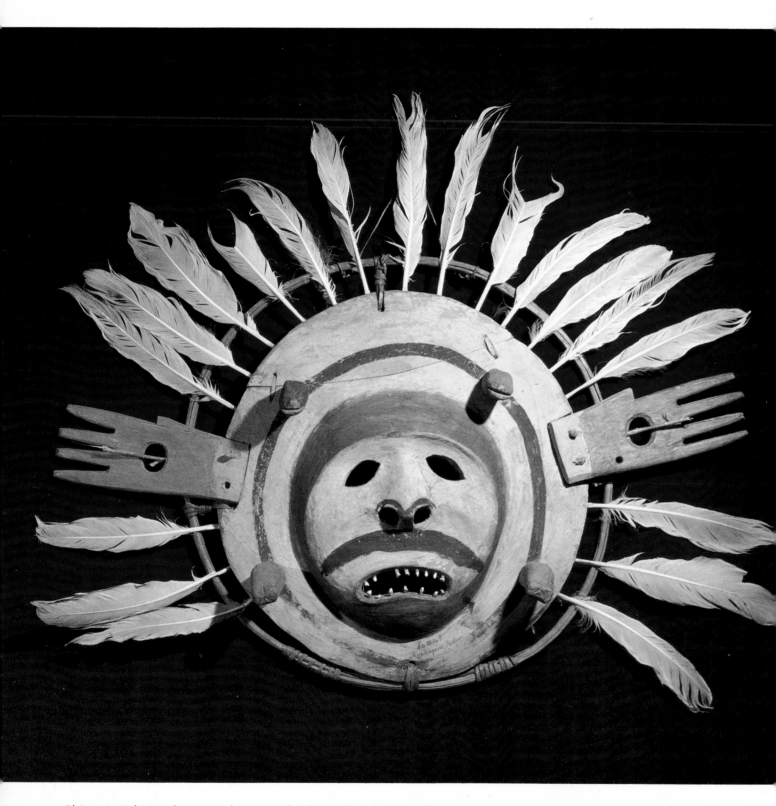

Plate 11. Eskimo shaman's dance mask of a seal spirit, made in southern Alaska over a century ago. The perforations in the flippers, a common Eskimo convention, may symbolize the unimpeded flow of the ocean currents that bring the seals within the hunter's range. The hoop encircling the central element stands for the topmost stratum in the multilevel Eskimo universe, which the shaman traverses in his spirit flights; the sea-bird feathers represent celestial bird spirits. (24" high. Smithsonian Institution.)

Plate 12 (opposite). The theme of metamorphosis is carried by an 1875 catlinite sculpture of a hawk or an owl with a human face. Though monumental in appearance, it is less than three inches high. It was originally part of a musical instrument, a flute stop mounted on a six-hole wooden Plains Indian "courting flute." The Bird Person was presumably the Sioux artist's guardian spirit, acquired on his ecstatic vision quest. (2⅜" high. Collection William E. Channing.)

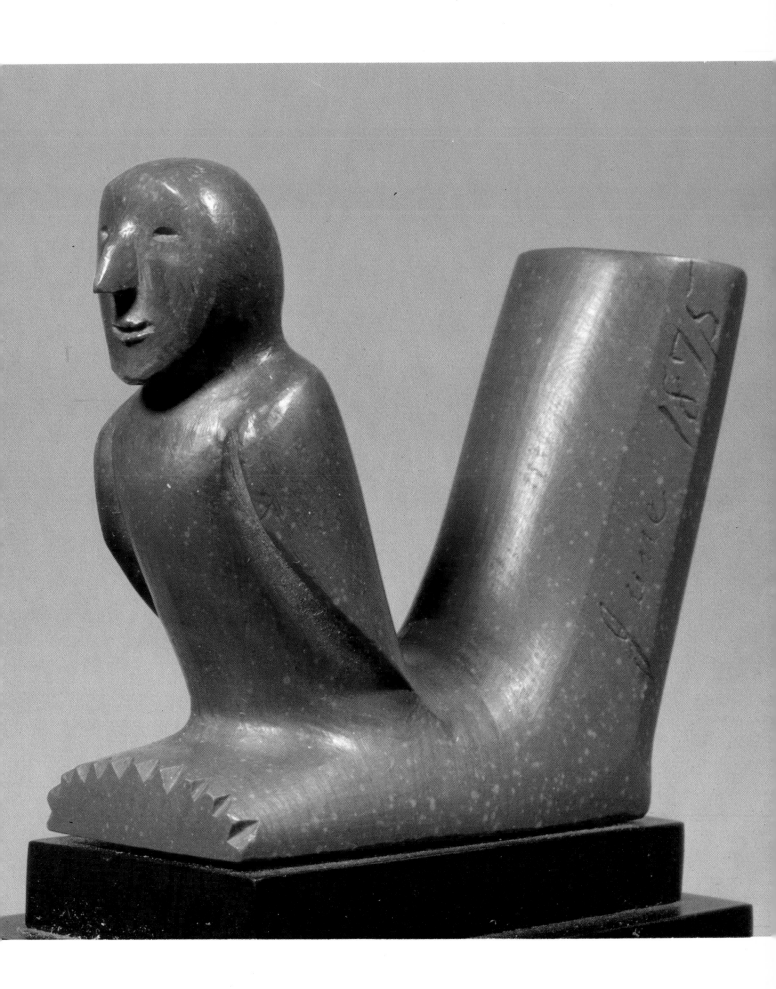

25

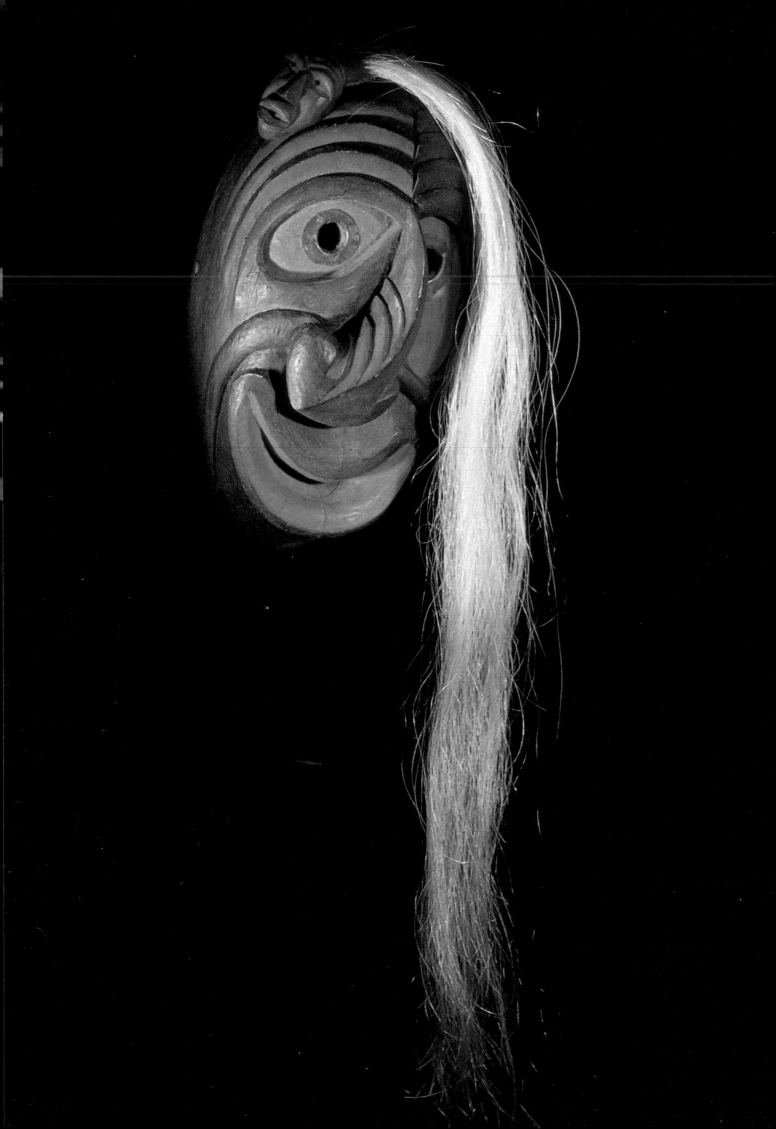

Plate 13. The Iroquois reverently address the wooden Faces used in their Midwinter and curing ceremonies as Grandfathers. Its twisted nose and mouth identify this Seneca basswood and horsehair mask as the Grandfather of all the Grandfathers. It represents Rim-Dweller, the great spirit at the edge of the world, whose face was permanently twisted in a collision with a moving mountain. Rim-Dweller is the patron of the curing Faces worn to this day in traditional Iroquois rituals. The small image on the forehead is a miniature guardian mask. (11" high. Allegheny Reservation, New York, 1920–25. Private Collection.)

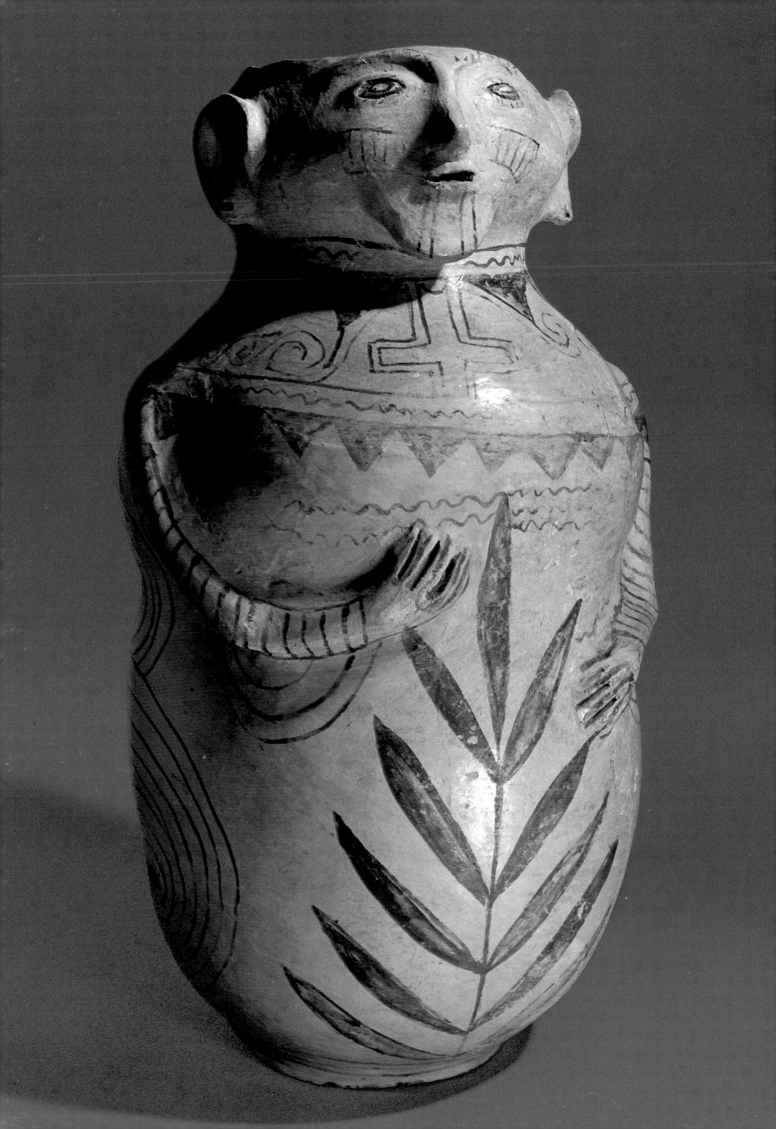

# Arts of the Southwest

## Kachinas: Hopi Spirits of Life

Just before dawn on a recent midsummer morning, a Hopi mother was heard to call, half in English, half in Hopi, from one of the flat-roofed stone houses lining the plaza of Shungopovi, on Second Mesa, Arizona: "Wake up, children, wake up! The kachinas are coming, the kachinas are coming!" It was the day of the Niman, the final ceremony of the kachina season, when Hopi villagers bid farewell to the masked spirits of life that have once again brought them the blessings of rain and growing corn. On the roofs above sat captive young golden eagles awaiting sacrifice so that they might hurry as messengers from the people to the world of spirits. Below, the children poured out of the houses, rubbing the sleep from their eyes to stare in silent awe and expectation as a long line of figures appeared at the lower end of the plaza, masked and costumed in the manner of the kachinas painted on the walls of prehistoric kivas, bearing gifts of new corn and squash and small carved replicas of themselves as gifts for women and children. Thus the kachina spirits continue to fulfill their ancient promise to return with blessings of life, as they have done for a thousand years, and as they will do the next season and the one after, for as long as there are Hopis.

The colorfully painted wooden effigies of the kachinas, the so-called kachina dolls, have been a popular form of Indian folk art for nearly a century, collected by tourists and museums alike,

*Plate 14. With its plant symbolism and its curiously haunting face, suggesting prehistoric effigy pottery, this tall, buff-colored Maricopa storage jar from Arizona, made about 1910, may represent a vegetation spirit or guardian of water plants. (18" high. Private Collection.)*

often without consideration of their real meanings to the Hopis and other Pueblo Indians who participate in this pervasive and very ancient religious cult and in its public and private art (Plates 1, 15, 20–25).

The Hopis live on three flat-topped mesas north of the Little Colorado River in northeastern Arizona (Plate 16). They speak a language distantly related to those of the Aztecs, to the south, and of the southern California Indians to the west. They divide the year into two ceremonial halves, a "winter" season, from about the middle of July to mid-December, and a "summer" season, from December to July. As a whole the year represents an unending cycle of birth, death, and rebirth. The winter season begins after the summer solstice and coincides with the summer rains and the harvest. It is also a time of death—the death of the sacred food plants, which give their lives to feed the people, and the seasonal death of other vegetation. The Hopis, unlike the Pueblos of the Rio Grande in New Mexico, are not even nominally Catholic, and so their ceremonies, unlike those of the Rio Grande peoples, reflect not varying degrees of accommodation between Indian and Christian but belief and custom that go back to pre-Columbian times. In the winter season, the religious ceremonies are held in the kiva, which is partly below ground and represents the underworld from which the Hopis believe their people emerged in primordial times, and where the germinator deities have charge of the new food plants of the coming season of growth. This season ends with the winter solstice, the kindling of New Fire in the kiva, and the initiation of the young, who symbolically die as children and are reborn as full-fledged members of Hopi society, just as the new beans and corn are reborn from their own seeds. The summer season that now commences is the time of the kachinas.

Kachinas as supernaturals are perhaps best understood as energizing spirit essences, the

noncorporeal counterparts of physical phenomena in the Hopi universe. Hopi dead join the kachinas, appearing as rain clouds drifting through the sky; thus the dead themselves are among the principal rainmakers, remaining forever vital components of Hopi life. Not only clouds but steam, rain, geological features, heavenly bodies, wild and domesticated animals and plants, birds, insects, historic personages, and even gods may be personified as kachinas. So may more abstract concepts, such as germination and growth. Nor is the system static. New kachinas are added, others disappear. At present the total number of kachinas is about two hundred and fifty.

The kachinas have distinct but interdependent manifestations—first, as spirit beings; second, as the physical counterparts of the spirit when they are given substance and personality through masks, costumes, paint, symbols, and actions by human impersonators, who thereby cease being ordinary people and are transformed into spirits; and third, as the small wooden effigies called *kachin-tihus* by the Hopis and kachina dolls by outsiders. The effigies are not dolls in the conventional sense, however. They are carved by Hopi men from pieces of cottonwood root collected from gullies or purchased. The carvers give careful attention to the distinguishing details of mask, costume, and colors. On special occasions the *tihus* are presented to infants, children, or females of all ages to familiarize them with the kachinas' characteristics. In this sense they function almost as educational toys. After the wood has been dried and seasoned and cut to the desired length, the carver outlines the rough shape of the *tihu* with a hand saw and then sculptures the doll, first with a hatchet and then with a succession of chisels, knives, and wood rasps. Arms and some details of costume are carved separately and attached with wooden pegs and glue. After sanding the *tihu* is primed, formerly with a fine clay paste, now with commercial gesso. Paint has also undergone considerable change. Old *tihus* were painted with mineral and vegetal colors. Inks and oil paints introduced by traders earlier in this century were judged inadequate, but opaque watercolors and poster paints found ready acceptance. More recently, acrylic paints have increasingly replaced the opaque watercolors, even though the latter most closely resembled the former natural paints in texture and hue. Color, of course, is of great importance to the Hopis, who associate specific hues with each of the six cardinal directions: most commonly mentioned are white with east, blue or green with west, yellow with north, red with south, black with the zenith, and gray with the nadir. Thus, along with its other characteristics, the colors of a *tihu* may indicate not only its functions in the seasonal and ceremonial cycle but also the directions with which it is associated.

Kachina dolls are not only instruction for Hopi children but are also meant to assure to the recipient the benefits of intimate association with the Hopi supernaturals. This is why Hopi children even today refuse to part with *tihus* they have received as ceremonial gifts from masked dancers, whom they may or may not have recognized as their fathers, uncles, or brothers, but whose human personalities are immaterial during this sacred time, when they have been supplanted by the spirits.

Neither the *tihus* nor the kachina spirits they represent are worshipped as idols, saints, or deities; rather, they are generally welcomed and treasured as powerful friends and guardians who bring gifts of rain, crops, bird songs, flowers, summer greenery, happiness, health, and long life. Some, particularly the "ogre kachinas" (Plate 23), occasionally serve the sterner role of scaring recalcitrant children into obeying the rules of life by threatening to kidnap them, to be eaten. The model of an ogre kachina might have been a real person who presented a threat to the people in the past; yet no ogre kachina may touch a child lest the youngster become too terrified.

If kachinas are not gods in the true sense, the dividing line is not always very clear. There are kachinas who function on both levels, as intermediaries between human beings and the gods, and as deities with a decisive influence on human, animal, and plant life. Ahöla (Plate 22), for example, has such a dual role through his close identification with the sun and the germinator gods Alosaka and Muyingwa. He is also one of the Hopi supernaturals who can be definitely traced to prehistoric times, for his characteristic divided mask, with its black inverted triangle and its crosses, is among those found in a kiva mural in the ruins of Awatovi, not far from where the Hopis live today. Ahöla makes his first appearance in December, when he inaugurates the new kachina season by ritually opening the kivas in anticipation of the impending return of the supernaturals to the Hopi villages from their winter homes in the San Francisco Mountains, near Flagstaff, to which they will return after the summer solstice. Ahöla makes the rounds of all the clan houses and invests the women's seed corn with fecundity and strength for the growing season. Before departing he offers prayers to the sun for an abundant harvest, long life, health,

and happiness for the Hopi people.

Another kachina who is also a deity, to many Hopis the most important of all, is Masau'u (Plate 15). More than any other member of the Hopi pantheon, this old earth and fire god embodies the essential complementarity of phenomena the western world generally regards as opposite. Masau'u is at once the giver of life and benefactor of the Hopis, to whom he awarded their lands in ancient times, and the master of death; he is the divine guardian of the fertile surface of the land as well as of the underworld and the deceased. He guards the subterranean passage of the souls of the dead to the land beyond, and, conversely, the road of the kachinas from the San Francisco peaks to the Hopi mesas, where they emerge through the hatchway in the roofs of the kivas. Because death is always present, Masau'u alone remains in the villages when the other kachinas bid farewell in July. As dread god of death he is the opposite of living things; he may actually walk backwards and reverse his speech. He is also the patron of the Kwanitaka, the One Horn Warrior Society; the members serve as guardians against witches, guides of the souls of the dead to the underworld, and protectors of the young novices in the Wuwuchim initiation rites in November near the end of the winter portion of the ceremonial year that foreshadow the new season of life. As guarantor of new life, fertility, and abundance, Masau'u is present at the making of the New Fire. This presence is also required at the sowing of the new corn and at its harvest. But agricultural activities belong to women, the owners of the fields, springs, and houses. Accordingly, Masau'u embodies female as well as male aspects, symbolized by the clothing in which he is represented as kachina doll and in which he makes his appearance in the villages: cape, wraparound blanket dress of rabbit fur, sash with designs representing the falling rain (male) and the fertile earth and vegetation (female), a fox skin in back that all kachinas wear in memory of the time when humans and animals had the same form, and dance moccasins. Like the women in the kachina ceremonies, he bears a basket tray containing food for the young people, to remind them that it was Masau'u who gave the Hopis their most ancient foods. The kachina's goggle eyes and protruding teeth, shared with the old Mexican earth and rain god Tlaloc, are said to represent the aspect of death in the death/life equation this complex deity embodies in Hopi thought.

The appearance of the *kachin-tihus* has undergone considerable change since they first caught the eye of collectors in the last decades of the nineteenth century. Early dolls are generally blocky, expressing little motion, resembling the kachina-like wooden pre-Columbian altar figures that have been found in several prehistoric Pueblo sites (Plates 18–19). With time, and in response to a lively demand for Indian arts and crafts, kachina dolls have become more and more naturalistic, leading to the modern "action doll" that depicts the masked kachina dancer in dynamic motion (Plate 1).

A question that has never been answered satisfactorily concerns the antiquity of kachina dolls as religious art. The kachina cult itself is obviously pre-Columbian. It is widespread among the Pueblos, and even the Navajos were influenced by it. Zunis and Hopis, in particular, have a number of kachinas in common, although the ancient dolls of the Zunis were easily distinguished because details of their costumes were often made of cloth or leather, not painted; their arms were sometimes movable; and they were frequently festooned with all sorts of extra details, such as rattlesnake rattles, bits of turquoise, and hair (Plates 20 & 25). Yet there is little evidence for kachina dolls prior to the latter half of the nineteenth century (Plates 21 & 24). This has led to speculation that this art form owes something to the carvings of Catholic saints, common in Southwestern Spanish-American culture. However, the masked kachinas bear no resemblance to saints. Others believe that the proliferation of kachinas toward the end of the century was solely a response to the growing interest in the Hopis on the part of anthropologists, museum collectors, traders, and tourists. It is true that traders prevailed upon the Hopis to carve dolls specifically for sale. But if the practice of carving effigies of the kachinas in large numbers is, in fact, a late-nineteenth-century phenomenon, perhaps there is another, more profound explanation, one that has to do with the Hopis' sense of self-preservation.

It was in the late nineteenth century that the Hopi lifeway came under the most determined foreign assault, an effort at forced acculturation to the white man's world that dwarfed anything the Hopis had ever experienced and that was first of all directed at the children. Children were forcibly removed from their parents, even kidnapped, and imprisoned "for their own good" in distant boarding schools under conditions that shocked many contemporary white observers. The white schools forbade them to use their native language and prohibited contact with their families for years at a time, to make the children forget their traditional culture and religion. Only occasionally were the Hopi children permitted to

go home for summer vacations, during which the parents tried desperately to undo the damage of deliberately induced alienation. Perhaps the carving of *kachin-tihus* and their presentation to the children on the occasion of the farewell to the kachina spirits were an effort to make the children know where they belonged, to remind them of the rightness of the Hopi way and of the benefits of the kachinas, as much as they were a response to any foreign stimulus.

Be that as it may, a hundred years later, rare is the Hopi house that does not have a few *kachin-tihus* hanging from the walls or rafters, and rare the child who does not invest some of his or her emotions in these household effigies of the Hopi spirits of life.

# Baskets: Oldest Art, Woman's Art

A long time ago, as the Navajos tell it, a woman was seated beneath a juniper tree weaving a sacred wedding basket (Plate 28). She had just completed the spirit path, the break in the mountain design by which the gods travel back and forth between this world and the lower world, and was about to start on the rim when the Hunting God, Hastseyalti, appeared and threw a juniper sprig into her basket. She understood this to mean that the god wished her to weave the medicine power of the juniper into her basket. This she did, by braiding the pattern of its folded leaf into the rim. Ever since, Navajo women, and also the Utes, Paiutes, and Apaches, who weave the same sacred bowls for use by Navajos, have finished them with a herringbone pattern.

The Indians' belief that basketry has been around almost as long as human beings—that this was one of the arts the gods taught women at the very beginning—is understandable. Basketry is one of the oldest of human arts, almost as old as toolmaking. In North America there is evidence for basketry eleven thousand years ago, before mammoth and other large Pleistocene game became extinct. In contrast, the oldest pottery anywhere in the New World has a history of just over five thousand years. Basketry is also basic to other arts. It is on the techniques and patterns of basket-weaving that the textile arts are based; indeed, basketry is rightly called a "textile art without machinery." Even pottery is based on baskets, and some of the oldest pots were actually pressed into basket molds.

In the Southwest, all the major basket-weaving techniques—wicker, plaiting, and, most impor-

tant and widespread, coiling—had been perfected a millennium before 1540, when Coronado came looking for his mythical Cities of Gold and the Spanish priests for souls to recruit to the foreign religion. Indeed, it is not always easy to distinguish by technique alone which is a well-preserved prehistoric Anasazi basket and which a well-used one made in the nineteenth century.

The sacred wedding tray of the Navajos, which has several functions in other ceremonies as well, has its counterpart in the flat coiled Hopi "wedding plaque," without which a Hopi man from Second Mesa would have difficulty being admitted into the underworld at his death (Plate 26). The plaque, called *po-ta* by the Hopis, is one of several kinds of coiled basketry that only the women of Second Mesa still weave today. It is distinguished from other Southwest basketry by its much thicker coils of shredded yucca or grass, only one or one and a half to the inch, and by the very tight sewing of fine yucca splints over the foundation. Except for occasional reinforcement with a commercial dye, the colors are of vegetable or mineral origin; the designs range from geometric representations of the four world quarters or clouds and rain to life forms and kachina spirits. Crow Mother, the mother of all the kachinas, with her distinctive crow-wing headdress, is the most prominent of the kachina spirits represented (Plate 26, left; see also Plate 21). From the symbolic point of view, the flat plaques are the most interesting. Not only does the sacred plaque replicate the flat earth disk, the Middle World on which the Hopi people live, but the coil, more than just a function of basketry technology, can be read as the most ancient and sacred history of the Hopis: their circular migration from the *sipapu,* the cosmic emergence hole in the center of the earth, to the horizons of the four world quarters, and back again to their point of origin, near which, at the behest of their gods, they established their first villages.

Pottery and, more recently, metal progressively reduced the need for basketry among the Pueblos of New Mexico and Arizona. The true inheritors of the fine old Anasazi basketmaking tradition were the Pimas and Papagos of southern Arizona, the western Apaches, and some smaller Yuman-speaking tribes. Both the Pimas and the related Papagos employed a variety of basket-making techniques for mats, storage bins, granaries, and shamans' baskets. But it was in closely coiled food bowls and winnowing trays of great strength, durability, and dynamic designs that women really came into their own as consummate artists (Plates 27 & 30).

In utilitarian and ceremonial Pima basketry,

the traditional design motifs known as the fret and the terrace, alone or combined with variations of the whorl, spiral, rosette, or cross, are not only the most common but the oldest as well, inspired in part by decorations on prehistoric Hohokam pottery found in Pima and Papago country and presumably also used by the ancient Hohokams in their own basketry. The triangular whorl, seen in Plate 27 on a large tray of a type used both for food and, turned upside down as in the Navajo wedding tray, on a shaman's basketry drum, may have three to five triangular arms extending from the base, with a corresponding number of triangles extending downward from the rim. Although even before 1900 most Pima basketmakers were following well-established abstract design traditions of which the original meanings had long been forgotten, the triangles elongated into whorls on this and similar baskets would probably have been identified as *martino*, the "devil's claw" (*Martynia proboscidea*) motif. This hardy desert plant furnished the black splints for designs on both Pima and Papago baskets, and it provided by far the toughest and most durable basketweaving material in the whole Southwest. *Martynia* grows wild, but the Pima and their neighbors also seeded it in their fields. The long, elliptical pods, harvested in the fall when the seeds have ripened, are distinguished by pairs of tough, slender hooks sometimes more than a foot in length. From these the weaver strips black splints and soaks them to make them pliable. This is done at the sacrifice of precious water; the Pimas once had plenty for farming and drinking, but they have been desparately short of water since the nineteenth century, when the white man diverted their traditional supply from the Gila and Salt rivers for his own use. The *Martynia* pattern was basic, but at the turn of the century Pima women identified other favorite patterns as "juice falling from saguaro fruit," "coyote tracks," "turtle," "deer in woods," and *tasita,* or swastika, referring to either stationary or whirling crosses with horizontal arms of equal length (Plate 30). Except for the swastika, however, most such designs were too stylized to be readily recognizable.

A new basket form that appeared toward the end of the last century was the flat-bottomed bowl of the type depicted in Plate 30. Though inspired by white taste, such forms were made for domestic use as well, probably as trinket boxes, with abstract designs adapted from the traditional shallow food bowls and also with the life forms favored by collectors. The juxtaposition of bold black swastikas with horses, or of people with horses and even camels (unsuccessfully introduced into the Southwest in the 1800s by the U.S. Army), as on the shallow tray and the large bowl shown in Plate 30, represents a late-nineteenth-century departure from traditional conventions. However, free-standing figures, perhaps of spirit beings, were used on earlier Pima ceremonial baskets, and repeated life forms also occur on prehistoric Anasazi basketry.

Skilled as the Pimas were in the art of basketry, it was the western Apache woman who emerged as queen of Southwestern basketmakers, with a truly splendid inventory of dynamic designs that has no equal outside of California. Two forms predominate, shallow trays or bowls (Plate 29), two to four inches deep and anywhere from ten inches to two feet in diameter, for ceremonial and practical use, and large storage jars that sometimes approach the monumental (Plate 31), ranging from fifteen inches in height to two and even three feet. Apart from their obvious utilitarian functions in the gathering and preparation of food, the bowls came into their own as sacred symbols during the puberty ritual for girls, a communal celebration that transformed the maiden temporarily into White Painted, or Changing, Woman, divine mother of the Apache culture hero Monster-Slayer, whose father was the sun. Changing Woman, of course, is the holy earth, whose blessings radiated outward from the pubescent girl as mother-goddess incarnate into the whole society. During these rituals, which lasted four days, the finest baskets were used, and new ones were made, to be heaped full of ceremonial foods, tobacco, and sacred cattail pollen, symbol of fertility and plenty. Complexity and beauty of design, however, are no certain evidence of a basket's ceremonial function, for even baskets normally used in food preparation were likely to be superbly decorated. Besides, baskets easily passed back and forth between everyday and ritual use, there being no sharp dividing line between them. For example, at the conclusion of her puberty celebration, the maiden would scatter pollen from a basket over the guests, taking special care to bless the children; she would later use the same basket for winnowing.

The foundation of Apache baskets typically consists of three slender, supple rods of willow, cottonwood, or sumac, with the same material used for the binding. Four or five coils and about twelve fine and even stitches to the inch were the norm. The black designs were made with the same plant material used by the Pimas and Papagos, the seed pod of *Martynia,* or devil's claw. The red dye occasionally seen in Apache as well as Pima storage jars (Plate 27) came from yucca bark. Apache bowl designs, like those of the

Pimas, start with a black element in the center, often a star. The designs are all-over, well integrated, animated, and often very complex, always in perfect or near-perfect balance. Life forms include men and women, horses with and without riders, dogs, deer, birds, and what appear to be spirit figures. However, purely geometric designs appear to predate the use of natural forms.

# Textiles

Although basketweaving and the weaving of spun textile fibers are based on the same general principles and techniques, the latter is much more complex, requiring manipulation with some mechanical device, however simple. By A.D. 500, Anasazi weaving techniques had advanced to the point where footwear and bags woven of finely spun yucca or *apocynum* (dogbane or Indian hemp) cordage resemble finely spun and woven cotton in quality. Agave fibers were similarly used. By Pueblo III, about A.D. 700, the Anasazi had the simple upright loom, consisting of two vertical poles supporting horizontal bars at top and bottom, perhaps invented locally, perhaps introduced from Mexico. The warp, or foundation (comparable to the coil in basketry), was tied to the upper and lower poles, the weft material woven over and under from side to side. It was on such a simple vertical loom that an ancient Anasazi weaver, some eight centuries ago, produced the fine polychrome blanket pictured in Plate 32, one of very few to have survived in almost pristine condition from the prehistoric Pueblo period. Far from being simply a practical craft, weaving involved (and in places still involves) much sacred symbolism that tied it specifically to the woman as weaver of the thread of life, which is why the Moon Goddess is commonly the divine patroness of the art of weaving. It was certainly a sacred occupation among the ancient Pueblos, for the vertical loom was usually set up inside the kiva. But here men, not women, would have to have done the weaving, and, indeed, this is still the custom among the Pueblos, at least for weavings that are used only ceremonially, such as the sashes worn by kachina spirit impersonators.

In addition to the upright loom, early weavers also used the backstrap loom, one end of which is tied around the weaver's waist and the other attached to a beam or tree. Not nearly so simple in construction as it may appear, the backstrap loom produced narrow lengths of cloth—used for headbands, belts, and breechclouts, for ex-

ample, or for the ceremonial kilts and sashes worn by the kachinas. It is a very ancient weaving instrument, common to both hemispheres at least two thousand years ago, a distribution that has naturally raised questions of independent invention versus long-distance transoceanic diffusion.

Cotton came into use in the Southwest on a limited scale some two thousand years ago, but even after it was grown and processed to a significant degree, other plant fibers, and even feathers, rabbit fur, and mountain sheep wool, continued to be used. True wool weaving, however, did not begin until much later, when Navajo women, and some men, emerged as the master weavers of the nineteenth century.

The history of Navajo weaving should properly be counted from the first introduction of sheep-raising into New Mexico by the Spanish, around A.D. 1600. At some point during the seventeenth century, the Navajos—then still known to others as Apachü, a Tewa word meaning stranger or enemy, or Apachü-Navajo, but to themselves, as today, *Diné*, people—adopted sheep-raising, certainly for meat, possibly for wool. If they had not already learned to weave by then, weaving was certainly taught to them by the Pueblo Indians who sought refuge in Navajo strongholds of northern New Mexico following the unsuccessful united Pueblo Rebellion against the Spanish in 1680.

Early Navajo weaving was restricted to the natural colors of sheep's wool: white, black, and brown. Most blankets were striped, on the prehistoric Pueblo model, but designs were also inspired by Mexican serapes and blankets made in Saltillo and Oaxaca. Beginning in the early nineteenth century, new materials were introduced, especially *bayeta,* a baize flannel-like cloth imported by Spain from England and then exported to Mexico. Navajo women, in turn, unraveled, respun, and dyed it red with Mexican cochineal for use in combination with their own coarser homespun wool yarn. Other popular dyes introduced at this time were a deep indigo blue, maroon, purple, pink, green, and yellow, but red was decidedly preferred. Brightly colored European yarns and the distinctive red yarn produced in Germantown, Pennsylvania, soon came into use. In fact the Navajos not only purchased or, more often, traded for commercial yarns but recycled all kinds of other materials; for example, they unraveled red flannel underwear and yardage, old uniforms, and Army blankets. Some yarns were acquired already dyed, others the Navajos dyed themselves, initially with natural colors, then increasingly with aniline dyes. A great

many fine old Classic blankets of the second half of the nineteenth century were made with either aniline colors or aniline in combination with natural dyes, an important point because some people believe that commercial dyes disqualify a Navajo weaving from being included in the first rank (Plates 33, 34, 37).

The Classic period itself should probably be counted from the beginning of the nineteenth century because blanket fragments from a cave where Spanish soldiers massacred a party of Navajo men, women, and children in 1804 are very similar in design to the striped blankets produced around 1850–60. After 1850, and especially around 1870–80, Navajo women were weaving fine wearing blankets not only for themselves and for sale to whites but for sale or barter to other Indians. The so-called chief's blankets were especially popular with Cheyennes, Sioux, and other Plains peoples, being the best known of the Classic-period textiles (Plate 33). As late as the turn of the century, there were still Navajos who produced many excellent blankets, but, through the influence of traders and the need for steady sources of income, Navajo weaving was becoming increasingly commercialized. It was at this time that the old wearing blanket—even the chief's blanket—became a rug, for this was what the market wanted. And it wanted it not in the traditional styles but with borders, previously completely unknown, and in designs based on, among other non-Indian models, Oriental rugs, pictures of which were supplied by traders. However, Navajos would not have been Navajos had they simply copied. Invariably the artists took the foreign designs and experimented with them until they had produced something entirely new, more suited to the Navajo taste.

Still, commercialization inevitably resulted in an over-all loss of quality, even though some early traders—J. B. Moore at Crystal, for example—went to great lengths to encourage preservation of the old high standards. Moore even shipped wool back east for processing, supervised the dyeing personally, and commissioned only the best weavers to produce rugs in traditional as well as innovative designs. Unfortunately, the general policy of traders around the turn of the century to pay for rugs not by size but by the pound was bound to lead to degeneration, for the Indians were not slow to perceive that it was more profitable to make rugs as heavy as possible with coarsely spun wool than to produce tightly woven textiles with finely spun yarn. With some exceptions, mediocrity became the rule for several decades, until 1938, when the traders William and Sally Lippincott at Wide Ruins sponsored a vigorous revival of weaving in subdued earth tones and refused to purchase any rug made with garish dyes, poor workmanship, and, above all, borders (Plate 35). Nearly fifty years later, "Wide Ruins" is still a magic phrase in modern Navajo weaving, although rugs of equal quality are now produced in other centers on the Reservation.

# Sacred Sandpainting

In 1919 a respected medicine man named Hosteen Klah, "Left-Handed," occasioned much grumbling among his fellow Navajos and, some thought, but for his great prestige might even have put his life in danger by combining his extraordinary talents as a weaver and his ceremonial knowledge to produce a large sandpainting tapestry, as fine as any of the early Navajo blankets. This violated a cardinal rule: that sandpaintings (Plates 38–41) depicting the magical deeds of ancient heroes and the Holy People must be obliterated at the end of the curing ceremony in which they were used, and must not be made permanent. Hosteen Klah himself had thought long and hard before agreeing to weave a sacred sandpainting and did so only after he had assured himself that it would never be placed on a floor where people would walk over the Holy Beings but would surely be hung on a museum wall.

That Hosteen Klah had the skill to translate his ritual knowledge of the sacred male art of sandpainting into the woman's art of weaving, and that he could do so without harm, were due largely to his unique status as *nadle*, man-woman, a condition that in Navajo society confers prestige and sacred power. Hosteen Klah went on to make several more of his splendid pictorial tapestries, initially alone and later with his nieces, weaving the last one in 1930. All are now museum treasures (Plate 42).

By Hosteen Klah's time, weaving had long lost whatever sacred significance it may once have had among the Navajos, beyond the generalized one of beautifying the world. But sandpainting was another matter; it was pictorial prayer which, by depicting the Holy People, the gods, in a beautiful way, enlisted them in restoring health, harmony, and beauty to life. The Navajos call this condition *hozho*. *Hozho* is not only desirable; it is the natural condition of the world, the condition which must be restored if self, society, or environment has become unbalanced, ugly, or disharmonious. Song and art will bring this about or, where it already exists, reinforce it. This is why the Navajos have blessing and curing

rites for everything—people, places, houses, crops, livestock, the opening of a store, mental and physical illness, a young man leaving to join the army or returning from the outside world. Ritual song and ritual art recreate the world as it was in primordial times. Whatever needs to be set right is placed in the sacred center of the miraculous events of the mythic past, a time when everything was possible, a time when the Holy Ones, the benevolent gods, and the Hero Twins, children of Father Sky and Mother Earth, battled and vanquished the forces of darkness, evil, and disharmony and received all the sandpaintings and all the curing chants the medicine men use today. Sung into the living present and depicted in ritual art, the Holy Ones and their deeds generate a positive charge that drives out the abnormal state of ugliness and imbalance and restores the natural state of harmonious beauty. In the context of ritual, then, pictorial art functions in a special, sacred way, uniquely Navajo. The spirits enjoy seeing themselves depicted with technical skill and pleasing symmetry. But the two-dimensional depiction of the mythic past also helps blur the boundary between sacred history and the living present, as does the accompanying chant. Both have the same aim: to restore harmony.

The creation of a sandpainting is not an isolated act but part of an extended ritual, sometimes lasting as long as nine days. The ceremony is requested by an individual or the family of an individual who suffers from a disease or from a feeling of general malaise and being out of balance with himself, others, and the world. Sometimes a curing will be requested not to drive out illness but to secure a benefit—protection on a journey, for example. The one who wishes to be "sung over" first goes to a diagnostician to determine the cause of his trouble. For the Navajos every illness has a spiritual as well as a physical dimension, and to attempt to cure one while ignoring the other would be useless. Once the spiritual cause, which may lie far back in an individual's history, has been discovered, the diviner prescribes the appropriate ceremony or chant. The patient then seeks out a singer who knows the proper songs and paintings.

Shaman-singers must spend years learning the curative ceremonies, which consist of a series of interrelated ritual acts and accompanying songs. The sequence of actions is rigidly set, any deviation rendering them useless and even dangerous. In all, about two dozen chants exist, each with hundreds of individual songs and some four or five hundred sandpaintings that accompany them. The Hail Chant, for example, which confers power against diseases caused by frost, is one of the shortest and yet has 447 songs!

The shaman-singer having been selected, the time for the ceremony is set. The patient provides the assistants to help in making the sandpaintings and with the chanting. The family of the one-sung-over must provide food for all, for these cures are occasions for the gathering of family and friends who wish to receive the spiritual benefits of attendance. The family also pays the singer, who adjusts his fees according to their means. No one goes without treatment for being poor.

The complex preparations for the ceremony, held in a specially consecrated hogan—the traditional eight-sided dwelling—are intended to purify patient and participants and to strengthen them for their impending encounter with the spirits. Decorated prayer sticks and gifts of tobacco, food, and turquoise are placed in front of the hogan so that the Holy People will see them and be pleased. The ceremonies of the first night are repeated on three successive nights, becoming longer and more complex each night. The patient is instructed in the sacred lore, administered medicinal herbs, and purified with a sweat bath. On the fifth day the making of the first sandpainting begins, so that the patient may absorb its curative powers and, in turn, shed the forces of evil and illness. By nightfall the sandpainting must be obliterated and the sand, which has soaked up the negative forces, must be carefully restored to nature.

The painting is created with finely pulverized stone and natural pigments. White pigment is obtained from ground rock, yellow and red from ochres, and black from charcoal. Pink, used for "sparkling," is a mixture of red and white pigments; blue is made from white and charcoal, and brown by combining red, yellow, and white. The Navajos believe that these basic materials are alive, having come from the transformed body of Walking Rock, the last of a succession of monstrous enemies of humankind that were slain and transformed into forces for good by the elder of the Hero Twins, Monster-Slayer, or Slayer-of-Enemy-Gods. Roots are collected and burned and the ashes are mixed with the pigments to give them bulk and body and also to invoke the beneficial powers of the Plant People. In the strictest sense, then, these are not "sand" paintings but, rather, dry or ground paintings.

The designs are laid down on a bed of fine tan sand that has been smoothed with a weaving batten. The painter holds the pigment in his palm and, guiding it with his thumb, trickles it between his first and second fingers. When he changes colors, he first rubs his hand in some plain sand

to remove the traces of the old color. Bodies of figures are set down first in the preferred colors: black and blue for males, yellow and white for females. Then details of costumes, accouterments, and sacred symbols are added. The painter works from large areas to small details, and from the inside to the outside. Some particularly complex figures have five or six layers of sand when completed. Some sandpaintings are small, no more than a foot or so on each side, while others are fifteen to eighteen feet across, taking up the entire floor of the hogan. Sandpaintings tend to be square, but there are also some rectangular and circular forms, the latter often the result of encircling the scene with the protective and beneficent figure of the rainbow guardian or, as in Plate 40, with a snake spirit.

In recent years, the Navajos have added sandpaintings on boards to their inventory of folk art for sale, and some Navajo artists have drawn on them as subject matter for paintings on canvas (Plates 38–39). Despite continuing misgivings on the part of some traditional Navajos over recording sacred art for public consumption, the best of these permanent paintings are the work of men who are themselves practicing singers, much sought after for their knowledge and skill in creating curative ground designs and reciting the sacred chants that go with them. In works for sale, however, subtle changes in details are introduced to avoid giving offense to the Holy People and to render the sandpaintings ceremonially useless and therefore harmless. If the correct form were to be made permanent, the power of the painting would be too great for the uninitiated.

# Jewelry

Without question, the ephemeral dry painting and its transformational role are essentially Navajo. It was Navajo genius that brought this art to unparalleled perfection and complexity. This counts for more than the question of whether sandpainting, like weaving, was originally inspired by the Pueblos, whose kiva rituals also include ground paintings made with colored sands. But the Pueblo sandpaintings are much simpler and serve different purposes; if the Pueblo were indeed the teachers, therefore, they were soon outdone by the pupils.

In fact, the Navajo pattern for a long time has been to borrow a practice or trait and then perfect it according to their own taste and tradition. With its dual origin in Spanish metallurgy and Indian lapidary technology, silver and turquoise jewelry is another prime example (Plates 43, 44, 47).

The Indian peoples of the Southwest shared with the pre-Hispanic civilizations of Mexico a high regard for turquoise that bordered on veneration, for turquoise symbolized, above all, the blue of water and the green of growing vegetation, essential conditions for life. In very early times, certainly during the rule of the Aztecs, there was a lively turquoise trade between the Southwest and ancient Mexico, for the Aztecs and their Mixtec contemporaries used enormous quantities of the precious mineral for mosaics on funeral masks and other ritual objects, and the turquoise from the Southwestern mines had qualities found nowhere else. In the prehistoric Southwest, the Hohokams of southern Arizona in particular shared these skills with Mexico, but, curiously, these craft traditions were not passed on to their probable descendents, the Pimas and Papagos. Instead, it is in some of the Rio Grande pueblos of New Mexico that the prehistoric skills of jewelry-making are kept alive today. In fact, a clamshell ornament of classic Hohokam design, with a closely fitted mosaic of polished turquoise, shell, and jet (Plate 46), has long been practically the emblematic jewelry of the pueblo of Santo Domingo.

Silverworking, and particularly the combination of silver with turquoise, is a much more recent innovation, originating with the Navajos but now shared by many Native jewelers in the Southwest (and some non-Indians as well). The Navajos' first contact with metallurgy was during the Spanish period, when they observed Spanish smiths at work and when they also obtained a few silver ornaments, frequently by raiding. Soon after 1850, a Navajo named Atsidi Sani, and perhaps a few others as well, had learned to work silver from Mexican smiths. But it was not until about a dozen years later that Navajos began to turn to metallurgy in earnest, as an indirect consequence of their defeat after years of conflict with white settlers south and north of the Mexican border. Imprisoned for four years at Bosque Redondo in southeastern New Mexico, deprived of their normal pursuits, peaceful and otherwise, having lost their flocks of sheep and their fruit trees to Kit Carson's scorched-earth campaign against them, some Navajos began to try their hand at working in metal, initially iron, then copper and brass. Following their repatriation, these craftsmen soon assimilated the secrets of silversmithing from skilled itinerant Mexican *plateros*, or silver workers. And by the early 1870s, Navajo silversmiths themselves were turning American and Mexican silver coins into tasteful jewelry.

The earliest stamping tools for decorating Navajo bracelets were the dies employed by Mexi-

cans in tooling leather, but soon the Indians were making their own and, true to form, elaborating the designs far beyond the originals, so much so that it was not unusual for a Navajo silversmith's kit to contain a hundred or more homemade dies. During this period the Navajos also mastered the art of setting stones, especially turquoise, in silver. How this skill was in turn transmitted to the Zunis is not clear, but after a period in which Zuni silver and turquoise jewelry was rather massive, like that of the Navajos, the Zunis set out in their own direction, toward ever more delicate and skillful treatment of turquoise. At first this was done entirely by hand; after 1940 and the introduction of electricity, power tools were used as well. Zuni lapidaries became renowned especially for clusters of small, smoothly polished needle-pointed, oval, and round stones, for mosaics of white and red shell, and for turquoise and jet set in silver (Plates 45 & 48). For several decades silver was used alone, without turquoise. Brass and copper were shaped into necklace ornaments as early as 1830, and silver was in full use at least by 1879, when the Smithsonian Institution sent the Stevenson Expedition to Zuni and a twenty-two-year-old ethnologist named Frank Hamilton Cushing began a love affair with the Zunis that led to his adoption into the sacred fraternity of the Bow Priests.

# Pottery

When the Stevenson Expedition left Zuni, after collecting prodigious amounts of pottery (Plates 49, 50, 53, 56), Cushing decided to stay. And because he himself was adopted by the Zunis, he was able to gain insights into aspects of the culture that were not open to other observers. Then as now, Pueblo pots were the best produced in the Southwest, but the craft was in the hands of women who rarely confided much more than their technology to inquiring males. As an adopted Indian, and a Zuni priest besides, Cushing was allowed a glimpse not just of the technology but of the metaphysics of Zuni pottery-making as well.

The traditional Pueblo water canteen, of a shape used from the Rio Grande to the Hopi mesas, is a case in point (Plates 53, 55). Flat on one side and conical on the other, with a spout at the top and suspension rings for carrying, the pottery canteen was superbly functional. The form made it possible to transport the canteen safely suspended from a strap across the wearer's forehead and to be held snugly on his back, while also ensuring maximum volume; the porosity of the clay kept the water cool through evaporation. But Cushing found that the distinctive shape of the canteen had a metaphysical aspect as well. Water as the prime source of life, he was told, is the mother's milk of adults, the sacred gift from the bountiful breast of the Earth as Mother of All. It was no accident that the canteen looked like a female breast, for its very name in Zuni was *me'-he-ton-ne*, from *me'ha'na*, breast, and *e'ton-nai-e*, roughly meaning containing within. In prehistoric times, he learned, the spout was, like the nipple on the breast, at the apex, but this was found to be impractical. Yet the memory of spout as nipple persisted among the women potters of Zuni. When the potter had completed the canteen nearly to the apex by the common coiling method of Southwestern pottery, and before she attached the short cylindrical spout, she made a small wedge of clay to close off the apex hole. But at this delicate moment, the potter always averted her eyes, completing the task by touch alone. To do otherwise would invite misfortune, perhaps barrenness, or illness, or even the death of a newborn infant. *Seeing* made all the difference: were she to close off the metaphorical nipple of the breast-canteen in her sight, the potter would by analogy risk shutting off the exit-way for the source of life in her own breast.

Some of Cushing's observations from inside the culture on Zuni attitudes toward their pottery can be safely extended to other Pueblos as well. Pots were regarded as having a conscious existence of their own, capable of feeling and expressing emotion. The clang of a pot when it broke or cracked during firing was thought to be the cry of its escaping spirit, the source of its life. This in turn was related to the opening or break that was left in the heavy line dividing the neck of a water jar from its body (Plate 56). Other Pueblos, prehistoric and historic, shared this same convention (Plate 51), for which different explanations have been offered, but none so detailed as Cushing's. In Zuni pottery decoration, this lifeline or spirit path is clearly different from the red lifeline that connects the mouth of deer to the heart in Zuni pottery painting and that is thought to represent the breath or life force. The encircling broken line was always the first design element to be placed on the unpainted jar, before the brush touched either the upper or lower panels, which by Zuni tradition had to have different designs. The Zunis told Cushing that the broken line was the exit path of the spirit—the spirit of the vessel primarily, but also the living essence of whatever it might contain. The same explanation was given for the encircling open line inside food bowls.

(Plate 51). Were these lines to be filled in, there would be no exit trail for the invisible sources of life, no way for them to permeate the air with their breath. Writers who followed Cushing to Zuni in later years were told that the broken line represented the lifeline of the potter herself. Were she to close it off, this would signify the completion of her own life and thus presage her death. Symbols never being one-dimensional, no doubt one explanation is as true as the other.

The conviction that an earthenware jar was not simply a functional container but a living, breathing being is evident also in the potter's behavior during its production. When a woman had formed her vessel and dried, polished, and painted it, Cushing reported, she expressed deep relief that it was now a "Made Being," with a personal existence. This is why, when putting it in the kiln, she also placed a bit of food inside and beside it. Because of the pot's sentient nature, there were restrictions on the kinds of sounds one might make during its production. Because, as we have noted, the clang of a pot when it broke or cracked was thought to be the cry of its invisible essence as it separated itself from the vessel, and the ringing sound when it was struck or the hissing noise when it simmered on the fire were believed to be cries of distress, similar sounds might never be made by anyone while the pot was being finished lest they agitate the spirit and cause it to escape, which would crack the pot during drying or break it in the kiln.

Ideology aside, next to basketry, an art that has for the most part sadly declined in the Southwest, it is pottery technology that best exemplifies the extraordinary cultural continuity that is the hallmark of the Indian Southwest, from language and attachment to place to religion, social and ceremonial organization, architecture, and the other arts. New materials, forms, and technologies added to and modified the other crafts, but pottery has remained remarkably stable from its first appearance in the Southwest around 300 B.C. among the Hohokams to the present day. Now as then, Puebloan and other Southwestern potters form their earthen wares entirely by hand, primarily by coiling, using at most a plate or shallow bowl to support and shape the base, but not the potter's wheel, ancient in the Old World but unknown in the New before Columbus. Of course there have been changes over time in form and decoration, some slow, some sudden leaps. There has been much experimentation with different slips and colors. There have been real innovations as well, which broke with local tradition. Some of these have been eminently successful, like the matte black on shiny black

perfected almost by accident in 1918–19 by the famous María Martínez of San Ildefonso and her husband, Julián, in the course of experimenting with prehistoric blackware decoration (Plate 57). And there were some notable revivals of older styles, like that pioneered in the 1890s by the Hopi-Tewa potter Nampeyo of Hano Pueblo, on the approaches to Walpi atop First Mesa in Arizona (Plate 16). At that time Hopi pottery decoration was in decline. Nampeyo, whose husband was helping to excavate the prehistoric village of Sikyatki, restored Hopi pottery to its former distinction by using the dynamic designs on old Sikyatki bowls as an inspiration for a new style of her own (Plate 51) that still endures in the work of her descendents.

Almost all Southwestern Indians participated to one degree or another in the general pottery tradition, and all developed their own specialties. Considering their much longer history as potters, it is not surprising that the Pueblos excelled above all others; while sharing some dominant vessel forms among themselves, they had the widest range of design and color preferences. Some, like Santa Clara, preferred blackware. Others, like Acoma and its related villages, used a wide range of motifs and colors, from the completely abstract (Plate 55) to combinations of life forms and geometric designs (Plates 49–50). Acoma, famed since the time of the Spanish conquistadors as the virtually impregnable "sky city" atop its steep-sided, free-standing rock in western New Mexico, was also distinguished among other Pueblos for the thinness of its vessel walls and the hardness of its paste. Individual potters of great distinction are still carrying on these great traditions with adaptations of the classic designs and innovations of their own.

To stress continuity, as we have done in this chapter, is not to ignore or gloss over change. Change there has always been—gradual, from within, or sudden, through innovation and contact, not always benign, with other peoples and new materials and symbols. New technologies and the exigencies of a market economy have too often in this century depressed the quality of workmanship, taste, and artistic spontaneity. So the arts have had their ups and downs, some of them virtually disappearing among people who were not long ago their undisputed masters. Yet in some instances—silversmithing and the raising of sheep for wool, for example—new technologies and materials have actually helped expand the traditional range of arts and crafts and added new recruits to the ranks of first-rate artists among people who were not previously involved.

Nor do we mean to deny that as even those

most traditional of Southwestern peoples, the Hopis, have increasingly been forced to come to terms with a white man's world that let them be far longer than it did other First Americans, there has been some loss of unity of purpose, some weakening of old ties that bound art, religion, environment, social organization, politics, and economics into a single harmonious whole. Still, what impresses one in the Southwest today is that the same Hopis who carve kachina dolls for sale in the Hopi craft cooperative conduct sacred,rites in the kiva and participate in the masked dances intended to bring the blessings of the kachinas to the Hopi people. The same Navajo who makes sandpaintings for sale one day, once an unthinkable violation of ceremonial behavior, is apt to be creating a sacred painting the next day on the dirt floor of a consecrated hogan. In the Indian Southwest today, in the arts and in the cultural context from which they arose, continuity *and* change are clearly two sides of the same coin.

Plate 15. Masau'u Kachina, seen here in his wooden effigy, or tihu, carved in 1939 by William Quotskuyva of New Oraibi. This is the kachina aspect of the old earth and fire god Masau'u, whom many Hopis place at the very head of the pantheon. While he is the divine guardian of the crop-bearing surface of the earth, his death aspect as ruler of the underworld and the Hopi dead is expressed by the goggle eyes and protruding teeth of his skull-like mask. Because the dead become rain bringers, rain clouds are represented on his cheeks as colored spots. As kachina doll, he is usually represented wearing the kachina cape, a wrap-around blanket skirt of rabbit fur, a kachina sash with a fox tail in back, and kachina dance moccasins. Some of this clothing —the wrap-around skirt or dress, for example—is female, emphasizing the essential god's male-female nature and the unity of the sexes in the generation of new life. (13¾" high. Private Collection.)

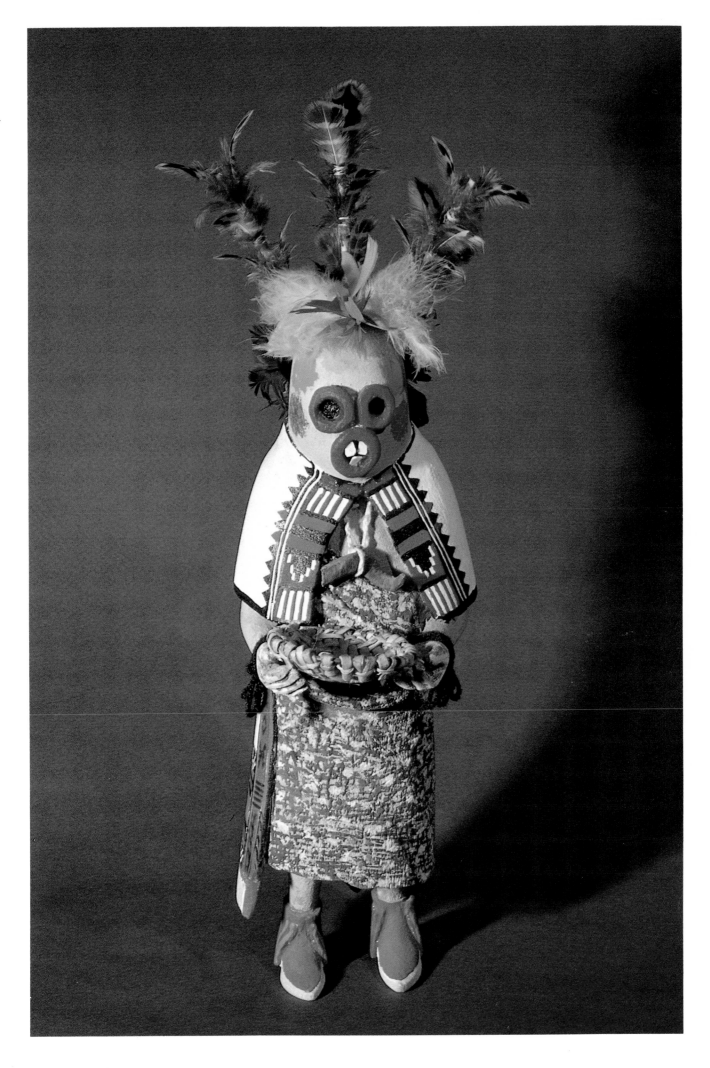

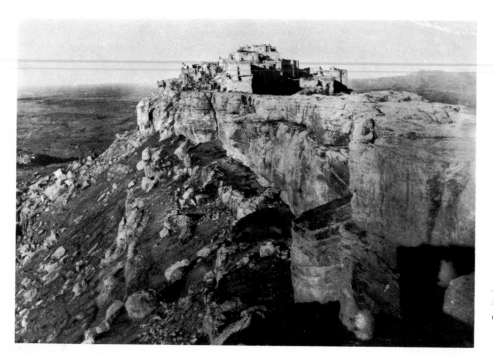

Plate 16. "Built without design, added to as need arose, yet constituting a perfectly satisfying artistic whole," is how Edward Curtis, the photographer and ethnographer of the American Indians, characterized the Hopi town of Walpi, dramatically perched at the end of First Mesa, which he photographed in 1906/07.

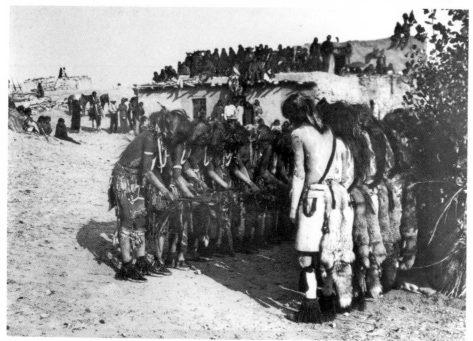

Plate 17. In this 1921 Curtis photograph from Oraibi, members of the Antelope Fraternity, at right, face those of the Snake Fraternity in a rhythmic chant that precedes the handling of the sacred rattlesnakes in the Hopi Snake Dance. The foliage at right decorates a cottonwood booth that shelters the custodian of the snakes, kept in jars.

*Plates 18 & 19. These striking kachina-like altar figures, found in an ancient cave in southwestern New Mexico, suggest a prehistoric origin for the Pueblo practice of representing the supernatural kachina spirits in portable wooden effigies. Radiocarbon analysis has placed these effigies in the thirteenth century A.D. The one at right is carved of cottonwood, like modern kachina "dolls," and represents a male kachina or deity; the one at left, of stone, represents a female. The paints are of mineral origin. Both effigies are embellished with spun cotton. (Left, male, 25" high; right, female, 14" high. Art Institute of Chicago.)*

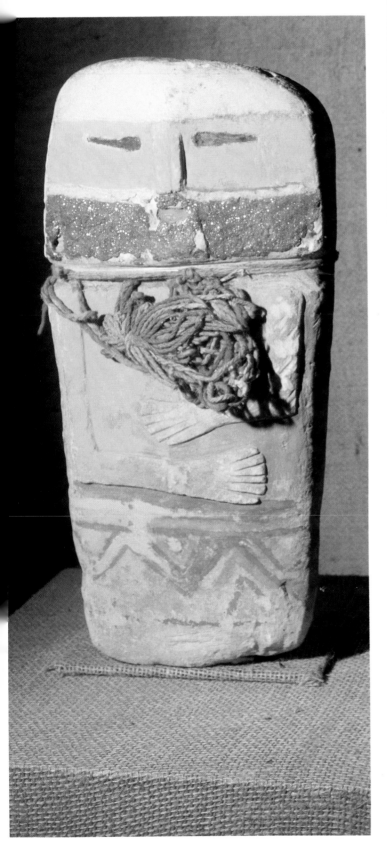

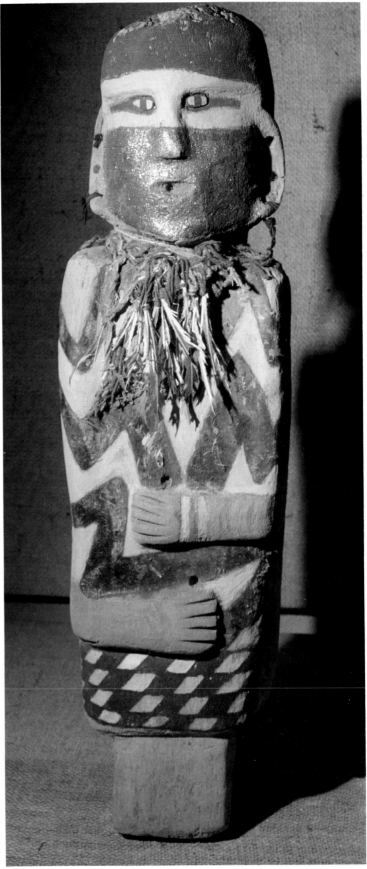

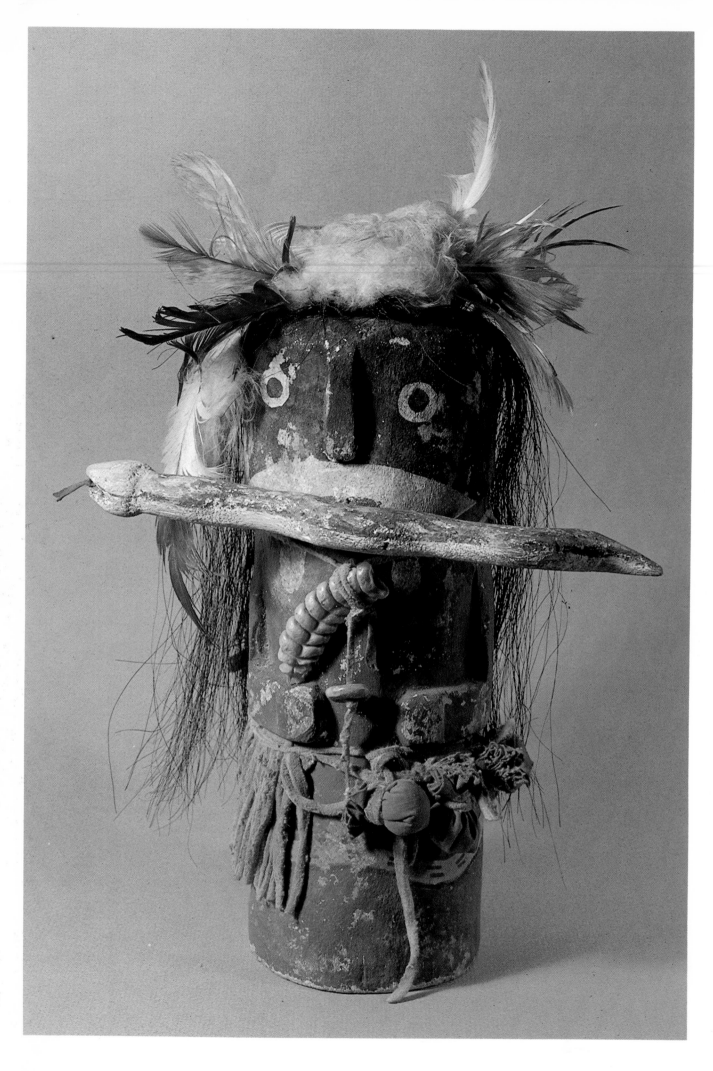

Plate 20 (opposite). *The wooden rattlesnake effigy held in its teeth and the real rattler fetish around its neck identify this century-old Zuni kachin-tihu, the proper Hopi name for kachina "doll," as Situlili, Rattlesnake Kachina, a spirit of life and fertility whose Hopi counterparts are the Snake Dancers. (10¼" high. Private Collection.)*

Plate 21. *Her distinctive crow-wing headdress and white cape identify this nineteenth-century wooden kachin-tihu as Angwushahai-i, Crow Bride, who assists in the initiation of youngsters into the kachina cult. (7⅜" high. Laboratory of Anthropology, Museum of New Mexico, Santa Fe.)*

Plate 22. *Kachina "dolls" are not playthings but are carved by the fathers and uncles of Hopi children to instruct them in the characteristics of the spirits who bring rain, fertility, and supernatural protection to the Hopi people and who are personified in the masked kachina dances. Some kachinas are gods. Ahöla, here portrayed by the late Jimmy Kwanwytewa, a famous kachina-doll carver, is one of the oldest identifiable Hopi gods. Ahöla helped bring the people to their present homes on three mesas, or tablelands, in Arizona, and in the growing season he activates the germination of seed corn and other food plants. (13" high. Private Collection.)*

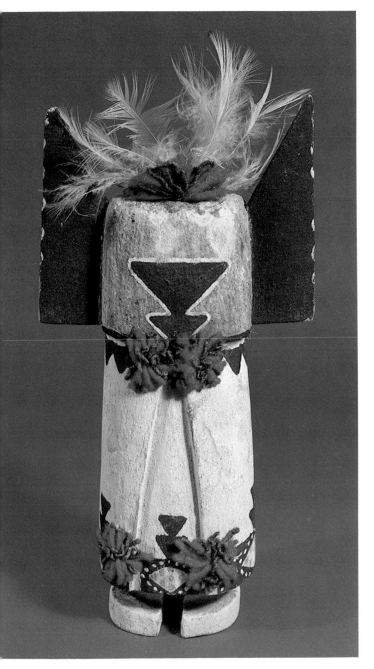

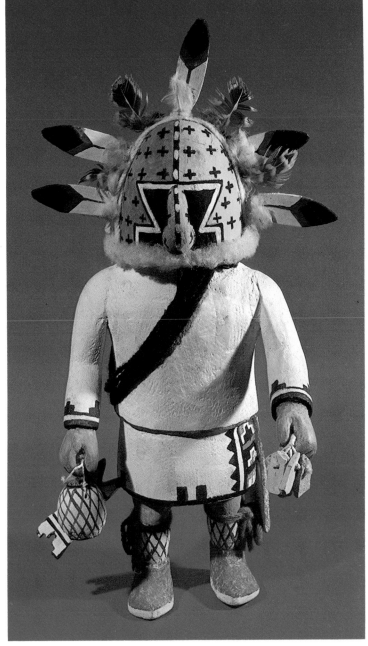

Plate 23. Most kachinas are benevolent spirits of life, fertility, and growth, and those qualities are embodied in their wooden replicas, the kachina "dolls." But some serve as ogres to warn people, and especially children, to adhere to the rules of life that bind the Hopis to one another, the land, the food plants, and the ancestors—the Hopi dead who themselves join the ranks of the kachina spirits as bringers of rain. One of the most prominent ogres is Wuyak-kuita, Broad-faced Kachina, represented here with his typical case mask of painted yucca basketry with buffalo horns, horsehair beard, and the wide mouth with jagged teeth that he shares with other ogre kachinas. Some ogres may have been inspired by historical persons, in particular the Spanish, who gave the Pueblos reason to fear them. (29½" high. Ca. 1900. Collection Rex and Bonnie Arrowsmith, Santa Fe, New Mexico.)

Plate 24. Some kachinas are thought to be especially powerful healers of disease. Among them is Bear Kachina, whose brown body paint was made from corn smut. This fine old kachin-tihu of Bear Kachina was collected in the 1890s by H. R. Voth, the Mennonite missionary and ethnographer of the Hopis, in the pueblo of Mishongnovi, on Second Mesa, Arizona. (8½" high. Laboratory of Anthropology, Museum of New Mexico, Santa Fe.)

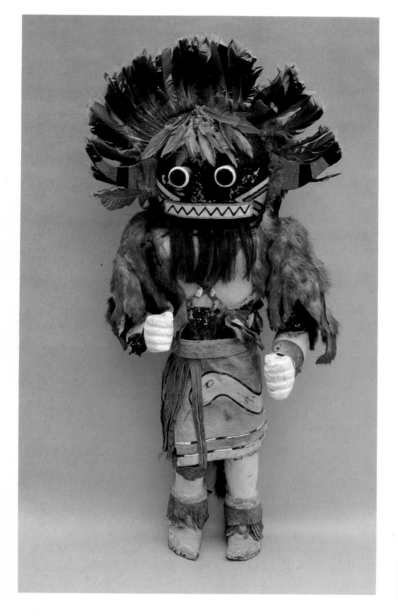

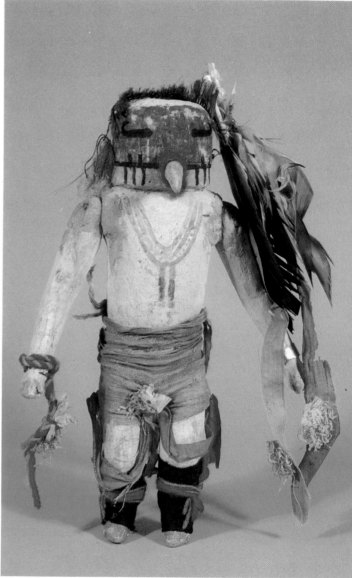

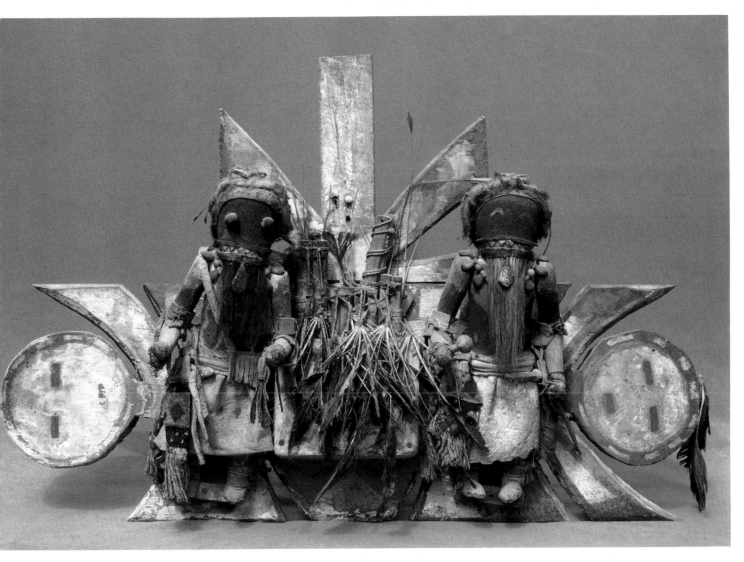

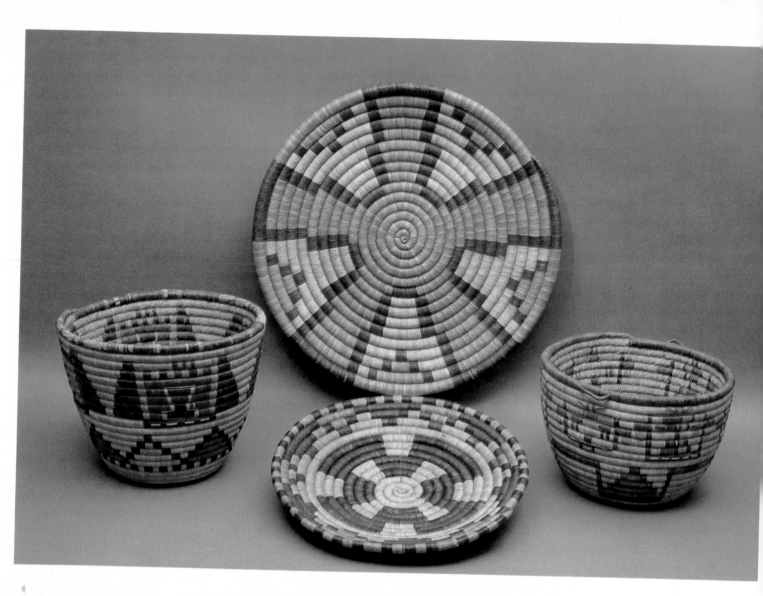

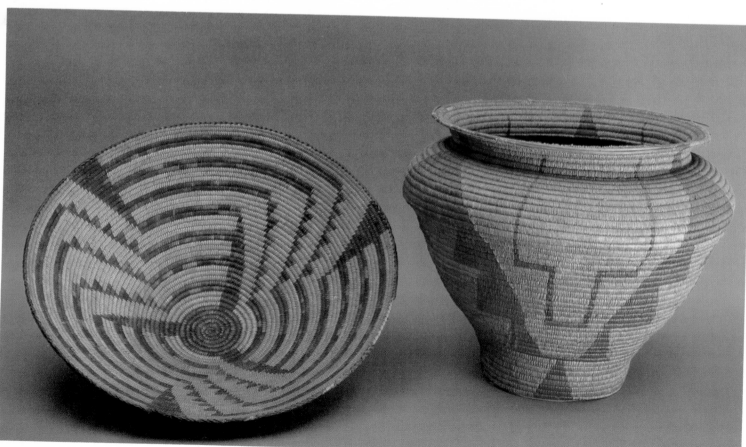

48

Plate 26 (opposite top). Only the Hopi women of Second Mesa still weave coiled basketry bowls and sacred meal plaques. Decorated with geometric life forms and four-directional designs, these are used in kachina and basket dances and other sacred ceremonies. The flat plaques also accompany the dead. Indeed, at least on Second Mesa, no male could hope to gain entry into the company of his ancestors without a sacred meal plaque. (Left, 8¾" high; center, 19" and 14" diameter; right, 8¼" high. 1900–20. Private Collection.)

Plate 27 (opposite bottom). For the nineteenth-century Pimas, the coiled basketry tray or shallow bowl served every purpose filled in the white woman's kitchen by pots, pans, bowls, and china. Shamans, or medicine men, also used woven trays to carry salt from the sea on the sacred salt pilgrimages and in curing the sick. Women used olla-shaped storage baskets like the one shown at right, with its rare dark-red vegetal dye decoration, to transport seeds, usually balancing the baskets on their heads. (Left, 19" diameter; right, 13" high. 1890–1900. Private Collection.)

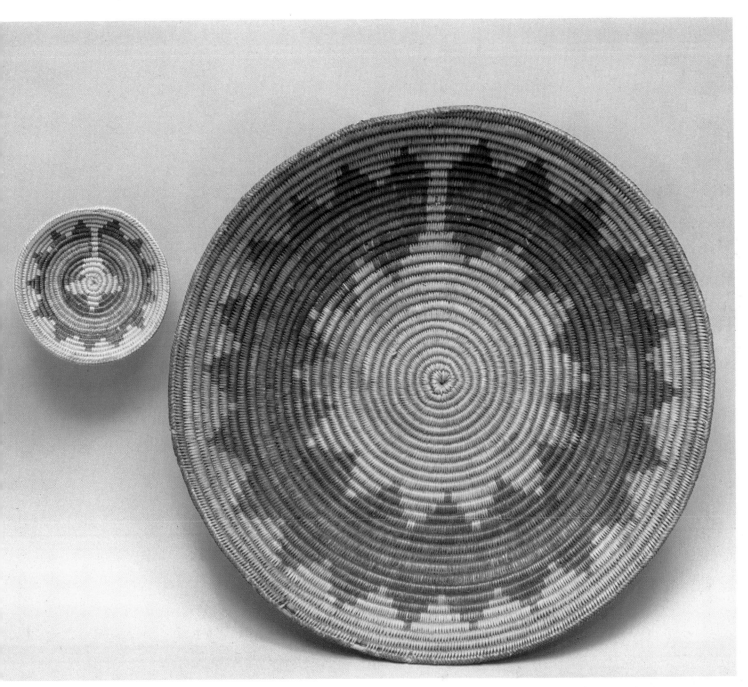

Plate 28. The construction of the Navajo ceremonial or wedding tray is not just a matter of basketry technology but is strictly regulated according to ritual requirements. Thus, the rim coil must always end in a direct line with the spirit path that interrupts the interior design of the sacred mountains of the world. As exit and entry way for the supernaturals, this pathway must face east when the basket is used ceremonially. In some rituals the same basket tray turned upside down may also serve as ceremonial drum. Sacred trays, usually woven for the Navajos by Utes and other Indian neighbors, are made both full-size and, occasionally, as miniature fetishes, as at left. (Left, 5½" diameter; right, 17¾" diameter. 1890–1910. Private Collection.)

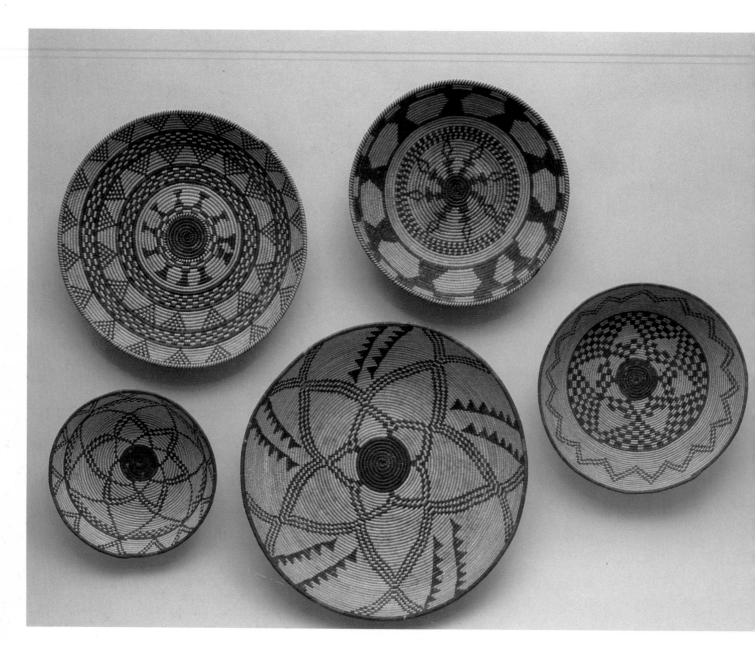

Plate 29. Few nineteenth-century baskets from the South-
west are as well documented as this exceptional group of
traditional geometric Apache ceremonial bowls. They
were collected between 1895 and 1898 by Brigadier Gen-
eral Edward Settle Godfrey while he served at Forts Grant
and Apache, New Mexico. By the time he was posted to
the Southwest, Godfrey had a long record of fighting In-
dians on the Plains, and only barely missed the fate of his
former commanding officer, General George Custer, at the
Little Big Horn. In that historic engagement in 1876, God-
frey, then a lieutenant, commanded Company K, the rear
guard of Custer's 7th Cavalry. He wrote an authoritative
account, from the Army's point of view, of that fatal en-
gagement, in which Sioux and Cheyenne warriors wiped
out Custer along with 265 of his troopers. (Diameters:
upper left, 13⅜"; lower left, 9"; upper center, 11¾"; lower
center 15¼"; right, 11¼". Private Collection.)

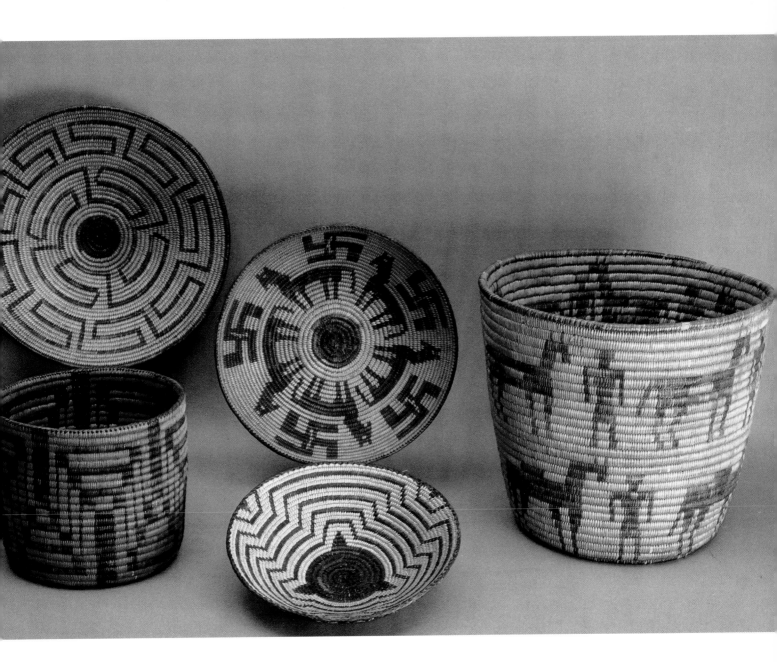

*Plate 30. Nineteenth-century Pima baskets were generally decorated with geometric abstractions of vegetation, the heavenly bodies, or animals and their tracks. Another important design motif was the tasita, or swastika, a symbol of the moving sun, which the Indians shared with Asian peoples. At the turn of the century, naturalistic forms be-* *came popular, particularly among white collectors. They were sometimes used in combination with the swastika and other more traditional geometric motifs. (Upper left, 12½" diameter; lower left, 7¼" high; upper center, 11½" diameter; lower center, 9½" diameter; right, 11½" high. 1890–1910. Private Collection.)*

Plate 31. The impressive basketry storage jars for which Apache women became famous in the late nineteenth century may have been inspired by old Pueblo pottery, but they also resemble European bottle-necked vases. Many of these baskets were made for sale to whites, but they also were used in the Apache household for storing seeds and grains. The earliest jars were decorated geometrically, like the oldest basketry trays, but toward the end of the last century life forms became increasingly popular. (28" high. New York State Museum.)

Plate 32 (opposite). The splendid development of the weaving art among the prehistoric Pueblos is evident in this detail from a 700-year-old twill-weave cotton blanket. It was found undamaged in 1895 in a southern Utah prehistoric cliff dwelling. The arid climate had preserved the blanket, which had been stored inside a pottery vessel that protected it from the elements, rodents, and insects. These blankets were woven by men on vertical looms inside the sacred kiva, or ceremonial chamber. (Full size: 57" x 59". San Miguel Historical Museum, Telluride, Colorado.)

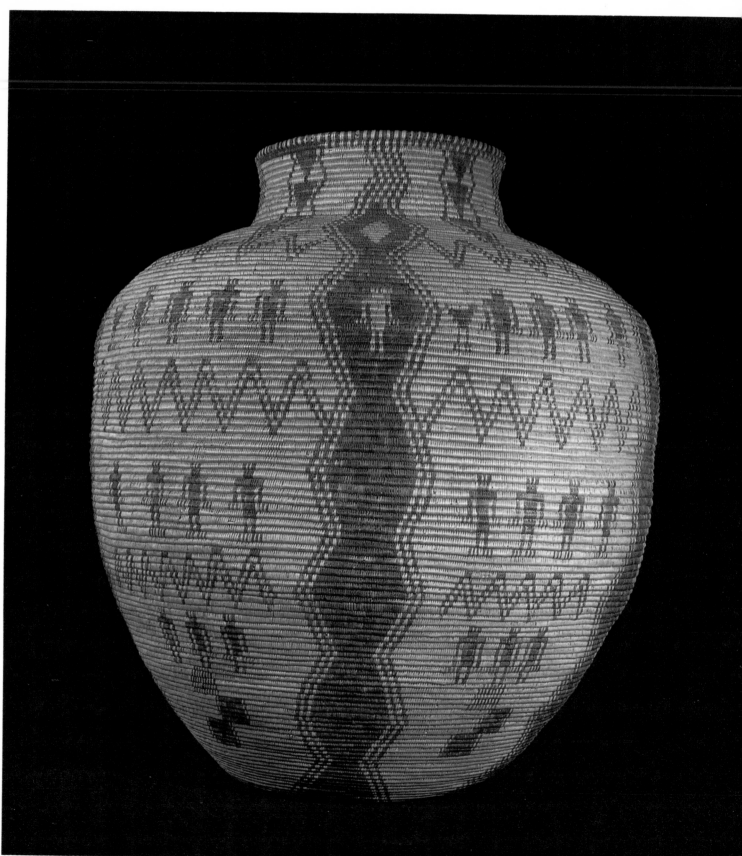

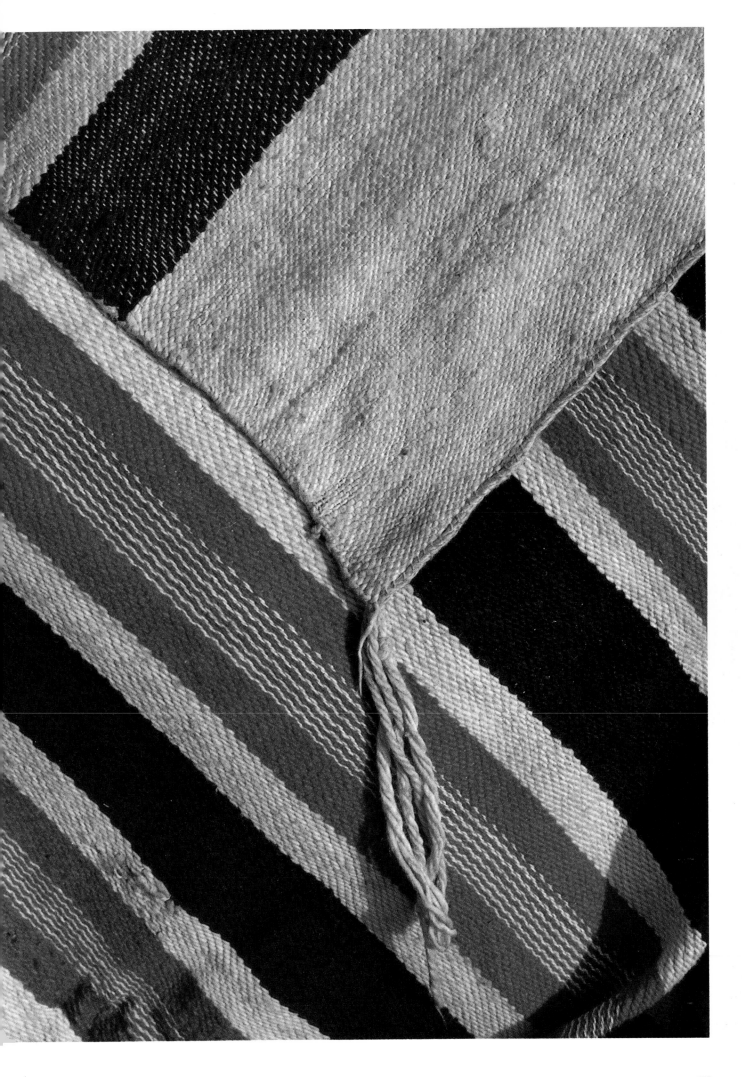

Plate 33. Although the famous Navajo "Chief's Blanket" was never a badge of chieftainship, its high quality of materials, precision in the layout and spacing of designs, and extra-tight weave made it so expensive that only people of some means could afford such blankets. Hence, owning one did confer some status, and the blankets were in great demand as far as the Northern Plains, where Indian men and women wore them. The earliest type, or First Phase style, ca. 1850–70, had simple patterns of red and blue stripes. In Phase Two the bands were elaborated with geometric designs. Phase Three blankets, like the one shown here, from about 1885, had serrated or terraced diamonds or triangles, inspired by Mexican weavings. (74" long. André Emmerich Gallery, New York.)

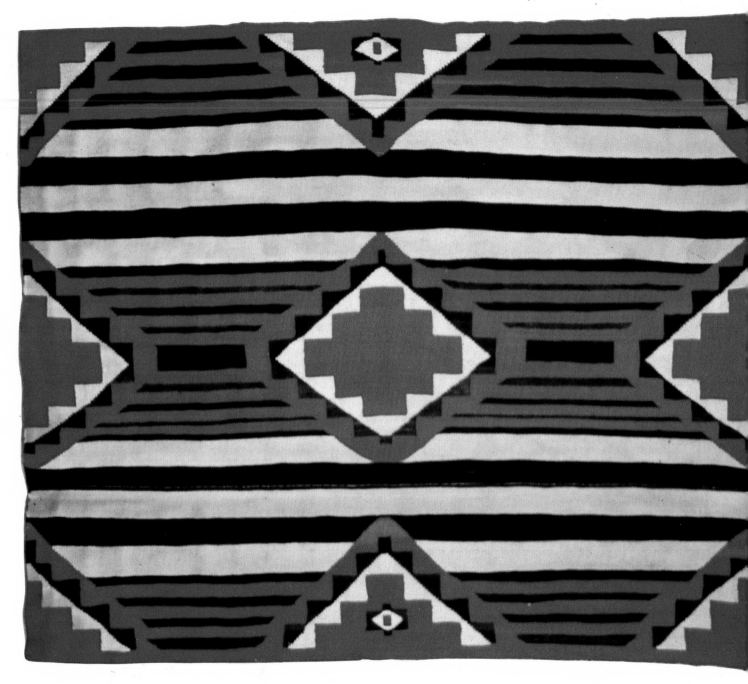

Plate 34 (opposite). The distinctive design of serrated diamonds and zigzag lines in this Navajo serape, or wearing blanket, woven about 1875, was inspired not by the Pueblos but by Spanish-American weavings and the Saltillo serape made in northern Mexico. Such shoulder apparel became known as Moki blankets, from an old name for the Hopis. (70" long. André Emmerich Gallery, New York.)

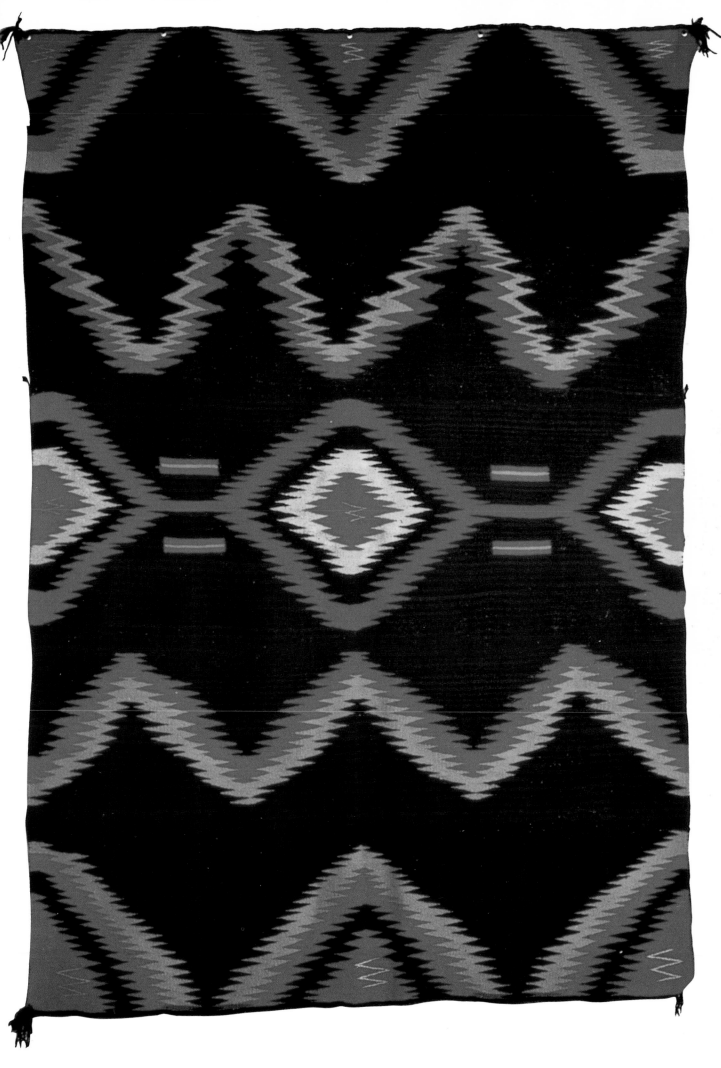

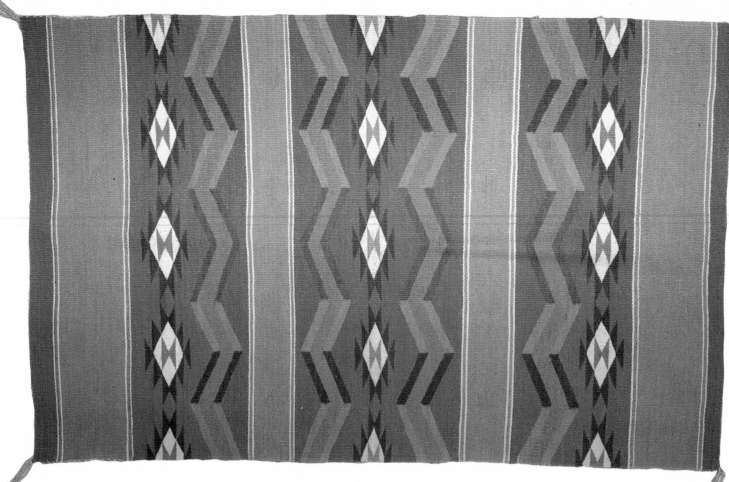

Plates 35 (above) & 37 (opposite). For collectors of modern Navajo weavings, those made at Wide Ruins, like the rug opposite, are the standard for museum-quality weaving. The style was first revived in the early 1920s, using natural colors instead of commercial dyes and traditional, border-less striped patterns in place of those introduced by white traders. The original revival had had its start at the Chinle trading post, under the sponsorship of a wealthy Bostonian, Mary Wheelwright, and the trader L. C. McSparron. Unfor-tunately, wholesalers in Gallup, the principal customers for Navajo rugs, demanded the gaudy colors and bordered designs that the public had come to believe, erroneously, were "typically Navajo." So the revival was slow and spo-radic until the late 1930s, when the Wide Ruins trading post, under Sally and William Lippincott, became the new center of high-quality, natural-dye, borderless rugs woven in the soft, pastel shades of the Painted Desert. The Wide Ruins revival style caught on, and today rugs of compara-ble quality are produced near other trading posts as well, including Crystal, Burnt Water, Chinle, and Pine Springs.

The blanket above, from between 1890 and 1900, shows a transitional style, still borderless and with serrated zigzag lines derived from the Saltillo serape and Spanish-Ameri-can tradition. It was woven with natural and aniline dyes, in the then-popular lightning pattern. (Left: 56" long. 1938–40. University of Colorado Anthropology Museum. Wolle Collection. Right: 66" long. Private Collection.)

Plate 36. Their hair dressed in the old style, called squash blossom, these Hopi maidens posed in 1914 for a photo-graph by Edward S. Curtis. Traditionally, however, the squash blossom symbolized the flower of the sacred Da-tura inoxia (Plate 80), a powerful hallucinogenic plant used for divination and personified in Zuni myth as a superna-tural boy-girl pair.

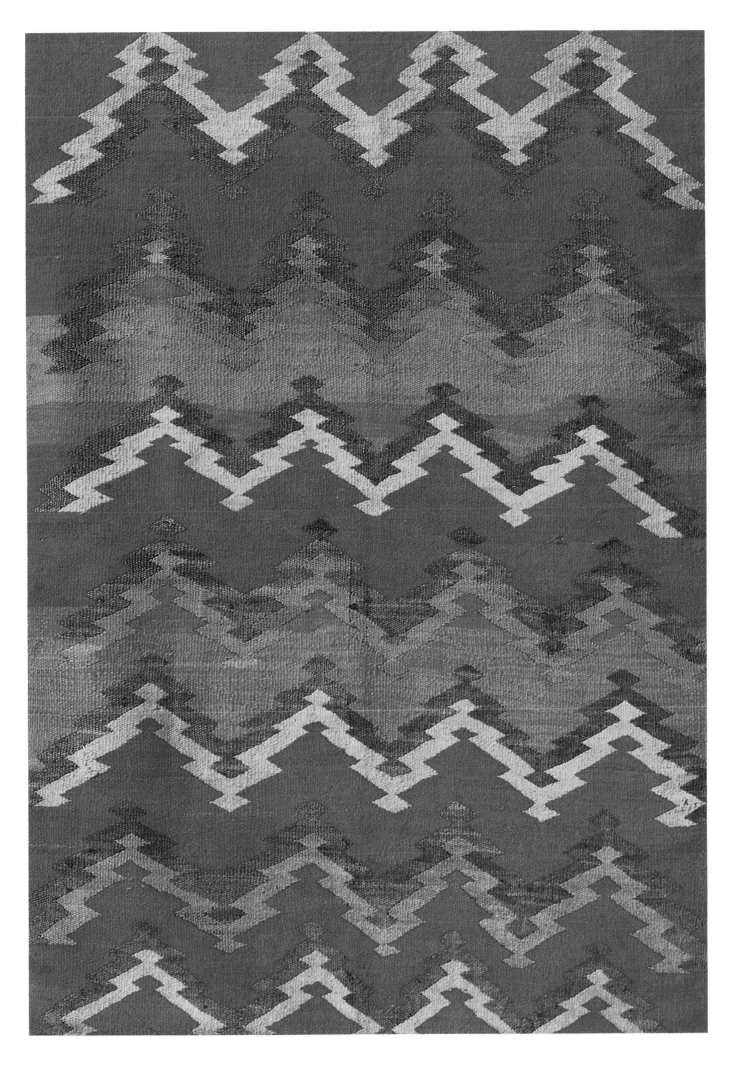

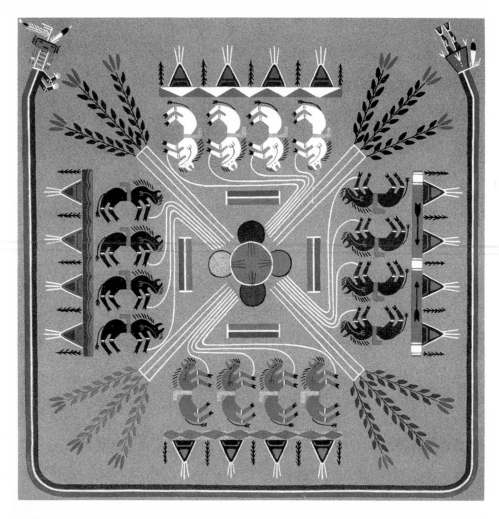

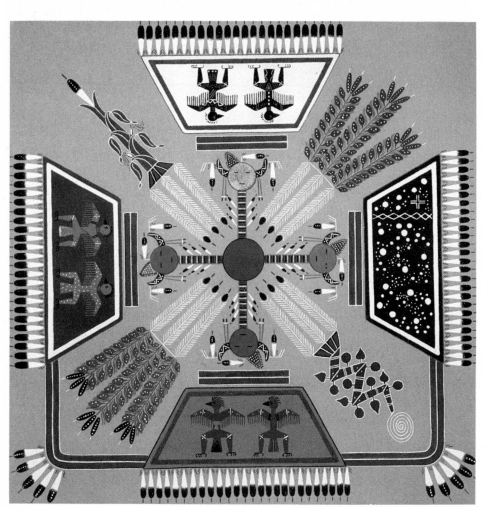

Plates 38 & 39. For the Navajos, control
evil and restoration of health and harmor
depend on the invocation of the supernatu
als and their mythic deeds in complex ar
lengthy rituals which often include dry pair
ings with colored sands and vegetable pr
ments as well as chants. The sacred c
paintings are so numerous and intricate th
it takes specialists years to learn to mal
them so accurately and beautifully that th
Holy Ones will feel compelled by the rul
of reciprocity to bestow their blessings ar
cure the patient. Once the patient and th
world have been thus restored, the paintir
is wiped away and its materials are returne
to nature.

Despite old taboos against making th
ephemeral sacred art permanent, in rece
years sand paintings on boards have bee
added to the Navajo art made for sale. Son
of the best, like these two, made in 1979 t
singer-sandpainter Herbert Ben, Sr., are th
work of practicing chanters, much soug
after for their skill and knowledge as maste
of the sacred form of this art. With certa
changes to avoid offending the supernatu
als, the two paintings belong to the fifty th
make up the Male Shooting Chant.

The sandpainting, Homes of the Buffa
People (above), depicts the buffalo broug
back to life in their houses in the Otherwor
and harmony restored after a near-fatal er
counter with the Hero Twins, Monster-Slay
and Holy Boy, children of Father Sun an
Mother Earth. Buffalo are Plains animal
which is why the four rows of homes ar
Plains tipis. The tipis also signify that th
mythic Navajo heroes traveled far into dar
gerous places to slay monsters and obtai
powers for good. The four rows of anima
represent the female White Buffalo People i
the east, the male Black Buffalo People i
the west, the male Blue Buffalo People in th
south, and the female Yellow Buffalo Peopl
in the North. In the center is the water tha
divides this world from the world beyond.
is the source from which the buffalo and th
medicine plants receive life-giving moistur
as indicated by the white lines leading fror
each animal to the water.

The Skies (below) is one of the sacre
paintings which Father Sun taught his twi
children. It depicts the Sky world, white rep
resenting dawn, blue the day sky, yellov
sunset, and black the night sky. Corn, bear
and squash plants represent the earth; th
birds are messengers, A protective rainbow
open to the east (top), connects day, eve
ning, and night skies. (24" square. Privat
Collection.)

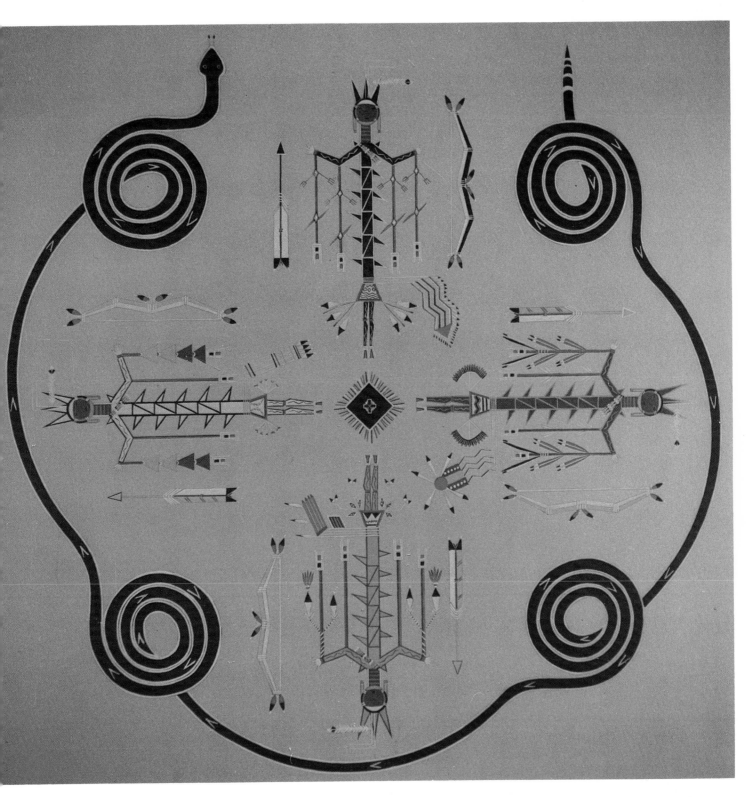

Plate 40. Endless Snake and Wind People, a sacred Navajo dry painting seen here in a 1936 watercolor copy by Mrs. Franc J. Newcomb, is prominent in the Big Starway Chant. This ceremony is held to cure troubles attributed to ghosts and witches, such as tension, nightmares, sleeplessness, mental upsets, and fainting. The patient sleeps on the sacred designs at night to absorb their curative powers. The four coils are said to encircle the four sacred mountains of the Navajo universe. Four of these dry paintings are made, with a black snake on the first day, and a blue, yellow, and white snake, respectively, on the succeeding days. (Wheelwright Museum of the American Indian, Santa Fe.)

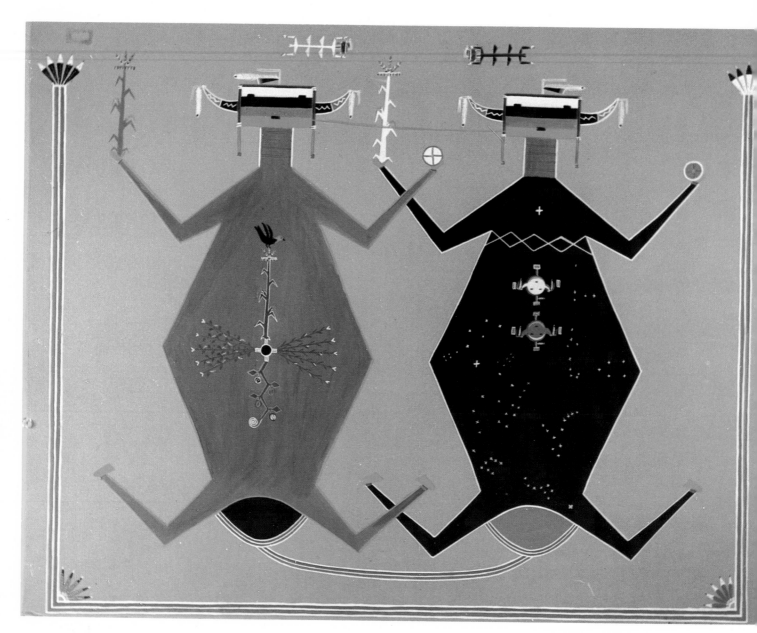

Plate 41. More than any other dry painting, this rendition of Blue Mother Earth from the Shootingway Chant, perfectly matched with Father Sky as her identically shaped complementary opposite—the two halves of creation—symbolizes the ultimate in perfection and cosmic harmony. Blue Earth, located on the south side and wearing the turquoise dress of the summer sky, holds a corn plant and a basket with corn pollen. In the center of her body is the water that filled the place of emergence after the people had ascended from the underworld. From it sprout the four sacred plants brought up from below—corn, beans, squash, and tobacco. Father Sky's body is the black night sky, with markings representing the Milky Way, crescent moon, stars, and constellations. He too holds an ear of corn and in the other hand his sacred tobacco pouch. A line of sacred pollen links their mouths, and their reproductive organs are likewise connected. Both wear buffalo horns marked with lightning and identical Shootingway Chant headdresses of turkey and eagle feathers. (Watercolor copy by Mrs. Franc J. Newcomb, ca. 1936. Wheelwright Museum of the American Indian, Santa Fe.)

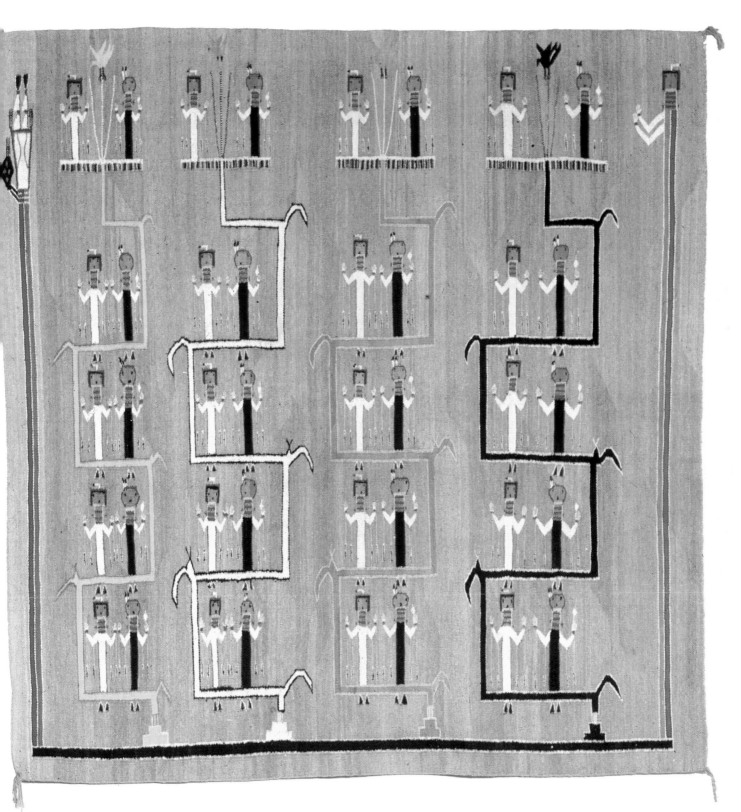

Plate 42. So much supernatural potency is ascribed to the ephemeral dry painting that only his great prestige and special status as "man-woman" allowed Hosteen Klah, the famous shaman and master weaver, to violate the customary rules and transfer its sacred subject matter to the permanent medium of tapestry weaving (usually a female occupation). Show here is his rendition, completed in about 1927 with his niece, Mrs. Sam, of a painting from the summer ceremony called Pollenway. The tapestry de-picts four many-angled corn plants in the sacred colors of white, blue, yellow, and black, with birds in the same four colors. Male and female Yeis (supernaturals) stand on each turn of the plant beside ripening ears of corn and on the tassel bar at the top. The bar below the roots is the earth. The whole is enclosed on all but the eastern side (top) by the Rainbow Guardian, a protective figure customary in virutally all dry paintings. (70" high. Wheelwright Museum of the American Indian, Santa Fe, New Mexico.)

Plate 44 (opposite left). The oldest Navajo silver bracelets were either all metal or else used stones sparingly to embellish the luster of the silver. In the early twentieth century, silver was increasingly used only as a setting to show off the beauty of the turquoise. The three bracelets in front date from the 1920s or earlier. The one in the rear, an abstraction of Spider Grandmother, the animal manifestation of the earth goddess and patron of weaving, was made about 1950. (Left, 2½" high; front center, 1" high; right, 1¼" high; rear, 3" high. Private Collection.)

Plate 45 (opposite right). Turquoise has always figured importantly in Pueblo religion; it is associated with sky and water when blue and with vegetation when green. Such mystical associations are reinforced by the tendency of some varieties of turquoise to change with time from blue to green. The four pins shown here date from 1935–40, the bracelet from 1970. Stones were originally polished by hand with sandstone slabs and after the introduction of electricity to Zuni Pueblo, around 1940, by emery wheels. (Top: 5⅝" wide; left and right, 4½" diameter; bottom, 2½" diameter; center, 3⅛" high. Private Collection.)

Plate 43. Nesjája Hatali, a renowned Navajo shaman and sandpainter, was photographed by Curtis in 1904.

Plate 46. Shell pendants delicately inlaid with cut turquoise, white shell, and jet mosaic, like this one from Santo Domingo, in the Rio Grande valley of New Mexico, are a high point of modern Pueblo lapidary art, just as they were in prehistoric times. The mosaic is not just glued to the back of the shell but inlaid after a thin layer of shell has been etched and ground away, thus achieving a smooth over-all surface. (3⅜" high. Ca. 1940. Private Collection.)

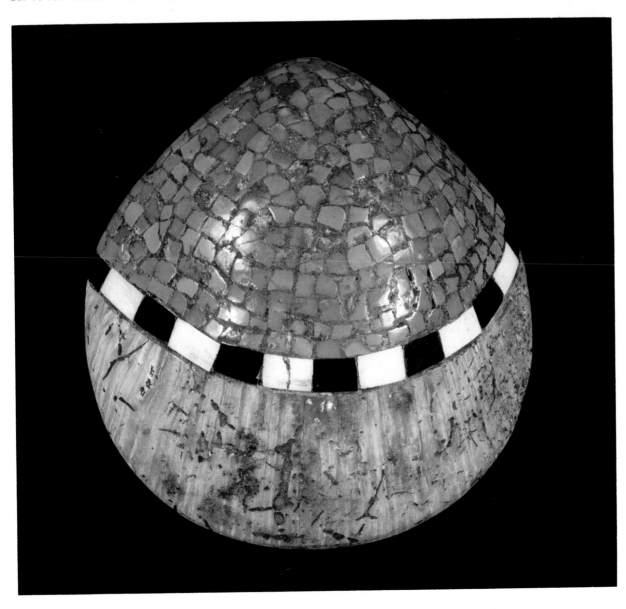

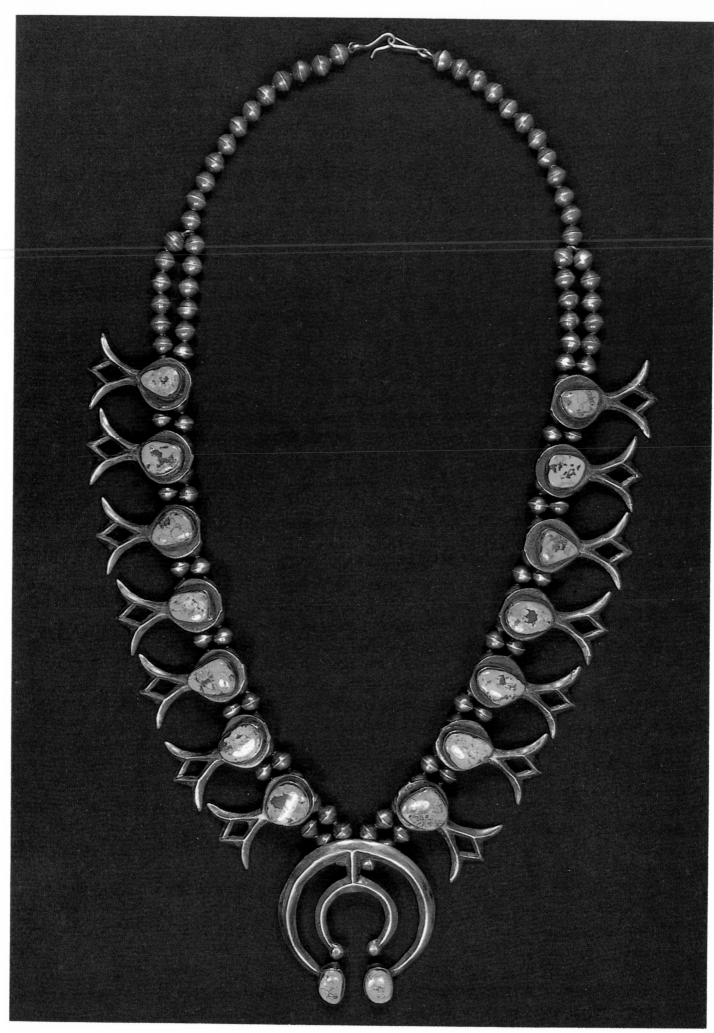

Plate 47. Navajo silver and turquoise necklace with sand-cast "squash blossoms." (16" long. Private Collection.)

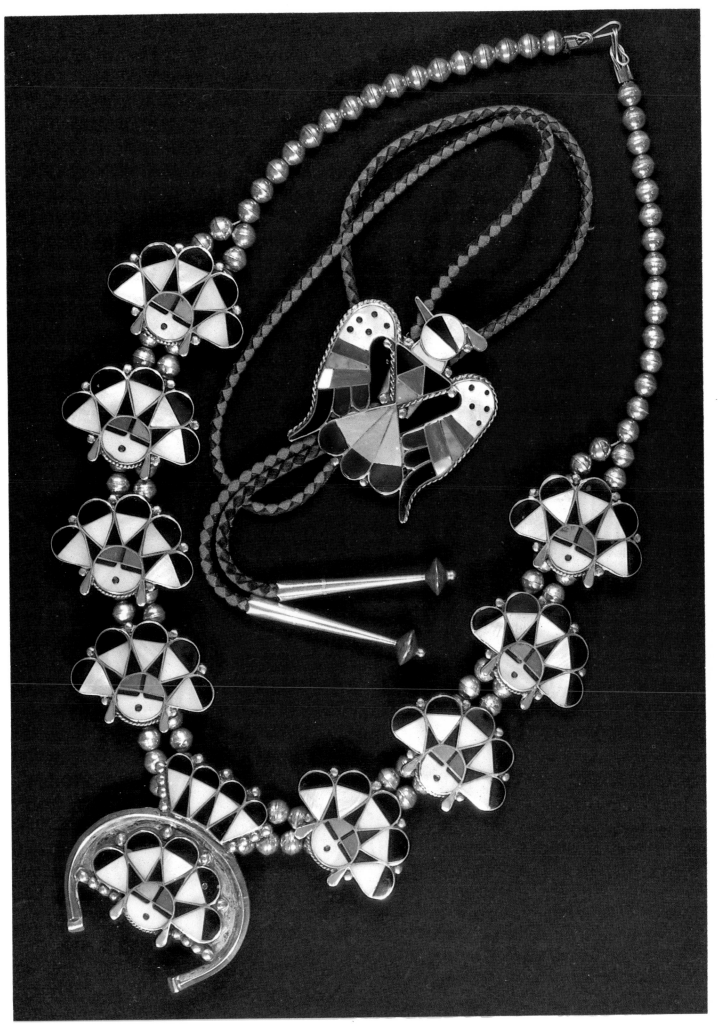

Plate 48. Modern Zuni mosaics of white shell, red spiny oyster, black cannel coal, and turquoise are descended from prehistoric mosaic jewelry. The modern necklace representing the Sun God, is by William Zuni, and the bird deity bola-tie slide by Bobby and Corraine Shack. (Necklace, 15" long. Tie slide, 2½" high. Private Collection.)

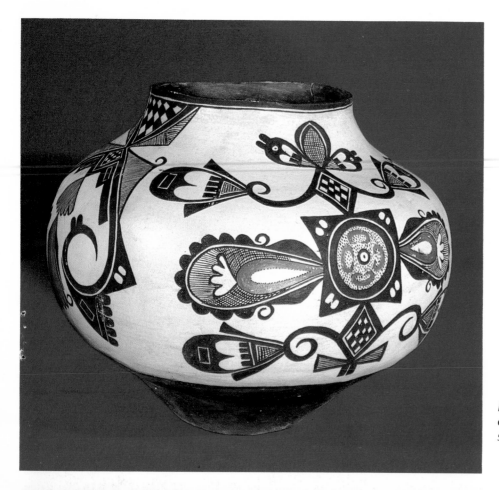

Plate 49. Decoration on Acoma water jar, collected in 1885, is reminiscent of Zuni designs. (9¾" high. Smithsonian Institution.)

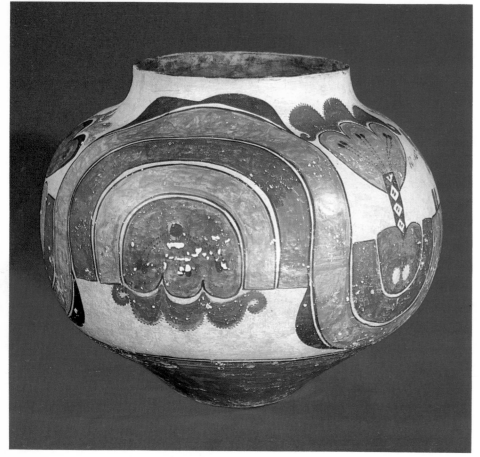

Plate 50. Acoma water jar from the 1880s, with flowing band and floral decoration. (10½" high. Smithsonian Institution.)

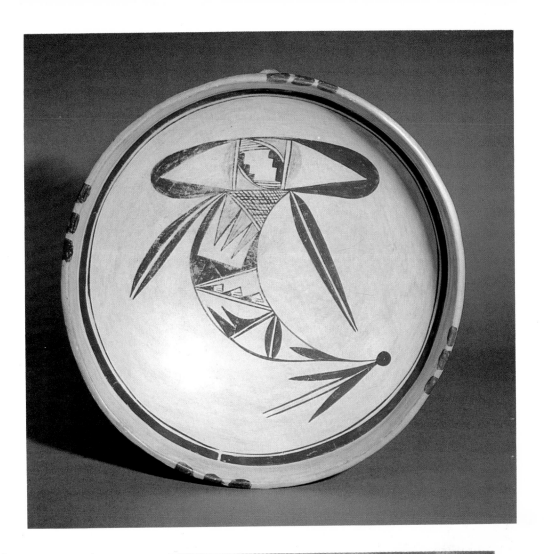

Plates 51 & 52. Little was left of the great painted-pottery tradition of the Hopis when it was suddenly revived shortly before the turn of the century by Leah Nampeyo, a talented young potter from the Hopi-Tewa pueblo of Hano on First Mesa. Nampeyo, seen here in a photograph made by Edward Curtis in 1906, was inspired by the beauty of the fine painted burial ceramics found in the ruins of a small pre-historic pueblo called Sikyatki ("Yellow House"), and adapted the old designs and ceramic style to her own talents. With the firm, graceful lines and dynamic sweep of its highly abstracted interior figure, perhaps representing a sacred insect, the unsigned painted bowl (top) is typical of some of Nampeyo's earliest efforts. (10" diameter. Private Collection.)

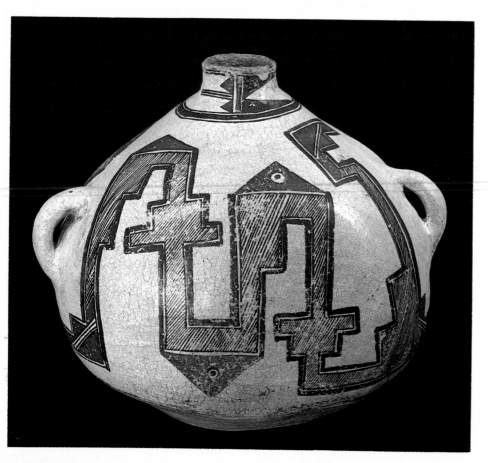

Plate 53. The pottery water canteen of the Zunis and other Pueblos, like this one with abstract snake and bird symbolism, is supremely functional. Its globular shape maximizes the amount it can contain while keeping the water cool by evaporation. But its makers also assigned an ideological dimension to the canteen: water being to adults what mother's milk is to infants, in Zuni terminology as well as symbolic meaning, the canteen was synonymous with the mother's breast. The same symbolism extended to a double-lobed canteen used by hunters, whose Zuni name translates as "mammaries joined together." To reinforce the symbolism and perhaps even magically influence the game, the potter, a woman, added to her husband's hunting canteen two pairs of non-functional teats. (9" high. Before 1880. Smithsonian Institution.)

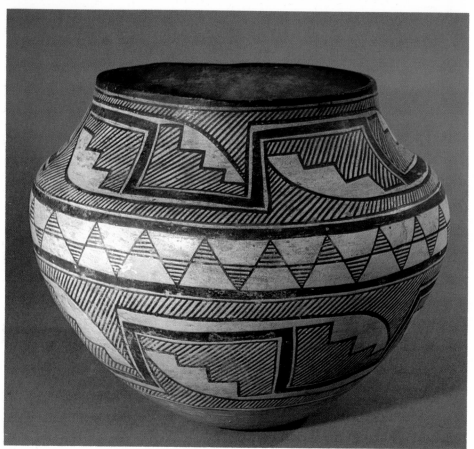

Plate 54. Of all the pueblos with strong pottery traditions, none had greater variety in its designs than Acoma. There decoration ranged from recognizable abstractions from nature and combinations of life forms with flower-like medallions and geometric patterns, as in Plates 49 and 50, to fine-line all over geometrics, as on this water jar, made about 1910. Whatever the motif, Acoma pottery painting was always very exact, often with a preference for fine parallel lines, a design convention also found in geometric Zuni decoration and derived, as at Acoma, from prehistoric sources. (9" high. Private Collection.)

Plate 55 (opposite). The basic form of the pottery canteen was essentially similar in the pueblos of Zia, Acoma, and Zuni in the east and in the Hopi pueblos in the west. Derived from prehistoric prototypes, it did not vary over several centuries. This example from Acoma, the old "Sky City" in western New Mexico, or from Acomita, one of its farming villages, probably is mid-nineteenth century. (6½" high. Private Collection.)

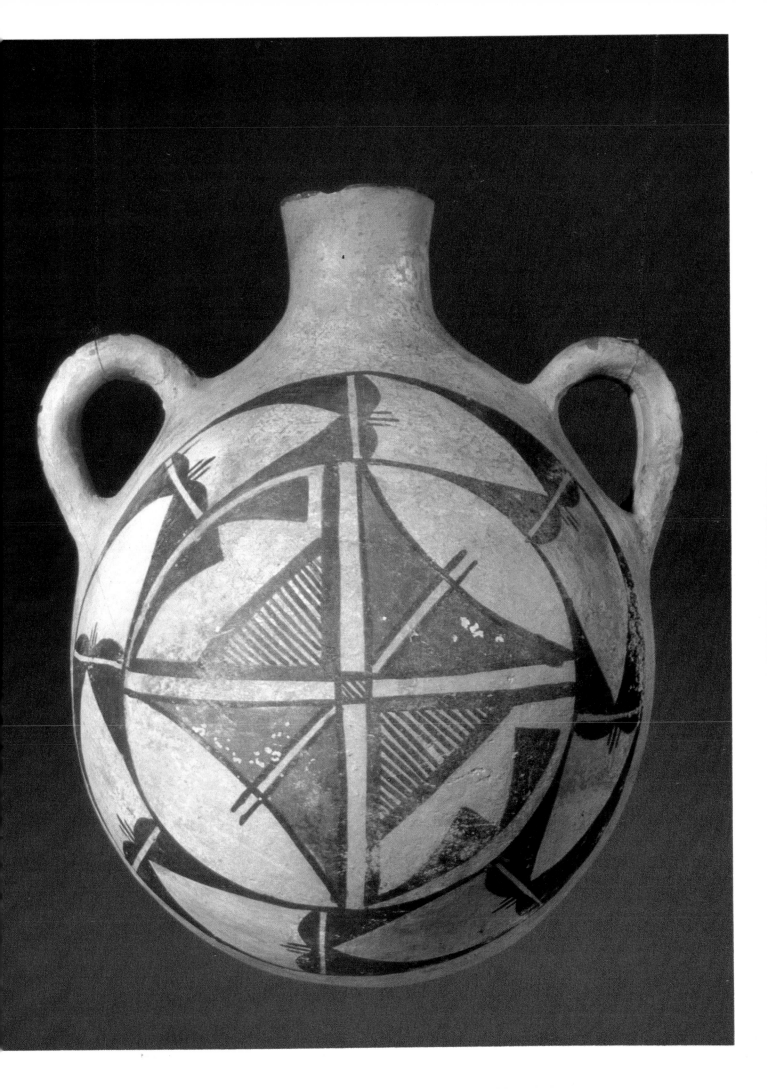

*Plate 56. Although the deer with a red arrow-tipped line leading from mouth to heart is one of the common life forms on Zuni polychrome pottery after 1850, it is not usually so large and prominent as on this old water jar. An attribute also of the Zuni water serpent and generally recognized as characteristically Zuni, the heart line has been borrowed by other Pueblos, including the Hopis and Acoma. Its Zuni name is o-ne-yäthl-kwa'to-na, Entrance Trail, specifically of the source or breath of life. Closely related to this symbolism is the break in the double line around the vessel's shoulder. A common Pueblo convention derived from prehistoric pottery decoration, the opening has been interpreted as the path for the spirit and source of the vessel's own personal existence, or as symbol of the potter's own as yet uncompleted life. (9½" high. Smithsonian Institution.)*

*Plate 57 (opposite). The small, Tewa-speaking pueblo of San Ildefonso, in the Rio Grande valley of northern New Mexico, was bound up for more than fifty years with the fame, artistry, and vitality of María Martínez. Few Native potters in the Southwest or anywhere else have had so profound an effect on the fortunes of their contemporaries.*

*Before she died in 1980, at an estimated age of either 96 or 99, five generations of her family were making matte black on shiny black pottery in the tradition she and her late husband, Julián, established in 1918. Other Indian potters had adopted the same technique, and virtually no major museum in the world is without at least one example of the distinctive ware represented here in an elegant tall vase collected in 1927 and bearing the famous Mariá/ Julián signature. Actually, Santa Clara Pueblo had long been making polished blackware, but its clay was coarser and did not take nearly so lustrous and mirror-like a polish as that for which María and her family were to become famous. A firing accident led to Julián's first success, and by 1910 the couple was making blackware for Hewett by smudging and smoking the cow-dung fire built around their pots. Decoration at first was polished black on a matte background, later reversed, after many attempts, to matte designs with an iron-bearing refractory slip on a black background polished to a silvery-black luster. They began signing their work in the mid-1920s, though prices then were so low that Julián once had to sell 30 of their beautiful pots for a total of $60. (14¼" high. 1927. Collection William E. Channing.)*

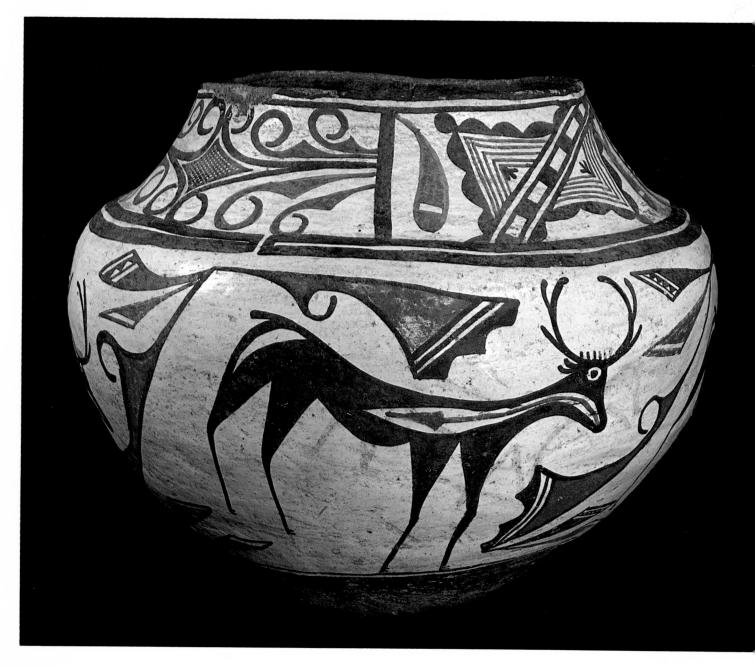

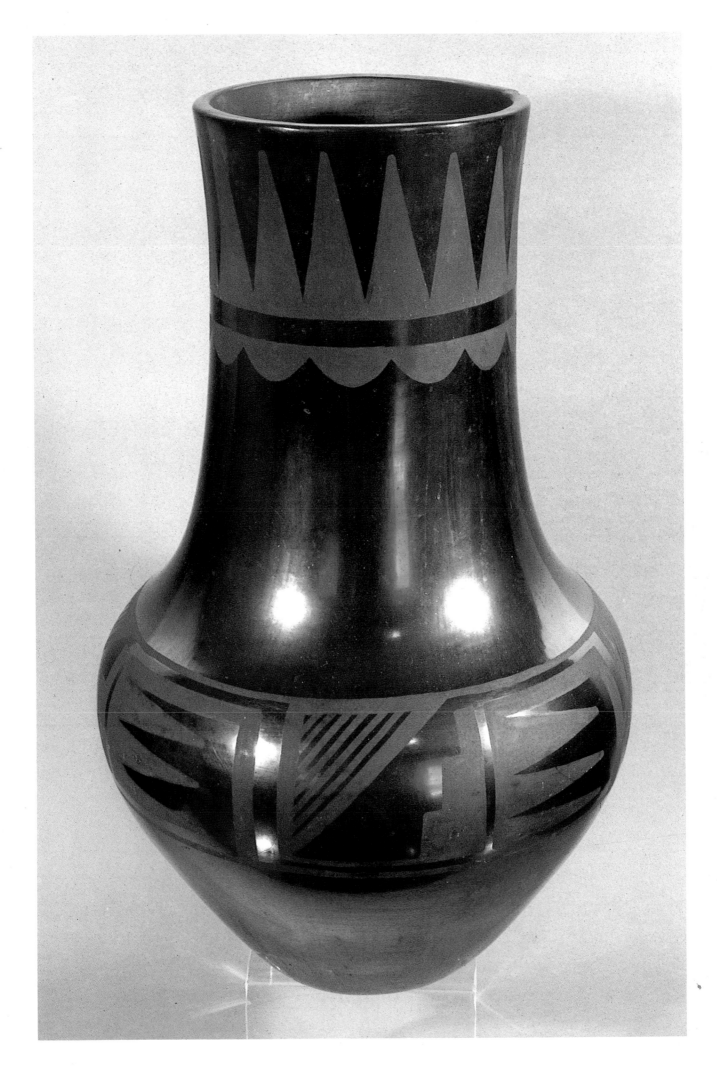

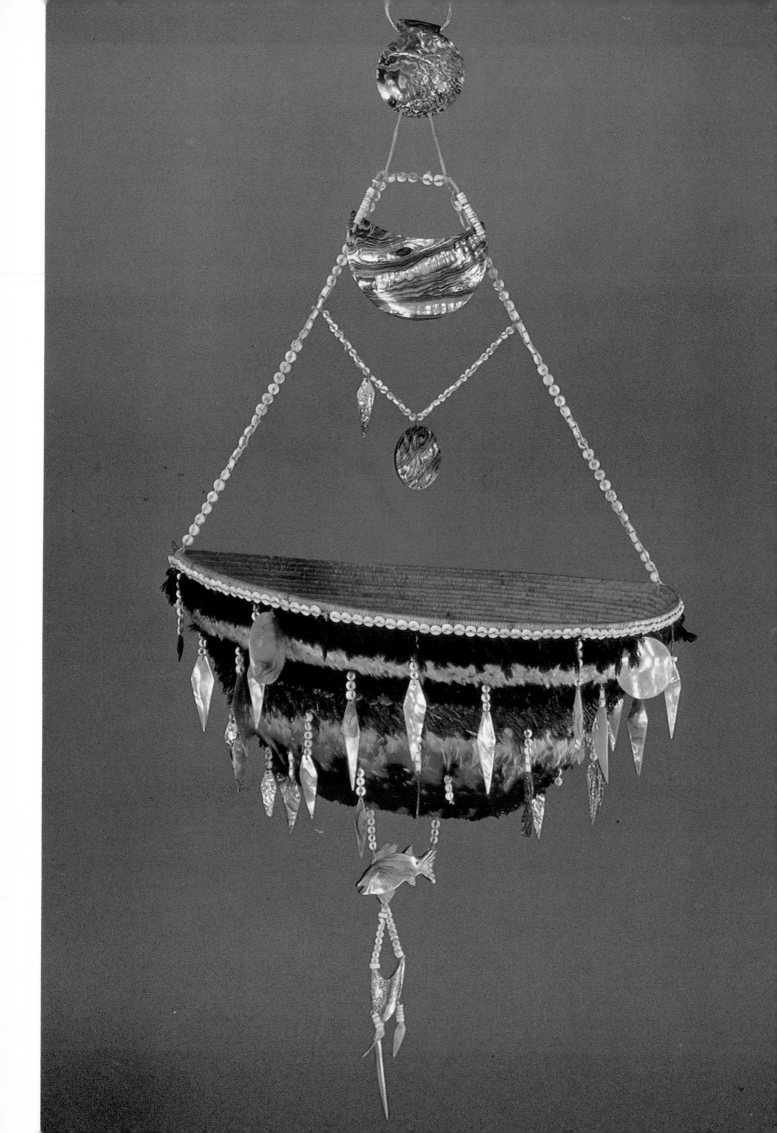

# Arts of California

The California Indians were hunters, fishermen, and collectors of roots, seeds, and other wild foodstuffs in climates and environments that for the most part were remarkably benign. They relied as much on the nutritious acorn, seed of the scrub oak, as agricultural peoples did on corn. And just for that reason, they were derided and abused as "primitive" and "brutish" by Spanish and Anglo-American settlers, who used the Indians' pre-agricultural lifeways to deprive them of their lands, their religions, and not infrequently their lives. Yet the technical and aesthetic excellence of their arts—especially their splendid basketry—along with highly elaborated ritual and oral traditions, provides an object lesson for those who would judge a people's intellectual or artistic capacities by standards of economic or technological complexity.

## Basketry

With pottery absent almost everywhere in aboriginal California, baskets were indispensable to every phase of life, including storing, milling, roasting, and even boiling food. They had uses in dress and ornament, in baby care, as household furnishings, in religious ritual and social life, from celebrations of birth, puberty, and marriage to funeral rites. At the same time, they afforded the female half of the society its widest opportunity for aesthetic expression and the display of

*Plate 58. Five kinds of feathers were used in this splendid nineteenth-century Pomo basket. According to legend, it is exactly like the one the supernatural culture hero used when he stole the sun from the otherworld and hung it up in the sky to light the earth. The suspension cord of the cosmic basket is laced with tiny white clamshell beads, as are the rim and the string holding the fish and other pendants below. Sun and moon are represented by the abalone-shell disks above. The elongated abalone-shell pendants represent stars, and the fish the cosmic ocean in which the earth was thought to float like an island. (Rim, 13" diameter. Smithsonian Institution.)*

technical skill. The Native American women who produced these baskets raised a practical necessity to the status of fine art—an art that, moreover, was allowed to flourish long after the principal arts at which the men excelled had become obsolescent with the loss of the old freedoms. The Wintun, Pomo, Klamath, Modoc, Maidu, Yurok, Karok, Hupa, Shasta, Washo, and other tribes in the north (Plates 66–67, 69–70, 72, 74), the Yokuts, Mono, and other peoples in the central region, and the Chumash and various "Mission Indians" in the south (Plate 71) all knew and excelled in almost every type of basketry and technical basketmaking process used anywhere in North America, and some known nowhere else. The Pomos of northwestern California are perhaps the most striking example of this artistic and technical versatility.

If you were to watch an Indian basketmaker at work, wrote Otis Tufton Mason at the turn of the century in his classic study of Native American basketry, you would look in vain for models, drawings, or patterns: "Her patterns are in her soul, in her memory and imagination, in the mountains, water courses, lakes, and forests, and in those tribal tales and myths which dominate the actions of every hour. She hears suggestions from another world."

The other world of tribal tales and myths was certainly the inspiration for the brilliantly feathered nineteenth-century hanging basket that is the centerpiece of the Smithsonian's California Indian basketry collection (Plate 58). This masterwork of northwestern California basketry is said to reproduce exactly the spirit basket in which Oncoyeto, the creator-culture hero, stole the sun from the other world and hung it up in the sky to light up this one.

According to the myth, before the earth came into being, Oncoyeto had the form of a beautiful white spirit feather that floated endlessly through the dark and empty space above the cosmic ocean. When at last he came to rest upon the

surface of the water, a whirlpool spun him round and round, so fast that foam began to collect and air bubbles were drawn from every direction. Foam and bubbles coalesced and became the solid earth, floating like an island in the primordial sea.

Now Oncoyeto transformed himself from spirit feather into human shape and began to think of how he might illuminate the newly formed earth. Seeing a distant light glimmering through the darkness, he resolved to travel to it and learn its secret. After a long journey he came to a place brilliantly lit and inhabited by people who offered him hospitality but gave no clue about the source of their mysterious light. Oncoyeto was welcome to visit every house save one—the sacred sweat lodge, guarded day and night because only those who were sick were allowed inside, to be cured. Suspecting that this was the source of light, Oncoyeto feigned an illness. When his hosts invited him on a hunt, he claimed he was too weak to accompany them, hoping in their absence to investigate the house of medicine, religion, and ritual gambling.

His hosts agreed to allow the stranger the benefits of their sacred sweat house but designated a few old men to remain close by.

Entering the sweat house, Oncoyeto found himself nearly blinded by a light more intense than any he had ever experienced. When his sight returned he saw that the light came from many beautiful baskets suspended from the roof, each containing a sun of different size and intensity. Resolving to steal one of the sun baskets for the earth, Oncoyeto waited patiently and, when he saw that the old men were sound asleep at last, climbed up quietly and took down the basket with the brightest of the suns. As he was leaving the house with his precious burden, the old guardians awakened and pursued him angrily.

Safe once more on earth, having eluded his pursuers, Oncoyeto first carried his sun basket to the East, where he hung it just over the horizon. But the amount of light it gave did not suit him, and so he moved it a little higher. Still the light was insufficient, and he suspended the sun basket higher still, and so on and on across the entire sky dome. Oncoyeto still does this to the present day, the myth concludes, which is why the sun always travels high over the earth from East to West and then back again to its starting point.

The suspension cord of the magic sun basket is laced with tiny white clamshell beads, as is the rim. The circular abalone disks represent the sun, the crescent shapes the moon; their location above, around, and below the basket is symbolic of their respective positions above the earth is-

land by day and in the underworld by night. The primordial sea surrounding the earth is symbolized by the fish suspended by strings of shell beads below the basket, while the arrow-shaped abalone pendants are said to represent the stars. The colors of the feather bands encircling the basket are likewise symbolic, the Pomos having associated red with pride and bravery, personified by the woodpecker; yellow with love, fidelity, success, and gaiety, personified by the lark; blue with cunning and trickery, represented by the jay; green with astuteness, discretion, and watchfulness, symbolized by the duck; black with beauty and conjugal love, personified by the quail; and white with riches and generosity, represented by the white clamshell.

Of the three principal basketweaving techniques—coiling, twining, and plaiting—the Native Californians used the first two. Southern California baskets were made exclusively by coiling, northern ones by twining, while central Californian peoples employed both methods. In coiling, the weaver uses an awl to sew together a spiralling foundation of one or more rods or bundles of grass with split willow stems or some other flexible material. The sewing is usually so tight that the underlying foundation can no longer be seen. In twining no awl is used. In plain twining, two or more horizontal wefts are twisted around a series of vertical warps. In the more complicated lattice twining, used mainly by the Pomos, very strong and tightly woven baskets are produced by binding horizontal warps at right angles to vertical warps with two wefts, which pass in and out between the intersecting warp elements. Baskets made in this manner are so watertight that they can hold liquid for days without losing a drop. They were used as cooking vessels for acorn mush which was heated by dropping red hot stones into the gruel. The meal itself was first ground in specialized milling baskets without bottoms that were tied to stone mortars. Then the meal was leached of its highly astringent tannic acid on beds of sand. Actually, both the twining and the coiling methods were capable of producing baskets sufficiently tight to be used for cooking with hot stones, although coiled water jars were often made more impermeable with a coating of pitch.

Straddling as they did the technological frontier between the major basketry techniques of north and south, the Pomos and some of their neighbors participated in the technology of both areas. In addition to making twined and coiled baskets with woven design motifs, geometric or taken from nature, the Pomos were supreme in integrating clam and abalone shell and brilliant

feathers into some of their finest baskets—sparingly, perhaps to heighten the effect of a woven design, or to add to the basket's spirit power and ceremonial value, or so lavishly that the stitching and even the design were completely hidden beneath thick feather mosaics in brilliant reds, blues, greens, yellows, and black (Plates 58, 59–63). The masterpieces of Pomo women's art became known among nineteenth-century collectors as "jewel baskets." The Indians themselves distinguished between two types of feather basketwork—*tapica* and *epica*. *Tapica* were shallow, saucer-shaped ceremonial baskets completely covered with red woodpecker feathers and decorated with small perforated disks of clamshell "money" and with pendants of cut and polished clam and abalone shell (Plate 61). *Epica* referred to any other shape of feather basket, whatever its color, decoration, or function.

Individual beads of abalone and haliotis shell were sometimes woven into baskets or hung along the rim and sides. Vegetal material used in Pomo baskets included several varieties of sedge and willow, pinenuts, Douglas spruce, wild grape, and California flax. The feathers of many species of birds were individually plucked from carefully prepared skins and tightly secured under the stitches. Unless the basket was meant to be completely covered, only two kinds of feathers were employed, the deep black head plumes of the quail and the fine, brilliant red feathers from the head of the woodpecker. These were thinly applied to the stitching, usually mixed with or bordered by clamshell beads. According to the Pomos at the turn of the century, in former times only red feathers were used, those of other colors being a more recent innovation.

The "jewel baskets" were presented to newborn and pubescent girls, to a bride as a premarriage gift from the groom and his family, and to women generally at various other transition points in their lives. Among some groups mothers presented their daughters with a fine feather basket at about age seven, with the admonition to take good care of it, for any ill that befell such a basket was believed to transfer itself to its owner. Not surprisingly, the owners of such precious gifts were reluctant to part with them, although in the nineteenth century many Pomos were desperately poor and had no other source of cash income. Many a white collector bargained for days with a Pomo woman for a basket in which she took special pride, had never intended to sell, and had reserved for her own enjoyment in life and after death. Such persistence sometimes paid off, sometimes not. Some whites saw themselves as on a kind of artistic rescue mission, for many of the greatest baskets were destined to be burned with their owners. Until California passed from Mexican hands to U.S. sovereignty, the Pomos, like the Maidus and other peoples, practiced cremation burial, not once but twice, each time with some of the finest examples of the basketmaker's craft. The first cremation took place four days after death, to give the spirit time to take leave of the body; on this occasion personal possessions and gifts were burned (except for some sacred heirlooms that were passed down in the family from generation to generation) and the house was abandoned or destroyed. The following year there was a memorial ceremony at which the ashes were reincinerated along with additional gifts of baskets and other offerings, denoting the grief of friends and relatives. Basketry jars with woven figures and perforated shell beads served as mortuary urns on these occasions.

Although it has generally been assumed that the feather-mosaic "jewel baskets" were never intended for everyday use, this is not strictly true. Most of them played a strictly ceremonial role, but some feather baskets that were collected in the nineteenth century and are now in the Smithsonian Institution show not only considerable wear but even burn marks and berry or acorn-mush stains, and some still bore the unmistakable odor of fish years after they arrived in Washington. That a woman might spend months weaving and painstakingly feathering a basket and then use it to store berries or dried fish or to cook food in with hot stones was as incomprehensible and almost as appalling to white collectors as was the custom of burning such priceless works of art. But as Mason noted admiringly, the Pomo woman had need for beauty even in strictly utilitarian objects.

Some Pomo women took particular delight in reducing the size of their baskets (Plate 68), producing tiny masterpieces that faithfully reproduced the materials, techniques, and designs of full-size models. Decorated bowl baskets measuring less than an inch across and a half-inch in height, with nine coils from base to rim and ten stitches per quarter inch, were not unusual; more remarkable still are perfectly stitched baskets small enough for six of them to fit easily on a Roosevelt dime, and some so minute that they hardly cover the former President's ear!

With few exceptions, the American Indian basketweavers were women, and so they are wherever baskets are still made today. Among the Pomos, however, there was some limited division of labor; men made some of the noncere-

monial open-work utility baskets, such as those employed in catching or transporting fish. The designs were the property of women. Unfortunately, by the time ethnographers began to study California basketry seriously, many of the original meanings had been forgotten. Most abstract geometric symbols in Pomo basketry represented animals or parts or tracks of animals, as well as phenomena of the environment and of the weather. More or less naturalistic human or animal figures were used more rarely and may have been a relatively late innovation, perhaps in response to white demand.

Women worked on baskets throughout their lives but generally laid them aside during menstruation. At this time a woman was supposed to cease all ordinary chores and, if possible, seclude herself in the menstrual hut. If she did wish to continue weaving, she could protect herself against supernatural harm by inserting quills of the red-shafted flicker or yellowhammer into the stitches. Few surviving baskets have these quills, however, which suggests that women generally preferred to follow the taboo against any kind of work for the duration of the menses.

A beautiful Pomo story expresses perhaps better than any other the function of the private vision in the making of a basket and the powerful spiritual bond between the art and the weaver's crucial role as provider of the mainstays of life.

Long ago, according to the myth, there was a young Pomo woman whose family was so wealthy and prestigious that she never left the house to collect food or basketmaking materials, as Pomo women customarily did. Life was good, and there was an abundance of wild plant foods and plenty of game and fish for the men to catch. But one year the seeds suddenly disappeared, the hunters could not find deer, and famine struck the people. Everyone grew weaker, and the young woman, too, had nothing to still her hunger. Then one day an unfamiliar sensation impelled her to rise from her sleeping place, take up a collecting basket, and leave the house for the river. Her relatives marveled, for never had they seen her do anything like this before.

When she came to the river, she was confronted by a terrible water monster, and suddenly she knew that it was he who was causing the famine. Scolding the monster for the evil thing he was, she vowed that one day she would have the power to defeat him. But the monster took no notice.

From the river her feet took her to the hills, where she gathered roots and grasses, as though this had always been her occupation. Somehow she knew that she was to weave a very special basket and that this would have magical power. When she returned and sat down to weave, her family and friends were again astonished, for no one had ever taught her the art. Yet she knew exactly how to begin and how to weave into the basket designs that were in her head. As the work progressed the designs did not remain the same but changed form. When at last the basket was done, deer and grains suddenly reappeared. From then on, if any members of her village were hungry, they could reach into the basket of life and take as much food as they needed. The basket never became empty, not even after a great feast.

Once again the people were well fed and content. But the young woman knew that as long as the evil monster was still in the river, famine could return at any time. One morning she left the village for the river to find the monster and destroy him forever. With a long hair from her head she made a magic trap and staked it to the ground at the water's edge. All that night she remained awake, keeping vigil and singing her medicine songs. At dawn she carried her magic basket to the river to see whether the trap and her songs had succeeded. Finding the monster caught in her snare, she took four sticks of green wood, decorated them with special designs, and cut her own body, using the blood to stain the designs, all the while singing for power. The monster tried to escape destruction by her power songs by changing the patterns on his back. But each change in pattern brought about a corresponding change in the living patterns on her basket, and in the end the basket won out over the monster. The young woman now placed her basket before the motionless monster, telling him that control over the food supply had passed from him to the basket. Then she returned with her basket to join the people in a harvest feast.

But the monster had not died. At the height of the celebration, he suddenly appeared, and as he wildly lashed his tail from side to side, the young woman was struck a fatal blow. Her body became transformed into a white fawn that swiftly disappeared into the woods. Since the death and transformation of White Fawn Woman, according to the Pomo storyteller, "Evil has come into the hearts of men, and they have been forced to search for food with much difficulty. This has brought greed, dishonesty, and unkindness of every sort into the world. It has brought wars without number." The Pomos still sometimes see White Fawn, spirit of the basket of life, but she is rarely glimpsed except by those of pure heart.

# Rock Paintings of the Chumash

As a female art that was, except for private communion with the spirit world in its initial stages, essentially a social activity, California Indian basketry stands at the opposite end of an ideological and social continuum from an art form that was both private in the extreme and exclusively the province of men: the translation into two-dimensional polychrome rock art of supernatural dream experience. In California, these rock paintings seem to have been exclusively the work of the Chumash. The art is also apparently functionally related to a powerful hallucinogenic plant, *Datura* (Plate 80), whose ritual use these Indians shared, though in different forms, with many other Native peoples in southern and central California and adjacent regions.

In the Southwest, Puebloan and other groups used *Datura* in a variety of religious and shamanistic contexts. The mythology, medicinal use, and role of *Datura* in vision-seeking and divination by Zuni rain priests and directors of religious or ceremonial fraternities, for example, were well documented early in this century with the publication in 1904 of Matilda Coxe Stevenson's massive Smithsonian report on Zuni intellectual culture. A few years later, the same writer, who with her husband, James, had led the 1879 expedition to Zuni Pueblo, discussed the subject more thoroughly in a study of economic and religious plant use among the Zuni Indians. Nowhere in these and other accounts, however, is there a hint that the ecstatic *Datura* experience influenced art, beyond having inspired a well-known flower motif in Pueblo symbolism and hairstyle (Plate 36) that whites in the nineteenth century mistakenly took to be a "squash blossom." That misidentification has been with us ever since, perhaps because, as Mrs. Stevenson wrote about the Zunis, the Indians were only too pleased to let whites remain in ignorance of what to the Indians was so sacred a flower.

The religious and shamanistic use of *Datura* extended in one long continuous arc, across geographic, cultural, and linguistic boundaries, from the agricultural Pueblos of New Mexico to the food-collecting peoples of California, whose basic vegetable staple was the acorn. Many of the Indian populations of southern California whom the Spanish named after their missions, among them the Luiseño, Diegeño, and Gabrieleño, observed related forms of puberty initiation in which *Datura* was repeatedly administered to boys to make them fall into a deep ecstatic trance, in which they were to relive the ancient myths and confirm for themselves the truth of all they had been taught by their elders. Among southern California Indians who used *Datura*, though not, apparently, in puberty rites, were the Chumash, a talented people some ten to twenty thousand strong, who formerly inhabited all of Santa Barbara County, most of Ventura County, and portions of San Luis Obispo, some 6,500 square miles in all. Except for a small number of Californians with Chumash ancestry, the Chumash have become extinct, leaving behind as evidence of their former greatness cemeteries, the buried foundations of their villages, a great amount of archaeological art in stone, shell, and bone some of the most spectacular rock paintings in America (Plates 79, 81–85), and basketry that ranks with the best produced in aboriginal California (Plates 75, 78).

Almost all of the paintings surviving in the Chumash country are found in caves and rock shelters or on perpendicular cliffs in the mountains and densely wooded canyons covered with spruce, laurel, alder, or, more often, virtually impenetrable chaparral. This remoteness from the scene of everyday life is a characteristic that Chumash rock art shares with that of other peoples—those of South America, for example—whose shamans are known to have employed hallucinogens in their supernatural quests and who later depicted some of their experiences on rocks. In the case of the Chumash, it is this isolation that protected the paintings from Spanish eyes and so preserved many of them into modern times. Their age is unknown, but most appear to date between about a thousand years ago and the Mission period, in the late eighteenth and early nineteenth centuries.

Some of the rock paintings are simple figures painted in red; others are large and complex, making use of several colors, principally red, white, black, and yellow, and sometimes other hues as well. Some sites were apparently used only once; others, like the famous Painted Cave near Santa Barbara (Plate 81), show evidence of repeated visits and paintings by several individuals over time.

It appears from what the Spanish wrote during the Mission period and what was seen or remembered of the culture at the turn of the century that the Chumash were exuberant and even extravagant in their use of color, employing it for ritual body painting and the decoration of buckskin clothing, the sides of plank canoes, and the wood and stone effigies that once marked their dancing grounds and burial places. Of all this lavish use

of color only the pictographs remain, and even they have been largely destroyed by erosion and, more often, by willful vandalism. Incredible as it may seem, whites in the past few decades have used some of the most beautiful and mysterious of these religious paintings for target practice. Thus, an extremely complex, forty-foot-long painting in the Cuayama area of northern Santa Barbara County, in perfect condition when it was first photographed in the 1870s and still mostly intact in the early 1900s, now exists only in badly damaged fragments and a reconstruction painting by Campbell Grant (Plates 84–85), most of it having been obliterated by rifle fire and hundreds of names painted, incised, and written over the sacred designs. To recreate this and other Chumash paintings as they looked before they were eroded or vandalized, Grant worked from old and new photographs and inch-by-inch examination of the entire rock surface for traces of color.

Along the coast, Chumash artists used large fish vertebrae as well as seashells as portable paint cups. In the interior, the artists mixed their pigments in depressions hollowed out from the living rock, in some of which traces of paint have survived to this day. For their ceremonies, the Chumash thinned their paints with water, but rock art was made water-resistant by the addition of animal and vegetable oils and vegetable binder, and perhaps also by the whites from the eggs of wild birds. Exactly which plants the Chumash painters used is not known, but the neighboring Yokuts employed milkweed juice as a binder, mixed with oil from the seeds of the chilicothe. The techniques of painting varied from area to area, ranging from drawing directly on the stone with a lump of pigment to extremely delicate brushwork executed with remarkable skill. Brushes were probably made of yucca fiber or, as among the Yokuts, the outer husks of the soap plant.

The subject matter of Chumash rock art is essentially of two types. Some of it is *apparently* representational, including recognizable plant and animal motifs as well as figures of humans or supernaturals with human characteristics, and some is *apparently* abstract or geometric, with a wide variety of elements, among them zigzags, dots, concentric circles, wheels, diamonds, squares, triangles, grids, ladders, checkerboards, crosses, spirals, chevrons, parallel lines, and lattices. A single surface may have scores or hundreds of designs, many of them extraordinarily elaborate and intricate and executed with great care and some of them variations on a single motif, a disk or a wheel, for example, which

may or may not represent the sun or an abstract solar deity (Plate 81). Although there are great numbers of anthropomorphic and zoömorphic figures as well as plant motifs, Grant has found only two instances of "realism," a swordfish and four men on horseback, the latter clearly representing a real event, perhaps the passing of Spanish soldiers through the Chumash lands.

Some of the design elements can be read on the most superficial level as plant, animal, or human forms; most, particularly the geometric configurations, cannot be deciphered at all. A few designs are so widely distributed throughout the world as to be intelligible even in the absence of written accounts. So, for example, a horizontal line with small vertical lines extending downward is, by analogy to the symbolism of the Pueblo Indians, among others, a symbol for rain falling from the clouds; a circle with a vertical line through it is a sign for female fertility; and a horizontal wavy or zigzag line indicates water. But even where some objective explanation is possible, we do not know precisely how these motifs or concepts fit into the intellectual culture of the Chumash. Indeed, any attempt to understand their significance leads us into the deepest levels of the human mind. For many of the geometric or abstract elements may, in fact, be representations of subjective inner-light experiences, luminous patterns originating in the brain and eye, "phosphenes" triggered by changes in body chemistry and shared to a remarkable degree by all human beings.

To understand these remarkable phenomena of subjective vision and their possible connection with the esoteric rock art of the Chumash and other peoples, we need to enter the field of neurophysiology, for phosphenes arise spontaneously out of the neurochemical impulses that pass through a system including the eye, the cortex, and the subcortex of the human brain. Although they briefly illuminate the visual field, they owe nothing to any external source of light. They are, in fact, a normal function within the brain. They can best be seen with eyes closed, but they may also appear when the eyes are open, as brilliant, luminous patterns superimposed on the external world.

Considering the time and effort required to execute a painting or engraving on rock, one wonders how the California Indian artist was able to retain so fleeting an image as a phosphene long enough to reproduce it. Modern research has shown that although these inner-light experiences are often little more than sudden flashes when they appear initially, they can repeat themselves as after-images for several months under

similar stimulation of the brain or through changes in the body chemistry, such as those induced by hallucinogenic chemicals. They may be produced by so simple an act as pressing gently on the eyeballs with the lids closed, but they are typically and most forcefully associated with altered states of consciousness, whether induced by sensory deprivation, meditation, or the use of such plant hallucinogens as mushrooms, morning-glory seeds, peyote, or, as among the Chumash, *Datura*. In fact, it was the hallucinogens that under laboratory conditions produced the greatest number of complex images, including not only geometric patterns but also man-made objects, plants, animals, and features of the landscape, all typically enhanced by brilliant colors. The appearance of phosphenes was also induced by meditation, fasting, or sensory deprivation, all of which are thought to release chemicals in the brain that are strikingly similar in structure and effects to those produced by hallucinogenic flora. Needless to say, these findings are crucially important to a better understanding not only of American Indian rock art but also of the near-universal Native American vision quest, which in most areas, especially the Plains, relied for its effects upon fasting, sensory deprivation, and sometimes even pain and self-mortification rather than on psychoactive chemicals. Significantly, many of the images and symbols in Plains Indian art are known to have originated in the dreams and ecstatic trances of such vision quests (see Chapter Six).

*Datura* use among the Chumash belonged to a much wider shamanistic complex that included many Native peoples in southern and central California. With effects resembling death during the deep trance and rebirth upon awakening, it played an important part in initiation rituals, mostly of boys but sometimes of girls as well, among several southern California populations that spoke languages belonging to the same family as Aztec in Mexico or Hopi in the Southwest. Further north *Datura* seems to have been primarily a sacred means by which shamans triggered ecstatic trances in which they experienced the separation of spirit from body. In Spanish California the use of *Datura* came to be known as the *toloache* cult, from the Aztec *toloátzin* for *Datura*, whose hispanicized form the priests applied to California Indian rites that reminded them of what they had seen or heard of among the Aztecs and other Mexican peoples.

*Datura*, whose powerful hallucinogenic effects are accompanied by considerable physiological risk from its poisonous alkaloids, was readily available in California, and, indeed, the genus as a whole is found over much of the world. It and other members of the Solonaceae (potato or nightshade) family have been important not only, as among North and South American Indians, in ritual shamanistic ecstasy but, in the Old World, in sorcery, witchcraft, and divination. In the eighteenth century the medical profession recognized its therapeutic possibilities as, among other things, an analgesic. The two most widely used species in North America were *Datura inoxia* (known in Stevenson's time as *D. meteloides*) in the West and the well-known "Jimsonweed" (*D. stramonium*) in the East. The popular name is a contraction of Jamestown Weed, named for Jamestown, Virginia, because it was there at the turn of the seventeenth century that some English soldiers became intoxicated while on duty following the supposedly unintentional ingestion of *Datura* as a "pot herb."

The Chumash personified *Datura inoxia* as a powerful, aged supernatural, Old Woman Momoy, *momoy* being the Chumash word for *Datura*. Momoy lived in ancient times, before the Universal Flood, in the company of a child or grandchild. She possessed great supernatural power and knowledge, which she gave to those who drank the water in which she washed herself, that is, the intoxicating infusion made with the pounded root of the *Datura* plant. The Chumash were very much aware of the danger of overdosing on the potent hallucinogenic drink. In one story, Momoy gives a grandson a drink of the water in which she had washed her arms, which causes him to fall into a deep six-day sleep. He had wanted more, but if he had drunk all of her bathwater, she tells him, he would have gone mad and died.

When digging for the root from which the *Datura* beverage was brewed, the Chumash addressed it reverently as "Grandmother." Before and after drinking *Datura*, one had to abstain from sex for a given time. Just as Momoy subsisted only on tobacco, so one who ingested the potent·*Datura* infusion had to fast or at the very least abstain from meat and fat while being allowed, and indeed required, to take tobacco.

In the typical *toloache* initiation rites of other Indians, the youthful neophytes were kept in a state of ecstatic trance and were instructed by elders in esoteric knowledge. In their visions, they were also expected to encounter the supernatural heroes of tribal tradition. Elaborate ground paintings played an important part in instructing the novices, but unlike the sandpaintings of the Navajos, these are not known to have been used in curing.

The Chumash, too, used ground paintings in

initiation as well as in mortuary ceremonies, but *Datura* played no part in instructing the young as they reached puberty. Rather, the Chumash used *Datura* individually, most often to establish contact with a guardian spirit or spirit helper. The taking of *Datura* was not obligatory, but it was generally agreed that *Datura* gave one access to the spirits and, with their aid, to the strength and bravery necessary to deal with whatever hardships life might present. Some peoples limited the potent hallucinogen to men or boys at puberty, but the Chumash felt that *Datura* was especially efficacious for women, for it would give them courage to face the dangers and pains of childbirth as well as protection while collecting food in the wilds: no bear, for example, would harm a seed-gathering woman who had taken the *Datura* drink. But the emphasis was always on moderation, lest the poison do irreparable harm—as indeed it could.

The last Chumash rock paintings were probably made in the nineteenth century, and there are no Chumash left alive to provide the information to enable us to relate the art to the hallucinogenic experience. But we know that there are certain universals in the shamanistic use of plant hallucinogens, however much the content of the visions and their interpretation are culturally determined. Thus we know that when the Chumash used *Datura*, they did so because the divinity ascribed to the plant enabled them to make contact with the unseen forces in their environment—the "supernatural," if one will—and, by experiencing in ecstatic trances the beginning of the world exactly as described by the elders and the shamans, to reaffirm for themselves the validity of the traditional culture. The ecstatic *Datura* trance transported the Chumash shaman "out of body" to other worlds, to acquire tutelaries and add to his practical knowledge the essential supernatural sanction that allowed him to function as diagnostician and curer of illness, retriever of lost souls, traveler through "inner space" between the seen and unseen worlds, interpreter of dreams, locator of game, and predictor of the weather—in short, as the quintessential guardian of the accumulated knowledge, traditions, and cultural integrity of his social group and of its internal and external equilibrium. The Chumash artist-shaman translated his visions into the symbols of Chumash pictorial art. Certainly he gave these symbols meanings drawn from his own specific cultural experience. Nonetheless, there are present in this art many of the same basic motifs and patterns and the same transcendental luminosity that characterize the pictographs of peoples as far apart in time and space as modern

South American Indians, the ancient inhabitants of the Pecos River area of Texas, the ancestral Bushman people of South Africa, Australian aborigines, and even the inspired Upper Paleolithic painters of Lascaux and Altamira. This is not to suggest that the Bushman artist or the European cave painters of twenty to twenty-five thousand years ago necessarily made similar use of their psychoactive floras. What can be said is that, like the paintings of the Chumash, rock art everywhere is often more complex and more closely tied to the inner shamanistic experience, whatever the specific technique of ecstasy, and thus more significant for the origins and history of art than the old notion of "hunting magic" as the primary purpose of cave art would suggest.

*Plate 59. Clamshell disks, red woodpecker feathers, and the topknots of quail decorate this coiled Pomo presentation basket. Feather baskets were made for young girls by their mothers and other female relatives and were treasured by the recipients throughout their lives, often cremated with their remains. (7" diameter. 1890–1910. Newark Museum.)*

*Plate 60. Unusually large Pomo feathered ceremonial basket was made about 1900 and festooned with triangular abalone-shell pendants. Small cut and perforated clamshell disks line the rim. These clamshell beads were widely traded among California Indians as a money-like standard of value. (16¼" long. Newark Museum.)*

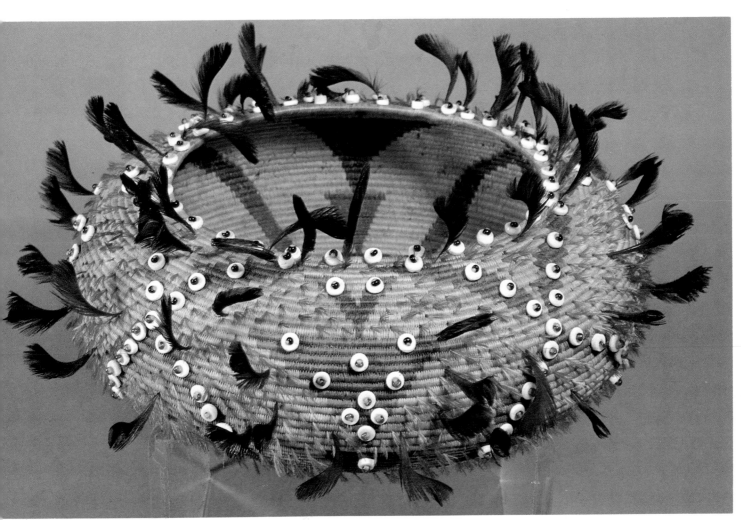

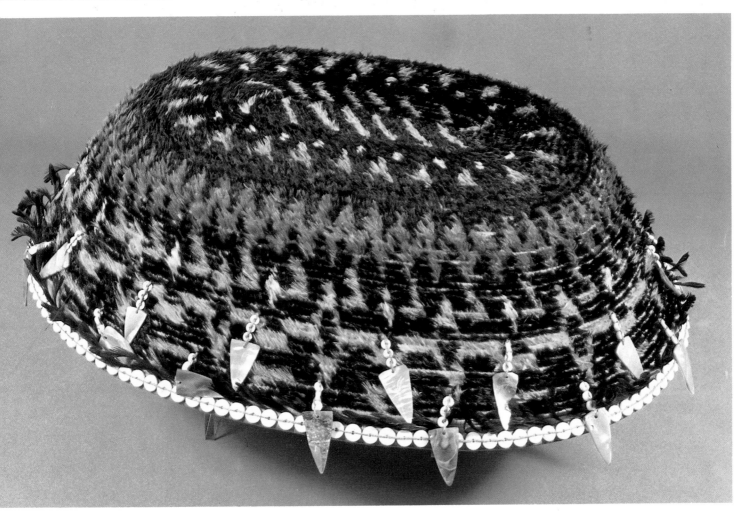

Plate 61. Collectors at the turn of the century called the tightly coiled Pomo trays covered with the bright crest feathers of the redheaded woodpecker "sun baskets," and those with green mallard feathers "moon baskets." The Indians themselves made no such associations. Still, the all-red baskets had special significance, for red was the color of blood and life. Pomo tradition says that formerly only the crest feathers of the woodpecker, the green head plumes of the mallard, and the jet-black topknot of the quail were used, other colors being added only in response to the growing popularity of these baskets among whites. (5¼" diameter. 1890–1910. Newark Museum.)

Plates 62 & 63 (opposite). The shallow tray with its whirling design (top) and the boat-shaped trinket or treasure basket (bottom) are both decorated with bright yellow breast feathers of the meadowlark and iridescent plumage of mallard and hummingbird. Other species whose feathers were used by Pomo basketweavers include bluebird, oriole, thrush, robin redbreast, red-winged blackbird, and brant. Clamshell disks and abalone pendants adorn most Pomo feathered ceremonial or gift baskets. (Tray, 6⅝" diameter; bowl, 10" long. 1890–1910. Newark Museum.)

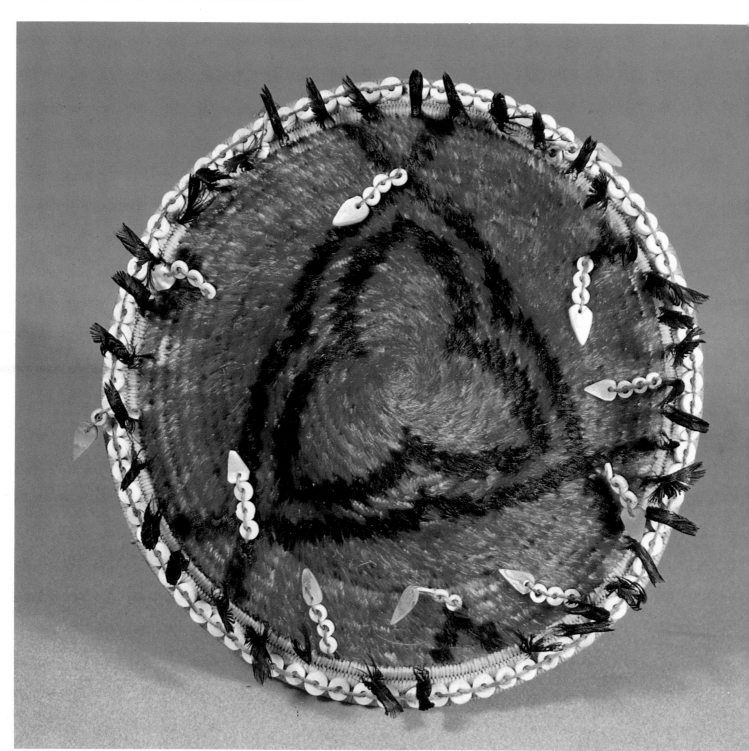

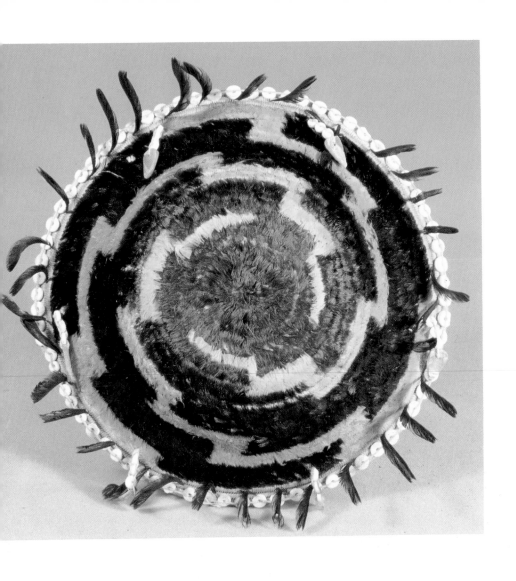

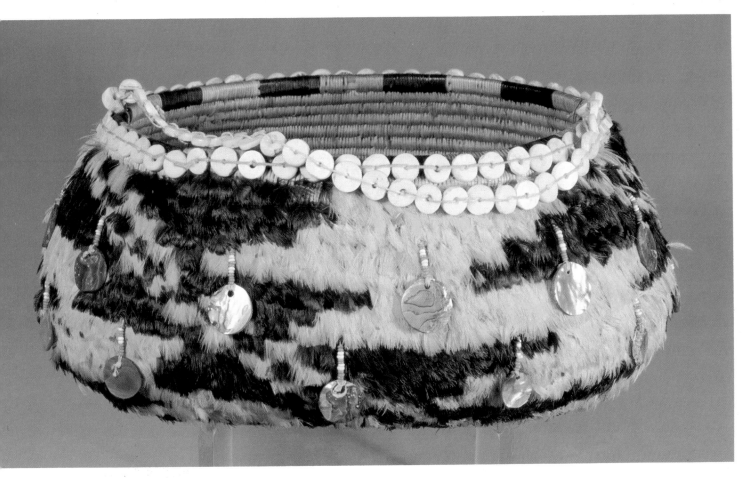

*Plate 65 (opposite). Hupa ceremonial headdress made of deerskin with red woodpecker feathers and white deer hair. (8½" high, 20" overall width. 1880–1900. Collection William E. Channing.)*

*Plate 64. The Redheaded Woodpecker Dance, also called Jumping Dance, was photographed by A. W. Erickson between 1890 and 1900. A Hupa men's ceremony, it was performed annually to ward off disease. The men wore spectacular headdresses made of a wide band of deerskin covered with rows of brilliant red woodpecker crest feathers, narrowly edged with white deer hairs. A deerskin robe was worn as a kilt, and each performer displayed all the precious shells he possessed. In the right hand the dancers held cylindrical baskets with narrow slits, but the significance of these dancing baskets, which were stuffed with dry grass or straw, was no longer known in the early years of the twentieth century.*

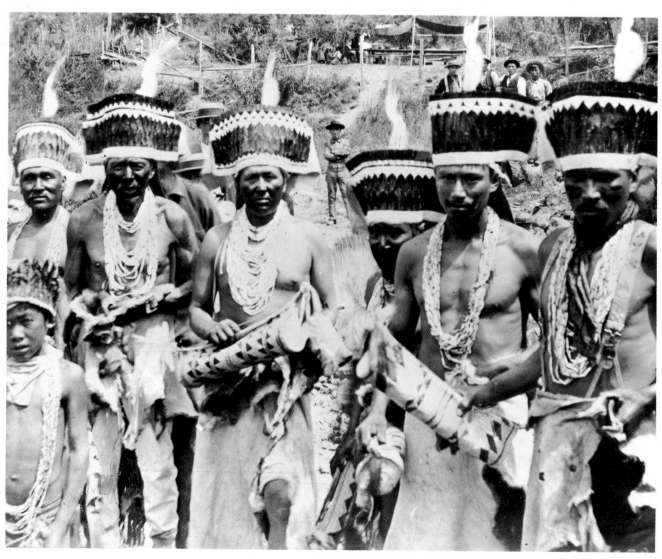

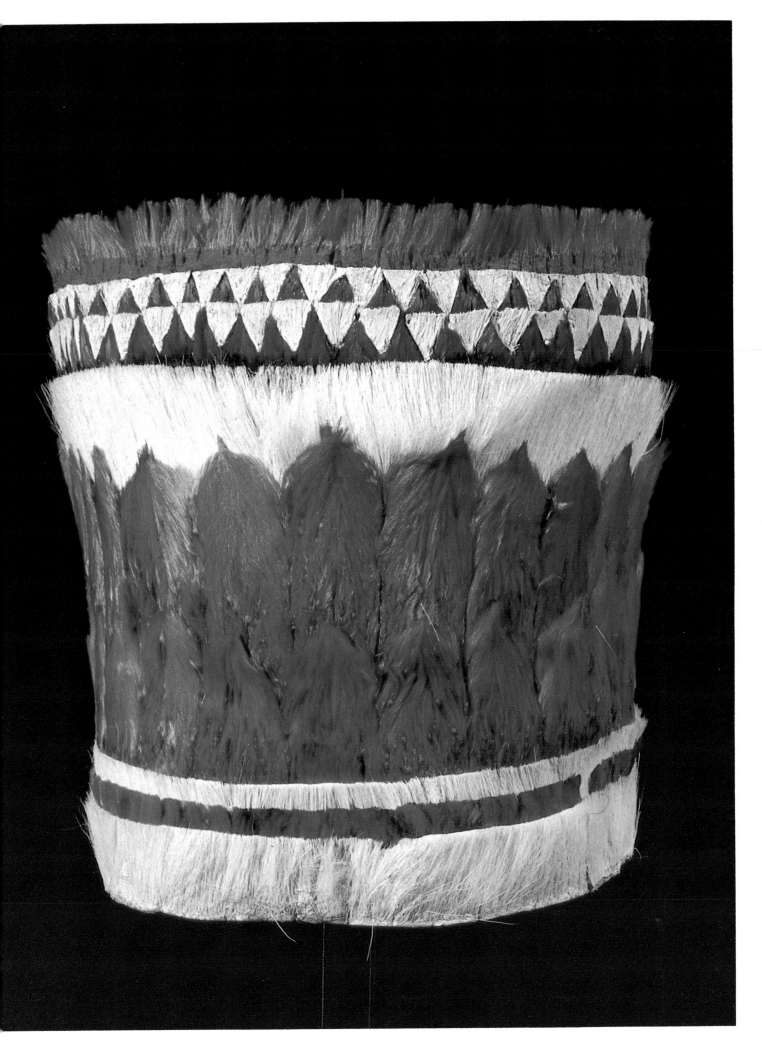

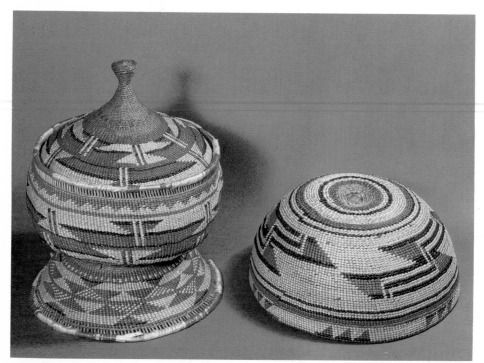

Plate 66. Covered baskets with pedestals were a late nineteenth-century innovation among the Hupa, probably inspired by glassware or china. The twined woman's cap is a traditional form, worn also by Karoks (Plates 69 and 70) and other northern California Indians. (Left, 8½" high; right, 3½" high. Private Collection.)

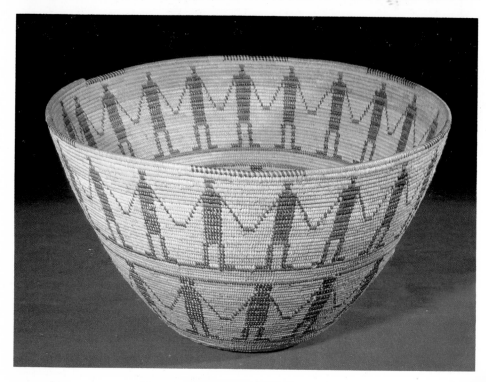

Plate 67. Linked figures representing dancers or, metaphorically, members of a lineage decorate this large nineteenth-century Tulare ceremonial basket from northern California. (8¼" high. Peabody Museum of Natural History, Yale University.)

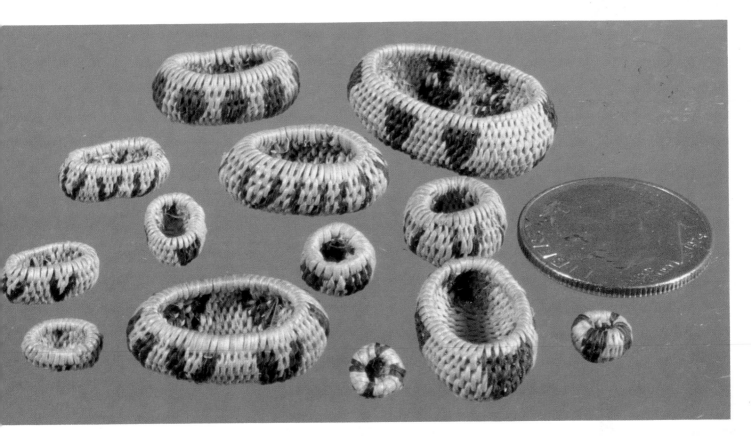

Plate 68. At the turn of the century, some Pomo basket-weavers competed with one another to see who could produce the smallest basket, complete with decoration and utilizing the same willow splints and dyed black bulrush used on full-size coiled basketry. Nine or ten of the tiniest baskets would fit comfortably on the dime at right, which dwarfs all but the largest miniatures. (From about 1/8" to 1" long. Newark Museum.)

Plate 70. A nutritious ground meal made from acorns after they had been leached of their tannic acid was to most California Indians what corn was to the Pueblos and other agricultural peoples. In 1923, when acorn meal had not yet been largely replaced by commercial products, Curtis photographed this Karok woman of northern California preparing acorn meal mush in the time-honored manner, with hot stones in a watertight, twined cooking basket.

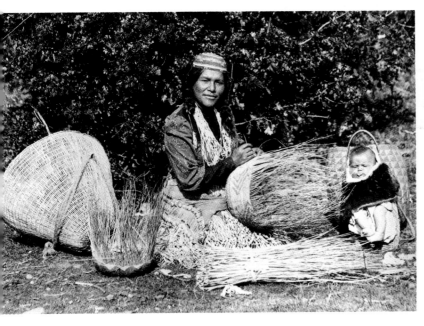

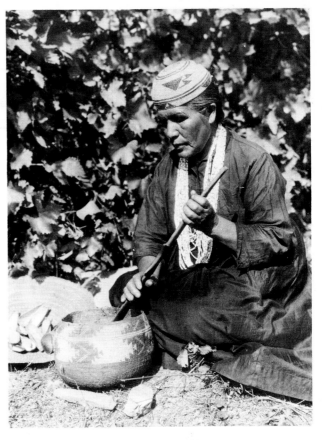

Plate 69. Photographed in 1894, this young northern California mother, probably Karok, is shown working on her baskets while her baby sleeps nearby, secure in its basketry cradle. (Smithsonian Institution. National Anthropological Archives.)

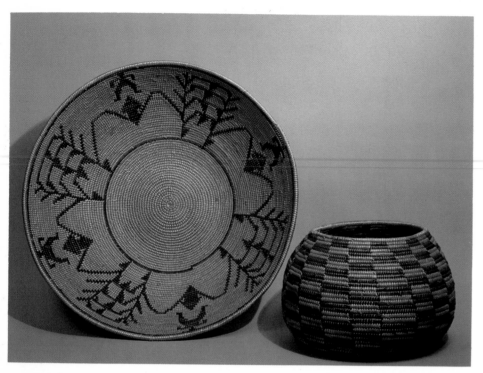

Plate 71. "Mission basketry" is the collectiv⎯ name for baskets woven by diverse souther⎯ California Indians who in the late 1700⎯ came under the tutelage of such Francisca⎯ missions as San Gabriel, San Diego, and Sa⎯ Juan. Except for the distinctive basketry ⎯ the Chumash, these coiled mission baske⎯ share techniques of weave and design mo⎯ tifs, which makes precise identification diff⎯ cult. It is documented that the large shallov⎯ bowl and the smaller seed basket shov⎯ here were made about 1900 by the Luiseñc⎯ named after Mission San Luis Rey de Francia⎯ (Left, 8" diameter. Right, 16½" diameter⎯ Smithsonian Institution.)

Plate 72. Although there were many fine bas⎯ ketweavers among the Washo, who liver⎯ around Lake Tahoe in California and Ne⎯ vada, none achieved greater renown for per⎯ fection of stitching and uniform placemen⎯ of elegant abstract designs than Dat-So-La⎯ Lee, whose name means "Wide of Hips."⎯ Her work spans a quarter-century, fron⎯ about 1900 to her death in 1925. This splen⎯ did coiled basket, the first she ever made⎯ with a lid, was completed in a single wee⎯ in April 1905, with designs the weaver ex⎯ plained, in words reminiscent of Haiku⎯ poetry, as "Rainy weather in month suc⎯ ceeds by clear sky after the storm." (8¾"⎯ high. Natural History Museum of Los Ange⎯ les County.)

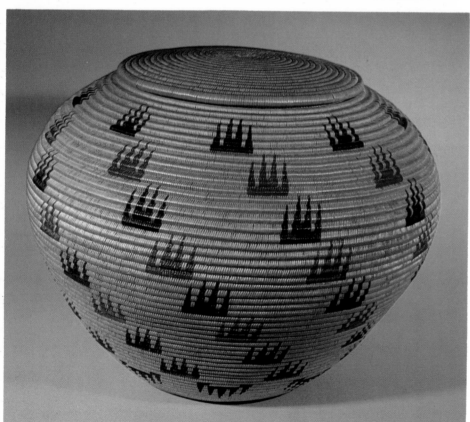

Plate 73 (opposite top). An old southern Cal⎯ ifornia food or ceremonial basketry bowl⎯ with traditional cascading lightning or ab⎯ stract rattlesnake design. (10½" diameter⎯ 1850–80. Private Collection.)

Plate 74 (opposite bottom). Much Maidu⎯ basketry from northern California was made⎯ of willow or the white inner bark of Oregon⎯ maple, with decoration of redbud. This large⎯ bowl from Eldorado County was made about⎯ 1900 by a member of the Prijunan family,⎯ whose work was highly prized by collec⎯ tors at the turn of the century; its pattern,⎯ called "Geese Flying," is one of more than⎯ fifty Maidu basketry designs representing⎯ animals, plants, mountains, arrowheads,⎯ and other subjects. (8" high. Smithsonian⎯ Institution.)

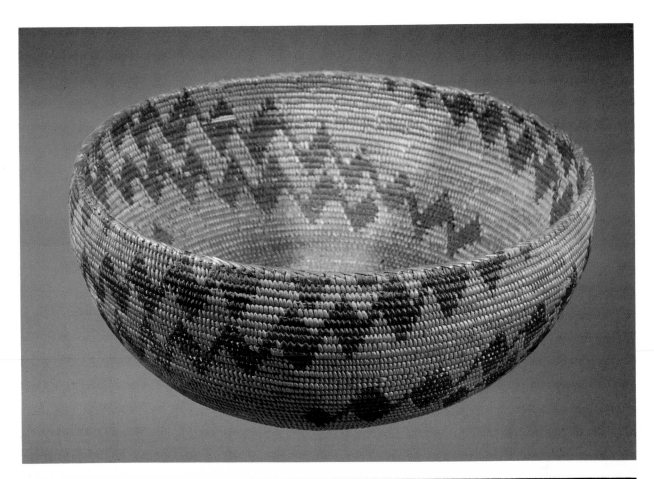

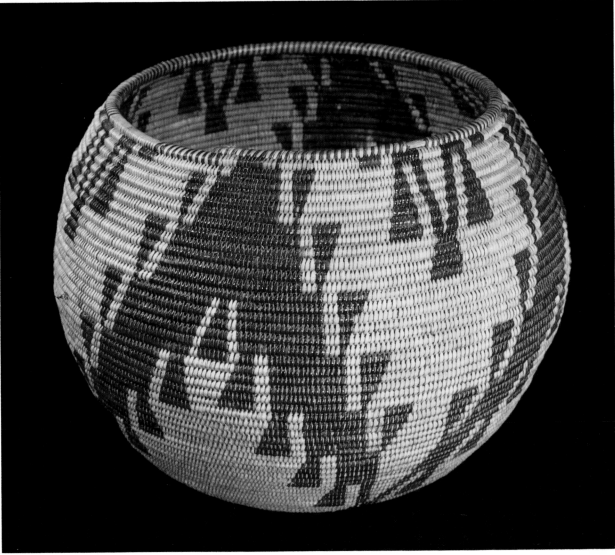

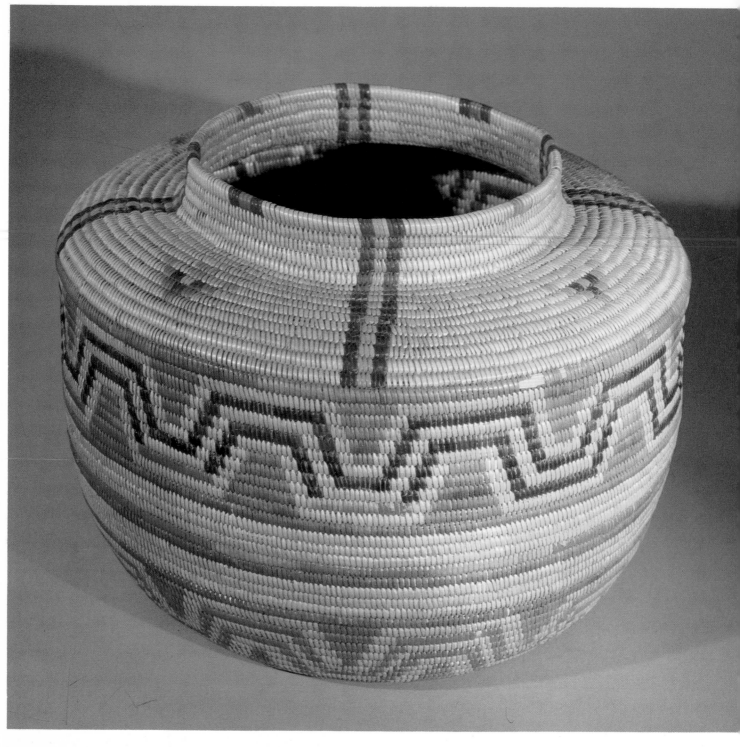

Plate 75. This handsomely decorated shouldered bottle basket, a familiar form in southern California, is attributed to the Chumash, of whose once highly developed basketry relatively few examples have survived. It was made about 1880. (7½" diameter. Natural History Museum of Los Angeles County.)

Plate 76 (opposite top). Games of chance with sets of "dice" and counters were virtually universal among North American Indians, both for diversion and as parts of divinatory rituals. But the "four-stick game," in which the player won or lost by guessing the relative position of pairs of hardwood sticks covered by a flexible basketry tray, was limited to western peoples. The gambling mat is a classic nineteenth-century Klamath example from northern Cali-

fornia or Oregon. Warp and weft are of dyed and undyed tule, with finely woven decoration of porcupine quill dyed yellow with wolf moss, a tree lichen. (20" diameter. Private Collection.)

Plates 77 & 78 (opposite bottom). Though it was made as a presentation basket for the Spanish governor of California, with Spanish colonial heraldry and a legend in Spanish around the rim, this large Chumash basket tray (right) signed by "the neophyte Juana Basilia," dating from the 1830s, is one of the finest examples of Native American basketweaving art. The six cartouches around the central motif were copied by the weaver from the heraldry of the Spanish Crown, perhaps from a silver coin of the period (left). (Basket, 23½" diameter. Santa Barbara Museum of Natural History.)

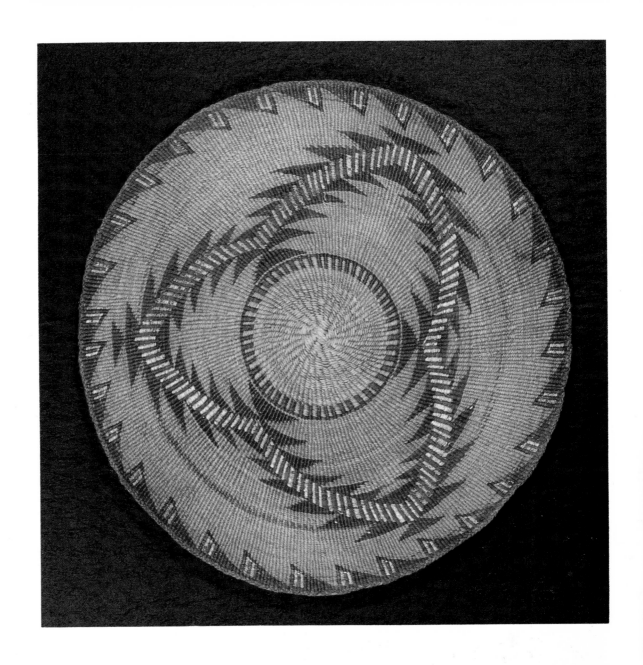

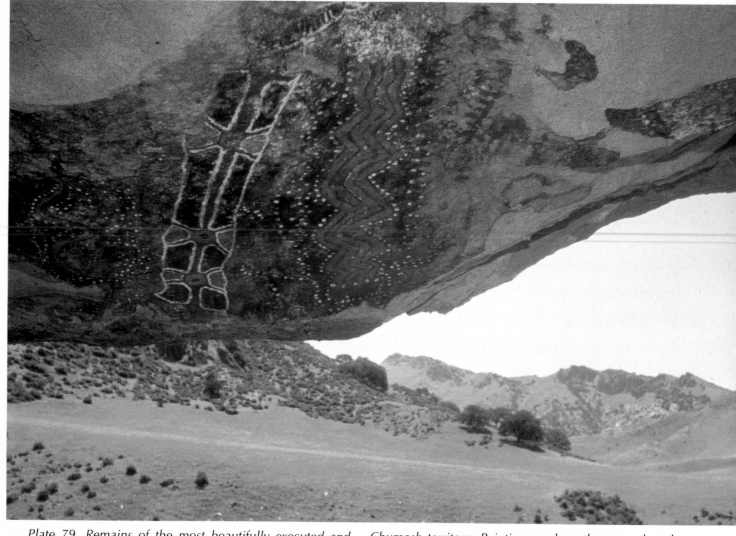

Plate 79. Remains of the most beautifully executed and elaborate polychrome Chumash rock paintings were found in this natural shelter in the San Emigdiano Range of Kern County, in the northeasternmost corner of the extensive Chumash territory. Paintings such as these are thought to have been executed by shamans and other vision-seekers when recovering from ecstatic trances triggered by the potent—and highly toxic—hallucinogenic Datura inoxia.

Plate 80. Widely used by California Indians in shamanistic and puberty initiation rituals, and in the Southwest for divination and communication with the spirits by shaman-priests, Datura inoxia and its sister species are characterized by showy, trumpet-shaped flowers, said to have been the inspiration for the well-known Puebloan motif commonly called squash-blossom (see Plate 36).

Plate 81 (opposite top). Many stylized figures in Chumash rock art are thought to represent supernatural beings, heavenly bodies, or the animating spirits of wind, air, animals, plants, and other phenomena as the artist experienced them in his dream or trance. Purely abstract patterns and even such motifs as spoked wheels, like these in Painted Cave, near San Marcos Pass above Santa Barbara, may depict phosphenes, the brilliant, luminous images that spontaneously illuminate the field of vision in quick flashes during altered states of consciousness.

Plate 82 (opposite bottom). Except for some of the paintings on the ceiling, most of the complex art that once covered the interior of the principal painted rock shelter in the San Emigdiano Range, in southern California's Kern County, has been eroded by wind. This small painting is apparently a self-contained portion of the assemblage of surviving polychrome pictographs in Plate 83. (24" x 18".)

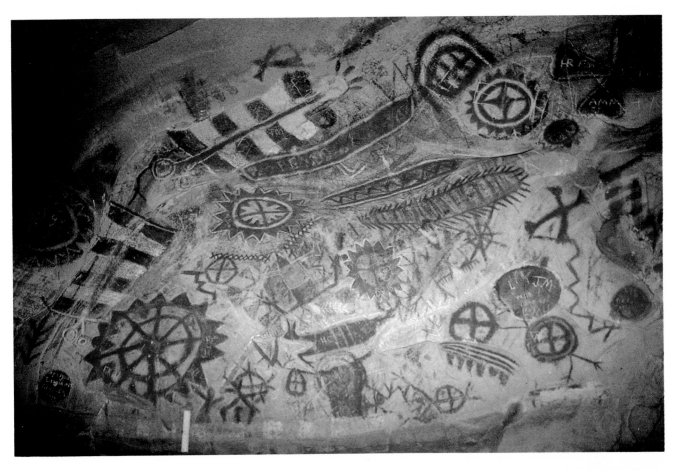

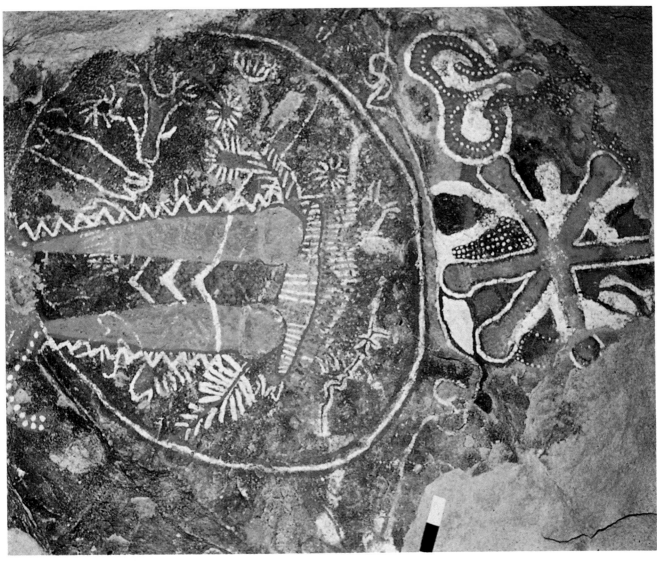

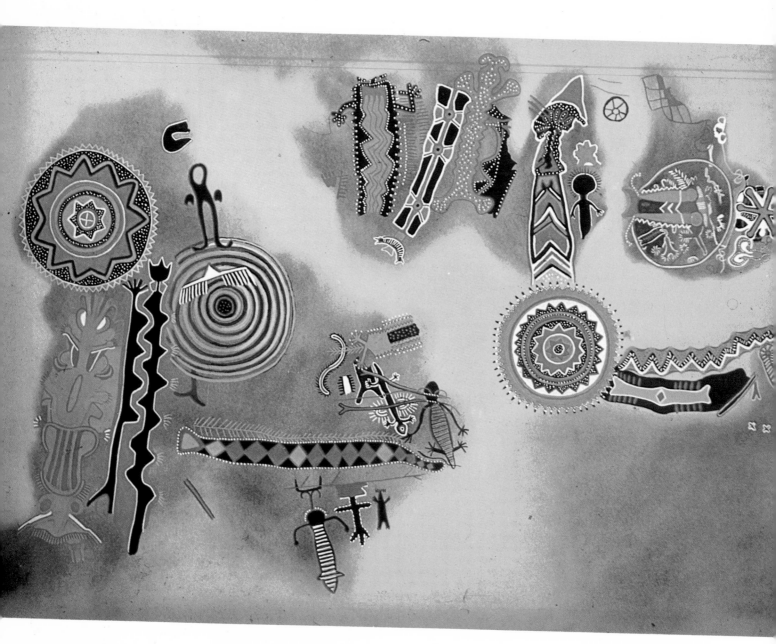

Plate 83. The surviving paintings on the San Emigdiano rock shelter roof, here seen in a reconstruction painting by Campbell Grant, include extraordinarily delicate and aesthetically pleasing renditions of visionary experiences by shamans who were consummate artists as well as specialists in the sacred realms of the Chumash universe. Grant, a California artist who has made the study and preservation of Chumash rock art his life's work, found considerable overpainting at the right, where beautifully executed designs were placed over older, cruder work. (78" x 120".)

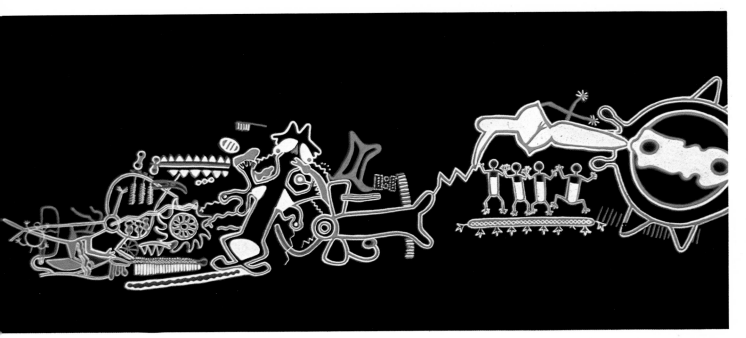

Plate 84 & 85. One extensive polychrome pictograph, over forty feet in length, from the Cuyama area in the northern part of Chumash country now survives only in this luminous restoration painting by Campbell Grant. Grant identified more than forty rock art sites in this region, which was virtually free of Mission control during the Spanish period. The original of this painting was located in a spectacular sandstone formation rising like a natural amphitheater above the desert floor of the Carrizo Plains, a perfect setting for sacred rites. In modern times, however, its easy accessibility by car invited its destruction by vandals. The pictograph was still intact in 1870, when it was first photographed, and in the early 1900s, when additional pictures were taken. But in the past several decades it has been virtually destroyed by rifle fire and by the scribbling, painting, and scratching of hundreds of names over the sacred designs. The old black-and-white photographs, together with color slides and inch-by-inch examination of the surviving fragments, aided Grant in reconstructing this Chumash painting. Its age, like that of other southern California pictographs, is unknown, but the last of this sacred art is thought to have been executed during the time of the Spanish missions, after 1769 and before California came under the American flag in 1848.

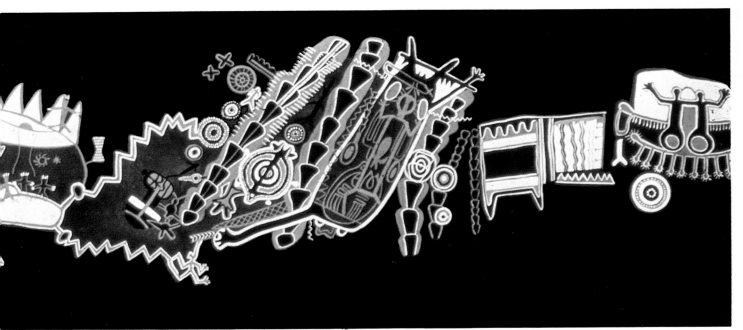

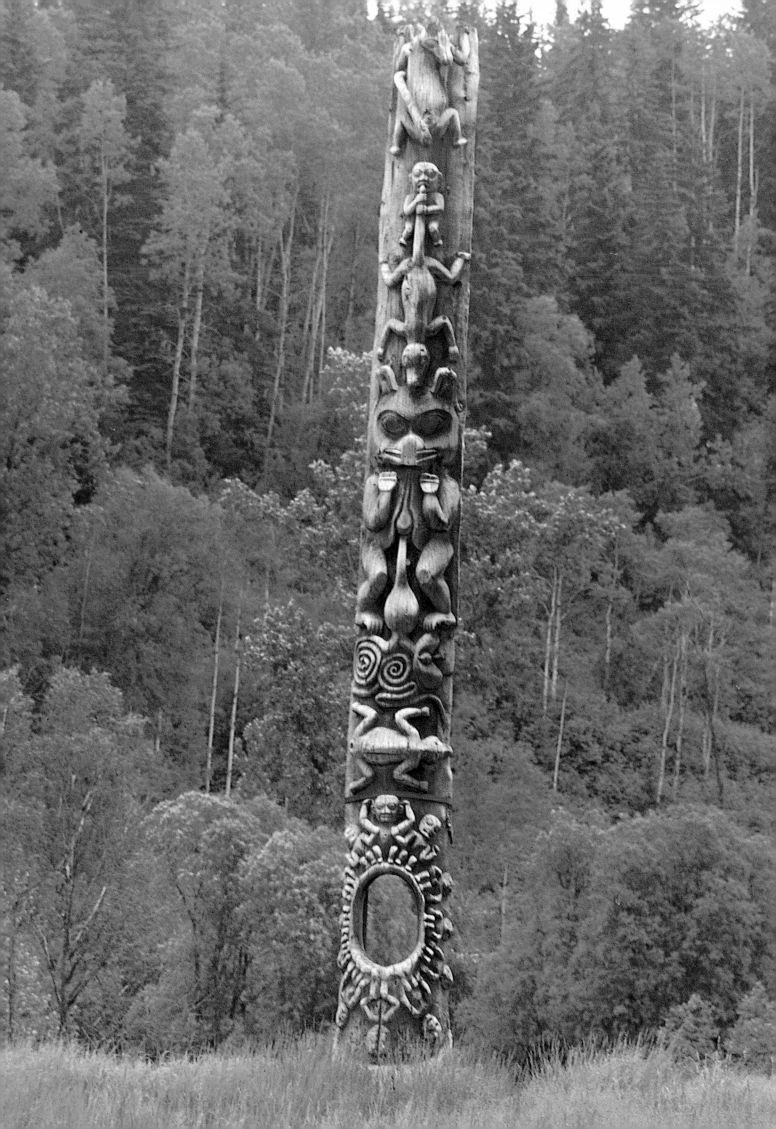

# Arts of the Northwest Coast

Northwest Coast art is dominated for the most part by one overriding shamanistic theme: transformation. Its principal subjects are animals—not usually, as one might expect, those most essential to the maintenance of life for people who lived by hunting and fishing, but those that figure in the great family traditions. These are the ancient myths that account for the founding of noble lineages and validate their inherited right to certain animals and spirits as their crests or emblems, the right to songs, ceremonies, and art that recreate the magical past, and, above all, the right to names that link their owners to the spirit donors of their supernatural property. Thus, the arts were linked not only to religion but to status and wealth—indeed, to the whole complex ordering of a class society.

Having noble parents did not automatically confer nobility. Nobles received their status by inheriting the name of an ancestor or of a spirit helper and its concomitant power and privileges, which the people called "treasures." Thus, if a family owned four noble names, the first four children, male or female, had noble status; the unfortunate fifth child and its descendants joined the ranks of the commoners. Still, among those commoners were skilled carvers of wood and builders of the great canoes, professions that were both lucrative and held in great respect. Households might also include slaves who had been captured in war and thereby lost whatever status they might have held among their own people.

*Plate 86. Still standing in the Tsimishian village of Kitwancool, on the upper Skeena River in British Columbia, this magnificent pole was raised over a century ago. It was originally a house front pole, the "Hole in the Sky" near its base serving as entrance and exit for the family dwelling. Thus, anyone who came or went re-enacted the ancestral cosmic passage between this world and the otherworld. Seventeen figures adorn this pole, not counting the dozen small, human-like beings surrounding the cosmic hole. The carver of this cedarwood sculpture, Haesemhliyawn, is still remembered and celebrated.*

For the nobles were reserved the privileges and prestige of sponsoring public performances of the ritual re-enactments of ancient events in the founding of their lineages and commissioning the masks and costumes for these ceremonies. Nobles could also commission "totem poles," houses, and other objects bearing family crests and representations of the ancestors and their spirit helpers. They in turn provided feasts during the public performances or at the dedication of poles or houses.

The highest-ranking member of the most prestigious family in a village was more the spokesman for the family and repository of its accumulated prestige and supernatural power than he was the maker of decisions. His power was largely nominal; his status and prestige were a function both of his greater claim to supernatural sanction and his generosity in holding feasts and distributing gifts from his store of tangible and intangible property. There was often also a merging of chief and shaman—the latter the most important figure in his kin group—to the extent that among the Kwakiutl, for example, shaman and chief were addressed by the same term, *paxala*, even though shamans were not necessarily chiefs, nor chiefs necessarily curing shamans. The shamans, however, everywhere occupied a special, even crucial, position. They were specialists in the sacred, religious philosophers, guardians of the traditions, transformers and mediators, who, by virtue of their unique powers, techniques of ecstasy, and their helping spirits (as distinct from the personal guardian spirits of ordinary people), had special access to the supernatural. With transformation as the central theme, shamans as the religious specialists, and chiefs invested with the shamanic powers of transformation in certain ritual circumstances, the religions of the Northwest Coast were no less shamanistic in fundamental ideology and in the acquisition and manipulation of supernatural power than, say, the religion of the Eskimos (see

Chapter Five). What distinguished the Northwest Coast religions was their far greater elaboration in art and in ceremonial performance and their far more complex hierarchical social context. Indeed, on the Northwest Coast even the role of shaman tended to travel in the family line; often the novice was supernaturally selected by his own dead shaman uncle or father, inheriting from him and earlier members of the lineage some of his most potent spirit tutelaries. Moreover, species widely respected as "shaman-makers" and invested with a special capacity for transformation—the killer whale, wolf, or otter—frequently figured prominently among the founding spirits, animal patrons, and emblems or crests of noble lineages.

# Houses and "Totem Poles"

Everyday life and ceremonial activity were centered on communal houses that made up the permanent villages strung out along the coast. These dwellings were rectangular in shape and sometimes of enormous size, with gable or shed roofs resting on massive cedar posts from three or four to fifteen feet in height and two or more feet in diameter. The framework was covered with cedar planking several inches thick and two or three feet wide. Northern houses were roughly square, fifty or sixty feet across on the average, with two doorways, one in the center of the façade, facing the sea, the other, used mainly for ritual purposes, at the rear. The southern houses were longer than they were wide; the largest known communal dwelling was five hundred feet long and sixty feet across! Built by communal effort, these dwellings were considered as sentient as any human being or animal. Each bore as its own distinguished name the hereditary name of its owner (e.g., Killer Whale House, Grizzly Bear House), and sheltered several related families ("the people of the house"), arranged in private quarters along the walls. The rear of the house, with its ceremonial door on the back wall, was reserved for the family of highest rank and its hereditary head. The main hearth fire was located in the center of the floor, beneath a hole in the roof through which the smoke escaped. The house was more than a dwelling; it was the universe in microcosm. Its central hearth was the navel of the world, its posts the supports of earth and sky, the smoke hole the cosmic passage between this world and the celestial realm above.

Crest poles, sometimes attached directly to house fronts, covered the doorway and were fit-ted with a round or oval hole that served as a passageway to and from the dwelling. These passages within or outside the dwelling symbolized death and rebirth from the mythological or supernatural tutelary of the family, for the opening often represented an animal's vagina or gaping jaws. Sometimes the opening replicated the cosmic emergence hole through which the ancestor passed into the present world or the ancestral shaman traveled to the upper or under world to obtain knowledge, masks, and ceremonies. One of the oldest poles of this type still standing in its original village is the elaborately carved "Place of Opening" or "Hole Through the Sky" at Gitwancool, a Tsimshian Gitksan settlement near Hazelton, British Columbia (Plate 86).

In former times, boards for building houses or canoes were split off from the living cedar by fire and chisel. The tree was generally left standing. The Kwakiutl called the tree from which boards were cut "begged from" because before the wood could be taken the cutters would look reverently up into the crown of the tree and address it: "We have come to beg a piece of you." Yew, ash, spruce, and other species which yielded wood for weapons, tools, or masks were thus honored and their spirits propitiated with prayers of thanks and expressions of regret at the violence done to the tree. When a tree had to be cut down completely, it was considered to have been "killed" in the manner of game slain for the hunt.

The first Europeans to explore the Northwest Coast in the eighteenth century commented on the carved interior and exterior crest posts but did not mention the majestic totem poles. Nor are these seen in the earliest drawings and engravings of life in the Pacific Northwest. Crest poles are no doubt ancient in the region, predating by many centuries the first European colonization. But their development into the towering commemorative monuments of nineteenth-century British Columbia and southern Alaska seems to have been relatively recent, associated with the introduction of more efficient metal tools and the increased material wealth that flowed into, and soon distorted, the aboriginal culture through the fur trade. Nevertheless, as an elaboration of the much earlier three-dimensional carved interior houseposts and effigy columns, the totem pole clearly belongs to an aboriginal cultural tradition that is now known to reach back in a virtually unbroken line for some twelve hundred years. The monumental cedar totem poles that stood in front of many houses as family crests (Plates 88–89), some reaching sixty feet or more, were erected as memorials to dead chiefs and embodied the family's sacred history back to the mythic

past, when the lineage was founded in an ancestor's transformation or in his encounter with a spirit who gave the family his supernatural power and his image, to "own" forever after as its heraldic name.

Two poles standing today in the Tsimshian village of Kitwanga on the Upper Skeena illustrate very clearly the complex nature of the crests and how they were acquired. The two memorials, one called "Mountain Lion," for the animal effigy astride its top, and the other "Ensnared Bear," are among the oldest poles that survive on the Skeena; the former was commissioned about 1865 and the latter ten years later (Plates 90–91).

Both poles belong to the widespread Wolf family. The Gitksan Tsimshian branch at Kitwanga owned five crests of which three are represented on the two poles. All their crests have lengthy oral histories. One legend concerns the "Ensnared Bear," a common figure in Northwest Coast art and myth, usually in the context of the "Bear Mother" tradition, different versions of which are shared by peoples from northern Washington State to Alaska. Among the many depictions of Bear Mother in art, few sculptures of any size anywhere can rival in sheer emotion or conceptual monumentality a small argillite carving by the Haida artist Skaowskeag, collected in 1883 and now in the Smithsonian Institution (Plate 120). Less than six inches long, this naturalistic sculpture was made for sale; at the other end of the scale, in size and purpose, are the monumental Tsimshian totem-pole sculptures, intended not for sale as curios but to confirm and publically proclaim the heroic and supernatural history of a noble family.

The Tsimshian Gitksan legend of Bear Mother as ancestress is practically identical to that of the Haida. It tells of a young woman who offended the bear people by making insulting remarks about them when she slipped in bear dung while gathering berries in the forest. Soon after, two bears appeared and took her to the feast house of the Chief of the Bears, where she was married to his son. Gradually she herself changed into a bear and gave birth to twins, half-human and half-bear, who could easily transform themselves merely by taking off or putting on their bearskins. The girl's brothers searched for her, and when her bear husband heard them approach he realized that he had to die. He asked the brothers to delay their killing long enough to permit him to teach his wife the sacred songs that he owned. His wish granted, the bear taught her two songs to be sung over a bear's dead body to assuage his spirit and ensure good luck for the hunters. Then he offered himself to be killed. The brothers returned to their own village with their sister and her twin sons. Whenever there was a bear hunt the children led their uncles to the dens of their bear-relatives.

With their knowledge of the sacred bear lore and the ritual funeral dirges, they became successful bear hunters and adopted the "Ensnared Bear" as their crest. It is in this form that the bear is depicted on one of the two poles. But the families also obtained a second form of the bear crest —an ensnared mother bear holding two cubs— from the Kitwanga Wolves at Kisgages. This crest was given in payment for the murder of a member of one of the Kitwanga Wolves, compensation that avoided a lengthy fratricidal feud. This second version of the bear crest was incorporated into the "Mountain Lion" pole.

Like other creatures in animal mythology of the Northwest Coast, the mountain lion is not an ordinary predator but a supernatural monster, also known among the Kwakiutl and other Native peoples of the region. The Gitksan Wolves obtained it as a crest in the following manner:

Long ago, the fearsome monster was coming up the Skeena River from the coast, laying waste all in its path and devouring whatever it encountered in the water. When it reached the settlement of the ancestors of the Kitwanga Wolves, it ate an old woman named Eyebrow, who had gone down to the river to fetch water. Her relatives took to their canoes in pursuit of the mountain lion. After killing it with arrows, they cut open its carcass and inside discovered shiny haliotis-shell labrets, ornaments that are inserted into a slit in the lower lip (see Plates 10 & 97). In this way, they acquired the mountain lion as a family crest and the shell labrets as magical charms.

The commissioning of a pole as a mortuary monument and its festive erection were important ceremonial events, fraught from beginning to end with mystical power and involving the expenditure of wealth for the lavish entertainment of many families and strangers. For even as it commemorated the deceased by proclaiming his sacred lineage, it confirmed, by public exhibition of his actual or mythic ancestry, the right of his successor to inherit and hold the ranking office, with its privileges and its supernatural attributes. The poles were never "idols," though some missionaries saw them as such (a misunderstanding that led to the wanton destruction of many of these magnificent works of art), and they were never "worshipped." But nor were they the purely secular status symbols some ethnologists have thought them to be.

The best carvers of the Northwest Coast, and

they numbered in the hundreds, achieved renown and status far beyond their own communities. Though a carver's services might be engaged even by distant strangers speaking a different language, rules of inheritance governed who could be asked to carve a commemorative monument for a particular family. A carver might be personally unknown to those who engaged him, but he had to be one of the "fathers"—that is, related to the family of the deceased or of his heir. If the chosen carver felt he lacked the requisite skill, he might appoint a substitute who worked under his supervision. Credit for the completed pole went to the supervisor, making it difficult to assign with certainty many poles to particular artists. Nevertheless, the authorship of many of the memorial posts that still tower over some Tsimshian villages on the Upper Skeena is very well remembered by their present owners, along with the lineages to which the artists belonged, even though the pole might have been carved and erected more than a century ago. And this will no doubt be true a hundred years hence of the poles being carved today by the modern inheritors of this great tradition.

The carvers almost always worked with tools they had made themselves. Chief among these were a curved knife, an elbow adze for rough work, and a D-shaped adze used throughout, from the initial outlining of the figures to the final creation of a perfect surface. This adze was held with the blade down, the sharp beveled edge facing backward. In pre-European times, adzes had blades of polished stone, most often a local jade. With European trade, steel became the preferred cutting material.

A felled trunk was laid out for the carver in horizontal position, off the ground on blocks, close to where the finished pole was to be erected. The carver was free to range from near-naturalism to near-abstraction. Even the most complex and tallest memorials were rarely made from sketches. The completed work was in the carver's mind when he set out to strip the felled tree of its bark and outer surface. Nor did the carver draw an outline on the trunk of the figures to be carved. A carver noted for his sureness of hand and for the power conveyed by the finished sculpture was thought to be supernaturally inspired and was honored and celebrated for his genius.

Except for one or two feasts at two-year intervals following their original placement, the poles were left alone. They were neither repaired nor transplanted, for to do so would have required the same ritual preparations, the same invitations to the "fathers" and strangers, and the same ceremonial festivities as the initial raising. In the damp climate of the Northwest Coast totem poles rarely survived unaided for more than a few generations. When a pole finally fell over, it was allowed to decay naturally or even cut up for firewood. Only as part of the recent renaissance of traditional culture and art has there been a conscious effort to save old poles where they stand. Some still in place on the Upper Skeena River, for example, date back to the 1860s and others to the early years of the twentieth century. Still others have been copied by leading modern Native artists to replace those salvaged by the University of British Columbia.

The Tsimshians, Haidas, Kwakiutl, and Tlingit all shared basic style elements in their wood sculpture, which suggests both an older common art tradition and some borrowing among groups. Even so, each people also developed its own characteristics in carving. Tsimshian carvers, for example, emphasized scale by the use of two superimposed figures, one very large, the other very small, with clear-cut horizontal separations between them (Plate 89). Tsimshian sculpture is also closer to nature than that of other Northwest Coast peoples. Haida totem poles give the effect of continuous design by the use of overlapping elements that connect the superimposed forms. The Kwakiutl style is well represented by the model totem pole in Plate 87, carved between 1890 and 1900 by the famous carver Charlie James (ca. 1870–1938), who taught several major Kwakiutl artists and whose work featured mainly the crest figures of his mother's people—thunderbirds, killer whales, ravens, bears, and chiefs.

# Masks and Headgear

Masks were the other most widely distributed art form on the Northwest Coast (Plates 10, 94, 96–101). Masks and the right to commission, carve, and wear them were part of the supernatural treasures of the noble families. Like names and crests, they were originally conferred on the founding ancestor as a gift or as spoils of victory over a human, animal, or supernatural adversary. With their associated costumes, songs, dances, and myths, likewise inherited, masks were the primary vehicles of transformation in dramas that recalled the heroic deeds of the mythic founders, reaffirmed the social and cosmic order by merging mythological past with living present, celebrated the progression of the seasons, or reenacted a shaman's spirit quest and his acquisition of supernatural tutelaries. Northwest Coast masks share certain fundamental stylistic con-

ventions that, like the totem poles, point to a single ancestral tradition. All use more or less the same basic eye form, for example, and all make lavish use of the precisely controlled and beautifully modulated lines that are among the hallmarks of all Northwest Coast art. On many masks the sculptured surface is embellished by painted designs or broken up into discrete units that may be further emphasized by carving and painting; however, there is never any sacrifice of the basic unity that gives such extraordinary expressive power to images like the marvelously stylized, yet utterly human-like, Tsimshian dance mask shown in Plate 98. The great modern Haida artist William Reid has rightly called this mask, said to represent a specific spirit borrowed from the Kwakiutl, a true masterpiece, one of the greatest masks of any culture in the world, and certainly of the Northwest Coast.

Despite the borrowing and sharing of styles, there are enough differences to distinguish most, if not all, masks of one group from those of their neighbors. Kwakiutl carvers generally stressed weight and mass, and they managed to give their masks an expressive, almost unrestrained energy and force, matching in dramatic intensity their most important ceremonial, the Hamatsa rite, or Winter Dance. Tsimshian masks, and also those of the Tlingit, in contrast, sometimes have a feeling of lightness that borders on the ethereal.

The dramatic effect of some masks was greatly heightened by articulation. By far the most numerous and also most complex of the articulated masks were those used in the Kwakiutl Winter Ceremonial (Plate 93), which re-enacted the conquest and taming of a terrible man-eating spirit, whose devouring home at the "north-end-of-the-world" was actually a metaphor for the river mouth that annually devoured the Salmon People in their upstream migration. The founder of the lineage sponsoring the Winter Dance killed the monster, and he and his daughter revived all the dead tribesmen whose bodies were drying on racks, like salmon, over the Man-Eater's fire.

Initiates into the shamanistic Hamatsa society disappeared from the village for a time and were believed to encounter terrifying bird spirits (Plate 94) and other guardians of the man-eating spirit during their absence. Returning wild and half-crazed with craving for human flesh, like Man-Eater himself, they were tamed and reintegrated into human society in the dramatic re-enactment of the myth. The Hamatsa mask shown in Plate 94 consists of no less than four of the bird spirits with articulated beaks that could be manipulated by the dancer, either singly or all at once. Carved in 1938 and last used in a ceremony in 1947, this mask is characteristic of recent Kwakiutl carving.

Much subtler are masks with movable facial features, but these, too, must have been eerie to watch in dance performance, especially by firelight (Plates 10, 97). Even static, the painted portrait mask of a woman wearing a large, flat wooden labret in her hinged lower lip (Plate 10) conveys a feeling of power and individuality, but also of deep anguish. In a dance drama, to the sound of drums and rattles, with the costumed wearer manipulating the protruding lower lip by means of a hidden string passed through a small hole in the chin and disappearing beneath the costume, the mask must have come to life with electrifying effect. The mask presumably dates to the first half of the nineteenth century and, to judge from the degree of wear, was danced many times. Who carved it is difficult to say because the same style was shared by several peoples in British Columbia, including the Haidas on the Queen Charlotte Islands, the Coast Tsimshians, and the Bella Bellas. Nor do we know the symbolism of this emotion-charged mask, which could be a portrait of a real person but more probably represents a female spirit.

Helmets were also treasured heirlooms. The magnificent wooden war helmet in Plate 102, carved in the form of a human face, perhaps an ancestor or the human aspect of an animal, was already old when it was collected in 1867, the year Alaska became a U.S. possession. It may even date to the late eighteenth century and might have been worn in the great Tlingit uprising in 1802, in which hundreds of warriors clad in animal masks and headdresses overran the Russian fort and settlement at Sitka. The Russians who faced those unearthly masks must have felt something of the spirit power their Native wearers believed they had exchanged for their ordinary selves. Wooden effigy helmets of this type were worn with neck armor and with slat-armor tunics resembling and presumably derived from Japanese samurai armor and Siberian slat armor. The Tlingit who attacked the Russians were armed with muskets as well as with their customary Native weapons—fighting daggers of steel and hardened copper of Native manufacture (Plate 3), bows and arrows, spears, and elk-antler clubs (Plate 121). Great power was ascribed to such clubs; Northwest Coast traditions speak of clubs capable of traveling by themselves, slaying enemies, and capturing game for their hero-owners.

Another type of headgear that passed from generation to generation as supernatural treasure was the elaborately carved conical clan hat representing the group's principal crest animal. The

conical shape was similar to that of woven cedarbark hats, a form no doubt related to the characteristic conical straw hats common through much of Asia. Some hats were topped by a series of cedarbark rings, one each for the great ceremonies sponsored by the wearer and his or her family. Some clan crest hats were actually articulated, like masks, so that, for example, the leather wings and tail of a raven might flop up and down when the costumed wearer manipulated them with strings during the ceremonial dance (Plate 103).

A prominent crest figure among the Tlingit is the frog, whose adoption as clan emblem by the ancestors is accounted for in several different family histories (Plate 104). This animal's importance extends beyond inherited family or lineage property, however, for the frog was also a powerful supernatural helper of shamans and the animal manifestation of an earth deity variously called Mountain Woman, Copper Woman, Volcano Woman, and Weeping or Wailing Woman. The last of these names commemorates her sorrowful lament for her lost child, which, when it appeared by their cooking fire in the form of a frog, was thoughtlessly tossed into the flames by some arrogant young hunters. Piteously crying, Frog Woman searched high and low for her child. Discovering that its bones had been destroyed by the fire so that it could not be brought back to life, she destroyed the village of the culprits with a fiery lava flow which only one woman and her daughter survived. The story of Frog Woman as earth goddess weeping for her lost child is curiously reminiscent of a similar motif in ancient Mexican mythology.

Closely related to masks are frontlets, or forehead masks (Plates 92 & 95). Like many of the face masks, these represented mythic ancestors or donors of spirit power, names, songs and other supernatural treasures to the founders of the great lineages.

The dramatic frontlet of the transforming water monster Gonaqadet (Plate 95), which brought good fortune to hunters and fishermen who gained its good will and death to those who offended it, was collected in Alaska in 1867.

The origin of the Gonaqadet as family crest is related in a Tlingit myth. When the canoe of the head chief of the people living at the head of the Nass River capsized, his nephews disappeared, and the chief knew that the Gonaqadet had taken them. The people wanted to punish the Gonaqadet but the chief persuaded them instead to give a generous feast for Gonaqadet's people, arguing that perhaps the boys had not died but had merely gone to live with the Gonaqadet. In return

the Gonaqadet presented the chief with the dance headdress of the Sea Monster set with sea-lion bristles, four sacred songs, and a rattle of great spirit power.

Frontlets evidently descend from the old custom of wearing animal headdresses made from the head with the skin left attached and falling down the back, an expression of the dual shamanistic concepts of the animal as guardian spirit and of transformation by means of putting on the animal's skin. The right to wear these frontlets was inherited from one's mother's family, and they could be worn by women as well as by men. The greenish paint was made from oxidized copper, the pigment appearing initially as turquoise blue but turning green when oiled; the vermilion is an early trade pigment which originally came from China and may have been imported from Asia even before the Clipper trade.

# Blankets and Dance Skirts

Family crests were also displayed in the magnificent Chilkat Tlingit blankets and dance skirts of mountain goat wool and cedarbark fibers. The designs on these textiles are perfectly symmetrical. A diving killer whale is a common central motif, but the patterns are so stylized that they are difficult to interpret. The blankets and skirts were treasured as heirlooms and when not in use were kept in wooden boxes in casings of bear intestines that had been split and resewn in strips. It is therefore probable that, like so much other fine Northwest Coast art, the apron illustrated in Plate 106 had seen ceremonial use for many generations when it was purchased in 1882 for Princeton University. This is a particularly interesting example of the art because it echoes its prototype, the dressed and painted animal skin with long fringes that also continued to be worn, especially by shamans, in the late nineteenth century.

The Tlingit weaver spun her wool by rolling it on her bare knee, but other Northwest Coast people used the spindle whorl. The giant Salish carved spindle whorl illustrated in Plate 127 is a brilliant example of the care lavished on utilitarian objects and of the extraordinary symbolic complexity that may lie behind what at first sight appears to be a relatively straightforward, even "naturalistic" representation, in this case apparently of a hocker (squatting) figure in X-ray style, revealing an unborn fishlike fetus within the womb, symmetrically flanked by a pair of birds with faces in their bodies. When the long shaft is inserted, the apparent hocker is seen to be two

figures, the upper one human, the lower a frog or a toad, whose squatting posture is the birth position throughout ancient America. The animal's feet are clearly delineated, but its shoulders and arms are formed by the claws and legs of birds, while its head merges with the hands encircling the center hole. The fishlike form of the embryo is a tadpole with its characteristic gills and its fishlike tail brought forward to form part of the body. Among Salishan deities, the toad is associated with the moon, whose brilliance once rivaled the sun's but declined when the toad hopped on its face. The connection of a moon deity with the woman's craft of spinning and weaving is common in many Native American cultures and seems to be based upon likening the spindle as it fills with thread to the waxing moon and the growing stomach of a pregnant woman. The birds may be the mythological thunderbirds or the eagle and raven, who acted together in arranging the sky in primordial times. The pair of faces may be the sun and moon or complementary phases of the moon, full and new, the latter suggested by the thin horizontal crescent below the face on the right. The whorl, then, appears as a model of the sky, or "sky disk," which in native cosmology has a hole in the center to allow passage for the cosmic axis, or central world pillar, as well as for the shaman in his travels from one plane to another. This explains the placement of the figure in relation to the center hole, which forms its navel and by extension is the navel of the universe.

As long as Northwest Coast culture remained fundamentally intact, even the increasing availability of trade cloth did not greatly affect Chilkat-Tlingit weaving with wild fibers—indeed, even today some fine weaving in the traditional style and with the traditonal cedar bark fibers and goat wool continues among the Chilkat. Still, with the climate and terrain precluding the domestication of natural fibers on a large scale, trade cloth soon became popular. Indeed, the only cultivated crop was tobacco, and that only in recent times.

# Pipes, Ladles, and Rattles

Native cultivation of tobacco and the custom of chewing it with lime from crushed and roasted shells to extract the juice were reported by Spanish and other explorers of the Northwest Coast as early as the 1780s. But it seems that the idea of smoking the tobacco in pipes, a practice well established in the first decades of the nineteenth century, was borrowed from the Europeans, who also introduced clay trade pipes. In contrast to European recreational smoking, however, the Northwest Coast Indians limited tobacco use to important rituals, especially commemorative feasts for the dead.

The first native pipes, and indeed most pipes meant for personal use rather than for sale to tourists, were carved of wood; their ceremonial context explains why they were often decorated with crests such as Raven, Eagle, Bear, Frog, Killer Whale, and other animals, or with animals, people, and supernatural heroes acting out some mythological event. Other pipes were carved of ivory.

The wooden pipe (Plate 117) shown here is a virtuoso carving in every respect, reminiscent of the famous raven rattles (Plates 112, 114–116, 118) in general form and in its integration of subsidiary animals with the principal crest bird. The large bird mask at the tail is difficult to identify— it may be the cosmic Thunderbird or perhaps a hawk. A smaller bird with hawklike beak and large feet juts out from the raven's breast between the wings.

In contrast to pipes carved of wood or bone, those made of argillite were never smoked but were produced in increasing numbers as the nineteenth century wore on for sale or trade to sailors, merchants, museum collectors, and other foreign visitors (Plate 119). That many of these pipes are technical and organizational masterpieces, equal to the finest work in wood and other traditional materials, and frequently emphasize shamanistic themes is not surprising, for the carvers of argillite were also those who produced masks, headdresses, totem poles, and other art for indigenous use.

In commercial argillite art, of course, shamanic motifs were as much a response to white fascination with shamanism as "primitive wizardry" as to Native concerns. But the shamanistic world view informed all artistic expression, whether its purpose was to proclaim a noble family's ancestry and alliances or to give a spiritual dimension to a utilitarian object. Thus, the shaping of a mountain sheep horn into a graceful, long-necked water bird that is actually a monumental candlefish-oil feast ladle (Plate 110) is more than aesthetic play. Equally adept on, above, and under the water, water birds are preeminently shamanic messengers between the different levels of the universe; they assist the shaman and even serve as vehicle for his descent into the watery underworld in search of strayed or abducted human souls or knowledge of the dead. Salmon, likewise, are closely connected to shamanism, as transformers par excellence. It is the common belief of the peoples of the North-

west Pacific Coast that salmon live in the form of Salmon People in an offshore village under the sea until it is time each year to change into fish for their upstream migration (Plate 124). The fishermen await them as sacred bringers of life, do them honor, and allow their bones to float back to the sea, where the fish are reborn from their skeletal parts. A fine wooden feast ladle collected in Alaska in 1869, its handle carved in the likeness of a hollow, skeletonized salmon with its human alter ego inside, magnificently expresses this magical cycle of life, death, and transformation (Plate 122).

There is also a great deal of art that, beyond echoing shamanic themes, belonged specifically to shamans as supernaturally elected members of the society who were not bound by the normal limitations of the human condition. Masks, headdresses, charms, rattles, drums, staffs, and special clothing are among the material objects that assisted shamans in their crucial functions.

Elaborate bird-effigy rattles (Plates 112, 114–116, 118) are often called "chief's rattles," perhaps because they appear so much more sumptuous than the round or oval rattles representing the shaman or his helping spirits (Plate 113). In fact, both types were owned by shamans and both express typically shamanistic themes. If a chief who was not himself a shaman did own a bird-effigy rattle and used it in ceremonies, it may have been a gift from a shaman or a lineage treasure that came down to him from a shaman ancestor. Also, in certain ceremonies the chief himself became a shaman and was so addressed. In any event, such rattles have been found in the grave houses of shamans. Water birds were the preferred subjects; many rattles depict cranes, kingfishers, or gulls. When the bird is not some water or shore bird directly associated with shamanism but a crest such as the raven or eagle, the total configuration of symbols is unmistakably shamanic. One type depicts the oystercatcher (Plates 112, 114), a large, strikingly colored wading bird that is always the first to sound the alarm and take wing at the slightest sign of danger, thus serving as a kind of guardian for the other birds. Though primarily a shoreline feeder on bivalve mussels and barnacles, it is as expert a swimmer and as deep a diver as it is a high flyer. In short, it is a powerful helping spirit for the shaman. In one rattle (Plate 112), the oystercatcher's body terminates in the backward-facing head of a horned mountain goat, another animal that, precisely because of its powerful horns, was an important source for the shaman's own power. Between the horns, as though protected by their potency, sits the small figure of a shaman, sub-

duing a witch by tieing his hands behind his back and twisting his long hair, a common theme in Northwest Coast shamanic art.

The relationship of horns to shamans is evident in one form of the shaman's headgear—a crown of inward-curving horns (Plate 126), sometimes made of actual horns of immature or female goats, sometimes imitated in wood or by the long, sharp incisor teeth of beavers. There were many kinds of shamans' headgear on the Northwest Coast, from simple headbands to elaborately carved and inlaid frontlets or masks, but whatever form it took, a headdress was essential to the shaman's calling and to his power to summon his spirit helpers and mediate effectively between the world of humans and that of the supernaturals. Perhaps Northwest Coast shamans shared with their Siberian counterparts the conviction that without some sort of encircling band, their heads would actually burst from the pressure of their accumulated power. The shaman's headgear was often specialized, different types serving in different ritual contexts or in the curing of different kinds of disease. The type of crown in Plate 126 is said to have been used in curing illnesses attributed to witchcraft.

The image, the art itself, had the power to transform, replacing evil with good, restoring health and balance. True, the epic transformations occurred in mythic times, when everything was possible, when whale was now himself, now beaver, now canoe, now whale once more, when human beings and their animal counterparts easily assumed each other's form simply by taking off or putting on each other's skin. But in art, song, drama, and curing, that magic shamanic time was brought forward again into the here and now. Contradictions of form and divisions of time and space were erased, and all that was possible then could once more become reality. This, in essence, is the message of these masterworks of Northwest Coast art. To heed it requires less a suspension of belief than a willingness to see the world, if only briefly, with the Native eye.

Plate 87. The model totem pole of yellow cedarwood was carved about 1900 and painted with natural pigments by a Kwakiutl, whose name was Yakuglas but who is better known as Charlie James (ca. 1870–1936). From top to bottom, the figures depict the ancestral crests of the family of the artist's mother: Eagle, Killer Whale, a chief, Raven, and Bear. James prepared raw wood with a secret solution of herbs in rainwater and made his own pigments from berries, grasses, and bark. (34½" high. Private Collection.)

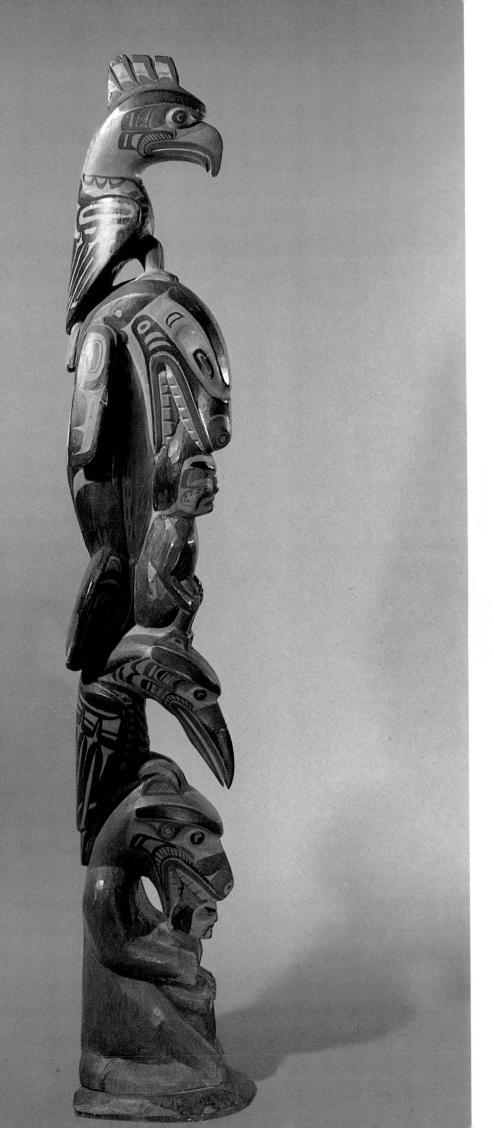

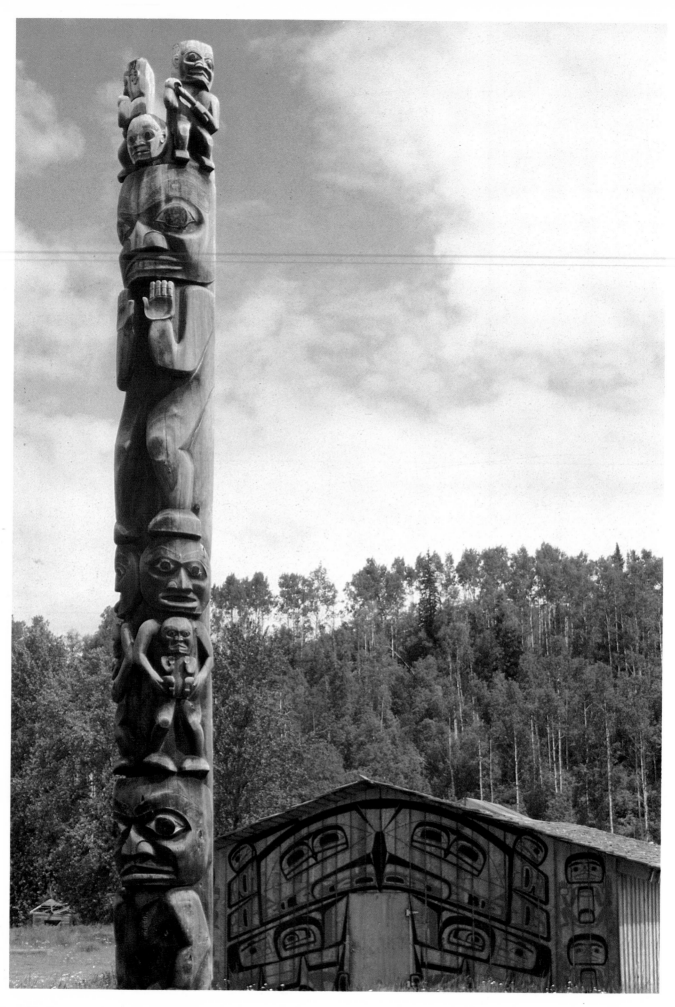

Plate 88. Totem poles in the traditional style typical of the Gitksan Tsimshians of the upper Skeena River, Kitwancool, British Columbia. The stories of the ancestral poles are remembered and sung today.

106

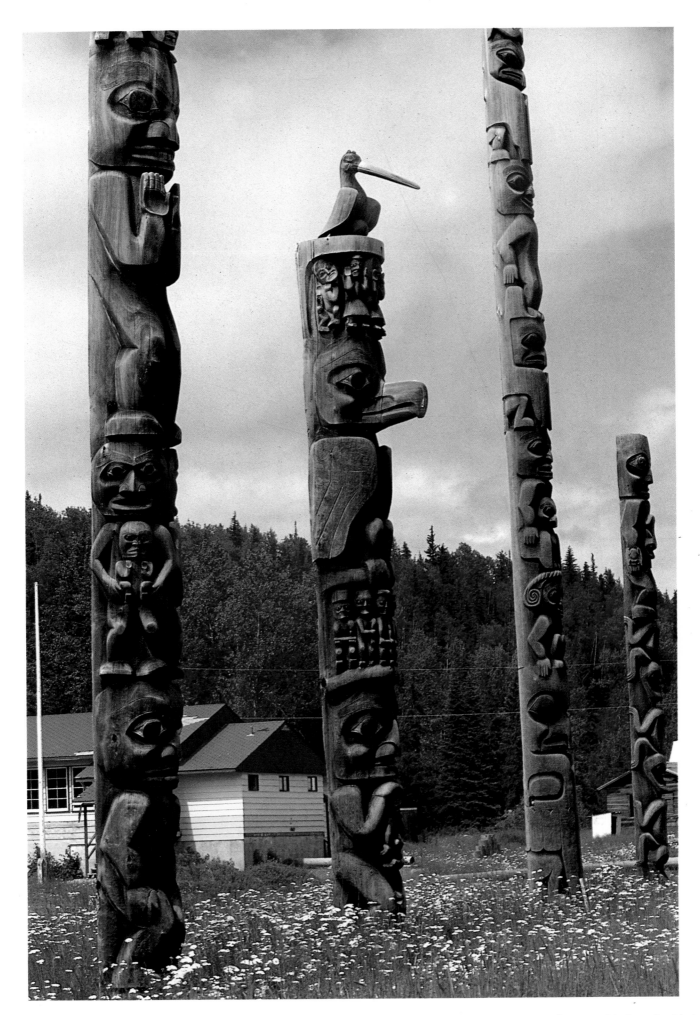

Plate 89. Poles in the old Gitksan village of Kitwancool. The pole in the center, known as Mountain Eagle or Thunderbird, belongs to an ancient Tsimshian family of the Wolf Clan. The two rows of children above and below the bird are offspring of an ancestress captured by the Mountain Eagle spirit.

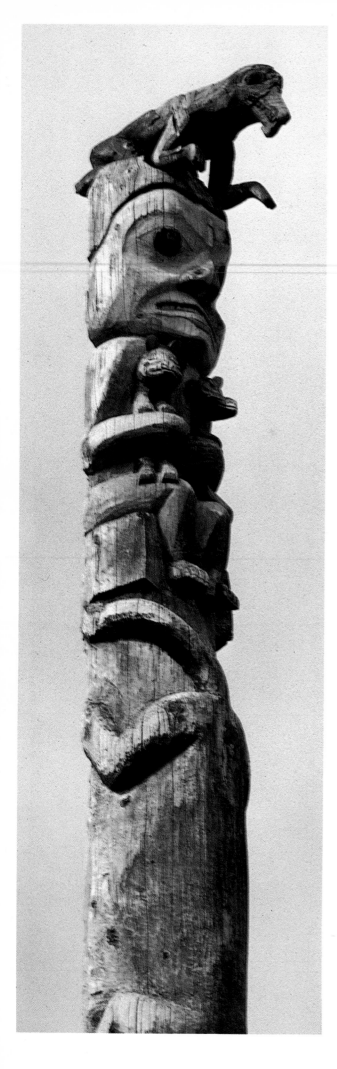

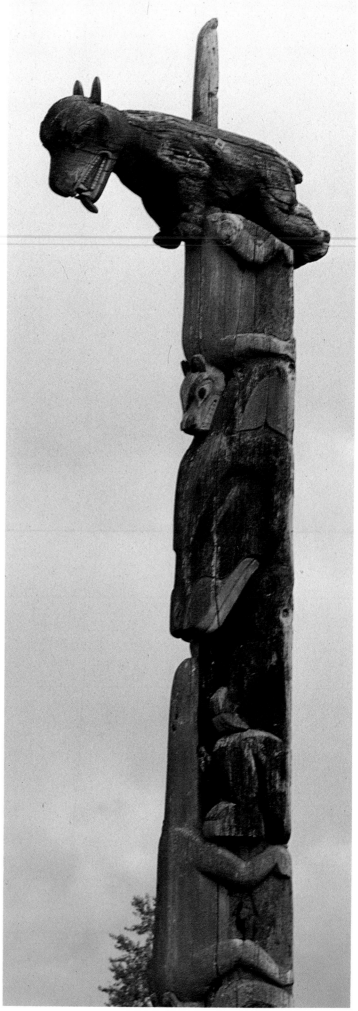

Plates 90 & 91 (opposite). Two Gitksan poles in Kitwanga, on the upper Skeena, are called, respectively, "Ensnared Bear" (left), and "Mountain Lion" (right), the former commissioned about 1870, the latter about 1850. Below the Wolf crest on top of the Bear pole is the mythical ancestress, Bear Mother, whom a bear took to wife and who is the subject of one of the most widespread myths on the Northwest Coast (see also Plate 120). The Mountain Lion on the other pole represents a water monster in mountain lion form slain by ancestors. Below him, beneath another wolf, is, once more, Ensnared Bear.

Plate 92. A Tlingit headdress frontlet representing a mother bear and cub, with lavish abalone inlay, vermilion paint of Chinese origin, and traces of copper-derived blue-green pigment. (7¼" high. 1830–50. Private Collection.)

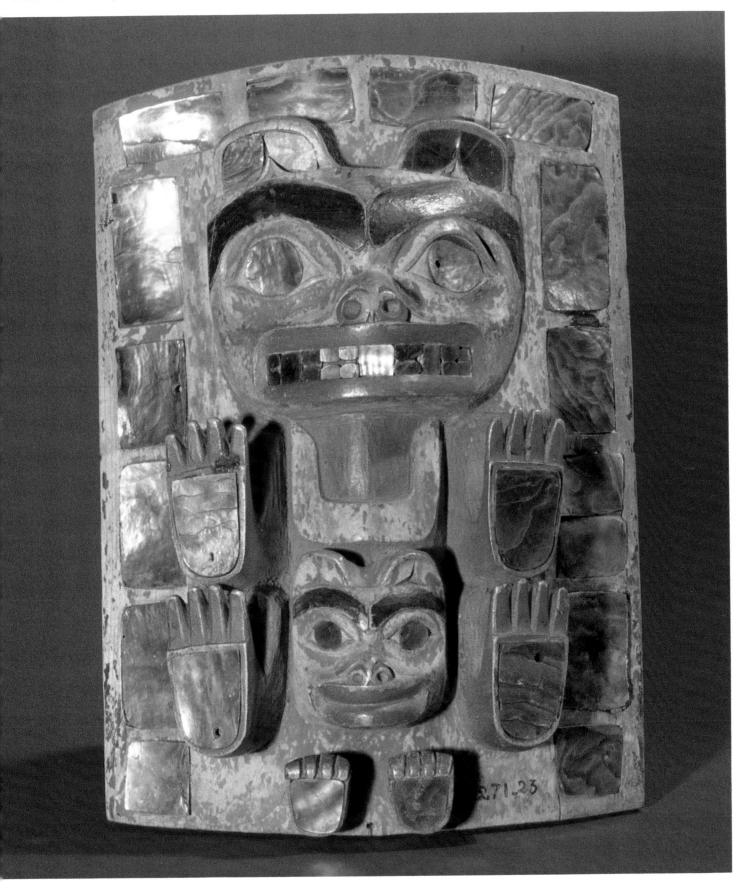

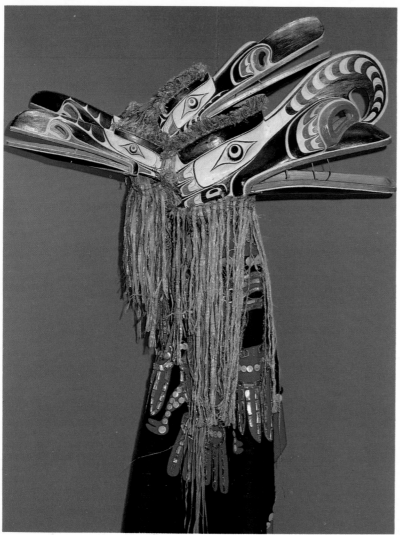

Plate 93. Taken in 1914, this Curtis photograph shows a pause in the dramatic Hamatsa initiation of the great Winter Ceremonial, with all its masks, costumes, carved houseposts, even the ceremonial house itself. As Curtis described the scene, "The chief who is holding the dance stands at the left, grasping a speaker's staff and wearing a cedarbark neck-ring and headband, and a few of the spectators are visible at the right. At the extreme left is seen a part of the painted máhwihl thröugh which the dancers emerge from the secret room; and in the center, between the carved houseposts, is the Awaitlale hams'pek, showing three of the five mouths through which the Hamatsa wiggles from the top to the bottom of the pole."

Plate 94. Multiple mask with movable beaks represents the giant man-eating bird spirits that guard the "cannibal" spirit, Man-Eater-at-the-North-End-of-the-World, in the Hamatsa Society dances of the Kwakiutl. Carved in 1938 by the Native artist George Walkus, it was once worn in the Hamatsa ceremony by the famous Chief Mungo Martin. (47" long. Denver Art Museum.)

Plate 95 (opposite). Tlingit headdress frontlet, representing the sea monster Gonaqadet, was collected in 1867, the year of Alaska's transfer from Russia to the United States, but it was then already old. Gonaqadet is a composite transformer-sea spirit which brought good fortune to the hunters and fishermen it favored and death to others. Painted wood, fangs of native copper, animal teeth, abalone inlays, sea-lion bristles, and bear fur. (12¼" high. Private Collection.)

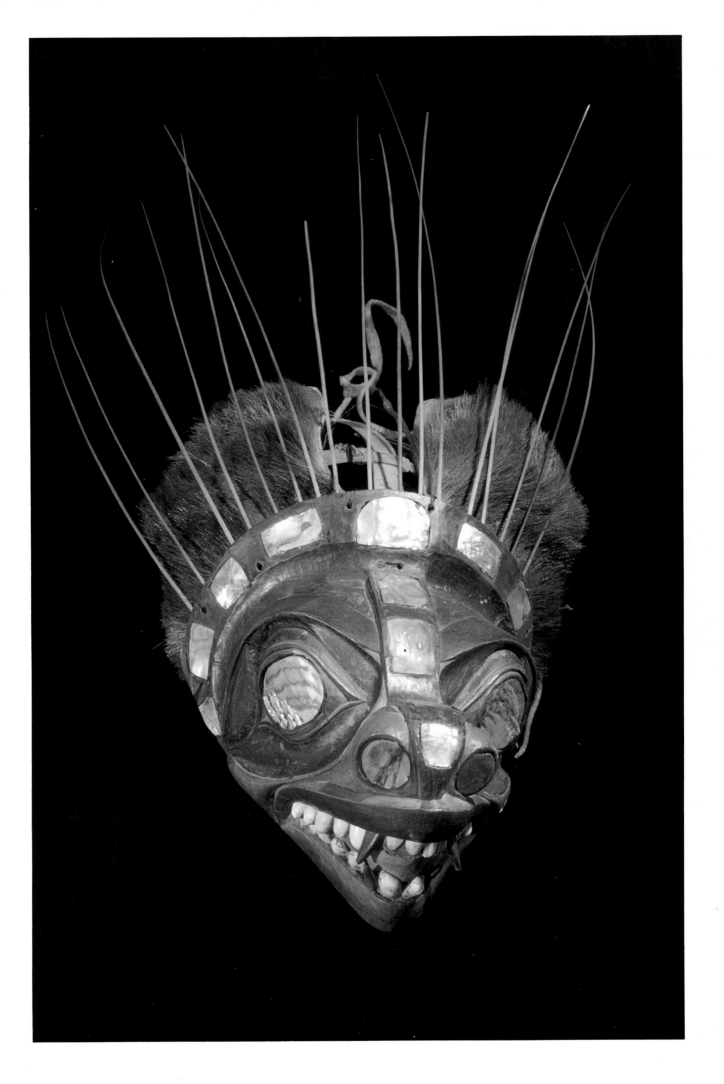

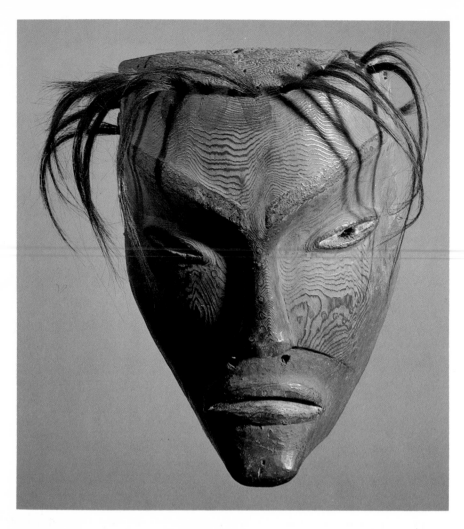

Plate 96. The European experience of Northwest Coast art began with the explorations of Captain James Cook, who in 1778 visited Nootka Sound to gather information on the land and its Native peoples and to acquire masks and other ethnographic specimens. This starkly beautiful mid-eighteenth-century cedarwood mask, with its fringe of human hair, was presumably once owned by a Nootka shaman. It may be one of the masks Cook collected and sent back to Europe, where, before its acquisition by an American collector, it rested in a museum in Dresden, Germany. (10½" high. Private Collection.)

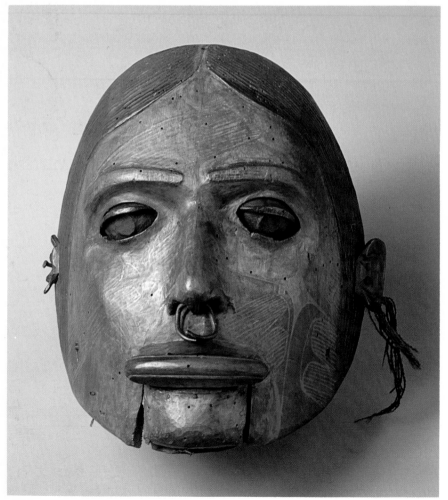

Plate 97. Despite its high degree of stylization, this Haida portrait mask of a noblewoman, probably from 1780–1800, is modeled with such sensitive naturalism that it conveys a feeling of living humanity. The lower lip, with the large, flat lip plug, or labret, worn by women of high birth, is articulated, as are the eyes, whose lids the dancer could open and close to heighten the mask's effect. (8½" high. Private Collection.)

Plate 98 (opposite). With all its stylization, the subtle and sensitive modeling of this Tsimshian mask conveys the deepest human anguish, making it one of the masterpieces of Northwest Coast art. Indeed, in the opinion of the modern Haida master carver William Reid, it is one of the finest masks of any culture. Collected in 1885 at Kitkala, British Columbia, it represents a Kwakiutl spirit borrowed by the Kitkala Tsimshians from the Bella Bella. It may have been a shaman's mask; more likely it was the spirit's manifestation in dramatic reenactments of the mythic past by human impersonators. The hair is human; the moustache and beard are animal fur. The bold face painting in red and blue-black represents bird spirits. (12" high. Private Collection.)

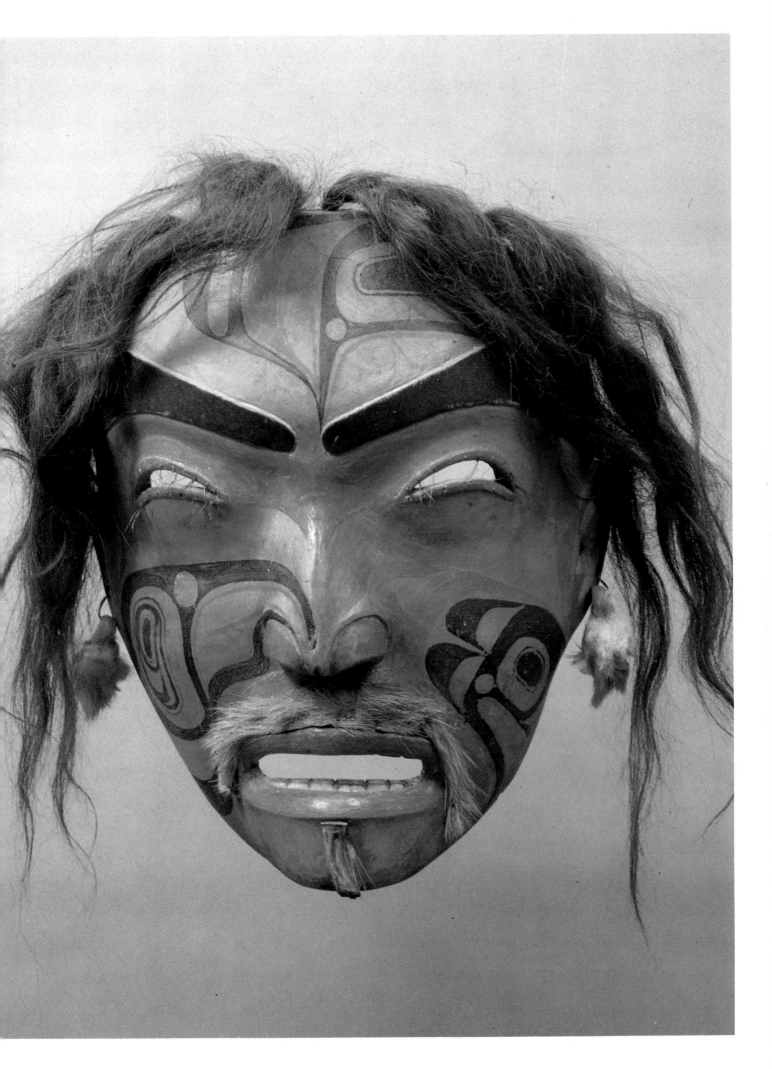

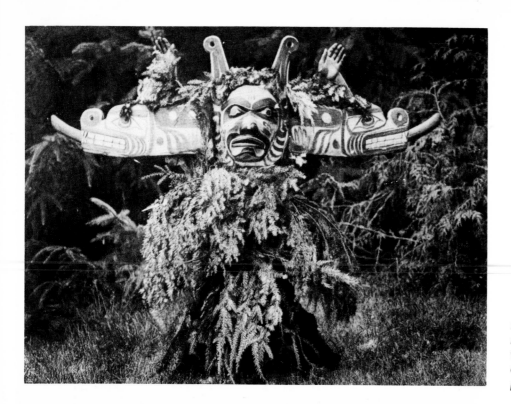

Plate 99. Curtis' 1914 photograph of a masked dancer representing a mythical water monster, the double-headed serpent called *Sisiutl* by the Kwakiutl. Its human aspect is in the center.

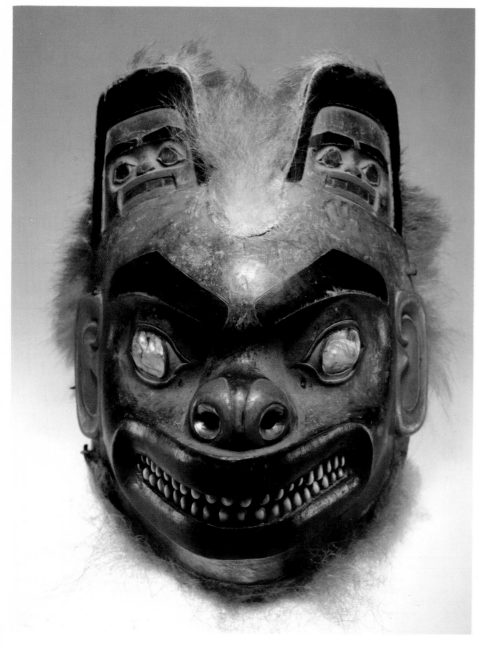

Plate 100. The powerful mask from Klukwan representing a Bear spirit, probably carved about 1800, was once the inherited personal mask of Louis Shotridge, a Chilkat of noble birth who became a Tlingit ethnologist. Its materials include wood, bear fur, abalone-shell inlay, and aperculum shell teeth. The brilliant blue paint is a traditional mineral pigment of crushed copper oxide with an organic binder, probably egg white; the red is vermilion of Chinese origin. (11¾" high. Private Collection.)

Plate 101 (opposite). One of the most spectacular performances of the Kwakiutl Winter Ceremonial was that of the Thunderbird, who announced his appearance with an unearthly screech, wings flapping, completely covered with eagle skins and feathers, and wearing the huge wooden mask with massive beak that identifies this celestial spirit. This full-size Thunderbird disguise from British Columbia may have been used in Curtis' ethnographic docudrama of 1914, the first full-length film of a Native American people. (67" high. Milwaukee Public Museum.)

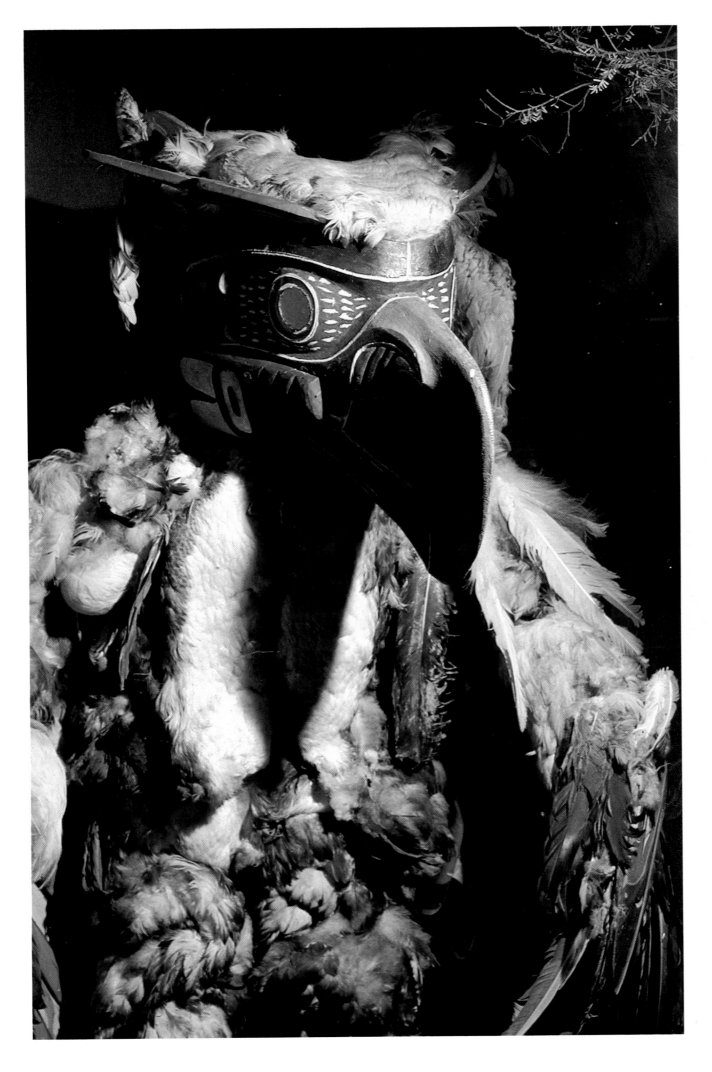

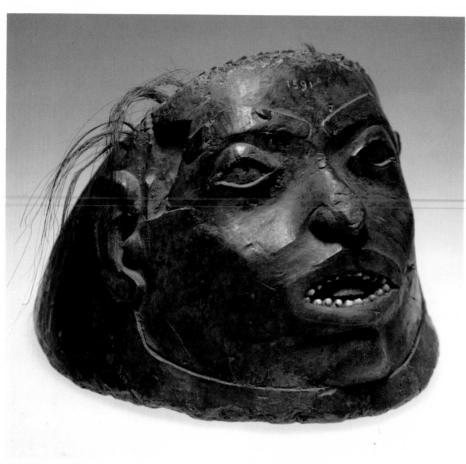

Plate 102. *With their associated body armor, wooden Tlingit effigy war helmets like this one reflect an Asian tradition. A visor-collar shielded the lower face and neck, and the body was protected by slat armor, giving the Tlingit warrior of the eighteenth and early nineteenth century an appearance not unlike his Siberian counterpart or the Samurai of feudal Japan. This helmet almost certainly dates from the eighteenth century and may have been worn in the great Tlingit uprising against the Russian garrison at Sitka in 1802, in which more than 400 soldiers and residents died. (8½" high. Private Collection.)*

Plate 103. *This unusual type of Raven clan emblem hat has movable wings and a tail of leather, which the wearer could manipulate with strings in ceremonial dances. The hat probably dates from the early nineteenth century and was handed down as part of the treasures of a noble family residing in the Chilkat Tlingit citadel of Klukwan, Alaska. (17½" wide with wings outspread. Private Collection.)*

Plate 104 (opposite). *On this fine old wooden Frog Clan hat, with abalone-shell inlay, each superimposed woven ring represents a gift-giving feast ("potlatch") that its owner had sponsored. The hat dates from about 1820 and came from Frog House, one of the named noble houses of the Chilkat Tlingit at Klukwan, Alaska. (17¼" high. Private Collection.)*

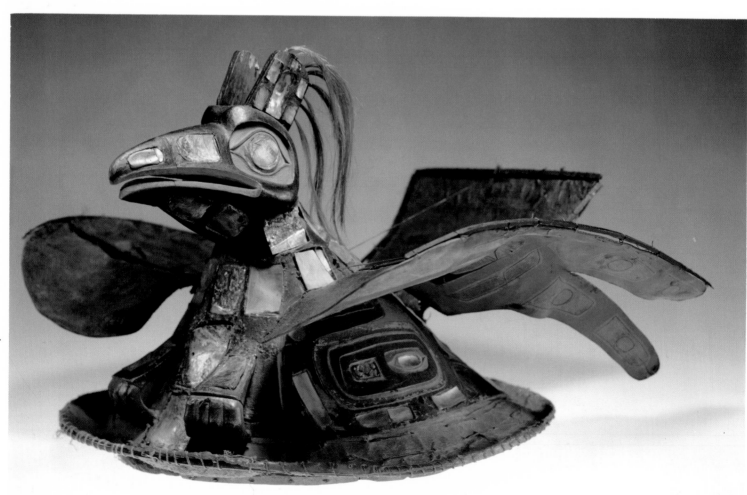

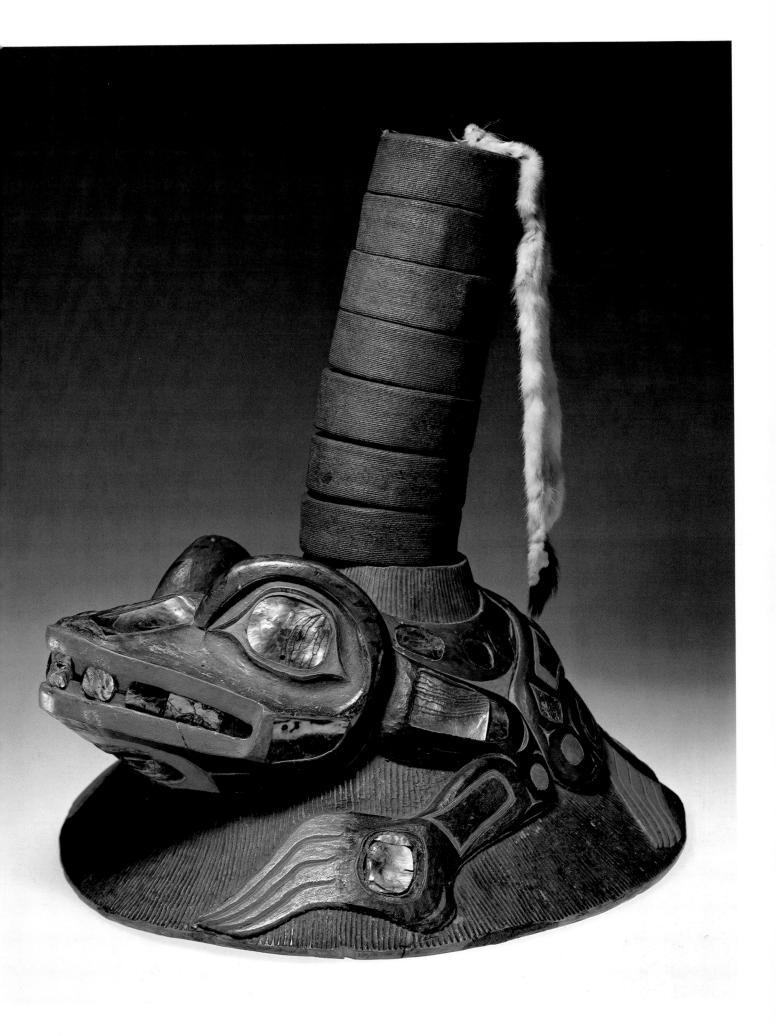

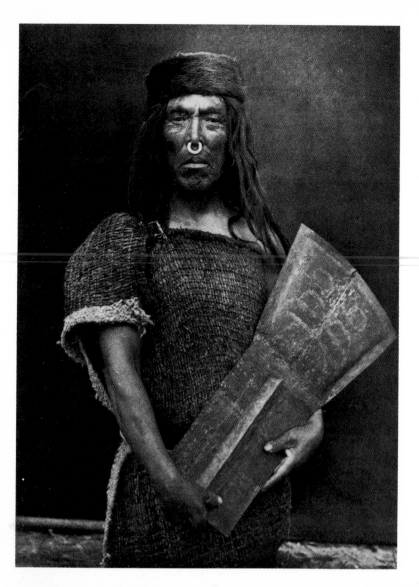

Plate 105. Although Curtis undoubtedly posed his subject in the traditional long hair and braided cedarbark tunic of a long-vanished past, his 1914 photo nevertheless has considerable historic and ethnographic interest. The Kwakiutl chief holds a decorated shield-like "copper," a product of Native metallurgy which assumed enormous symbolic, supernatural, and economic value in nineteenth-century Kwakiutl culture. Great wealth was sometimes expended for their acquisition; this one, because of its great cost, was called Wanistakíla, "takes everything out of the house." "Coppers" were considered to be alive, conceptually related to salmon, and when ritually broken and thrown into the sea at gift-giving feasts, were believed to return to salmon form. This helps explain their shape, for the coppers resemble headless salmon laid open for drying on the rack.

Plate 106. Chilkat Tlingit blankets and dance skirts of mountain-goat wool and cedarbark rank with Northwest Coast painting and carving in their symmetrical organization of space and, despite their primitive technology, rival the best weaving done anywhere. No loom was used; rather, the warps of spun goat wool, twisted around a core of bark fiber, hung down from a rod held by two uprights. The weaver created the designs by following a painted board pattern. The nineteenth-century shaman's dance skirt shown here fuses the woven blanket with its older prototype, the dressed and painted animal skin. (39½" long. Princeton University Museum of Natural History.)

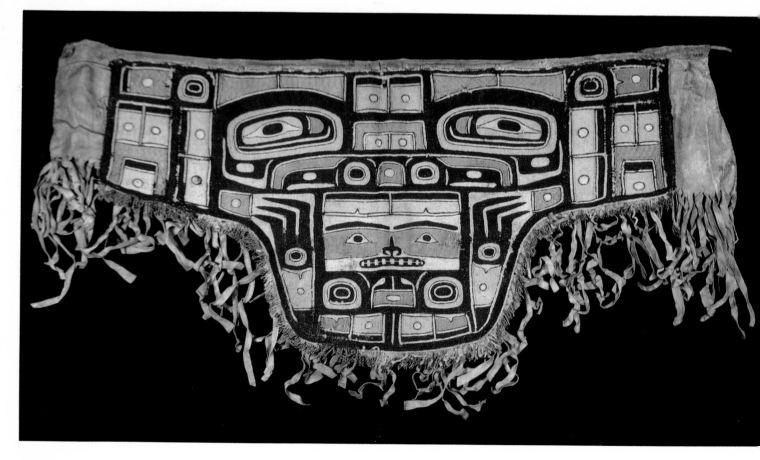

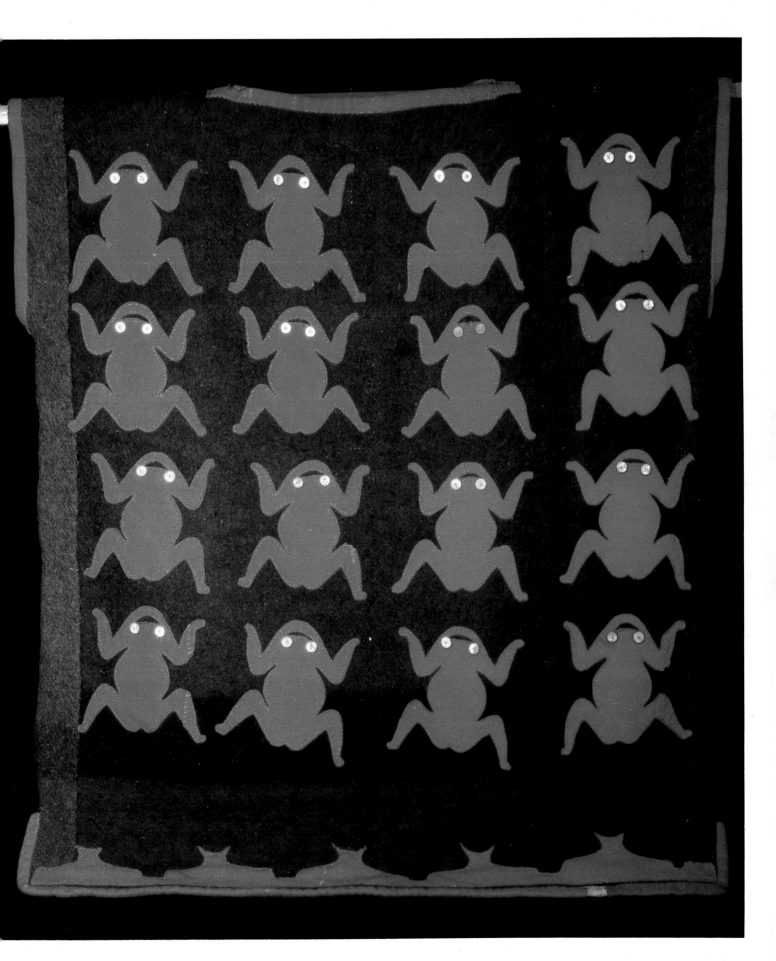

Plate 107. Woven almost a century ago, this shaman's
tunic of trade wool was once the property of Chief Hleng-
wah of the Gitksan Frog-Raven Clan at Kitwanga, British
Columbia. (31" long. New York State Museum.)

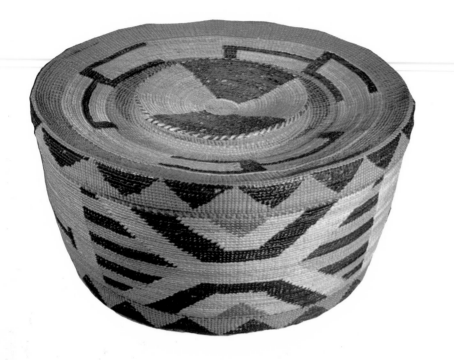

Plate 108. Tlingit women were renowned basketweavers who specialized in twined work with from 10 to as many as 30 stitches per inch. The basic basket was spruce root, embellished with "false embroidery," a technique in which the pattern shows only on the exterior, with maidenhair fern stems and dyed grasses. Before 1890, when aniline dyes were introduced, the Tlingit used vegetal pigments. This covered storage basket has a rattle lid whose hollow center contains small stones or seeds. (4½" high. Natural History Museum of Los Angeles County.)

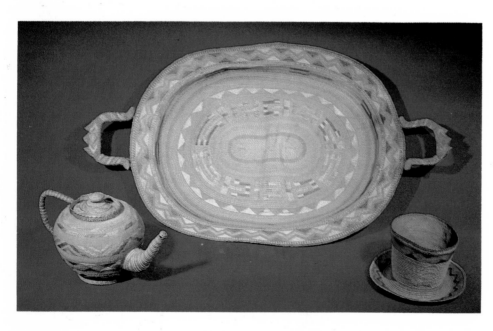

Plate 109. This copy of a Victorian silver tea service, a tour de force of late-nineteenth-century Tlingit basket weaving, represents a blend of traditional materials—spruce root, dyed maidenhair fern, and grasses—techniques, and designs with alien forms. The basketry teapot in particular, which is completely nonfunctional and was woven freehand, not, like some basketry-covered bottles of the same period, over crockery or glass, must have tested the weaver's skill to the utmost. (Tray, 27" long; teapot, 9" long; bowl, 6" diameter. Private Collection.)

Plate 110 (opposite). The graceful mountain sheephorn feast ladle exemplifies the skill with which Tlingit artists reshaped difficult materials into functional masterpieces that blend aesthetic and symbolic considerations with practical requirements. Upside down the ladle reveals itself as a long-necked waterfowl, the bowl its body and the whole an elegant sculpture of a swimming bird as it begins its dive. On its back is a relief sculpture of a youth with an animal helmet, or with his head in the upper jaws of a devouring monster. The total configuration of diving bird, youth, and protective or devouring animal recalls the shamanistic descent into the underworld. (19" long. 1850–70. Private Collection.)

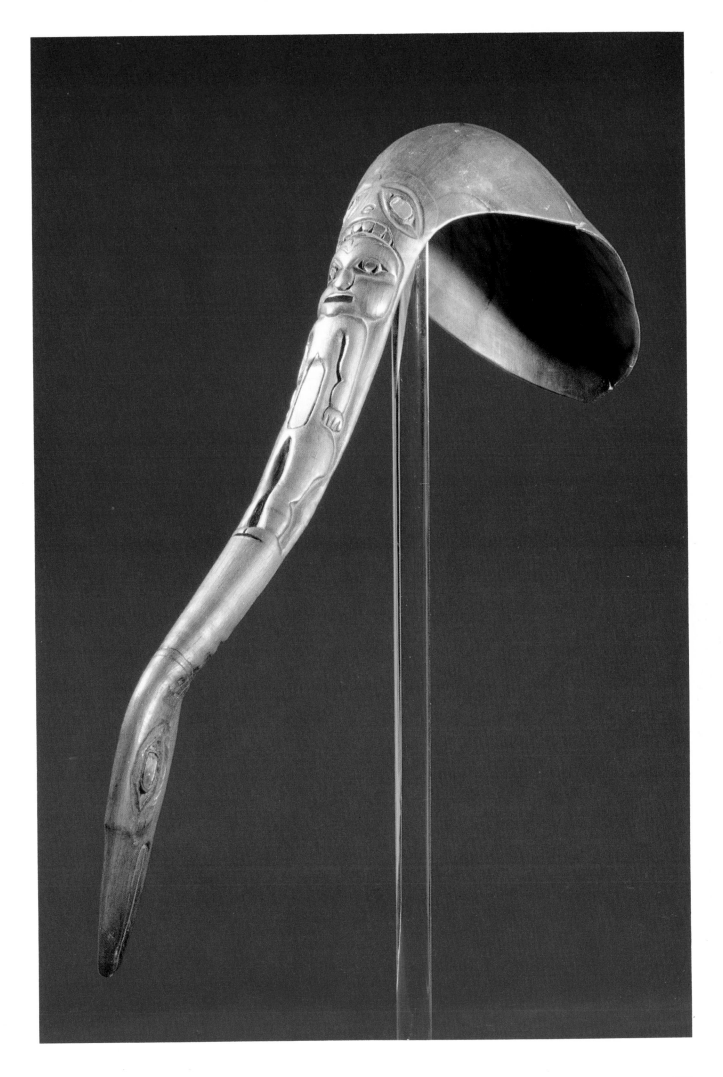

Plate 111. Kwakiutl chief dressed in a blanket decorated with mother-of-pearl trade buttons and holding his Raven rattle and speaker's staff, photographed by Curtis in 1914.

Plate 112. Elaborate bird effigy rattles like this one from Yakutat, Alaska, are often called chief's rattles. Its symbolism is typically shamanistic. The oystercatcher is a strikingly colored wading bird that is always the first to sound the alarm and take wing at any sign of danger, thus serving as a kind of guardian for other birds, as the shaman does for humans. That it is also a superb diver makes it an ideal helper for the shaman on his travels to the underworld. The bird's body terminates in the head of a mountain goat, an animal closely associated with the shaman and an important source of his power. Between the horns sits the figure of a shaman, subduing a witch or hostile shaman in the Tlingit manner, by twisting his long hair and tieing it to his bound arms. (17¾" long. Princeton University Museum of Natural History.)

Plate 113 (opposite). This elegant Tlingit shaman's rattle may well be one of the oldest of its kind, since there is no sign of its having been carved with anything but stone tools. Certainly it was made before 1800. The frog was an important spirit donor. Human face and frog have their counterpart on the reverse side of the rattle, but with an important difference. On this side the frog is alive, but the rather sharp outline of the human eyesocket suggests death, however subtly. On the other side the frog is unconscious or dead, but the face is alive. (8⅞" high. Private Collection.)

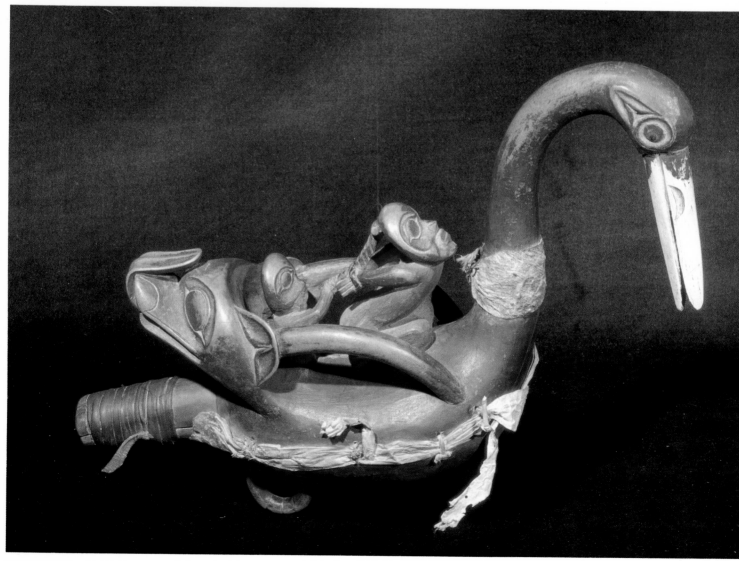

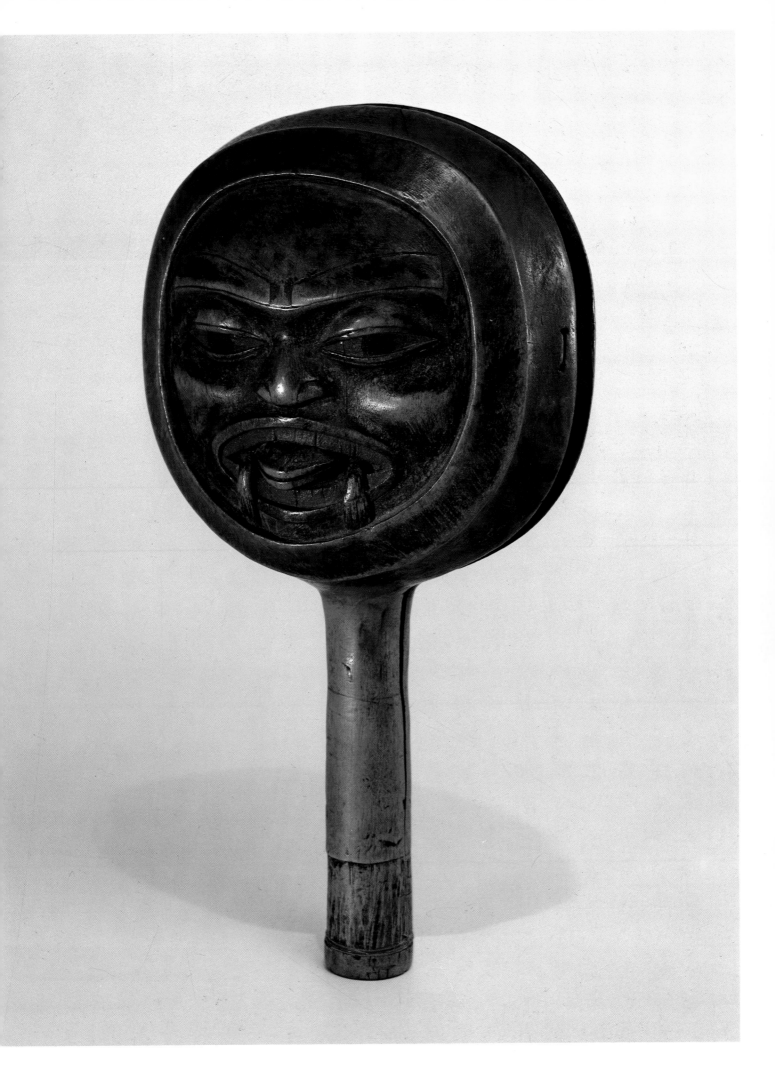

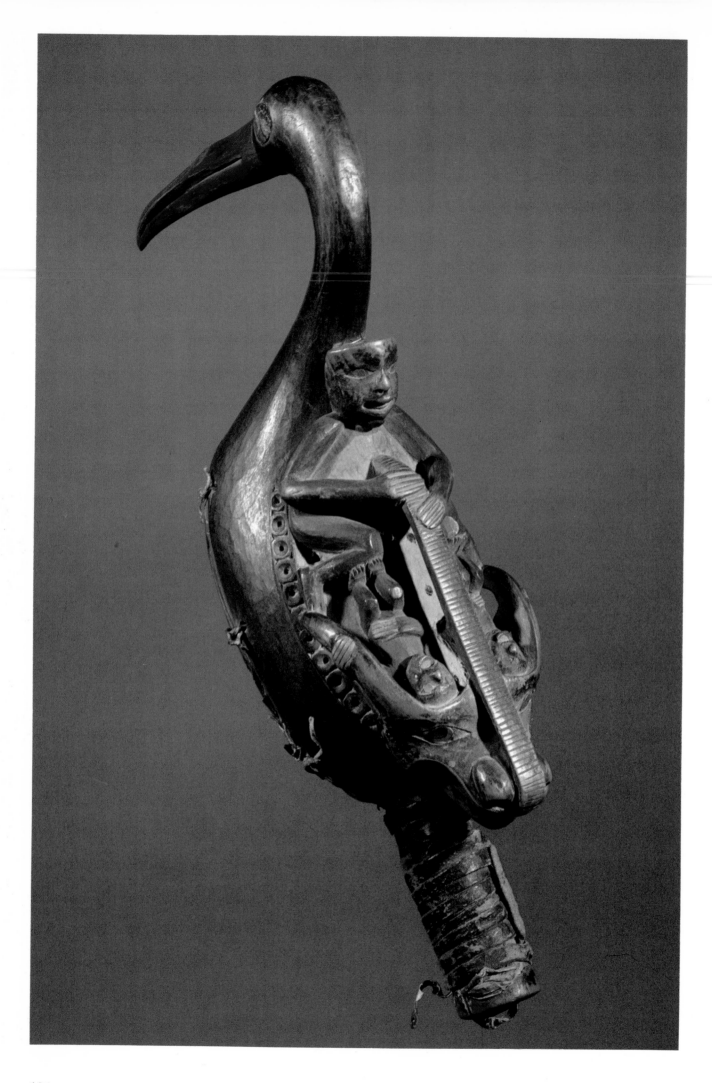

Plate 114 (opposite). Here again the iconography of the Tlingit shaman's rattle mirrors his magical arts. On the rattle lies a shaman pulling mightily on the tongue of a mountain goat. This is because the tongues of certain animals, especially mountain goat and otter, are among the most important power objects a novice shaman can acquire on his initiatory vision quest and on subsequent occasions. The goat's agility in leaping across perilous chasms is analogous to the shaman's leap from the human to nonhuman worlds, while its horns relate to his own metaphorical "horns of power" (see Plate 126). The shaman does not pursue the animal; rather, it is said to come to him unbidden, dropping dead of its own volition at his feet as he sits in lonely vigil and sensory deprivation in some secluded spot. He pulls out its tongue, cuts it, and hides it where it will not be agitated by sounds reminding it of its former life. The twin figures on this rattle may be specific to the family history of its owner, but the tentacles along the sides refer to another powerful shaman's ally, the octopus. (12¼" long. Collected in 1867. Private Collection.)

Plate 115. A long tongue, probably the Spirit Frog's, is the bridge across which power flows from animal donor to human shaman on this mid-nineteenth-century Tlingit Raven rattle. (15¼" long. Lowie Museum of Anthropology, University of California at Berkeley.)

Plate 116. On this mid-nineteenth-century Tlingit raven rattle the reclining shaman with the features of a bear seems to be receiving power from a Thunderbird through the medium of the spirit frog he holds clamped between his jaws. (14" long. Private Collection.)

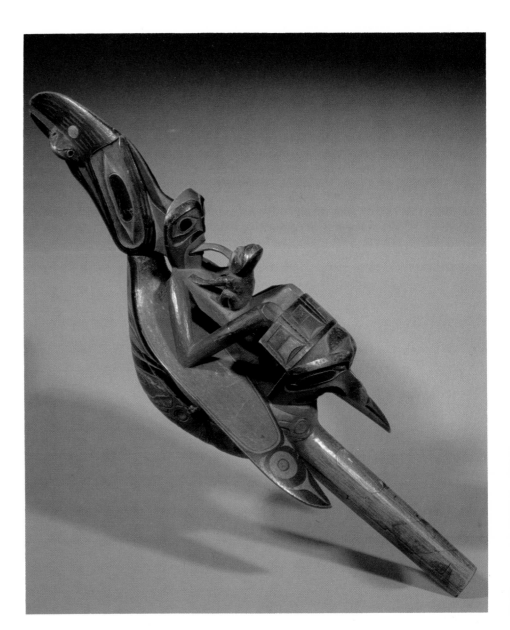

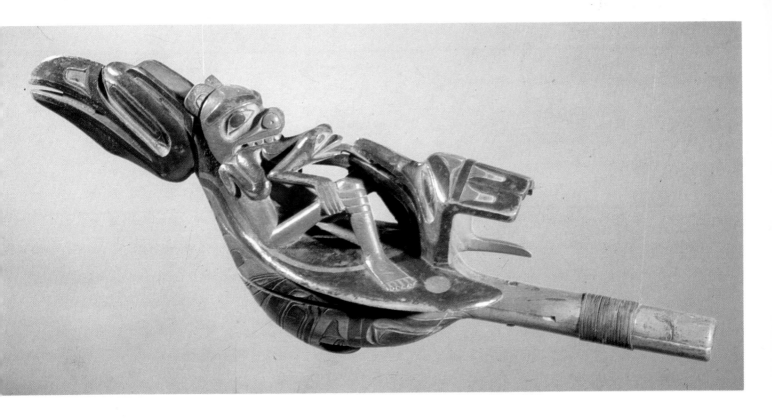

Plate 117. *Haida tobacco pipe, from the Queen Charlotte Islands, British Columbia, reminiscent of Raven rattles in its general form and its integration of subsidiary animals with Raven as the principal crest bird. The body of the pipe is wood with abalone-shell inlays; the small cylindrical metal bowl is hidden between the ears of the raven. Native cultivation of tobacco and the custom of chewing it with lime from crushed and roasted shells to extract the juice were reported by Spanish and other white travelers as early as the 1780s. But the idea of smoking tobacco in pipes, a practice already well established early in the nineteenth century, seems to have been borrowed from the Europeans. In contrast to European recreational smoking, however, smoking among the Northwest Coast Indians was limited to important rituals, especially commemorative feasts for the dead. The first native pipes, and indeed most pipes meant for personal use rather than sale to tourists, were carved of wood; their ceremonial context explains why they were often decorated with crest animals such as Raven, Eagle, Bear, Frog, or Killer Whale. (9½" long. 1820–50. Private Collection.)*

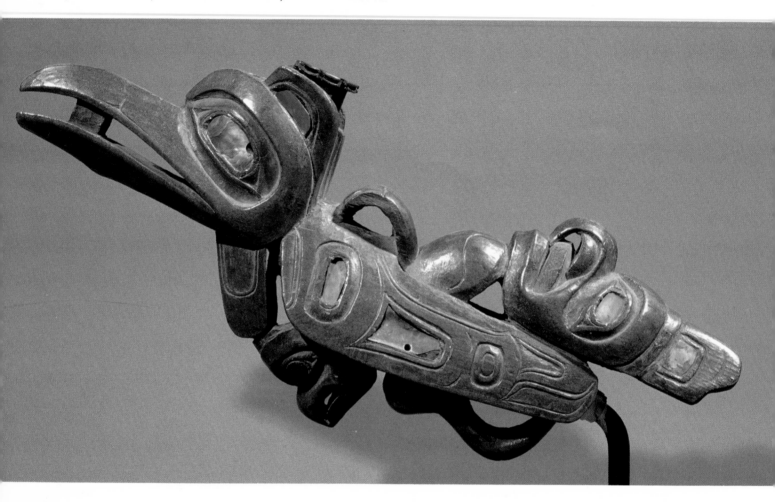

Plate 118 (opposite). *A Raven rattle collected from the Haida on the Queen Charlotte Islands repeats the familiar theme of the bird in flight with the shaman on its back, the celestial thunderbird as ally, and the transfer of spirit power to the shaman from a frog. The raven plays a part in the mythological ancestry of some noble lineages, but as the principal figure in these rattles its role is primarily that of mediator between the worlds. Essentially Raven is a culture hero of North Asiatic origins; in myth he is celebrated as both creator and trickster, that curiously ambivalent figure found in different identities over much of Indian North America, who offsets his positive acts with foolish tricks that more often than not backfire. He is also primordial bringer of light, for it was Raven who first placed the sun into the sky after liberating it by trickery from its imprisonment in the house of a rival (the underworld) and escaping with it through the smokehole in the roof, thus accounting for the first sunrise. He discovers humankind in a clamshell, brings dead bones to life, gives animals their present form. He is loquacious, intelligent, a creature of the sky, but his scavenging habits and his black color associate him as well with the underworld. Raven is the Great Shaman of the First Times, when the world was given its present order; and when the shaman shakes his rattle, it is Raven who summons his spirit helpers and the ancestors to the shaman's side. (11½¼" long. Collected in 1883. Smithsonian Institution.)*

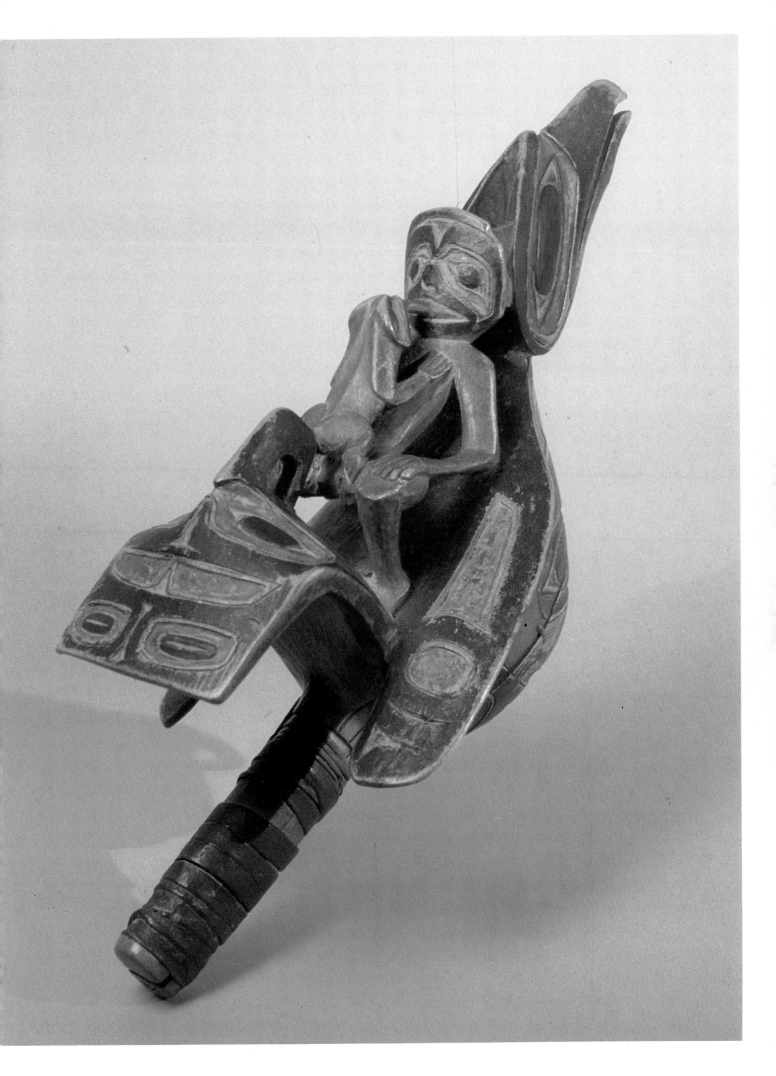

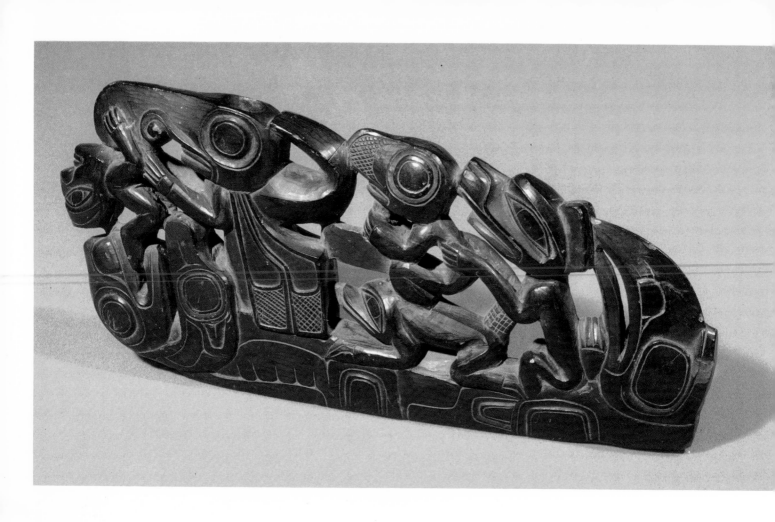

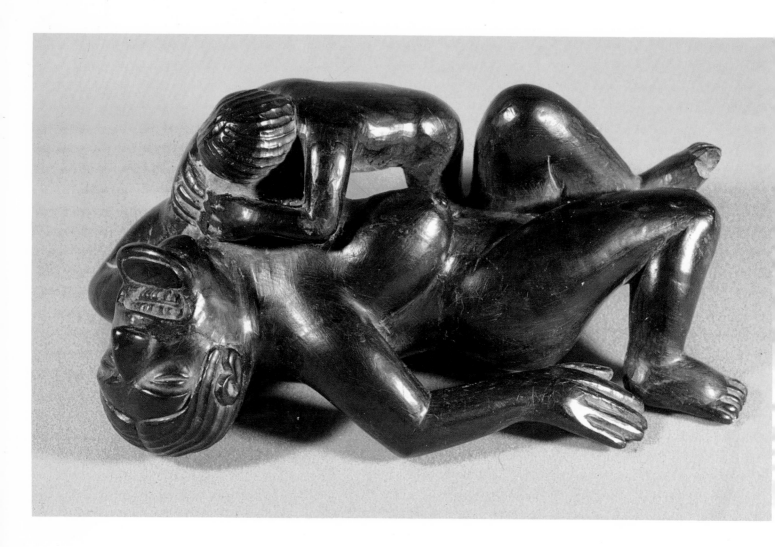

Plate 119 (opposite top). In contrast to pipes of wood or bone, those carved of argillite, a fine-grained, carbonaceous black shale found only in one locale on the Queen Charlotte Islands, were never actually used by Indians but were made for sale or trade to sailors, merchants, museum collectors, and other foreign visitors. This Haida pipe comes from Skidegate and dates from the nineteenth century. That many such pipes were organizational masterpieces, equal to the finest work in wood and other traditional materials, is not surprising, for the carvers were the same ones who also produced masks, headdresses, totem poles, and other wood sculptures for indigenous use. The utility of argillite for carving with ordinary gravers was first discovered around 1820. Argellite art quickly became popular with Europeans, and from the early nineteenth century into recent times Haida artists turned out great numbers of such carvings; these included figural groups taken from Native mythology, miniature totem poles, platters and dishes of European form decorated with indigenous and Victorian motifs, as well as pipes. (8⅜" long. Peabody Museum of Natural History, Yale University.)

Plate 120 (opposite bottom). In sheer humanity and conceptual monumentality, few stone sculptures of any size can rival this powerful depiction of the Bear Mother myth. Yet it is small enough to have fit into the hand of its creator, the nineteenth-century Haida artist Skaowskeag. The carving was collected at Skidegate, Queen Charlotte Islands, by J. G. Swan in 1883.

The myth of Bear Mother is common to virtually the whole Northwest Coast. The Haida version tells of the daughter of a chief who, while in the forest picking berries with her friends, took it as a personal affront when she stepped on some bear droppings and cursed the bears for their dirty habits. Toward afternoon the strap on her basket broke, spilling all the berries to the ground. Not realizing that she was being punished for insulting the bears, she told her companions to go ahead while she repaired the damage. She was occupied with this task when a young man came up and offered to help. By the time the basket was full again it was getting dark, and the stranger invited her to his house in the mountains. It turned out that he was really a bear, and the house the Bear Chief's den. There she remained, marrying Bear Chief's sister's son (his legitimate heir in the matrilineal Haida system) and giving birth to two children. Breast-feeding was painful, for the children had long, sharp claws, and it is her agony while nursing that the carver has here captured so masterfully (if untraditionally) in argillite. One day her brothers came to rescue her. The bear husband offered no resistance but asked that his death be postponed until he had taught his powerful bear medicine songs to his sons. He did so, and after he was killed the brothers returned to their village with their sister and her bear children, who became the founders of the clan with the bear as its crest. (5¾" long. Smithsonian Institution.)

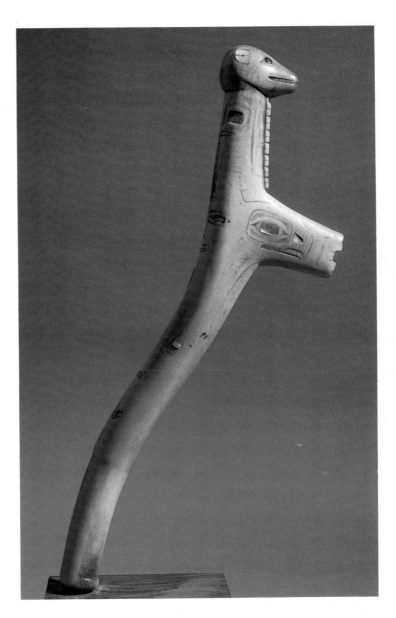

Plate 121. The engraved designs on this elegant Tlingit or Tsimshian elk antler club, with abalone and jet inlays, have been so eroded by handling that the club must already have been ancient when it was collected in the last century, an heirloom piece of great power. (18" high. Eighteenth century or earlier. Private Collection.)

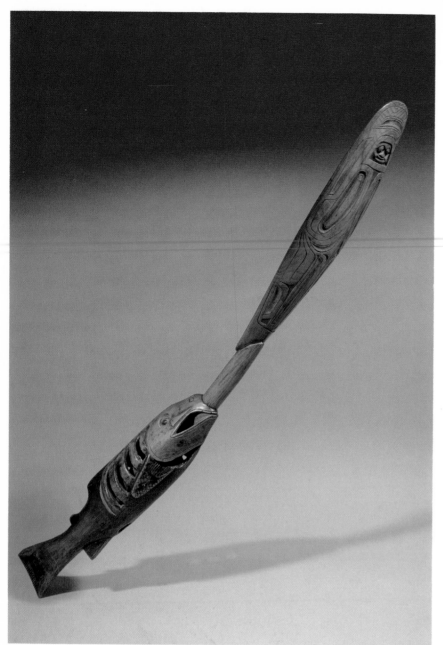

Plates 122 & 124 (opposite). Northwest Coast Indians, for whom the annual salmon runs not only were the mainstay of life but constantly reconfirmed the cyclical flow of life and death, thought of salmon as people in another form. Every year the Salmon People, living in their village beneath the sea, exchanged their outer human garments for those of fish to migrate upstream and become food for the Indians or die after spawning. Their bones floated back to the sea, where they were once again transformed into living Salmon People, to start the cycle all over again. It is these concepts that are expressed in the elegant Chilkat Tlingit feast spoon at left, collected in 1869, and the two Tlingit wood sculptures at right, collected in 1898. The handle of the ladle, which is carved from a single piece of wood, is a skeletonized salmon with a small free-floating person inside, symbolizing the living human essence of the fish and its alternate form. The sculptures convey the same idea in two different ways. One is half fish, half human, but retaining the gill slits; the other emerges from the jaws of the salmon while the fishtail splits into human legs. (Ladle, 17¾" long. Salmon People: left, 17½" high; right, 17⅛" high. Lowie Museum of Anthropology, University of California at Berkeley.)

Plate 123. A shaman's charms of carved bone, the one at the left representing a skeletonized fish with human skull, the one at the right, bears. Both are Haida or Tlingit, and date from the nineteenth century. (Left: 3⅜" long; right, 3⅞" long. Lowie Museum of Anthropology, University of California at Berkeley.)

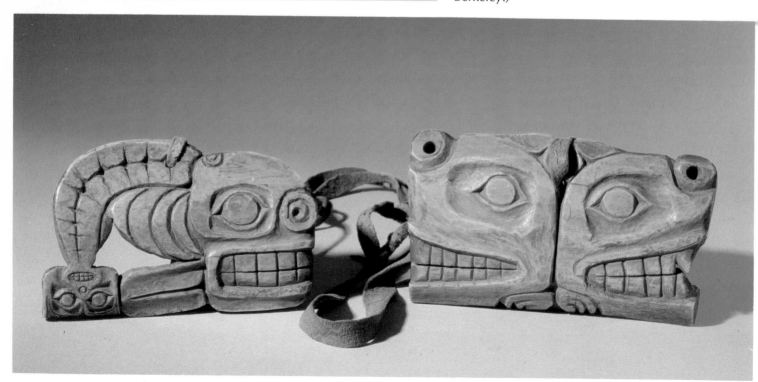

130

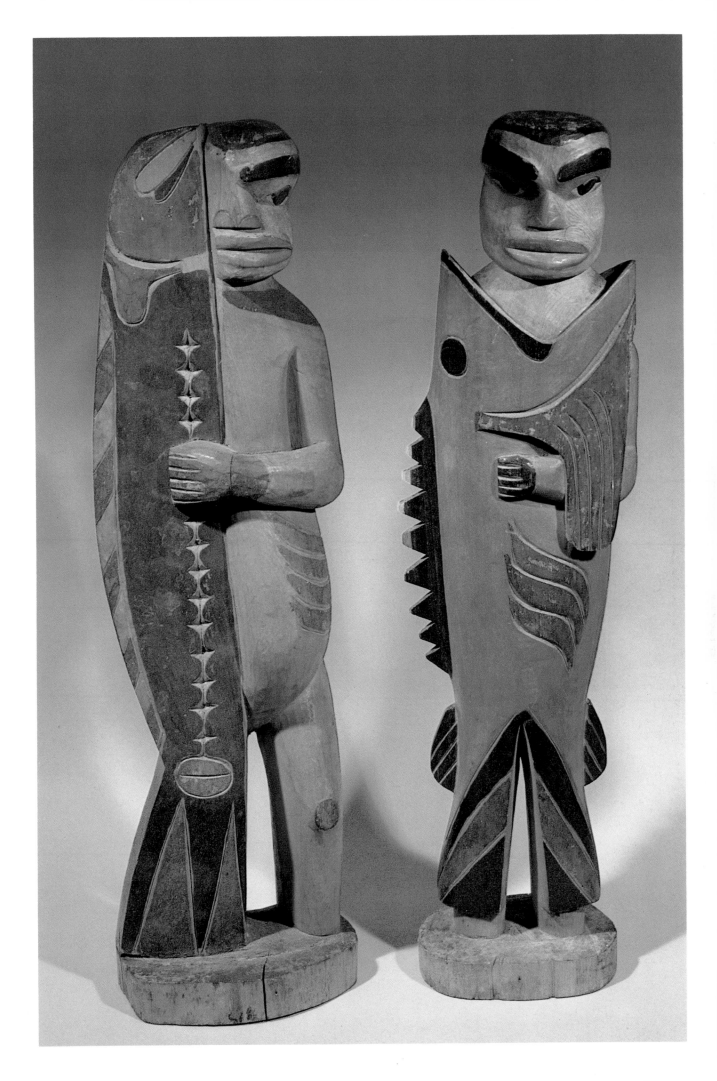

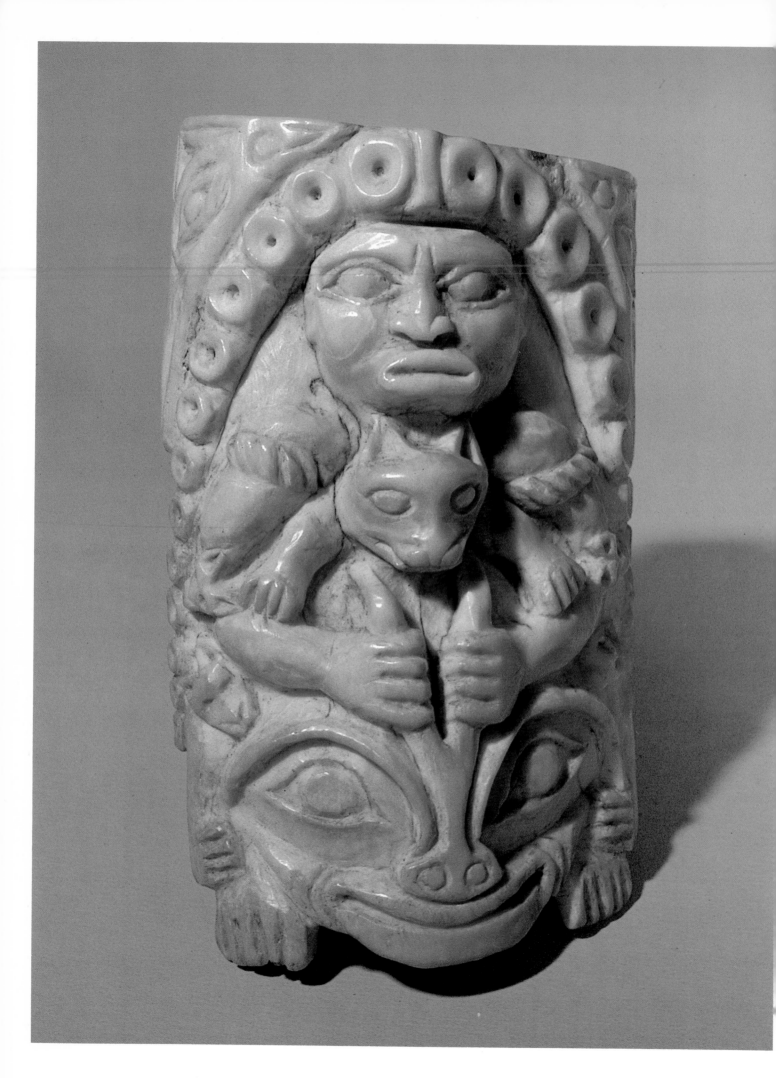

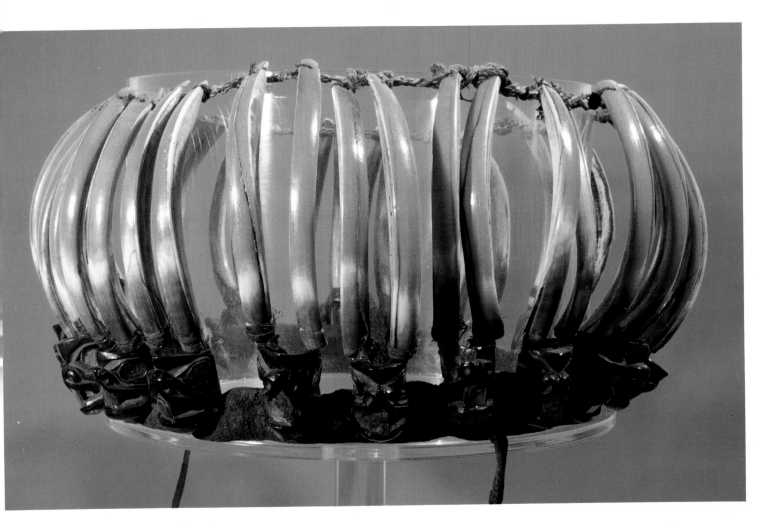

Plate 126. In this mid-nineteenth-century Tsimshian shaman's crown, the horns of the mountain goat are simulated by the long, sharp incisors of beavers, attached in pairs to small, vermilion-stained mountain-goat heads carved of goat horn. (9½" wide. Private Collection.)

Plate 125 (opposite). A shaman's bone charm depicts him with some of his principal spirit-power donors—Mountain Goat, Octopus, and Land Otter. The charm is Tlingit, and was carved in the nineteenth century. (4½" high. Lowie Museum of Anthropology, University of California at Berkeley.)

Plate 127. Symbolic analysis of this giant Salish spindle whorl made in the early nineteenth century reveals it as a cosmic model. The central figure is really two figures, a human above, a toad below, in the generational, or "hocker," posture. Inside the spindle is an embryonic tadpole. In Salish cosmology, Toad is linked with Moon, and Moon with the woman's craft of spinning and weaving. The symmetrical birds are Raven, with the sun disk as bringer of light. The central hole is the celestial orifice or "hole in the sky," through which the long spindle fits as metaphorical world axis. (8⅝" diameter. Private Collection.)

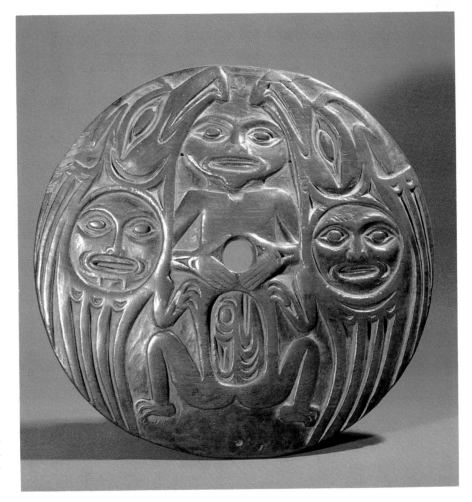

Plate 128. Although spear throwers were common among Eskimos, they were extremely rare among Northwest Coast Indians. Of the handful that are known, all are quite old, eighteenth century or earlier, and are carved with stone tools. All come from areas in Alaska close to the Eskimos and thus reflect Indian-Eskimo contact. This splendid example is northernmost Tlingit, probably mid-eighteenth century. The underside, shown here, is heavily decorated in characteristic Tlingit style, with a raised hole as finger-hold. The flat reverse side is grooved for the spear, which was buttressed against a hooked edge. Serving as an extension of the throwing arm, spear throwers added considerable range and force to the projectile. Their wide distribution, from aboriginal Australia to Mexico, suggests that they are extremely ancient among hunting weapons. (14¾" long. Private Collection.)

Plate 129 (opposite). The Haida carver Charles Edenshaw's deeply moving wood sculpture represents a dead shaman as he would have appeared lying in his grave box, knees drawn up, holding his magical clacking sticks, and wearing his dance skirt. The same figure exists in several similar versions, all apparently by the same artist and all dating from the last part of the nineteenth century. This is the only one lacking paint, however, which gives it a special poignancy as the image of suffering and death. The subject seems indeed to have suffered: according to an old label attached to a similar sculpture in the British Museum, he was a shaman who was lost in the woods and starved to death after breaking both legs. (23" high. Princeton University Museum of Natural History.)

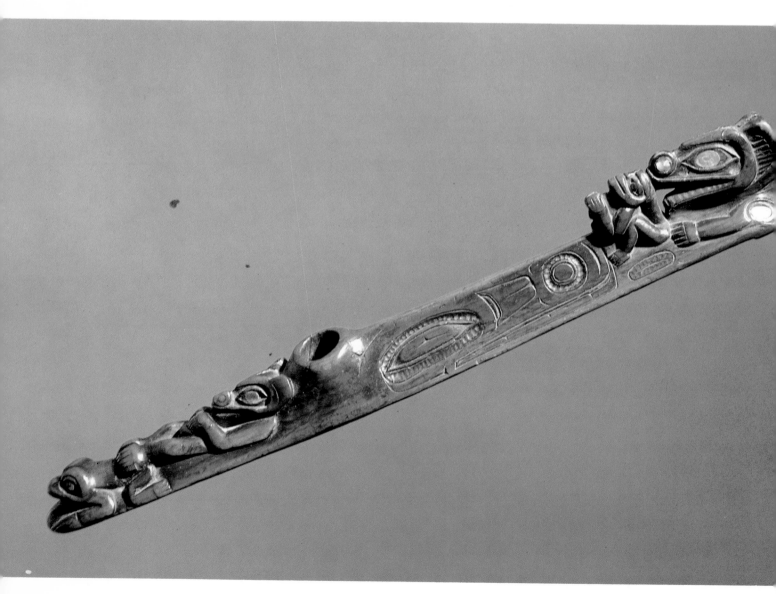

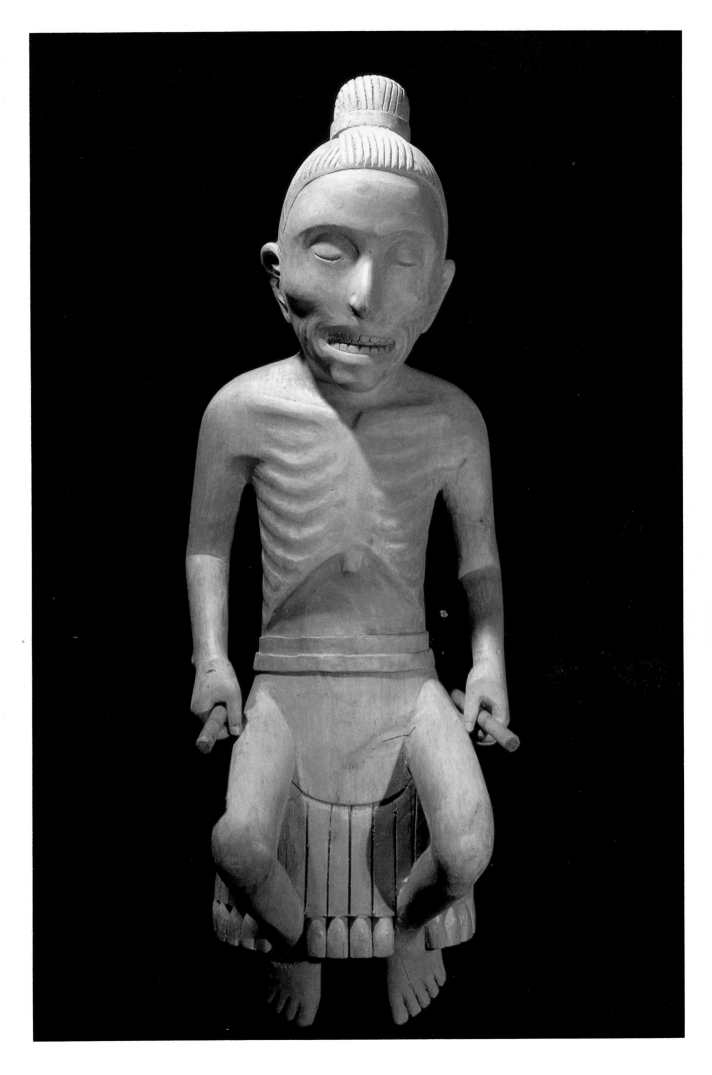

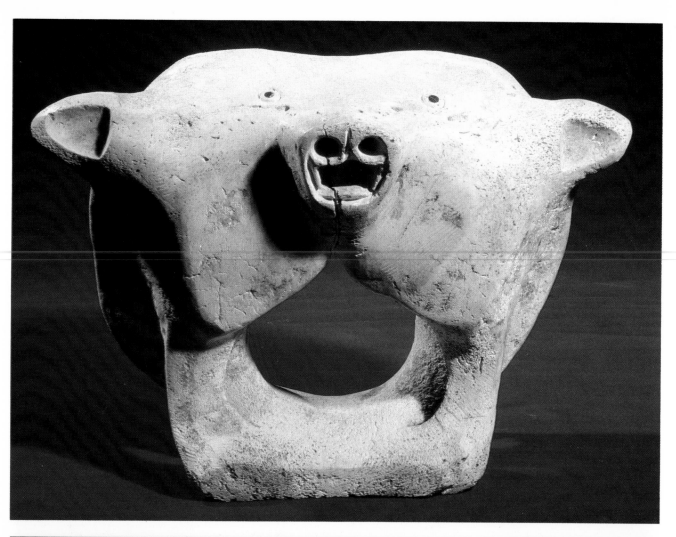

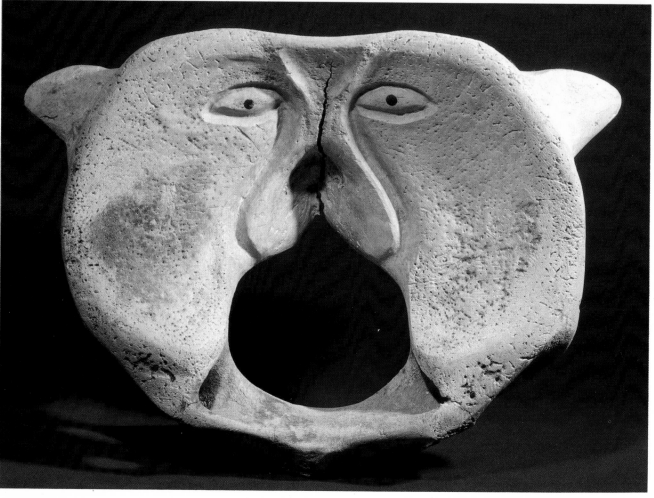

# Arts of the Eskimos

Eskimo art, in its original, pretourist, context, was ultimately concerned with a single, overwhelming imperative: survival. However much we may be charmed by the streamlined form of a fish cunningly evoked from a piece of fossil ivory (Plate 155) or awed and puzzled by the surrealism and abstraction of a shaman's mask (Plates 11, 135–139), for the Eskimo these were necessary components of the struggle to stay alive, to keep in balance the essential reciprocal relationship between himself and the spirit forces shaping and controlling his environment and ultimately his fate.

Probably few Eskimos would have agreed with the judgment of whites that theirs was an impossibly harsh environment, better left to animals naturally adapted to it than to humans, who could exist there only by supreme effort and luck. To the Eskimos, rather, the Arctic was as much a place of generous bounty as was the fertile land to agricultural peoples, provided that all the rules of life were observed. Still, it was a precarious environment, with peril at every turn. Art was one means of neutralizing these perils, even of turning them around in one's favor.

The key to the astonishing survival of the Eskimos in the four or five thousand years since they settled the Arctic, of course, is adaptation. From the start their astonishing success has depended

*Plates 130 & 131. It has been said that a traditional Eskimo carver about to start work might ask his material what manner of being was waiting to be "brought out" by his hands. If so, the natural form of the massive old whale vertebra, perhaps washed up on the shores of the Bering Sea, itself suggested this monumental image of a polar bear to the twentieth-century carver. But there is another image behind the powerful features of this mighty Arctic predator: the spirit owner of the animal, whose human features are visible only to the shaman's X-ray vision. It is this second face which the artist has carved on the back, to please and thus propitiate it. However, by dividing the bear spirit's face vertically in half, two mirror images of a leaping killer whale suddenly become visible. This kind of subtle "visual punning" was a favorite device of Eskimo carvers. (14" wide. Private Collection.)*

on a range of ingenious and efficient inventions that have astonished and delighted whites since Martin Frobisher's Arctic explorations in the sixteenth century, and of which some—the parka and the kayak, for example—have been widely copied in the industrialized world. But Eskimo adjustment went beyond the material. Not least among their remarkable adaptations was the creation of a very special mental universe that, revolving unceasingly around the need to appease the souls of game, helped them to preserve emotional balance in the face of extreme environmental stress. Art, the abundant and skillful creation of visual and acoustic images, was very much part of that process. If animal imagery predominated, and if animals were sculpted or engraved with more attention to detail than were images of humans (Plate 147–148), from early times to late, the reason lay in this special, delicately poised relationship of human beings with the animals whose generosity made their life possible. For virtually everything the people ate and used came from animals which, the Eskimos believed, gave themselves of their own free will to humans, so long as proper conduct was observed. It is a tragedy of human beings, and their mortal danger, an Iglulik Eskimo shaman once told Danish ethnologist Knud Rasmussen, who was himself half Eskimo, that they must live on the souls of animals; in return humans had always to make certain that the animals were pleased with human behavior. Displeasing the spirits of the game, the supernatural masters or mistresses of the species, or, worse, those superior spirits that had charge of all the animals—the sea goddess Sedna among central Eskimos and Moon Man among those of the Bering Sea—could be a sentence of hunger and death, for an individual, his family, and the whole community.

Animals took pleasure in hearing themselves praised in song or skillfully depicted in an image. If artistic creativity delighted human beings as

well—as it obviously did the Eskimos—this was nevertheless incidental to the primary objectives imposed by obligatory reciprocity between people and the souls of animals and those larger forces that controlled weather, winds, tides, the alternation of the seasons, the coming and going of the pack ice, and all the other natural phenomena that were so crucial to survival. Animal souls had their human aspect and those of men their animal selves, and each at any given moment might manifest these dualistic but complementary natures in a dream, as might the souls or spirit essences of any other aspect of nature. In such a system there is really no way of setting up firmly bounded categories such as "art," "social life," "religion," or "material culture." How might "art" or "religion" be isolated from economic life in a society in which souls inhabit all material objects no less than they do animals and plants? Art transforms a projectile-point container into seal (Plate 156) and a harpoon head into bear, perhaps. The spirit of the seal slips into the weapon that killed it, demanding comfort and warmth by the fire of its slayer's wife, and she, in turn, does what she must to make the spirit comfortable and content. Ivory swivels ingeniously designed to keep a sled dog's harness from becoming entangled and drag handles for seals contain the images and spirits of wolf, seal, caribou, or bear (Plate 150); a pipe is walrus (Plate 146); a fish lure or sinker is fish—all at once work of art, implement, prey, and spirit. But it is even more complex than that (or, to the Eskimo, perhaps more simple): because it was walrus that furnished the ivory for the carving, each image contains not only some of its own spirit essence but some of walrus as well.

# Pictorial Art

The creamy white color and flat, long-lasting surfaces of walrus ivory and bone gave Eskimo artists a chance to practice an elaborate system of picture-writing and record-keeping and with it to produce a permanent, amazingly detailed record of virtually every aspect of Native existence. In fact, whole ethnographies of Eskimo life in the nineteenth century and earlier could be written based on nothing more than a collection of engraved pipes and other objects of bone and ivory like that illustrated in Plates 142–145. The earliest such pictorial records date back to prehistoric times, before A.D. 1500, but the practice continued to the end of the nineteenth century. By that time, however, it was mostly produced for the tourist market. Remarkably, the same graphic style, marked by schematic suggestion more than by realistic detail and shading to express a great range of action, endured virtually unmodified for hundreds of years. Only around 1880 did the old conventions begin to give way to greater realism under the influence of sailors' scrimshaw art and white taste. At first, the old engraving style was only slightly modified by closer attention to anatomical detail, but by the turn of the century Eskimo engraving was fast becoming virtually photographic in its treatment of animals and human beings.

The new style was, of course, facilitated by the availability of more precise and delicate engraving tools. But, as is not generally appreciated, Eskimos knew steel even in prehistoric times, centuries before their "discovery" by whites. They were actually the first Native peoples of the New World to make use of sophisticated metallurgy—not their own but that of Siberians and Chinese. It is not that Eskimos did not use stone tools with great precision for their art, or that stone burins and blades were incapable of turning out work as fine as that found on old ivory. Still, some of the oldest art and other objects found in Eskimo archaeological sites on both sides of the Bering Sea, dating from the first centuries A.D., already bear the unmistakable marks of steel blades, adzes, burins, and drills. In addition, blades of carburized furnace steel, products of advanced mainland Asian metallurgy, have been found in some of the oldest Eskimo sites in western Alaska and eastern Siberia. However, much cutting and carving were also done with rock crystal and engraving and drilling with flint and chalcedony, the lines being filled in with a coloring material made from a mixture of oil and burnt grass.

Metal was not the only thing the Eskimos borrowed from Asians in prehistoric times. Fighting armor was another. Not only did Europeans see Eskimos wearing body armor made of rows of flat slats of bone as recently as the early 1800s, but pieces of such armor have also been found in prehistoric sites. Eskimo slat or plate armor, based on Siberian and Japanese samurai models, was worn in fighting between neighboring villages and also the periodic clashes between Eskimo communities on the Alaskan and Siberian sides of the Bering Sea. These occasional small-scale "wars" were still very much part of Eskimo oral traditions in recent times. It was not that Eskimos were particularly "warlike," as that term has been applied, often wrongly, to some other Native American peoples; rather, because they were never unified into groupings larger than the village, anyone not related by kinship or friend-

ship could be considered and treated as an enemy. Bone slats from plate armor dating to the early Punuk culture of western Alaska, which began around A.D. 1000, was sometimes decorated with incised geometric designs. By about A.D. 1200–1300, western Thule influences from northern Alaska and Canada introduced into Punuk culture a schematized pictorial engraving style that depicted people as stick figures with little sexual differentiation but was nonetheless able to convey a remarkable sense of naturalistic action and even emotion. This was the birth of the Alaskan pictorial style that was to endure virtually without change for about six centuries.

The bone armor slat (Plate 154), stained a rich brown by age and long burial, is a particularly interesting example of this earliest pictorial style because it juxtaposes two apparently unrelated scenes, one of hunting, the other of fighting, or preparation for war, in an upper and lower register. The piece dates from the Punuk culture, before A.D. 1500, and while the engraving may have been added later, style, erosion, and wear suggest that bone and ornamentation may be contemporaneous. The two scenes are contained within a border whose pattern has been identified as representing rows of seal teeth.

In the detail shown in Plate 155, two men in the upper register are butchering a small whale they have harpooned, while a third approaches from the right with a sled drawn by a single dog. Less self-evident is the scene in the bottom register. Here men sprint from the left toward another group of men, five of them armed and facing in different directions, and a sixth, unarmed, heading toward the runners. At first glance this looks like an impending fight, without any relationship to the peaceful whaling scene above. But the absence of weapons in the hands of the runners, and the evident lack of alarm among the others at their approach, suggests that they are allies. What may actually be recorded here is a shorthand version of an old Bering Strait Eskimo tradition that tells of continuous warfare between Alaskan Eskimos and their Siberian cousins who kept interfering with their whaling and raiding their villages. The warfare finally ended in a decisive victory by the beleaguered Alaskans. The battle was joined after an Alaskan Eskimo lookout spotted two war umiaks loaded with Siberian Eskimo warriors approaching the Alaskan shore. In response to his call to arms to the beat of a drum, many men came running, armed themselves and stood fast against the raiders with such ferocity that the surviving Siberians had to acknowledge their superior fighting skills. Peace was declared and the survivors on both sides joined in a great trading feast. This historic event is said to have occurred "long before the Eskimos of Alaska saw the first white man."

Ivory pipes, particularly the large ones carved and engraved between 1870 and 1880 for sale rather than personal use, afford a much broader look at Eskimo culture, for these became a favorite story-telling medium (Plates 142–145). Behind the pipe as art, however, there is one of the more extraordinary stories of cultural diffusion. Tobacco, of course, cannot grow in the Arctic, and the custom of smoking it, thousands of years old elsewhere in the New World, did not reach the Alaskan Eskimos until the late eighteenth century, brought by Russian and Siberian Chukchi traders. By then tobacco use had traveled clear around the world, first to Spain from the Caribbean with Columbus, next across Europe into Russia, and finally over the Urals to Siberia. Native peoples not only took readily to the strange new aromatic weed but some even integrated it into religious ritual in ways reminiscent of New World custom. Europeans, of course, from the start smoked it only for recreation.

With trade tobacco for smoking and chewing the Eskimos also adopted the characteristic Siberian and north Asian form of the pipe (Plate 141). It was also from the Siberian Chukchi, close neighbors to the Eskimos, that the Alaskan Eskimos first learned to make pipes from walrus ivory. In the first half of the nineteenth century, these were carved only for personal use, but before long decorated walrus ivory pipes became popular souvenirs among whalers and other sailors. The first Siberian-style pipes decorated in the old engraving style were sold to whites as early as the 1850s, but most date to the 1880s, when the Siberian type of pipe gave way to more European forms.

Trade tobacco was never in generous supply, so Eskimos devised ingenious ways of making the most of even a pinch. The small size of the Siberian-style bowls allowed only a modest amount to be smoked at a time. Cut very fine, the tobacco was placed in the bowl atop a bit of animal fur, which acted as filter, and lighted with tinder, steel, and flint. When the tobacco had been thoroughly lighted with two or three puffs, the smoker consumed it all in a single powerful draught, drawing the smoke deeply into his lungs with one continuous inhalation. Early travelers noted with amazement that some men would hold the smoke so long, without expelling it, that they fell into a deep trance. Among some Native peoples of the Americas that was one technique of altering one's state of consciousness in shamanistic ritual, but there is no evidence that Es-

kimos viewed the experience as mystical or that tobacco for them had any of the deep religious significance that marked its use elsewhere among Native North and South Americans (see Chapter Six).

The large ivory pipe shown in Plates 142–145, although never used and so evidently intended for sale or trade, is one of the earlier examples, dating to around 1850. It is also one of the most interesting of such pipes, because its pictorial engraving not only depicts hunting at sea on one side and on land on the other but also includes shamanistic ritual and even mythological scenes. The engravings are executed in the early style, but the pipe is considerably more opulent than most because the two sides of the upper ridge are also embossed with raised reliefs of swimming walrus, twelve in all, plus two more heads facing in opposite directions. Each animal is decorated with geometric patterns of the "seal-teeth" type. In addition, one pair of walrus has engraved bird tracks that in Alaskan pictographic writing stood for Raven, the trickster-culture hero Eskimos shared with Northwest Coast Indians as well as Siberian peoples.

Below the fitting for the bowl, an engraved human figure with a bushy animal tail, perhaps a masked shaman, perhaps a spirit, seems to be directing a large black bird—Raven, presumably—on the ground on one side, and watching him fly on the opposite side. Another stick figure with arms raised, clearly male, is pictured on each side between the walrus head and the full-figure walrus reliefs. In Alaskan Eskimo sign language this gesture is one of want or distress. The flat engraved panels on each side obviously tell consecutive stories, with the action proceeding from mouthpiece to bowl. It begins, on one side, with a hunting camp, indicated by conical skin tents, and ends at left, with a permanent habitation with tunnel entrance, in front of which people are watching a ritual conducted by dancers with animal heads or masks and bushy tails, dancing to the beat of a shaman's drum. Similar animal-headed figures with bushy tails recur in several places on both sides of the pipe. Whether these, or all the individuals with animal characteristics, are meant to be masked shamans or spirits is uncertain. The left side of the pipe (first and second photos from the top) depicts caribou hunting, the right side the walrus chase. Swimming caribou pursued through the water by a hunter in a kayak are also shown on this side, but upside down. The artist has included at least one more being from Eskimo mythology, a bird powerful enough to carry away a whale, depicted on the left side near the mouthpiece, and perhaps another, on

the opposite end and side—a bear of monstrous size, lying prostrate with legs pointing stiffly skyward and a hunter's spear sticking in his belly. Eskimo tradition tells of an eagle or thunderbird of such strength and size that he could lift a whale out of the water; however, Big Raven, too, had this ability, so that the whale-bearing bird might be Raven, the culture hero.

Rich in ethnographic detail as is this remarkable pictorial art, it is nevertheless only a collection of shorthand clues to a complex mental life that, as noted, concerned itself unceasingly with the well-being of animals in life and in death because this, in turn, directly translated into the well-being of humans. Hunting walrus, for example, was never just a matter of waiting for the right moment, when the ice was breaking up and the animals began to migrate northward. The hunt was preceded by ritual preparations and the purification of hunters and their equipment. Walrus were credited with great intelligence and sensitivity and a superb sense of hearing over great distances that was especially attuned to idle boastfulness: a hunter who proclaimed his lack of fear of the walrus and his certainty that they would never do him harm was sure to feel their wrath later on. In approaching the animals special songs were sung and the walrus calmed with ritual speech-making (Plate 146). When they had been killed, there were rites of mourning analogous to those for human beings and addresses of conciliation to placate their souls. As with seals, before butchering could commence the carcasses were offered fresh water to drink to assuage their thirst.

Because of their huge size, walrus were butchered on the spot; the tusks, meat, blubber, flippers, skin, and other useful parts were transported home while some of the bones were ceremonially returned to the sea. Three or four skins sewn together were sufficient to cover the wooden frame of an umiak, but though the skins were tough and durable, they had to be changed frequently, because certain animals—whales, especially—did not appreciate being hunted from umiaks covered with old skins (Plate 151).

The whale cult of Alaskan Eskimos itself is legendary for its complexity and pervasiveness, for it extended not only through the whaling season but through the entire winter, when old men and successful whalers told stories of the whale and when the coming hunt was the focus of much shamanistic activity, including séances as well as ritual games, sports, and even apparently purely social events, and much of everyone's thought. The *karigi*, or ceremonial house, was the center of these activities, which were directed by the

*umealiq*, the hunt chief and master of the umiak. He had charge of the preparation of all the necessary paraphernalia, the ritual banners, the whaling charms, and their use in magic rites. He was not necessarily a shaman, but he frequently conferred with the shamans to make certain that all the ritual instructions and restrictions were properly carried out.

The whale cult involved the women no less than the men. They were busy with making new clothes, for the whale would not allow himself to be approached except by those wearing clothing that had never before been used on a hunt. When the hunt was over, the clothes were carefully cleaned and ritually purified and then could be worn again for hunting, but never again for whales. All had to observe strict food taboos and sexual restrictions that compelled the members of the whaling crew to sleep away from their wives in the *karigi* instead of their homes, from the moment the new umiak cover was completed and placed over the frame. No gaiety was permitted during the four final days before the hunt, the men sitting in quiet contemplation, turning all their thoughts and their reverence toward the whales. While they sat deep in thought, the *umealiq*'s wife brought the principal float to be used on the hunt to the umiak, together with the special wooden vessel from which fresh water would be offered to the dead whale, and placed them solemnly in the boat. Singing her whaling songs and predicting success, she circled the umiak, blessing it with fresh water. And when finally the boat pushed off, she gave her husband the mitten from her left hand and her belt, these constituting a mystic link between the land, herself, and the whalers, reinforcing the bond formed by her observation of the same restrictions at home that applied to the men at sea. Her main concern, everyone's concern, what dominated the cult of the whale from the very first thought directed at the animal months before to the emotional greeting of the bowhead when it was brought in and the ritualized distribution of its meat, was first and foremost that the whale's soul, its *inua*, be pleased and remain well disposed toward the hunters and their families, for without its good will there could never again be another successful hunt.

# Shamans and the Soul

Eskimos conceive of the soul as a tiny replica of the being it inhabits. The soul of a bowhead is a miniature whale, a caribou's soul is a miniature caribou, that of seal is a tiny seal, the soul of

polar bear is a tiny bear (Plate 5), and that of a person a diminutive man or woman. This imagery helps to account for the profusion of miniature ivory effigies of game animals and people that are so admired in Eskimo art. The little soul resides in an air bubble in the groin—specifically the bladder—which helps to explain why Eskimos to this day, when the culture as a whole has become so drastically transformed by modernization, still preserve and give honor to the bladders of seals they have caught. The bladders are ceremonially returned to the sea at the annual Bladder Festival, so that they may reunite with the bones and come alive again as new seals.

The Eskimos believed not only that animals were not offended by their death and even gave themselves voluntarily to hunters but also that animals sometimes chose to die because they had grown tired of their present existence and wished to come back as some other form of life. In one Eskimo tale, the soul of a dead human fetus is successively dog, fjord seal, wolf, caribou, dog again, and finally, by slipping into the body of a woman as she bends over a seal, once more a human fetus, eventually to grow into a dutiful son and successful hunter. In another story, it is a little grass plant that, having grown weary of being eaten by grazing animals, keeps changing its appearance. This is more than transformation, however; each being contains many forms simultaneously, sometimes manifesting itself as one, sometimes as another.

The spirits of animals might be seen by any person, and everyone had some direct experience with them. But it was the specialist in the soul, the shaman or *angaquog*, master of ecstatic trance and of out-of-body travels to other worlds, who dealt most directly and intimately with the spirits. It was he who had helpers among them, who had knowledge of the sacred geography and of the different shapes of supernatural beings, and who could most effectively translate and dramatize the extrahuman phenomena into visual and acoustic imagery. As everywhere in the traditional world, the shaman was the crucial figure in religion and hence in life itself, for life and religion were synonymous. It was he who reconciled contradictions, transcended the ordinary limits of the human condition, and restored balance through direct interaction with the world of spirits, from individual souls to the rulers of the environment.

Each society, of course, has its own conceptions of these greater powers, which are influenced, though not necessarily determined, by the specific environments in which the people make their lives. This is particularly evident among the

Eskimos, for despite many basic similarities in Eskimo culture from Siberia to Greenland, there were also many local differences that extended to the cosmology. Broadly speaking, most Eskimos adhered to the "cult of Sedna," a mother goddess who dwells on the bottom of the ocean as guardian of the animals, whom she releases to be caught by men or, sometimes, pens up when taboos have been violated. Sedna, as she is called in Baffinland, was known by different names across the Arctic, some emphasizing her beneficent nature, others the terrible side of the Great Mother. So, for example, she was known as "Spirit of the Sea Depths," "Food Dish," "Place of Food," "Woman of the Sea," or "The Ever-Copulating One," the last an Iglulik name that particularly impressed early-nineteenth-century English explorers. But the Iglulik, who live on the east coast of Melville Island and whose intellectual culture is better known than that of any other group because of Rasmussen's long stay among them, also emphasized her fearful, punishing nature by calling her Takanakapsaluk, roughly meaning "The Bad One" or "The Terrible One Down There."

Even Eskimos who never went to sea, relying instead on caribou for their main sustenance, had a Mother Goddess of all the animals who corresponds in many ways to Sedna, but who resides in the air rather than the sea. Some of the Caribou Eskimos called her Pinga and conceived of her as an omnipresent spirit who kept careful watch over how humans treated animals they killed. She was especially concerned that nothing be wasted and that all food be treated with respect. Pinga guards the souls of animals and becomes angry if more are killed than humans need for food and shelter. These are all ethical attitudes the Eskimos shared with other Native American peoples. West of the Caribou Eskimos the cult of the Woman of the Sea as guardian of marine mammals reappears in full force among the Copper Eskimos. They call her Kannakapfaluk and regard her as the greatest of all the supernaturals. She dwells on the bottom of the sea in a house exactly like that of the Eskimos themselves and, like Sedna, she punishes by withholding seal from hunters when she is offended. In contrast, the Bering Sea Eskimos, who rely almost exclusively on the bounty of the sea, attribute to the male Moon Spirit the powers their cousins farther east ascribe to the sea goddess, which only goes to show that environment and economic imperatives are not by themselves always decisive in these matters of the mind.

Sedna's origin is accounted for in myths that also connect her with the origin of the first sha-

man and the magic he works by virtue of his superior powers. In these traditions, Sedna was formerly a human being, a young woman who lived with her father by the sea and who pridefully rejected all suitors. In one mythic account, a kayak passed by one day and a man called out from offshore that he wished to marry her. Seated in his boat he appeared to be tall, and handsome as well, so the girl decided to go with him as his wife. But after paddling for some distance, the young man pulled up alongside an ice floe and, to her shocked surprise, revealed himself as not tall and good-looking but puny, ugly, and red-eyed. He was, in fact, a bird, Stormy Petrel.

Still, her choice was not too bad, for her husband provided ample food and warm, snug shelter. But Sedna missed her father, and when one day he came in search of her she left with him. Finding her gone when he returned from the hunt, the bird husband flew all over the ocean in search for her. At last he spied his father-in-law's boat. He pleaded to be allowed to see his wife, who was hidden beneath a pile of skins, but the father only mocked him. Stormy Petrel, enraged, flew back and forth over the kayak, raising a furious storm with his wings. As water began to fill the boat, Sedna's father grew frightened and, to appease the bird, threw his daughter overboard so that her husband might reclaim her. The young woman, however, clung in terror to the kayak and refused to let go. Her father then took his knife and one by one cut off the top joints of her fingers. As they fell into the sea they changed into seals. Still she refused to let go, and he cut off the second joints. These turned into bearded seals. Still she held on, and when her father hacked off the last finger joints, they became walrus. No longer able to grasp the boat, the girl sadly slipped into the ocean and sank to the bottom, where she was transformed into a spirit.

The father returned to his village, but so remorseful was he that he lay down to die at the water's edge. The waves came and carred him off to the bottom of the sea, where father and daughter were reunited. He is known as the Father of the Woman of the Deep, and he punishes especially those people who have had incestuous relations. The Mother of the Sea Beasts also has a fierce dog that guards the passage into her house. Together these three are the ruling spirits of the underworld and the abode of the dead. Sedna rewards those who obey the rules, but her anger is terrible when she is offended. Then only the shaman has the power to assuage her fury and persuade her to release the game.

Long ago, the story continues, before there were shamans, before the sun shone, before the

rules of life had been laid down, there was a time of famine and great hardship. No one knew what to do. Then one day a man suddenly decided to retreat behind the skins hanging across the back of his house, saying that he was going to see the Mother of the Sea Beasts to ask her to release the game. He insisted that no one watch him, but after a time the people became curious and looked behind the hangings. What they saw was the man diving down into the earth, with only the soles of his feet still remaining above ground. To explain how he had come to think of this remedy for famine, the man said the spirits had given him instructions. Thus he became the first shaman to travel to the house of the woman on the bottom of the sea, to persuade her to let the game come to the hunters.

Stories of these out-of-body experiences also reveal the shaman as a very special kind of artist, whose creative gifts will help restore balance to a world suddenly gone awry. In myth, the Great Mother's house is like that of the Eskimos on earth. Like them she warms herself by the heat of an oil lamp, and her sleeping platform and all her utensils are like those of human beings. Her fierce dog lies by her side, guarding the land of dead, as Cerberus guards Hades in classical mythology and, indeed, as dogs commonly guard the abode of the dead in funerary and shamanic mythology the world over. To induce her to release the seals and other game in time of want, Eskimo shamans have two techniques. One is to haul her or her father to the surface with a rope and refuse to let them go until they have agreed to forgive the people their trespasses. The other, less coercive but more perilous for the shaman, is for him to make the journey himself. The father is generally conceived as a grouchy old dwarf, so small that when the shaman brings him up through a hole in the floor of the ceremonial house, he can hide beneath his parka. None of the people present can see him, although they may hear his cries, nor may they set eyes on the Mother herself, who is never drawn up higher than just below the level of the floor. Were the shaman to pull her up any higher, she would become so angry that the people would surely starve to death.

When the shaman decides that to appease her anger he himself must go into the depths of the icy sea, he may dive down head first into the floor of the dance house or he may, in his trance, set out in his frail kayak to search for the entrance to the underworld. In one story, a shaman, after thus traveling for a long time, hears a distant crashing sound and, coming closer, sees two gigantic icebergs which, pulsating with a life of their own, clash together again and again. In vain he tries to go around them, for the icebergs move in whatever direction he takes. Finally, realizing that he has no choice but to brave the dangerous passage between them, with a mighty effort he forces his kayak forward into the gaping jaws just as they open, hoping to get through before they close again. Furiously he plunges and paddles and he does reach the other side—but not before the stern of his kayak is caught and crushed between the crashing ice. On the far side he at last sees the entrance to the home of Sedna, Goddess of the Sea.

Among the Iglulik, the shamanic descent most often begins in a house where people gather with the shaman to assist him in his quest. Sometimes the descent is made to cure an individual or to help a family that has had no success in hunting. But when game has become scarce and starvation threatens, an entire village may request the shaman to make the dangerous journey. The onlookers loosen their clothing and footgear and sit with eyes closed. All oil lamps are extinguished. The shaman strips completely and sits breathing deeply. He calls for his spirit helpers, all the while intoning, "The way is made ready for me; the way opens before me." The people answer, "Let it be so." When his spirit helpers arrive, the earth opens and closes again behind his spirit, for he is now in deep trance and his spirit has left his body. He struggles with hidden forces and at last shouts, "Now the way is open!" The people hear his moans as if coming from farther and farther away, and they know that he has begun his journey. Their eyes still closed, they sing songs of encouragement. Sometimes the discarded clothes of the shaman come alive, flying about the room. The people hear sighs and the heavy breathing of those long dead who are the shaman's namesakes. They have come to help, but no one may call them by name lest they at once disappear. With the sighs and moans of the long dead are mingled the sounds of marine animals and the splashing water.

However skillful, an ordinary shaman encounters many dangers in his descent, the most dreaded of them three huge rolling boulders— another version of the clashing icebergs—on the floor of the sea. He must pass between them quickly, threading his way through the narrow opening and closing spaces. Eventually he comes to the stone house of Sedna. Some say it has no roof, so that she may watch the deeds of men above. Before the house stands a wall, which the shaman must knock down with his shoulder. Then he enters the house through a short passage, stepping over her fearsome guardian dog,

who allows him to pass unharmed. Inside the house the angry Sedna sits with her tangled dirty hair hanging loose, so that she cannot see. The foul smoke emanating from the bodies of people who have broken the rules of life has covered her with soot and dirt. When the shaman moves toward her, her father tries to stop him, thinking the shaman to be a dead man come to be punished before he may enter the land of the dead. But the shaman gives a mighty shout, "I am flesh and blood!" and the old man withdraws.

The shaman tries to reason with the goddess, but to no avail. Then he becomes angry, twisting her arm and beating at her with the penis bone of a walrus. Still she will not relent. Now he takes her by the shoulder, turns her toward the lamp, and gently begins to comb the dirt out of her long, matted hair. With all her power over life and death, over the sea animals and the people, the one thing Sedna cannot do is dress her own hair, for she has no fingers, these having become the sea animals. With her hair restored to its proper beauty, perhaps the goddess will now be disposed to listen and to forgive. The shaman informs her, "Those above can no longer help the seals up by grasping their foreflippers"—that is, the people cannot pull the harpooned seals from the water onto the ice. In a secret spirit language that only shamans understand, the Mother of the Sea Beasts tells him that the concealed miscarriages of the women and other violations of the rules of life have barred the way for the animals. The shaman continues to flatter her and to temper her anger and sorrow with poetic incantations as, one by one, he removes the transgressions of the people that have attached themselves to her as spots of soot and filth. Finally appeased, she now takes the animals from her pool and places them on the floor of her house in front of the shaman. A whirlpool rises in the passage, drawing up the water and floating the liberated animals out to sea, where they will once again offer themselves up to the human hunters.

Then the shaman takes his leave and ascends back to the terrestrial dance house, popping up into his physical self like a sea animal, with much puffing and blowing. After a moment of silence, he begins to relate his adventures, dramatically proclaiming to each of them, "I seek, and I strike where nothing is to be found. If there is anything you must say so." All the breaches of taboo are thus uncovered and rectified, and the equilibrium within the community, and between the people and the great Mother of the Sea Beasts, is restored.

# Masks

To act out these great cosmic dramas, shamans in western Alaska, or carvers working under their guidance, created extraordinary composite masks that simultaneously contained a whole range of beings and natural phenomena, with little indication where one ended and another began (Plates 11, 135–139). That, of course, was the idea: such masks embodied the simultaneous existence of various manifestations, not transformation from one to another. Some masks were hinged, concealing a human face behind a door that could be manipulated by the dancer with a string to allow his audience occasional glimpses of the human-like aspect of an animal tutelary or of the game the masked drama was intended to influence. A fine old mask of this type, depicting an otter, is shown in Plate 138. Here the human face within the body of the animal might be that of the shaman himself, having been permitted by his helping spirit to enter its body, perhaps to travel through the watery underworld. Or the face might be the animal's own human-like aspect. Probably it is both, and something else besides, manifesting itself now as one, now as the other, depending on the play of light and shadow, movement, sound, and place in the story.

Along with most other Native Americans, ordinary Eskimos had their personal guardian spirits, usually the spirit of some marine animal—whale, seal, otter, walrus, and the like—or, where hunting focused on the land rather than the sea, one or another land animal or bird. Shamans also had guardian spirits, acquired on some kind of lonely vigil, or vision quest. What differentiated the shaman from the ordinary person in this respect was his repeated acquisition of a whole series of helping spirits who facilitated his out-of-body journeys to other worlds, gave him special knowledge, and assisted in curing, weather prophecy and control, and other typically shamanic pursuits. Some of these spirit helpers he recruited himself, others recruited him, volunteering their services unbidden in a dream or ecstatic trance. There was frequently also a spirit spouse with whom the neophyte shaman had sexual intercourse.

Shamanic tutelaries ranged across the whole Eskimo landscape—birds, land animals, natural phenomena, features of land and sea, marine mammals, fish, crustaceans, supernatural beings, ancestors, and so on. The power of these helpers resided not only in the masks that represented them but also in the numerous amulets of wood,

ivory, metal, skin, or bone that the shaman carried on his person as gifts of the supernaturals or of grateful patients whom he had cured. Many wood and ivory effigies of this kind have been found in archaeological sites or collected from their owners in historic times (Plates 147–149).

The shaman actually had little choice as to the identity of his tutelaries. It was the spirits who selected him, and they almost always appeared in human form (Plates 130–131). During such recruitment even the shaman's family was involved, for none of them could participate in any hunting activity until the process was completed. The reason seems obvious: the shaman never knew which animal or animals would select him, and it would hardly have been wise for his relatives to kill an animal that might have become his tutelary.

Generally, the most important of the shaman's helping spirits was the first one he acquired in his initial ecstatic trance, a profoundly disturbing emotional experience. The candidate's divine election by spirits was usually signalled by their striking him (or her) with a serious illness. This "sickness vocation" is a universal phenomenon in shamanism; it is curable only by a shaman who correctly diagnoses the source of the illness and obtains the patient's consent to his divine election.

Among some Eskimos, the personality of this primary tutelary could not be disclosed without specific permission from the spirit, and this helps to explain why in masked shamanic performances the shaman may direct the action but not handle the masks himself. Sometimes a helping spirit became so fond of the shaman that the shaman was permitted to reveal the spirit's face, not just by opening the door of the mask to the world, allowing the spectators a brief glimpse of the spirit essence within, but by leaving off the concealing door entirely, so that the animal and its human aspect were seen simultaneously—as, for example, in the seal spirit mask shown in Plate 139. Allowing the shaman to reveal the human aspect of a spirit confirmed the tutelary's favor and the closeness of its bond with the shaman. North of the Kuskokwim River, where most of the masks shown here originated, the tutelaries apparently did not mind the shaman's sharing their identities with the people, for here the shaman himself often wore and danced with masks that openly proclaimed the nature of the spirit helpers.

Eskimo masks in general have a timeless quality, not only compelling as simple form but frequently conveying their message through a complex system of symbols in which a small part of something stands for the whole and was so understood by the initiated onlooker. Some early white visitors who were privileged to see such masks in action during shamanic performances took them to be crude and even grotesque. Noting the Eskimo propensity for humor, satire, and horseplay on even the most momentous occasions, they failed to understand that serious rites need not be solemn. Hence arose the misconception that Eskimo masks had no religious significance.

Some masks were danced in pairs to represent "The Good Shaman" and "The Bad Shaman." These were widely interpreted as having no more than entertainment value, when in fact what they acted out was the concept of complementary opposites that runs as a powerful ideological thread through much of Eskimo culture. It is one of these two characters from shamanistic mythology that is portrayed by the powerful Bering Sea mask, probably from King Island, shown in Plate 132; with its bulging forehead, protruding cheeks, widely flaring nostrils, and heavy lips, this is probably the "bad shaman," although the roles of "good" and "bad" are repeatedly reversed in the course of the performance, as they are in the mythology. Comparatively rare in such masks is the hinged lower jaw, attached with a leather thong and copper nails and lined with walrus teeth; the jaw could be manipulated by the wearer to heighten the dramatic effect. In some of these masks the eyes are perforated; here they are ivory disks. The dancer watches his audience and his rival through the large nostrils.

The dance drama of the competing shamans has many versions; in one, the bad shaman annoys the good shaman by transforming himself into a loon who continually emits ear-piercing shrieks while flying over his rival's house. The good shaman projects his spirit to the roof to set up a net trap in which the shaman-bird becomes entangled. He begs for mercy but is set free only at the price of his magic adze, which the victor adds to his own collection of power objects. In another version the bad shaman kills the good shaman, but his spirit, embodied in the mask, feels sorry for his victim and restores him to life. Certainly these masked dramas amused and entertained, but the message was profoundly spiritual.

Another misconception regarding Eskimo masks was that the peculiar construction of composite mobiles, such as those shown in Plates 11, 135–139, with a large central element surrounded by "appendages," was forced on the carver by a shortage of driftwood of sufficient size to allow him to make massive, one-piece masks

containing multiple images like those of Northwest Coast Indians. In fact, driftwood came in all sizes, from fragments to broken tree trunks, so that material shortage could not have been the major motivation for this characteristically Eskimo convention. Another erroneous idea concerns the concentric hoops that encircle many of the masks from the lower Yukon and Kuskokwim rivers. These were at one time thought to be only structural, intended to support appendages of wood or feathers that represented different animals and other phenomena. There was even a theory that the hoops were meant to give the mask a "frame." Actually, they correspond to the much larger hoops that were assembled in the dance house for shamanistic ceremonies and like them stood for the cosmic levels of the Eskimo universe, the realms above and below through which shamans move on their out-of-body travels. Where the rings are multiple the outer ring represented the world above, the inner the earth, the pack ice, the sea, and the underworld. The feather coronas were perhaps first and foremost the celestial realm with its flying spirits, where the shaman received enlightenment and where the great weather forces are located; however, depending on the nature of the spirit represented by the mask and the context in which it was used, the same feathers could have several meanings simultaneously.

Many masks of this type were collected for the U.S. National Museum by Edward W. Nelson, who traveled extensively among the Bering Sea Eskimos in the last quarter of the nineteenth century (Plates 11, 139). There is also one extraordinary integrated group, more than thirty masks in all, that are said to have been dreamed by a single shaman one night on the Kuskokwim River and that were acquired by an Alaskan trader named Twitchell after they had been danced in a great shamanistic drama. Three of these are pictured in Plates 135–137, representing, respectively, Wind Maker Spirit, Raven Spirit, and Walrus Spirit. The whole group was supposed to have been burned after the ceremony, but the participants agreed to let the trader buy the masks on his promise to remove them at once from the area, and after arrangements had been made to replicate them as miniatures and to have these burned in their place. The group was subsequently acquired by George Heye for the Museum of the American Indian in New York City. During World War II, finding itself short of funds, the Museum offered about half of the masks for sale. Their powerful surrealist quality immediately appealed to a group of exiled European artists and scholars associated with the surrealist movement, among them Max Ernst, André Breton, Yves Tanguy, Roberto Matta, Kurt Seligmann, and Enrico Donati, who purchased most of them. Ernst was so inspired that he set about creating an Eskimo-like composite mask himself. Some of the Eskimo masks were subsequently resold, others remained with their new owners or their heirs, but the largest group is still in the Museum of the American Indian.

All these masks were made to perform in complementary pairs, not by themselves. According to a contemporary description, the paired masks were danced or suspended at opposite sides of the ceremonial house, the performers moving toward each other to the rhythmic pounding of the huge, flat ceremonial drums, or placing themselves singly or in groups behind the images floating in mid-air from their suspensions. The complementary duality expressed in much of Eskimo culture was here expressed by color reversal. So, for example, the counterpart of the mask representing Tomalik, the Wind Maker Spirit (Plate 135), was painted white where its mate is dark, and vice versa, the two colors symbolizing winter and summer, respectively. The pair of hands or fins attached to the sides of the mask represent seal or walrus and probably other spirits as well. The slender danglers are the spirits of air bubbles—those that rise in the blowholes of seals in the pack ice, revealing the seals' presence to the hunter poised with his harpoon. This being Wind Maker, it is likely that the white feathers that frame the mask signified not only the celestial realm but perhaps also the gulls and the other seabirds that attend the wind, the foam of whitecaps, and the like.

The relationship of Tomalik, as Wind-Maker, to the most pervasive and powerful of all Eskimo spirits, known as Sila, Spirit of the Air and of the Weather, is unclear. The latter being, sometimes characterized as female but most often as male, is the one supernatural all Eskimos share, with roughly similar attributes from Siberia to Greenland, suggesting that Sila belongs to a very ancient ideological stratum predating the spread of the Eskimos throughout the Arctic some five thousand years ago. Sila—the full name is *Silap inua*, person, or soul, of the air—defies definition except as a mysterious force, sometimes abstract and nonmaterial, sometimes personified, manifesting itself in the behavior of the weather and other natural phenomena. Essentially Sila is the otiose ruler of all nature, and as such he has both a positive and a negative side. All taboos are ultimately associated with Sila, who punishes transgressions through the manipulation of natural phenomena. As a deliberative being Sila is

also subject to manipulation by the shaman, who may compel or persuade him to make the wind blow or, conversely, cause it to subside, or enlist him in curing disease. What sets Sila apart from other Eskimo supernaturals is that there seems to be no mythology accounting for his origin, as there is, for example, in the case of Sedna. In any event, apart from Sila as ruling spirit of air, weather, and all nature, the same word is also applied to a kind of generalized and benign supernatural force that emanates from the animal kingdom and is inherent in certain persons, songs, names, amulets, and other objects. A successful hunter, for example, is thought to possess *sila*, an unsuccessful one not. While this may sound like the Polynesian *mana*, it corresponds more nearly to the widespread Native American concepts of sacred power—the Algonquian *manitou*, for example, *wakan* of the Sioux, or *orenda* of the Iroquois.

Of the other two illustrated masks from the Twitchell group, Great Raven, called Doologiak or Tulugaak (Plate 136), was closely connected to the hunt for whales; the Walrus Spirit, Isanuk (Plate 137), with the chase of other game of the sea. As has been mentioned, the Eskimos shared Great Raven with Northwest Coast Indians and Siberians, as creator-culture hero, transformer, and trickster. It was Raven, for example, who brought up the first land from the sea by spearing it with his long beak, and he, too, who made the first daylight when he stole the sun by tricking his relatives, who had kept it hidden in an inflated bladder. On whaling expeditions, Raven participated by way of his skin, worn over the shoulders like a cape by the *umealiq* at sea, and also by his wife at home. The raven skin, in fact, was one of the *umealiq*'s most powerful magical whaling charms, as well as his badge of office, presumably because it pleased the whale to have his friend Raven present while his spirit gave up his body to the people. In fact, the raven skin was used in every activity related to the whale, up to and including the whale-greeting rite and the distribution of the meat.

There is an obvious contrast between these powerful abstract mobile masks and other Eskimo art that has been the particular concern of Edmund Carpenter, an anthropologist who has studied these images for a quarter century, and Eskimo creativity much longer. Eskimo carvings of animals, he notes, are often so detailed and accurate that it is possible to discern not only the species but often the sub-species depicted—a Red-Throated Loon, for example, as opposed to a Common Loon. Yet when the same artist depicts the world of dreams, of trance, realism is replaced by surrealism and space is structured with the ear rather than the eye. Lines between species and classes, even between human beings and animals, become lines of fusion rather than of distinction, and shapes cease to be fixed. The key, Carpenter thinks, is that Eskimo artists, in prehistoric as well as recent times, often treated diverse characteristics as simultaneous rather than successive, just as shamans have several different tutelary spirits all at once. In this system masks become visual puns. The same lines serve to depict the continuity of, say, walrus-caribou-man, but when the mask is turned this way or that, or touched in different ways by the dim, flickering light of the dance house, now walrus predominates, now caribou, now the person. At the same time, the other forms contained within the total structure never wholly disappear, for all remain relevant.

The monumental whalebone polar bear in Plates 130 and 131 is not a mask, yet it does provide a good illustration of what at first sight seems to be only playful visual punning, but which really reveals this deeper ideological structure of simultaneity. The artist has cleverly worked the natural form of the whale vertebra into the image of a powerful polar bear. On the reverse he has carved the bear's human-like spirit. But when one mentally divides the reverse vertically in half, the two sides are suddenly revealed as leaping killer whales; the bear's ears become the dorsal fins of a mammal that, however different in form, is linked to the polar bear by common habits as marine predators whose common favorite food, like that of Eskimos, is seal. What is true of visual art applies as well to the mythology, where again and again the shift from one form to the other is less a matter of transformation than of simultaneity, not of *becoming* but of *being*. And it applies in equal measure to other areas of Eskimo life; there are no formal units to measure space, just as there are no uniform divisions of time, because neither space nor time is static and hence subject to measurement. The same principles extend into language, which does not, like our own, emphasize nouns and often does not even distinguish between noun and verb. As Carpenter has noted, being polysynthetic, the Eskimo language is not composed of separate words chronologically ordered, "but of great, tight conglomerates, like twisted knots, within which concepts are juxtaposed and inseparably fused."

"The carver," says Carpenter, "when he chooses, is indifferent to the demands of the eye: he lets each piece fill its own space, create its own world, without reference to background or

anything external to it. Each carving lives within spatial independence. Size and shape, proportions and selection, these are set by the object itself, not forced from without.

"Like sound, each mask creates its own space, its own identity; it makes its own assumption."

Plate 132. The constant interplay and ultimate complementary balance between negative and positive forces were the real meaning behind the popular Eskimo dance drama of the "good shaman and bad shaman." In story, movement, and the play of masks like this one, from King Island, Alaska, the paired dancers played out their magic arts against each other, first one emerging as victor, then the other. If one was "killed," his adversary brought him back to life, only to forfeit his own life temporarily to the other, until both were in balance. Thus, while the play was nominally secular, performed to amuse, it also expressed some profound moral principles that governed the spiritual universe of the Eskimos. (12½" high. 1900–10. Private Collection.)

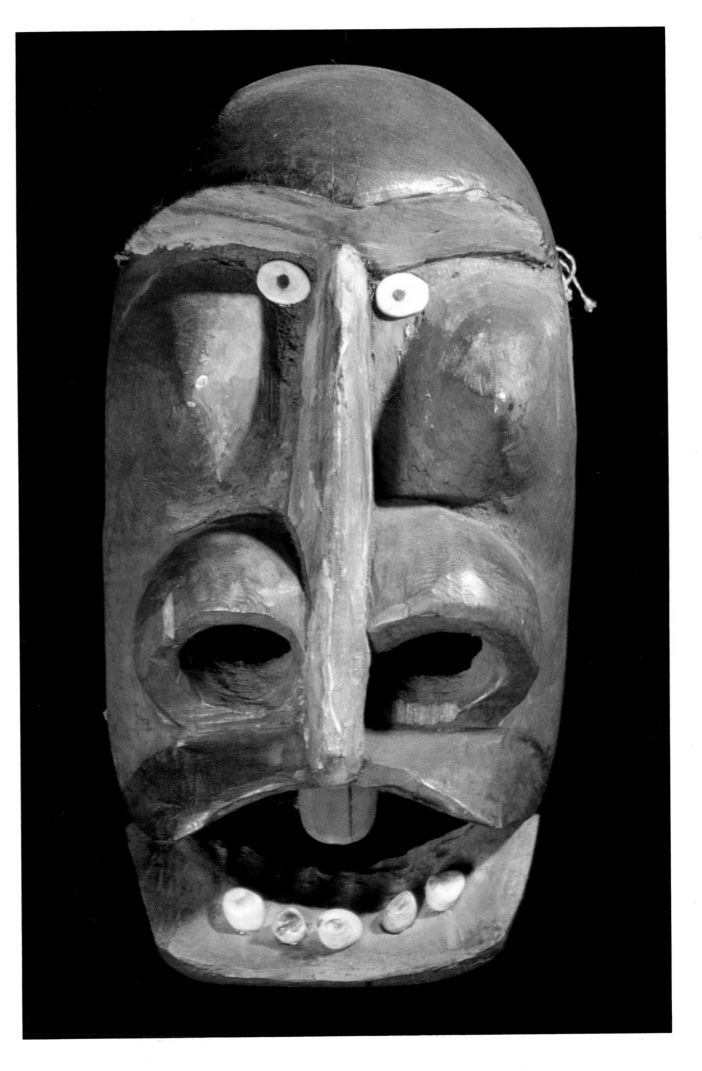

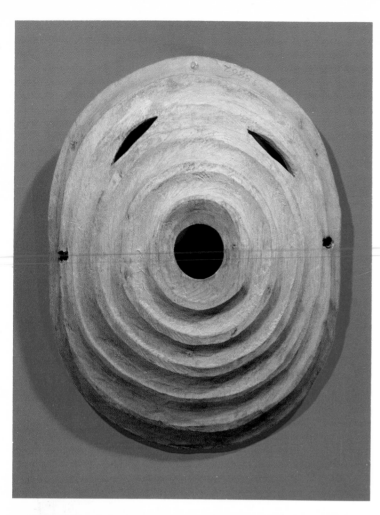

Plate 133. The ultimate in elegant abstraction, this face mask, collected in 1879 on the lower Yukon, evokes the image of a bubble in the sea or of the concentric rings that ripple outward when a stone is flung into the water. To the Eskimos these phenomena are alive and contain a spirit. In fact, however, the mask represents one of the tunghak, powerful spirits that control the supply of game. The tunghak reside on the moon, where shamans visit them in out-of-body trance journeys to plead for their favor. (8¼" high. Smithsonian Institution.)

Plate 134. Miniature masks that could be made to dance with the fingers were used by Eskimo women in ceremonial dances, frequently in matched pairs like these male and female ones. By Eskimo convention, the downturned mouth identifies the finger maskette at left as female, the upturned mouth at right being male. Reflecting the complementarity of the sexes in life, each of these little faces is matched on the other side by its opposite. Thus the downturned female mouth of the rear mask is visible through the upturned male mouth at right. Made at Kuskokwim River, Alaska, about 1880. (4¾" high. Private Collection.)

Plate 135 (opposite). This countenance of the potent spirit Tomalik, Windmaker, was one of more than thirty paired masks dreamed by a Napaskiagmut Eskimo shaman from the Kuskokwim River and used in a single great shamanistic dance drama around the turn of the century (see also Plates 136 & 137). The paired tubes represent the blowing of the winds of winter and summer, respectively; the slender danglers at the bottom represent the spirits of air bubbles rising from submerged seals; and the concentric rings symbolize the different levels of the Eskimo universe. (41" high. Private Collection.)

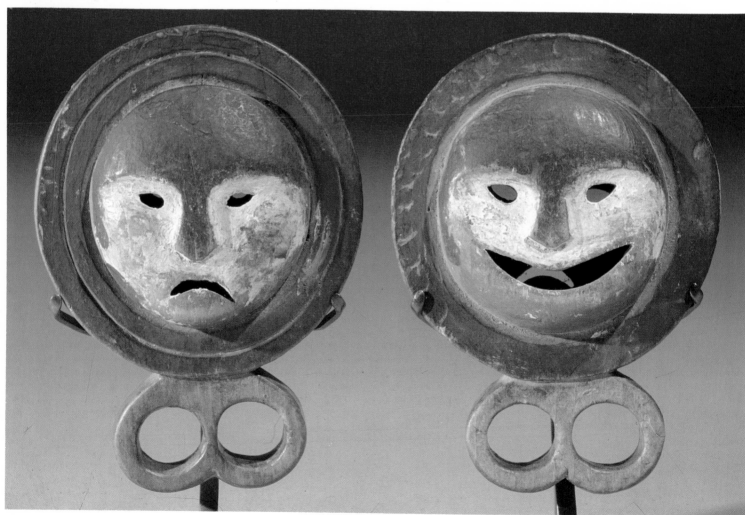

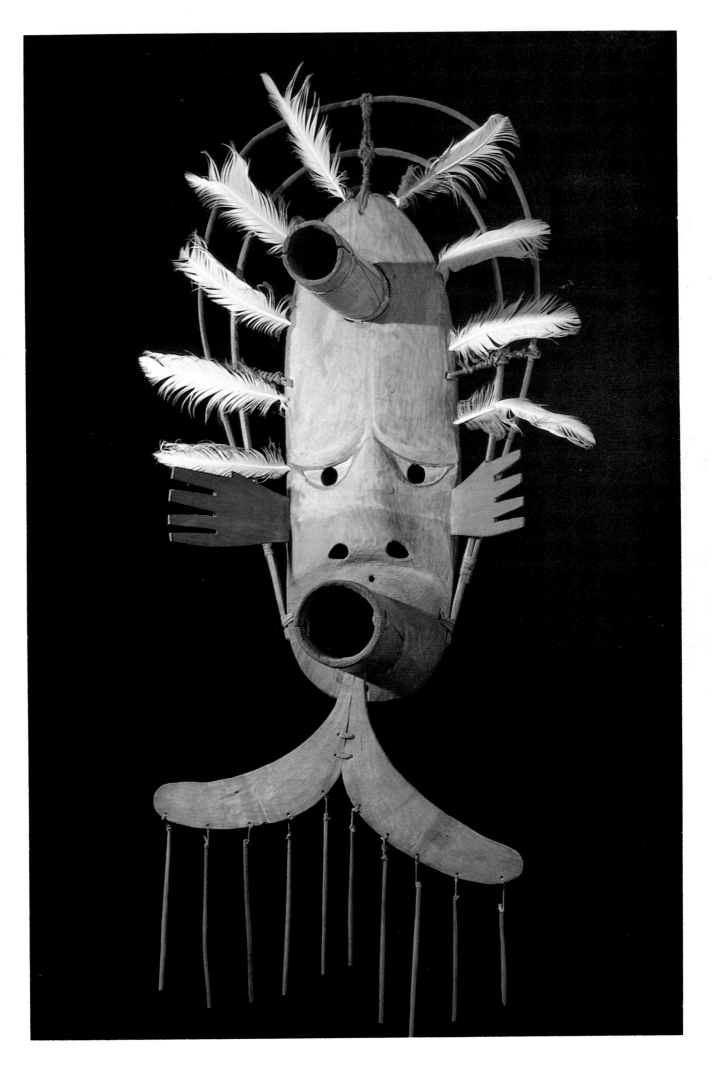

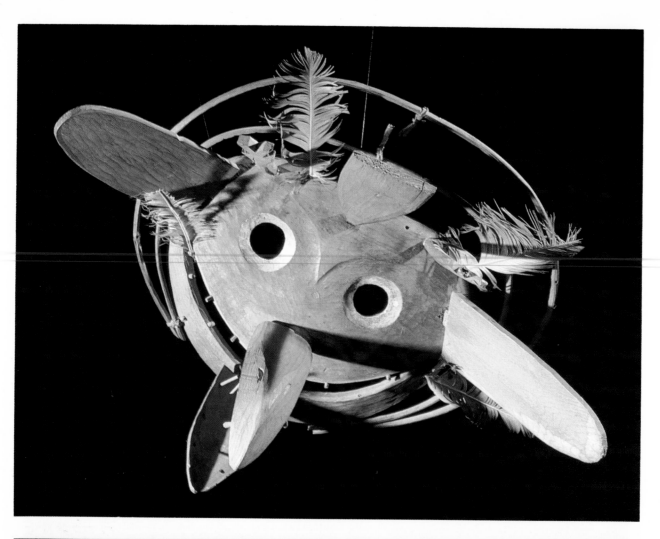

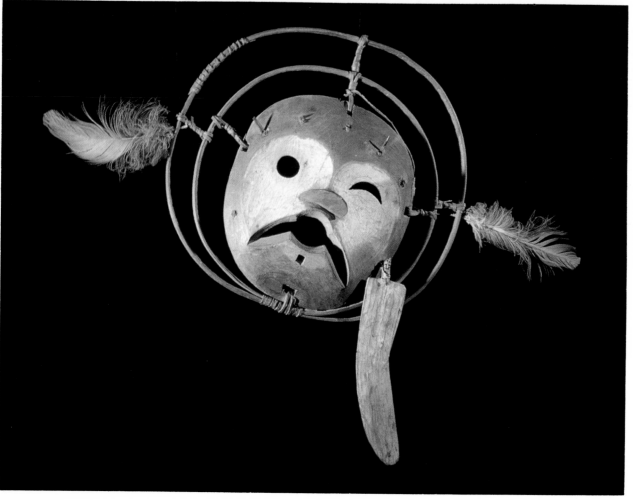

Plates 136 & 137 (opposite). The two masks, Doologiak, Big Raven (top), and the Walrus Spirit Isanuk, appeared to a shaman in a dream and were used in its re-enactment, a great propitiatory ceremony for the spirits that control the supply of game. The Eskimos shared Big Raven with their Tlingit neighbors in Alaska, with their own Eskimo cousins in Siberia, and with other Siberian peoples, as a creator-culture hero who had his slightly ridiculous side as trickster and buffoon. But Raven was also connected with the whale hunt, and it was probably in this capacity as friend and guardian of both whales and whalers that he participated in the shaman's dream. Walrus Spirit guided walrus and other sea mammals toward the hunters when pleased with their behavior or withheld them if offended. Both masks are Napaskiagmut Eskimo, from the Kuskokwim River. (Top, 23" wide; bottom, 26" wide. Private Collection.)

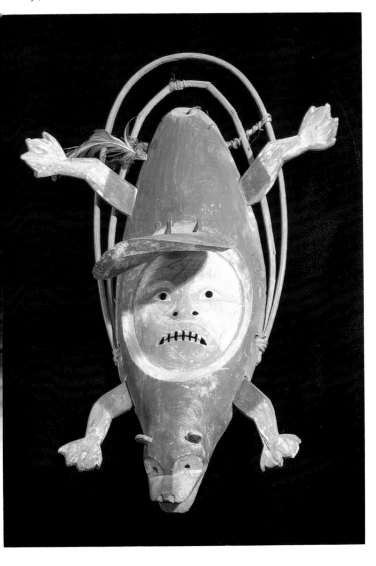

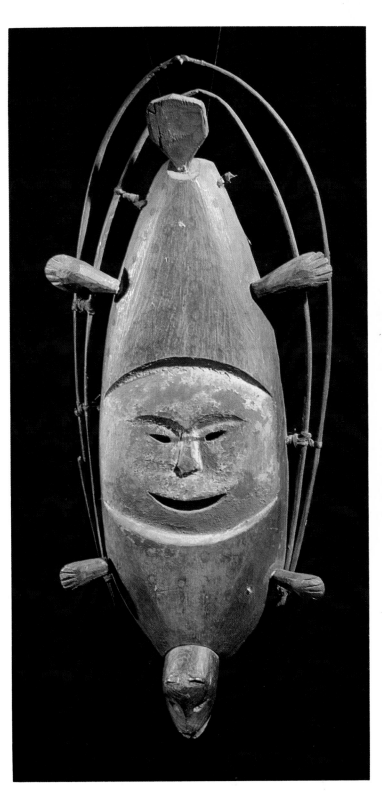

Plates 138 & 139. Some masks, like that of the otter, left, had hinged doors which the wearer flipped open to allow the audience brief glimpses of the spirit's human countenance. Others, like the seal mask, right, openly displayed their spirit image. These masks might be worn or held before the face or fixed in space in the dance house, the performers appearing behind first one, then another, in instant metamorphosis. (Left, 20½" high; right, 14½" high. Kuskokwim River, Alaska. Private Collections.)

Plates 140 & 141. Eskimos first learned of tobacco and smoking from Russian and Siberian Chukchi traders in the late eighteenth century, and their pipes continued to reflect this early contact throughout the nineteenth century. The all-lead pipe with inlay work (bottom) is typically Chinese-Siberian in form; Eskimos made such pipes for domestic use from wood or metal or both. The beautifully carved and engraved ivory effigy pipe (top), representing a walrus floating on its back with a female or baby on its stomach, also derives its basic shape from Asia; such elaborately decorated pipes were usually made for sale. Both date from the last quarter of the nineteenth century. (Top, 9¾" long. Private Collection. Bottom, 9¾" long. Peabody Museum of Natural History, Yale University.)

Plates 142–145 (opposite). Both sides of the walrus ivory pipestem, a form adopted by the Eskimos from the Siberian Chukchi, are unusually rich in ethnographic detail. Engravings are in the early pictorial style (Plate 154) that survived virtually unchanged from the thirteenth century to the late nineteenth century, when it gave way to greater realism. Both panels include mythological beings and scenes and masked shamanistic dancers, on one side in association with hunting activities at sea, on the other on land. These were two-piece pipes, with small detachable bowls of ivory or metal that allowed only a pinch of the precious trade tobacco to be smoked at any one time. (14" long. Ca. 1850. Private Collection.)

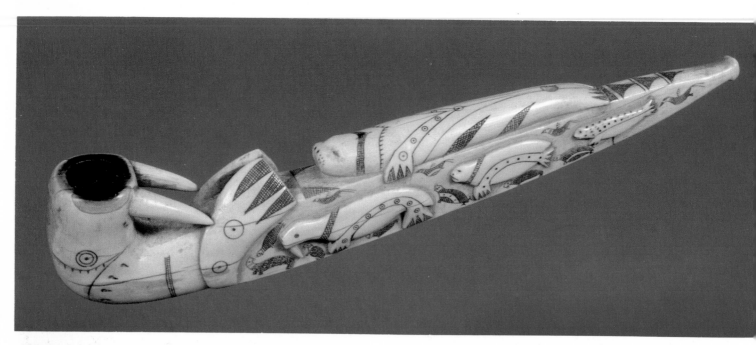

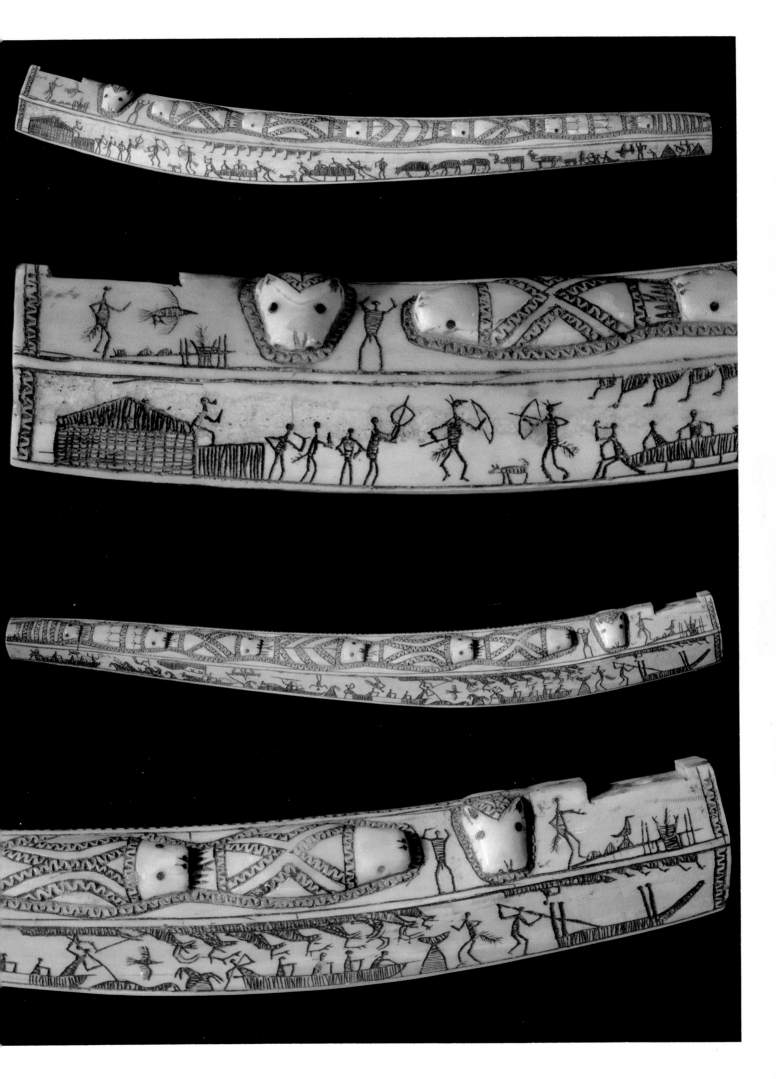

155

Plate 146. An ivory magic charm shows a tiny Eskimo
shaman propitiating a walrus, to thank its spirit for its
bounty or to seek its favor for the coming season. It was

carved six or seven centuries ago and comes from the
Punuk culture of the Bering Sea. (Left, ¾" high; right, 1¼"
high. Holbrook Gallery, Santa Fe.)

157

Plates 147 & 148. In its elegant abstraction, the armless and featureless shaman's amulet of fossilized ivory below left, from the Thule culture of the Bering Sea, evokes some of the schematized Upper Paleolithic "Mother Goddess" effigies found in central Europe. The Eskimo amulet may, in fact, represent a mother goddess or the supernatural mistresses of game generically. Like the more naturalistic rendering of a woman below right, from Shishmareff, a shaman's "doll" carved of wood, it dates to about the eleventh or twelfth century A.D. (Left, 2¾" high. Peabody Museum of Natural History, Yale University. Right, 10¼" high. Private Collection.)

Plate 149 (opposite). Much shamanic ideology is encompossed in this nineteenth-century amulet from the Pribiloff Islands: transformation, simultaneity of forms sharing the same vital essence, flight, descent, and the shaman's X-ray vision, which allows him to contemplate his own bones. Dominant is the shaman himself in ascending flight, arms outstretched like wings. He merges with Seal, whose back is splayed to reveal the bones. The interior is painted with vermilion to symbolize the vital essence, the "lifeline" the animal shares with its human counterpart. Upside down, the figure becomes bird-seal-man in descent. (5¾" high. Peabody Museum of Natural History, Yale University.)

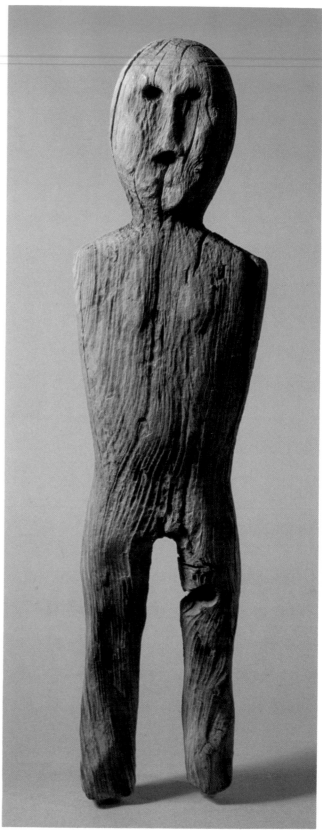

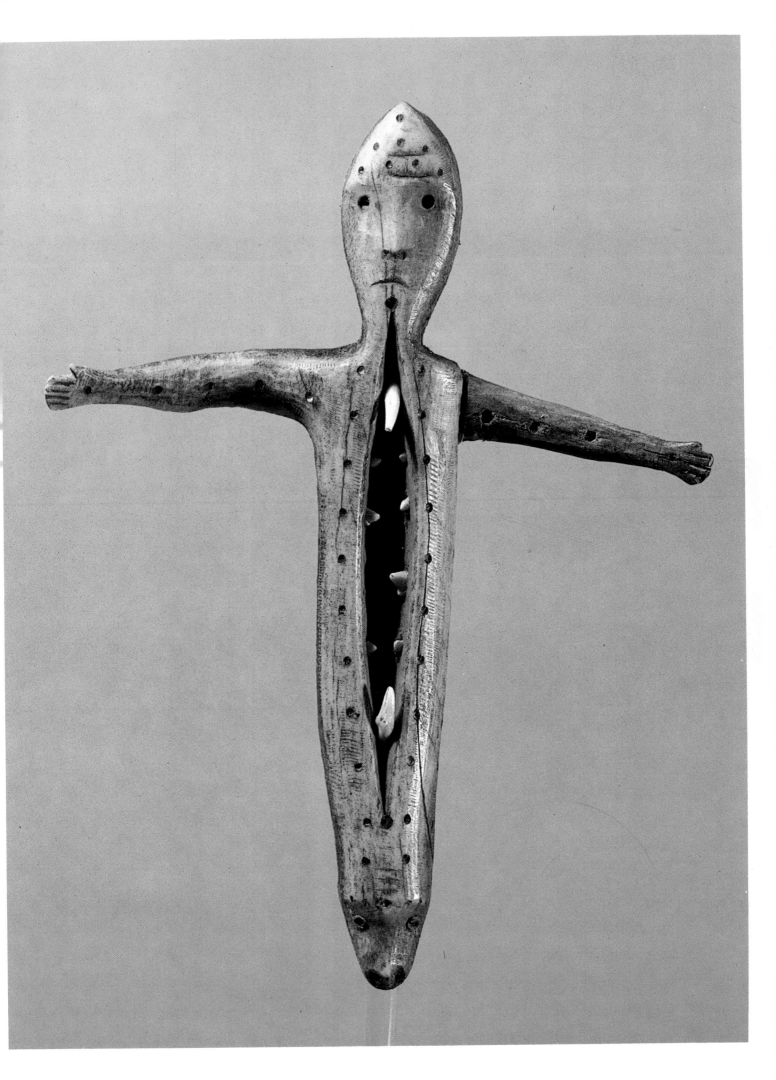

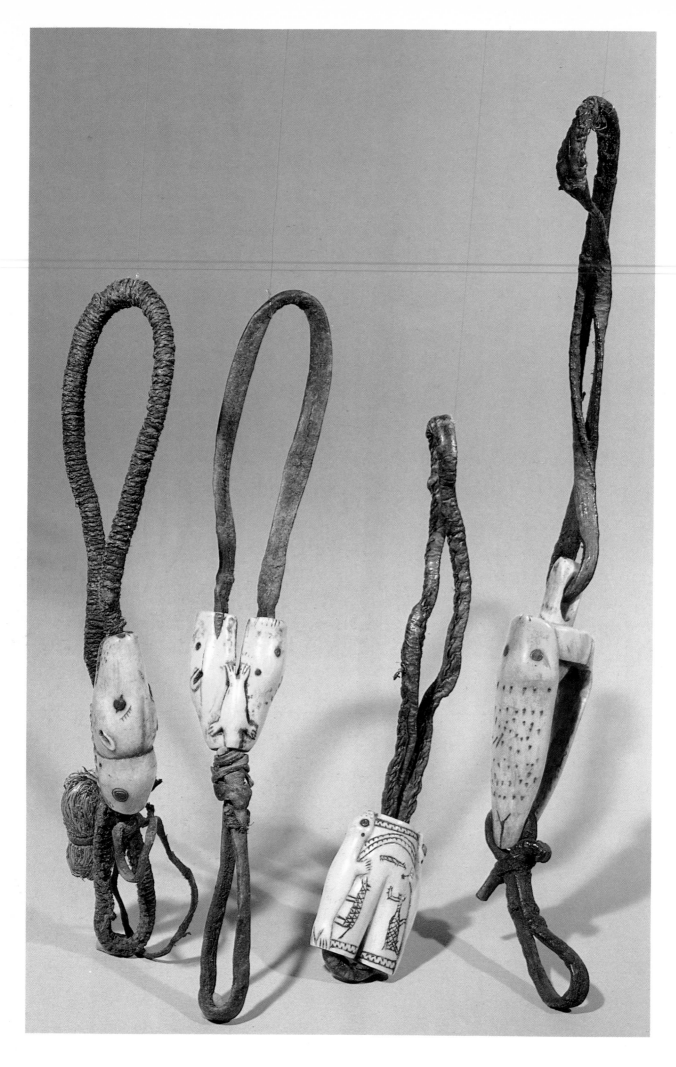

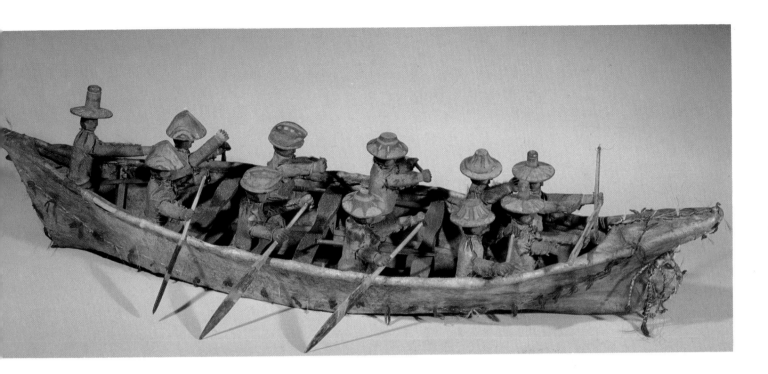

Plate 151. A nineteenth-century model of an umiak, the large walrus-skin-covered boats used for communal travel and for whaling, from Kodiak Island. Umiaks were also called "women's boats," as opposed to kayaks, because women not only played the major role in preparing and sewing the skins and covering the frame but also traveled in them. Women were also crucial to the solemn ritual preparation of the umiak for the whaling season and for the ceremonial greeting and thanksgiving for the catch and its distribution. The walrus hides were tough and long-lasting, but had to be changed frequently for reasons other than practicality: for example, whales did not like to be hunted from umiaks covered with skins used in a previous season. (21" long. Lowie Museum of Anthropology, University of California at Berkeley.)

Plate 150 (opposite). Like the Eskimos themselves, polar bears live largely on seals, which explains why this great Arctic beast of prey and its quarry were favorite subjects for representation on devices connected with hunting and transporting seals; they were intended to gain the favor of the animals and good luck in hunting as much as they were practical tools. Ivory carvings such as these, decorated with bears, seals, and other Arctic game, functioned as seal dragline handles; others, as swivels and separators that kept dog-sled harness lines from entangling. (Left to right, 2¼", 1½", 1⅞", 4" high. Lowie Museum of Anthropology, University of California at Berkeley.)

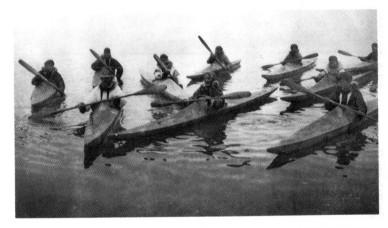

Plates 152 & 153. With the lightweight and supremely efficient kayak now universal throughout the world, few people remember that it was Eskimo genius that invented and perfected these skin boats centuries ago for the pursuit of seal. When Curtis visited and photographed the King Islanders in 1928, outboard motors and other modern technology had only just begun to make radical inroads into the traditional methods of hunting and fishing. At the time, the King Island settlement consisted of only 29 box-like stilt houses, built irregularly on seven terraces, the lowest almost 100 feet above the sea.

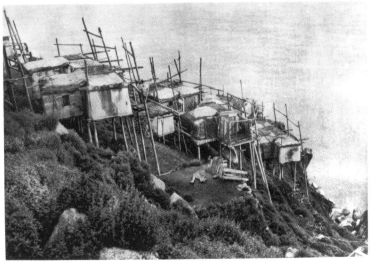

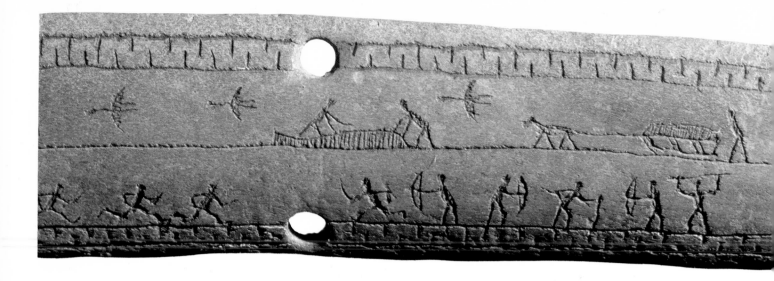

Plates 154 & 156. As in Eskimo myth, so in art the lines between utility and magic, form and function, weapon and quarry, tended to blur and fuse, as they do in the stream-lined fishing tool below, carved a thousand years ago of fossil mammoth ivory, and the nineteenth-century wooden projectile-point box at right, shaped like a pair of seals streaking through the water. The ivory lure must also have been a powerful charm, if prehistoric Eskimos shared with their nineteenth-century descendents the belief that the prehistoric mammoths that occasionally weather out of the permafrost were underworld monsters that moved from place to place by burrowing, and died instantly when ex-

posed to air. (Below, 11⅞" long. Private Collection. Right, Lowie Museum of Anthropology, University of California, Berkeley.)

Plate 155. Whaling and fighting scenes in the early pictorial engraving style decorate this bone slat from prehistoric bone-slat armor, a fighting gear that the Alaskan Eskimos adopted from Asian prototypes. The engraving shown here in a detail may be as old as the bone slat, which dates to Punuk times, before A.D. 1500, but could also have been added in the eighteenth or early nineteenth century. (6⅝" long. Private Collection.)

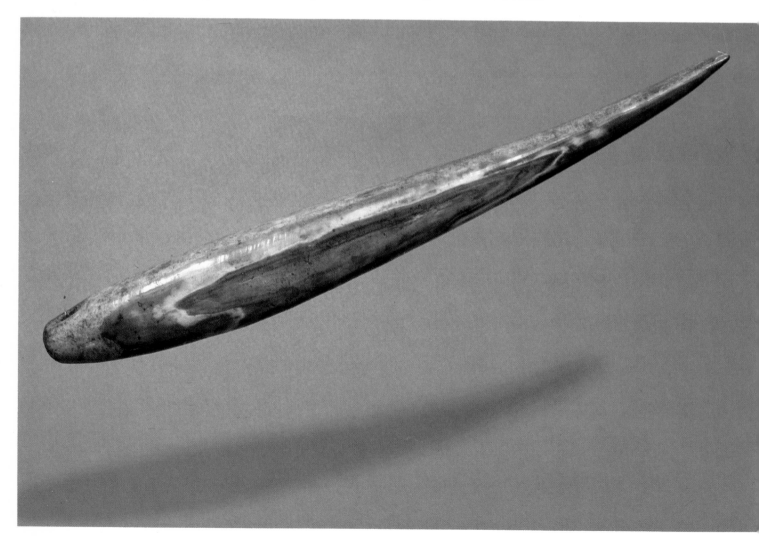

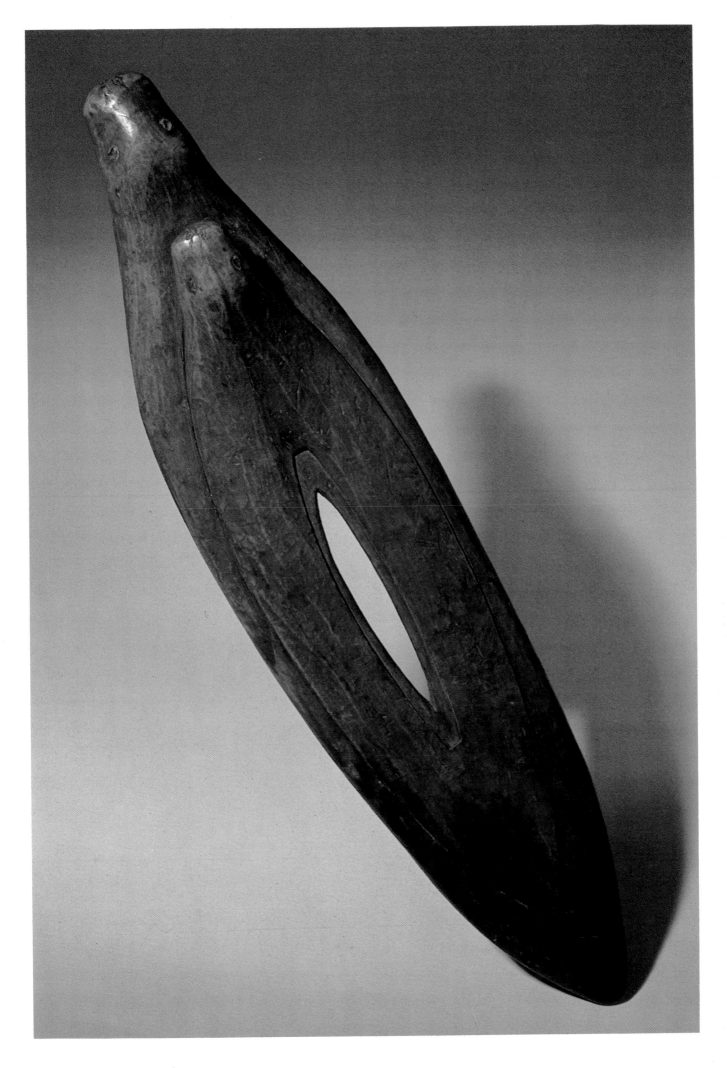

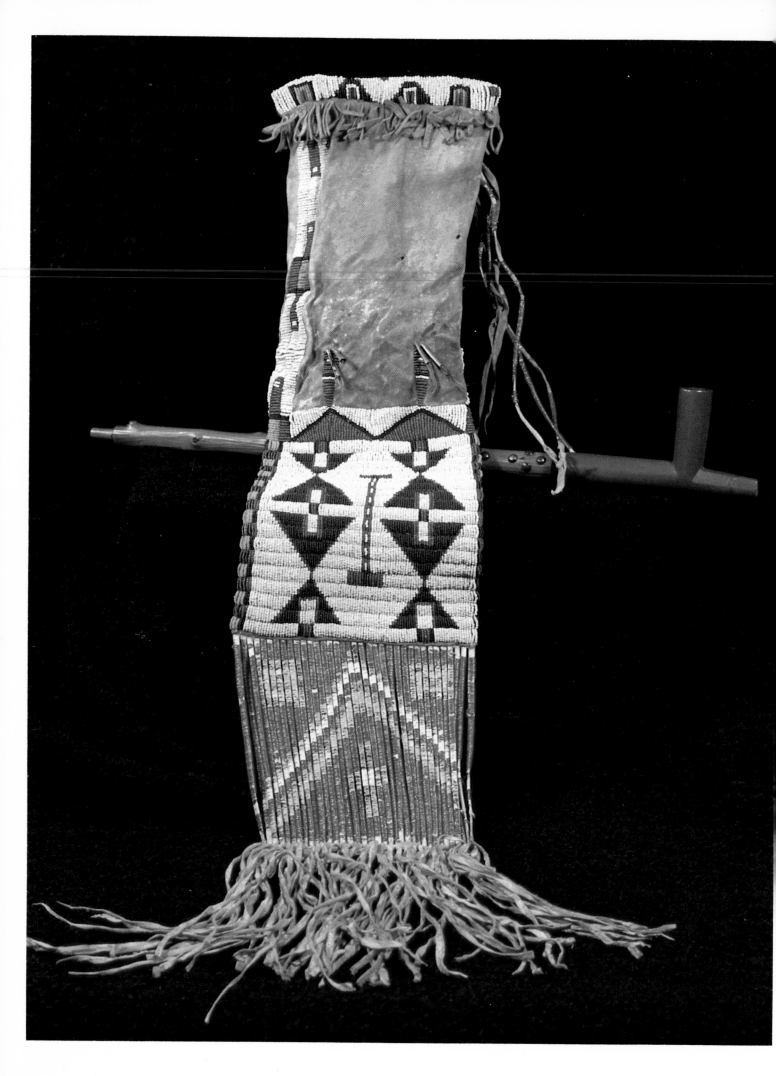

# Arts of the Plains

As everywhere in North America, the arts of the Great Plains were bound up with the social and religious fabric, with ceremony and custom, as necessary to the spiritual survival of the community and the individual as game was to their physical survival. But on the Plains the forms and materials were mandated above all by nomadism, a lifeway which some groups abandoned only in the early nineteenth century and which others adopted at that time, by compulsion or preference. Yet, the same creative impulse and the same close reciprocal relationship with the supernatural that inspired the magnificent three-dimensional art of the Northwest Coast were present throughout Plains culture. Where Kwakiutl or Tsimshian artists had unrestricted access to the majestic cedars for artistic and religious expression on a monumental scale, the Plains artist took his or her pleasure in the miniature and in works that were easily transportable—in a carefully crafted pipe, in small beadwork fetishes, or in paintings and embroidery on soft, pliable leather that could be worn or rolled up at a moment's notice for removal to a safer or more promising locale.

The skins of game were more than just practical, everyday material for clothing and shelter, for they contained some of the spirit power of the animals from which they had been taken. In life, the skin had given the animal its form. Wearing it, or resting in its shelter, symbolized and reinforced the constant and powerful spiritual bond between game and the people whose survival depended on the continued generosity of animals in surrendering their lives. Beautifying a dressed skin not only benefitted its human owner but also

*Plate 157. Typical of the northern Plains, this finely beaded and quilled Cheyenne pipe and tobacco bag reflect the respect and awe with which the ceremonial pipe and tobacco were treated. When not in ceremonial use, pipe bowl and stem were taken apart and stored separately in the bag; only when they were united did the pipe actually become charged with supernatural power. (Pipe, 22½" long. Bag, 35" long. Ca. 1870. Arrowsmith Collection.)*

did honor to the spirit of the animal. Art was part of the customary, indeed obligatory, propitiation of the slain animal to obtain its good will and prevent its wrath and revenge.

## Women's Arts

Skins were decorated according to tribal tradition, with painted designs or with quill or beadwork embroidery. While men usually executed the naturalistic figures or life forms, women elaborated abstraction to one of the major art forms on the Plains, particularly in the geometric polychrome decoration of parfleches, the all-purpose rawhide containers used by many peoples of the Plains, Prairie, Plateau and even Woodlands to store and transport food, clothing, and other belongings (Plate 162). In embroidery, Plains women attained unparalleled skill and aesthetic sensibility, and their arts embraced the many articles of buckskin, including clothing, saddles, umbilical fetishes, covers and bags for cradles, shields, pipes, tipis, and the sacred personal or communal medicine bundles containing objects charged with spirit power. For clothing, the dressed hides of elk, deer, mountain or bighorn sheep, and pronghorn antelopes were preferred. The buffalo was esteemed above all other animals, and none of its massive body was wasted. It furnished warm robes and blankets, with the hair left on and the inside carefully dressed and often embellished with painted designs (Plate 177). Moccasins were made with both soft and hard soles, the former used more in the north, the latter in the central and southern Plains (Plate 161). Almost every available surface was more or less elaborately beautified with symbolic designs, and every ornament bore a message, although many of their meanings have been forgotten or were never recorded by the whites.

Colorful embroidery, first with porcupine quills and later with glass beads, is the hallmark

of Plains Indians arts. In the eighteenth century, and presumably before, embroidery was done mainly with porcupine quills dyed with vegetable and mineral colors, and it was of primary importance among the northern Plains peoples. The armored rodent that furnished the material was native to the northern and eastern Woodlands, where the quill embroidery probably originated, gradually spreading into the central Plains. There its popularity for clothing and other leather articles, and for embellishing the wooden stems of sacred smoking pipes, stimulated a lively long-distance trade in the unworked bristles. The quills are about three or four inches in length, with the longest growing along the animal's tail and the shortest on its underside. The natural color is white shading into brown toward the tip. The women first sorted the quills, then dyed them and softened them with spittle. The quills were flattened with the thumbnail or a piece of bone and sewn onto a leather surface with a needle, neither puncturing the material, as in true embroidery, nor held in place from the underside with a sinew or thread. The technique was thus properly appliqué work. To provide a continuous length to cover large areas, the women spliced or tied the quills, and so skilled were the artisans that these splices are rarely obvious. The finished work instead looks as if it had been done with a long, unbroken skein (Plates 157 & 169).

In the course of the nineteenth century beadwork more and more supplanted quills. Nevertheless, the older technique never died out altogether, continuing to be made on a reduced scale even today. The striking yellow and orange quillwork ornament with pendant eagle feathers and beaded strips at either end illustrated in Plate 169 is a good example of the tasteful combination of older and newer techniques, as are the beaded and quilled pipe bags (Plate 157).

On the upper Mississippi and Missouri rivers the Indians preferred the small beads of colored Venetian glass, sometimes called "pony beads," first introduced by French traders into the Great Lakes region in the eighteenth century as gifts of amity and as currency for the purchase of furs. So highly did the Indians esteem these beads that a few strands might pay for a beaver pelt. The Europeans also introduced cloth, metal buttons, and other manufactured bric-a-brac which Native American women soon added to their own decorative inventory. Quite early in the first days of sustained Indian-white contact on the Plains, white clothing had its effect on Indian dress, as is evident in the Berlin Museum's finely tanned Dakota coat (Plates 164–165), dated about 1825, whose cut was inspired by the uniform frock

coats worn by American officers of the period. The decoration, however, with scalp locks, horsehair, beadwork, and pictographs, is characteristically Native American, as are the open sleeves.

By the mid-nineteenth century, pony beads were supplanted in popularity by the even smaller "seed beads," mostly imported from Venice and Bohemia (now Czechoslovakia). Around 1870, a buffalo robe was worth 80 eight-inch-long strings of seed beads, divided into hanks of ten strings each. With the seed beads came a change in the style of beadwork: whereas pony beads had been sparingly employed, especially in the Great Lakes area, allover beadwork now appeared covering entire surfaces. On the Plains, at least, the first articles of clothing so embellished appear to have been moccasins.

A tour de force of beadwork, and perhaps the greatest single garment of its kind, is the beaded buckskin dress in the Smithsonian Institution, illustrated in Plate 166. It was made about 1890, with over-all beading, identical on front and back, right down to the fringes, and it weighs more than seven pounds. The dress was acquired by the Smithsonian in a bequest, with little more documentation than that it came from western Dakota, probably from the Fort Peck Reservation. In February, 1948, a Sioux from Fort Peck visited the Smithsonian because he had heard from earlier Indian visitors that a dress that might once have been his mother's was on exhibit there. The dress, it turned out, had indeed been made by his mother, Mrs. Minnie Sky Arrow, a graduate of the Indian boarding school at Carlisle, Pennsylvania, and an accomplished concert pianist. Mrs. Sky Arrow, the son told curator John Ewers, had worn the dress as her formal concert gown in recitals around the country at the turn of the century, and an old photograph of her wearing it was still in his possession. Its considerable weight could hardly have made it comfortable to wear while performing in concert, but it would have left her audiences in no doubt of her Indian pride or of her traditional skills.

Typically, in former times at least, as much care and artistry were lavished on articles made for children as for adults. This is evident especially in children's clothing (Plates 160, 163, 167) and in infant carriers (Plates 170–172). Basically similar in form all over North America, cradleboards were most splendid on the Plains. It was customary for the prospective mother's female relatives to set to work and decorate them, formerly with quillwork and later with beads, before a baby was due. If the new mother was from a large family, her offspring might receive several

such gifts. They provided not only physical security but also power to ward off dangers from supernatural sources through their protective symbols.

Despite marked group preferences for particular background colors or design motifs, it is not always possible to ascribe a given object to a particular nation, at least not without reliable documentation, inasmuch as there was always a great deal of borrowing and exchanging among groups. Even documentation dating from the time of acquisition may not identify who made the object in the first place. Still, there are recognizable differences in style in the work of the various Plains nations. The Crow, for example, liked massive blocks of elongated triangles, rectangles, and diamonds (Plate 160) as opposed to the fine-line motifs popular with the Sioux (Plates 159, 166). Dark blue, green, and yellow, in juxtaposition with light blue and lavender, were popular colors among the Crow, who rarely used red. The Sioux also used triangles, terraces, crosses, and rectangles, as well as hourglass forms, but more spread out than the Crow and in lighter colors, usually white, blues, yellows, and greens.

The ready adoption of glass beads almost everywhere in North America, and especially in the Upper Great Lakes and on the Plains, was motivated in part by considerations of practicality and aesthetics. For one thing, there was a limit to the availability of porcupine quills, and for another, many more designs were possible with the tiny glass beads than with the traditional quills. But perhaps there were subtler considerations as well, arising out of the very high regard in which beads made of shell had been held for centuries before the arrival of their counterparts in glass. It may even be that the artists made a connection between glass beads and quartz crystals, whose icelike translucency and almost spiritual purity universally link them to the spirit power of ancestors, shamans, and the celestial sphere.

# The Warrior as Artist

The male graphic arts on the Plains were overwhelmingly representational, ranging from pictorial calendar histories, or "counts of winter" (Plates 173–175), to the depiction of events from tribal myth and history, memorable battles and hunts, and the content of personal visions. The tendency for women to use a largely geometric style and for men to use a naturalistic one echoes a similar trend in the Southwest. There, geometric decoration on pottery was the province of women and naturalistic painting that of men,

even though the women actually made the pottery.

By far the most spectacular form of graphic art made by men was narrative painting on buffalo hide. Painted robes were worn as personal clothing and were customarily the work of their owners. Stylistic differences within some particularly complex paintings, such as the outer surface of a sacred medicine lodge or its inner liner, suggest the occasional participation of more than one artist in a single work.

The splendid Dakota tipi liner shown in Plate 4, dating between 1820 and 1830, is clearly the work of two different artists, presumably working side by side. More than a hundred elements are included, grouped around a great vertical feathered pipe and executed in two distinct styles. The animals shown are the bison, horses with and without riders, bears, deer, turtles, various large and small predators and rodents, rabbits, and snakes. Winged creatures include cranes, eagles, and dragonflies. In addition to plants and fish there are also paired humans, heavenly bodies, two giant "suns," four-directional and world-quarter symbols, and several supernatural beings. How, or even whether, all these elements are related to one another is impossible to say. At least some symbols seem to form a unit; the pipe, a green star as symbol of the sky, a black bison as symbol of the earth, two snakes, and two sunbursts provide the central focus of the painting. It may represent, among other things, a version of the mythical arrival of the holy pipe among the Dakota, when the mysterious beneficent spirit called White Buffalo Calf Woman, giver of the pipe and the major ceremonies, manifested herself alternately as a black, a red, and a white buffalo cow. One thing seems certain: this magnificent painting was not meant for an ordinary tipi, or even for the eyes of ordinary people. It hung opposite the entrance flap on the interior back wall of a sacred lodge, perhaps the very one that housed the medicine bundle containing the holy pipe that is the painting's focus. The men met in these lodges to prepare for ceremonies and to discuss matters of importance to the society as a whole.

No one knows how long the North American Indians have painted tipi covers and liners or buffalo robes. Those intrepid explorers of the west, Meriwether Lewis and William Clark, were the first to collect a painted robe and to provide a detailed description of its subject matter (Plate 177). This fine old robe was painted with a battle scene by a Mandan warrior almost two centuries ago and is still preserved in the Peabody Museum of Harvard University as one of the earliest sur-

viving examples of the splendid art of narrative Plains painting. Lewis and Clark acquired the robe and other Indian artifacts in 1805 while wintering at Fort Mandan, North Dakota, on the banks of the Missouri, some seven or eight miles below the mouth of the Knife River. That spring, they shipped it back to President Thomas Jefferson with a note that it was a "buffalo robe painted by a Mandan man representing a battle fought about eight years ago [about 1797] by the Sioux and Recaras [Arikara] against the Mandan, Menitarras and Ah-wah-har-ways [Amahawi], Mandans &c on horse back."

The colors of this robe were all of mineral and vegetable origin, as were all colors used by Indian artists before commercial pigments became available to them. Red was made by applying heat to yellow ochre, black came from charcoal, white was ground from white clay or earth, and blue from a blue earth. For green, some Indians extracted a dye from water plants. The range of hues available in nature was considerable, and early travelers reported several shades of yellow as well as of blue, red, and brown in the palette of Plains Indian painters. From the early nineteenth century on, however, Indian artists increasingly turned to manufactured colors, with vermilion especially highly desired.

Robes were usually made from the hide of a buffalo calf or cow, for the hides of adult males were too heavy for wear. In painting, a separate brush was used for each color. Brushes were made by chewing the ends of cottonwood or willow twigs or by tying tufts of antelope hair to the end of a small stick. Another favorite tool was the spongy part of a buffalo legbone, the edge being used to make the finer lines and the side to spread the pigment evenly. The hide was spread flat on the ground and the artist, man or woman, crouched or knelt beside it. The designs were pressed in, not drawn, with a small stick. To set the paint in their characteristically geometric forms, women artists used a sizing or glue made by boiling the scrapings from the inside of the hide. This sizing was applied over the paint, both to fix it and to render it more luminous. It could also serve by itself as an additional color, to set off one form from another. In contrast, men did not use a sizing over their forms. A painted buffalo robe might take anywhere from a half day to two weeks to complete. According to Catlin, the great Mandan chief Mah-to-toh-pa, who was also renowned as a talented painter, labored for two weeks to record his many valorous exploits in a narrative buffalo-robe painting. Notwithstanding such effort, a painted robe seems not to have been worth more than two unpainted ones.

Some paintings on tipis or on dance and war shields (Plates 179–182) arose from personal visions. However, without knowledge of the ecstatic spiritual experience that inspired the artwork, on the vision quest or in a dream, the symbols tell us little of their subjective meaning. In a vision painting, the artist might, for instance, depict a bear, suggesting that this was the animal that offered itself as guardian spirit. But the single figure of a bear, a feather, or a heavenly body might also be a kind of shorthand for a whole range of profound spiritual experiences unknown to anyone but the painter himself. The symbols were intensely personal, painted for personal protection, although they might on occasion be passed on to someone else as a gift. Indeed, the real protective quality of a war shield painted with the symbols of a vision was thought to reside not so much in the tough buffalo hide, shrunk and hardened by heat to twice its original thickness, as in the magic of the designs. When painted on the tipi, of course, these designs exerted their beneficial powers not only on the one who had dreamed them in the first place but also on those who lived with him and those to whom the painted tipi passed by gift or inheritance.

Of all the surviving nineteenth-century vision shields, one of the most beautiful is the Cheyenne shield painted with five thunderbirds, sun, and moon (Plate 182). The shield was Little Rock's, who fell, along with some 150 other Cheyenne men, women, and children, to the guns of the 7th Cavalry in the Washita River massacre of 1868. This was Custer's first important engagement with the Indians, and in commemoration of his victory, he presented Little Rock's shield and scalp as trophies to Detroit's Audubon Society. Thunderbird is also among the symbols on the shield of the famous Oglala Sioux warrior, Crazy Horse (Plate 180).

In recent Plains history, there is one tragic instance when symbols received in an ecstatic private revelation achieved far wider acceptance. In the late nineteenth century, the millenarian Ghost Dance movement, a desperate religious cult, swept up adherents among several Plains peoples who suffered the common fate of ideological and physical displacement when their traditional way of life was destroyed. Painted on fragile cloth and buckskin, the dreamed symbols of the Ghost Dance religion were freely shared among members and were believed to be so potent as to give them immunity to the bullets of the white cavalry. They were also meant to prepare the adherents for the Indian millennium, when the Great Spirit would roll up the surface of the earth like a carpet, clearing away the corruption,

sickness, and death brought by the white man and purifying the holy ground for the return of the buffalo and the revival of all the Indian dead. The Great Spirit would recognize his people by their distinctive Ghost Dance shirts and dresses.

The magnificent scalp shirt shown in Plate 158 and the Ghost Dance shirt in Plate 159 belonged to Kicking Bear, chief priest of the Ghost Dance among the Sioux, who had earlier been among the warriors who destroyed Custer. In the fall of 1889, Kicking Bear was among the delegates sent west to Nevada by the Sioux chiefs to learn more of the vision of the Paiute prophet Wovoka, which gave birth to the Ghost Dance religion. The cult spread like wildfire among the dispirited Plains Indians on their reservations, but its end came quickly, in a hail of bullets. On December 15, 1890, the great Sioux medicine man Sitting Bull was killed as soldiers tried to arrest him. Earlier, thousands of Indians, with Kicking Bull among their leaders, had fled from the soldiers into the Badlands of South Dakota. On December 28, he and his people surrendered to a Catholic priest. Only a few hours later, on the morning of December 29, the Ghost Dance dream was finally drowned in the blood of some 340 Hunkpapa Sioux men, women, and children who had assembled at Wounded Knee Creek, on the Pine Ridge Reservation in South Dakota, to perform the trance-like dance for the spirits that had given the religion its name (Plate 176). The white man's guns had, after all, proved more powerful than the dream and its spiritual art.

# Art as Calendar History

Unlike paintings based on dreams or visions, which required explanations to be understood by others, pictorial calendars, or winter counts, were not idiosyncratic memory aids for the keepers of historical records but, rather, a picture-writing system in which the artist-historian initiated others into the meaning of his symbols. A full understanding might be facilitated by an accompanying oral narrative, but others in addition to the keeper could read and interpret the events and place them into their proper historical relationship.

In pictorial calendar art (Plates 173–175), an entire year was conventionally represented by a single symbol or, less often, by a group of associated symbols which stood for some outstanding occurrence. Some years are defined by a dramatic event, such as a battle or an eclipse, but others may record only the death of a single individual. Prominent in winter counts are out-

breaks of smallpox, a terrible scourge that killed millions all over the New World and that deeply affected the peoples of the Plains. The winter count of High Hawk (Plate 196), a chief of the Brulé subtribe of the Teton Dakota, begins in mythological times, in 1540 (Plate 175) and continues in an uninterrupted sequence into the early twentieth century. There is a special poignancy to High Hawk's calendar. It begins with the spiritual experience of the nation in mythical times, the encounter of their ancestors with the beautiful, mystic young White Buffalo Calf Woman. It ends 368 years later with the all too typical Reservation experience of the death, by alcohol poisoning, of one of High Hawk's fellow Brulé, an event the tribal historian considered to be as definitive for the twentieth century as the gift of the holy pipe had been for the sixteenth.

The convulsive end of the free-roaming horse and buffalo culture of the Plains did not spell the end of the traditional art of Plains Indian narrative painting and pictorial record keeping. Some artists turned to painting for sale to whites, partly to feed themselves and their families and partly to fix the past in some more tangible form than oral narrative and memory. The lined pages of hardbound ledger books became especially popular for recording, with pencil, crayons, paints, and inks, the remembered glories as well as the bitter new realities. Constantly on the move, driven from place to place by the white soldiers, the Indians seized upon the ledger book as a convenient and easily portable means of preserving the pictorial records, in a style only slightly modified from its earlier prototypes on hide.

Of the nostalgia-filled sketchbooks that have survived, perhaps none did more to keep alive the splendid picture-writing tradition of the Plains than those of several Indian artists incarcerated at Fort Marion, Florida, in the forbidding old Spanish fortress known as the Castillo San Marcos of St. Augustine. In 1875, some seventy-two Indians from five Plains nations were taken as hostages in leg irons and chains from Fort Sill, Oklahoma. Some had fought against the Army in defense of the rights guaranteed by government treaties; others were rounded up merely because they happened to be available. Among the latter was Howling Wolf (1850–1927), son of the southern Cheyenne Chief Eagle Head.

At Fort Marion, Howling Wolf's early drawings attracted the attention of white sympathizers, but it took nearly a century for the importance of the art of Fort Marion to be widely appreciated and documented. Howling Wolf himself became the subject of a published biography, and many of his drawings have been published in studies of

Plains Indian art from Fort Marion. But in the careful cataloguing of his work and that of his fellow Indian painters, one important sketchbook of seventeen spirited and colorful drawings by Howling Wolf remained unknown until 1981, when it was discovered in the manuscript collection of the New York State Library, which had purchased the drawings in 1911 for the grand sum of $45. (Plates 194–195, 197–198, 201–202, 204–205). Their rediscovery brings to eighty-four the number of known works in public and private collections by this remarkable nineteenth-century Southern Cheyenne artist.

Howling Wolf and the other Fort Marion artists followed and expanded upon the traditional two-dimensional Plains convention of drawing figures in stylized outline and filling the enclosed spaces with flat colors. Profile views were preferred, as they were in the older hide paintings. Howling Wolf employed a black pencil, six crayons, and three inks to draw ceremonial events, everyday life, hunting and fishing, his parents and relatives, and the members of the Bowstring Society, of which he had been dance director, all in their most resplendent regalia. His drawings, which are both strong and more colorful than his limited palette would suggest, stress the dignity of his people. In 1877, after nearly going blind and having his eyesight restored at a Boston hospital through the intervention of white friends of the Indians, he was allowed to return to Oklahoma, still the unreconstructed traditionalist he had been when he arrived at Fort Marion. After the release of the prisoners, the Fort Marion artists became leaders in a new renaissance of Plains Indian painting, nostalgic to be sure, for the old ways were gone, but one that continues to this day in the work of some modern Indian artists.

# The Pipe: Art and Ideology

Plates 186–193 give some idea of the care, technological skill and ingenuity, and highly developed aesthetic sensibility Plains Indians lavished on their pipes. But no object, no matter how splendidly proportioned or complex in iconography, can convey the enormous depth of feeling, ritual and belief, the very conception of the universe and how it came to be, the mutuality and interdependence of the sexes, and, indeed, the whole relationship of human beings to the holy earth and sky, which are embodied in these traditional Native American smoking instruments.

As the painter George Catlin observed during his travels among the Plains Indians in the 1830s, every man was his own pipe sculptor and excelled at the art, nor was any man ever without his private ceremonial pipe. There were other pipes as well that were the common property of all, and the holiest. Illustrated in Plate 192 is an old pipe of truly monumental proportions, with a correspondingly massive stem, dating to the first third of the nineteenth century. The bowl alone measures more than a foot in length and weighs more than three pounds. A pipe of such impractical size and weight must have been considered especially powerful and sacred, a medicine bundle all its own. However, there were even some personal pipes with wooden stems measuring four feet and more. Public or private, all pipes were thought to be charged with supernatural power, and all smoking was ceremonial. The reverence and religious emotion invested in the act and the sacred object are impossible to exaggerate.

Many nineteenth-century Plains pipe bowls were carved of catlinite, the distinctive blood-colored stone quarried since about A.D. 1600 at what is now Pipestone National Monument in southwestern Minnesota (Plate 184). Catlin's name came to be associated with it, not because he was the first white man to visit the site, but because he took samples of the unusual mineral back east for analysis. Presumably the Oto or Iowa had discovered the red mineral in a mile-long vein between layers of hard, pink metamorphosed sandstone, but the Sioux drove the Oto and Iowa southward from the area around A.D. 1700. By the mid-nineteenth century they had made themselves the sole owners of the sacred quarry, compelling other Indians to purchase pipestone from them. Previously the quarry had been considered neutral territory, where anyone might come for pipestone in peace and safety. Catlin was told by a local Sioux that long ago the Great Spirit himself had come to the quarry to carve himself a pipe, and that it was from him that the Dakota learned that the red stone was part of their own flesh. Other legends identify it as the blood of all the dead Indians and all the dead buffalo that had congealed together and petrified as living stone for the sacred pipes.

Making a pipe was no easy task. A hard quartzite overburden eight to ten feet thick had to be broken up and the fragile pipestone, in layers about one foot thick, removed from intervening deposits of shale. The rough pieces of pipestone were cut to the desired size with flint and string sawing. Then the bowl was drawn on the stone and the excess cut away. The Indian artists used wood, antler, flint, and later knives to drill and ream out the bowl and its stem. The bowls were

shaped and polished with flint, quartzite, and sand. Buffalo tallow and other animal fats gave the finished pipe its polish.

Stems were of great importance and in many cases were accorded greater respect than even the finest bowl. They were used by themselves as prayer wands, in dances or ceremonial exchanges. Two main techniques were employed in making a stem. The soft core of ash or some other hard wood might be burned out with a hot wire. In an older technique, the piece of wood was split lengthwise and the two halves hollowed out before being glued back together. Great care was taken to obliterate any sign of the seam. Some older stems, dating from the late eighteenth or early nineteenth century, are themselves works of art (Plate 191). "Puzzle stems" are so called because only the carver knew the precise direction of the narrow pathway for the smoke as it zigzagged from bowl to mouthpiece. The carver first cut the patterns out of the long flat stem, split it, and hollowed out the pathway for the smoke. Elegant spiral stems (Plate 190) also made their first appearance in the repertoire of Plains pipemakers at about this time. Plains Indians used natural spirals when they could, sometimes patiently twisting the stem of a young sapling, but the spiraling stems of pipes were always carved and not the work of nature.

Pipes were not considered to be supernaturally charged or activated until stem and bowl were joined. When the pipe was not in use, bowl and stem were taken apart and stored in a decorated bag, like that in Plate 157. The symbolic charging of a pipe for ritual use was clearly related to the pervasive emphasis on male and female unity. The bowl, its form and nature as a gift from the maternal earth, was female; the stem, with its phallic shape and its relationship to the tree as *axis mundi,* was male. But bowls were carved by men, and women had the responsibility of decorating the most important and sacred stems. The magnificent long pipe held by the Blackfoot chief in Catlin's painting of 1832 (Plate 185) must have taken months to embellish with porcupine quills and other decoration. Catlin observed that the wife of a Cheyenne chief whom he painted had spent more than a year dressing her husband's ceremonial pipe, which was so precious to him that he refused to part with it for any price.

Plains pipes are of two basic types. Tubular pipes are far older, having been used in other parts of North America for thousand of years. Some groups retained the straight smoking tubes. A later form, which also has antecedents in the prehistoric era, is the elbow pipe. In some early examples (Plate 193), a small projection in front

is vestigial, but over time the projection was enlarged until it gave the whole pipe the form of an inverted T. Some western Woodlands Indians around the Great Lakes, the eastern Sioux and the Ojibway among others, carved splendid effigy pipes with the likenesses of humans and animals. Most of those that have survived date to the late eighteenth or early nineteenth century, but their prototypes are also prehistoric.

The idea of embellishing pipe bowls with animals symbolic of the life force penetrated the Great Plains toward the latter half of the nineteenth century, but whereas on early pipes the animal or human effigy generally faces toward the smoker or, when the pipe is offered, mouthpiece first, to the superior powers of earth and sky, in their direction, on later Plains effigy pipes, like those in Plates 187–188, the figures face away from the smoker. The same reversal of position is true of animals carved on pipestems. Plate 186 illustrates an unusually fine example of a type of decorated pipestem that became popular in the 1880s but was based on an earlier prototype. The stem is of the old flat puzzle type, wrapped in dyed quillwork and carved in high relief with the traditional motifs of bighorn sheep, deer, turtle, and buffalo, all important animals in Plains culture. All of them face toward the bowl and away from the smoker, whereas in older examples of this type of effigy stem one or more of the animals look toward the smoker. The difference is significant if, as is the case with other effigy pipes, figures facing the smoker represented guardian spirits. This pipe, however, was presumably made not for personal use by the carver but for sale to a white man, pipecarving being one of the few sources of cash income available to men in the enforced idleness of Reservation life. The pleasure carvers took in elegance of form and in the demonstration of their skills is evident in such delicate sculptures as the lead-inlay catlinite crane bowl illustrated in Plate 187, probably dating around 1880, and in the adaptation of the traditional inverted T-form to represent a bear riding a horse (Plate 188). This is not to suggest that some of the later virtuoso pieces were devoid of religious imagery and meaning, but it is doubtful that Indians would have carved such works for themselves. Pipes meant for personal, religious use continued to follow the traditional, simpler T-form, as they do to this day.

No discussion of the Plains Indian pipe would be complete without attention to the appearance and rapid perfection of sophisticated Native metallurgical techniques to embellish pipe bowls (Plates 187 & 190). Cold hammering of copper

into a variety of ornaments, tools, and weapons had been practiced in prehistoric times, but it was the Europeans who first introduced the Indians to smelting, and to lead, then pewter, brass, and iron. Whatever first gave the Indians the idea of using metal in channeling and inlaying steatite or catlinite pipes with lead, lead alloys, and even pewter, the technique quickly spread in the last half of the eighteenth century and the first decades of the nineteenth century into the western Woodlands and the northern and central Plains.

Metal was used for forged or cast "tomahawk" pipes that combined a small smoking bowl with a hatchet. Most of these were of European manufacture, traded to Indians, who fitted them with perforated wooden handles that served both as pipestems and as hafts for these largely ceremonial, rather than functional, weapons. However, as early as the late seventeenth century, some Indians in both the eastern and midwestern Woodlands had learned the art of smelting ores from the English and French, and some tomahawk pipes of both iron and pewter were actually the work of Native American smiths. During the next century, the midwestern Algonquian Sauk and Fox produced lead ingots from local deposits for trade not only to whites but to other Indians, who used the metal to make bullets for their newly acquired firearms, for the repair of stone pipe bowls, and for channel inlays.

To prepare a stone bowl for metal inlay, the carver cut a channel in the desired pattern, placed the bowl in a mold, and poured in the molten lead or alloy. The mold was removed and the excess metal cut away and polished down to the level of the stone. The fit between metal and catlinite is often so close that no seam is visible. The two materials appear to be fused in the catlinite and lead inlay pipe illustrated in Plate 190, which dates to the early nineteenth century, and also on the crane-effigy pipe of a later date, when lead was used more sparingly (Plate 187).

Some tribes not only used lead as it came out of the ground but experimented with alloys to achieve a greater intensity of color and brightness. The well-smoked old effigy pipe in Plate 193 is particularly interesting in this respect because it represents a blending of Native style and stone-carving technology with new knowledge of the properties of metals. The style of the pipe, with its characteristic flaring bowl, pointed projection, and human figure, was common to several peoples, particularly the Algonquians of the Great Lakes region, in the early 1800s; it probably dates between 1800 and 1830 and may have been the work of a Sauk and Fox in Illinois or

Wisconsin. The seated Indian facing the smoker with his knees drawn up, a common motif in Great Lakes and Plains art, is almost certainly the owner's guardian spirit. One might have expected such a pipe to have been cast at least into its rough shape and then finished by cutting and polishing. Instead it seems to have been entirely carved and drilled from an ingot or metal blank, with the same tools and techniques employed on stone. X-ray analysis shows it to be an imperfect alloy containing 80 percent lead and 20 percent tin. The low ratio of tin to lead, of course, disqualifies the material as pewter, which from the seventeenth century on has been predominantly tin with very little or no lead, as does the absence of antimony, which a white pewterer would have added as a hardening agent.

In other parts of the world, the smith was preeminently cast in the role of priest-magician and transformer. We know nothing of how Indians fit metallurgy into a world view that recognized the bones of Mother Earth in stone. But ore was kindred to stone, and its transformation by fire should have presented no conflict in an ideology of transformation. Still, a Sioux would probably have found a pipe such as this incompatible, for to him the proper and sacred material for sending smoke to the spirits was the red stone that was the petrified lifeblood of his people and of the buffalo. When as a youth the Sioux holy man Lame Deer went on the lonely and terrifying quest for his first vision, it was his red-stone pipe that made the living connection between him and his forefathers and the spirit world, that helped him endure hardship and a terrible fear of the unknown. "As I ran my fingers along its bowl of smooth, red pipestone, red like the blood of my people, I no longer felt scared," he recalled many years later. "That pipe had belonged to my father and to his father before him. It would some day pass to my son and, through him, to my grandchildren. As long as we had the pipe there would be a Sioux nation."

Plate 158. Buckskin war shirt, from the Rosebud Reservation, was the property of Short Bull, a Brulé Sioux chief who fought Custer at the Little Big Horn and later became chief priest of the messianic Ghost Dance religion among the Sioux. (Ca. 1875. Smithsonian Institution.)

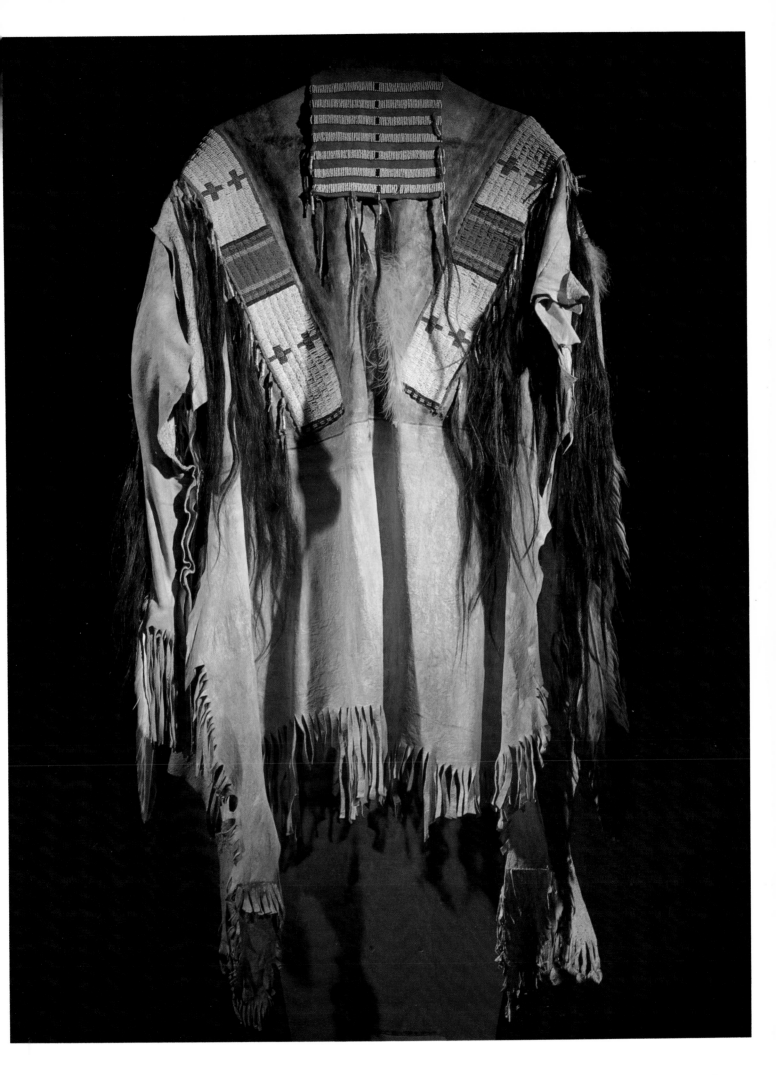

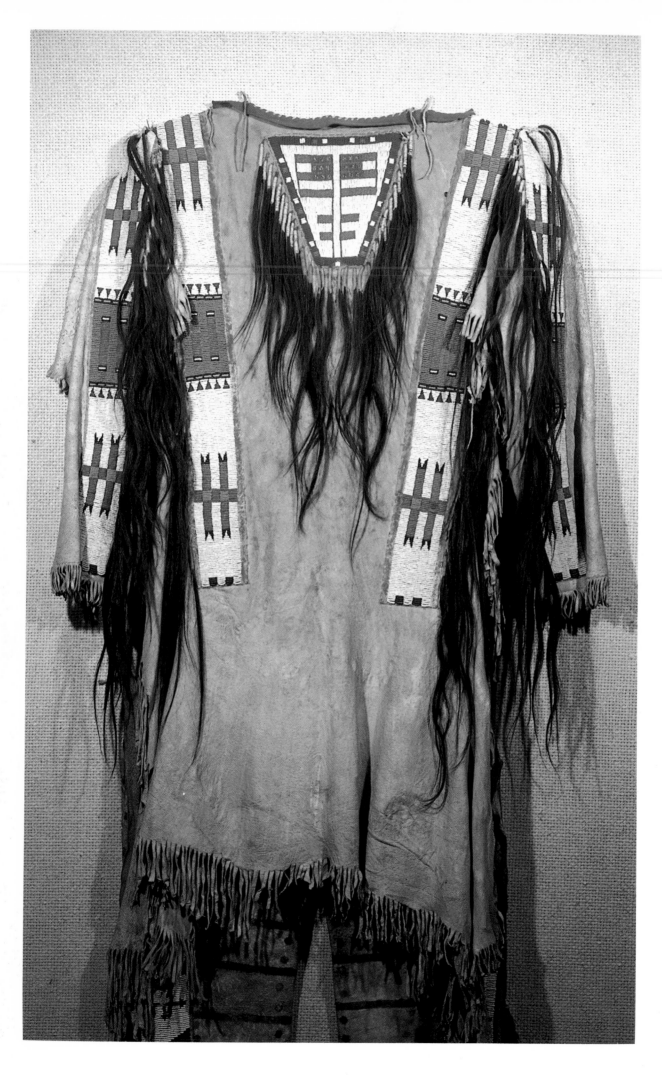

Plate 159 (opposite). The 230 hairlocks that adorn Short Bull's Ghost Dance shirt, including some locks taken from whites, attest to the considerable prowess of this Brulé Sioux chief in war before he gained prominence in the new messianic and millenarian religion. (40" long. Peabody Museum of Natural History, Yale University.)

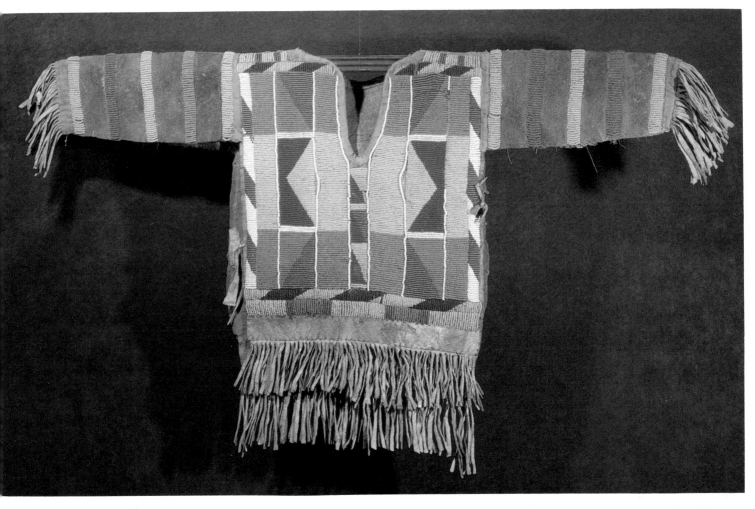

Plate 160. A nineteenth-century Crow boy's shirt, painted and beaded with the insignia of military, civil, or religious society membership. (33" long, 33" wide. Collection William E. Channing.)

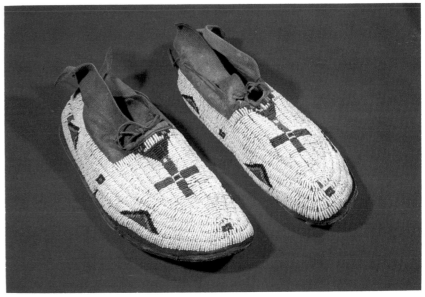

Plate 161. Moccasins with stiff rawhide soles and soft uppers of decorated buckskin, like this beaded Sioux pair, were preferred by most Plain Indians. The tipi-and-cross motif may be related to the syncretistic, pan-Indian peyote religion, which began in Oklahoma around the time of the demise of the Ghost Dance and now numbers more than 225,000 adherents, from the Rio Grande to Canada. (10¾" long. 1890–1900. Private Collection.)

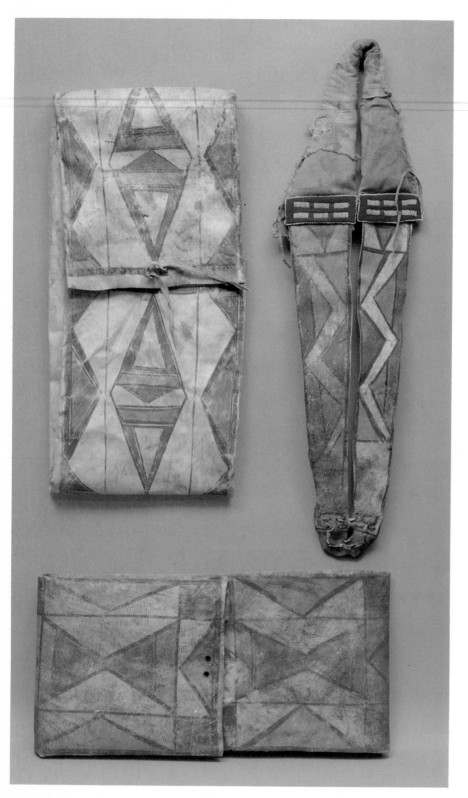

Plate 162. Probably nothing in Plains material culture is more "typical" than the parfleche, the ingenious rectangular, flat envelope of rawhide which women decorated with geometric painting and used to transport dried meat and other articles. The word comes from the French *parer*, to ward off, and *flêche*, arrow, and refers to the ability of stiff buffalo rawhide, from which the hair had been removed by soaking in lye, to withstand the impact of lances and arrows. By its decoration, the parfleche at upper left can be identified as Blackfoot, that at bottom as Crow. The painted Crow tail ornament, or crupper, at right belongs in the same category of rawhide art. The split and decorated rawhide band fit over the horse's rump, between the rider and the horse's tail, which was pulled through the canvas strap at top. (Upper left: 26" long; upper right: 33½" long; bottom: 24" long. Private Collection.)

Plate 163 (opposite). Kiowa child's buckskin dress, with beadwork, elk tooth, and fringe decoration, is in a style introduced to the Plains in the nineteenth century. It replaced earlier garments that draped down in front and back below the armpits, covering the breasts but leaving the shoulders bare. Resembling a poncho or the Mexican Indian huipil, the Kiowa dress consists of two skins sewn together to a yoke-like centerpiece with a neck opening. Sleeves were unnecessary because the wide yoke covered the shoulders and upper arms. Occasionally (among the Apache, for example), the decorated yokes were not attached to the garment itself. The child who wore this dress must have been honored indeed, for elk teeth were costly. The more than 300 teeth used on the front and back of this dress would have had the purchase price of at least three good horses. (32" long. Natural History Museum of Los Angeles County.)

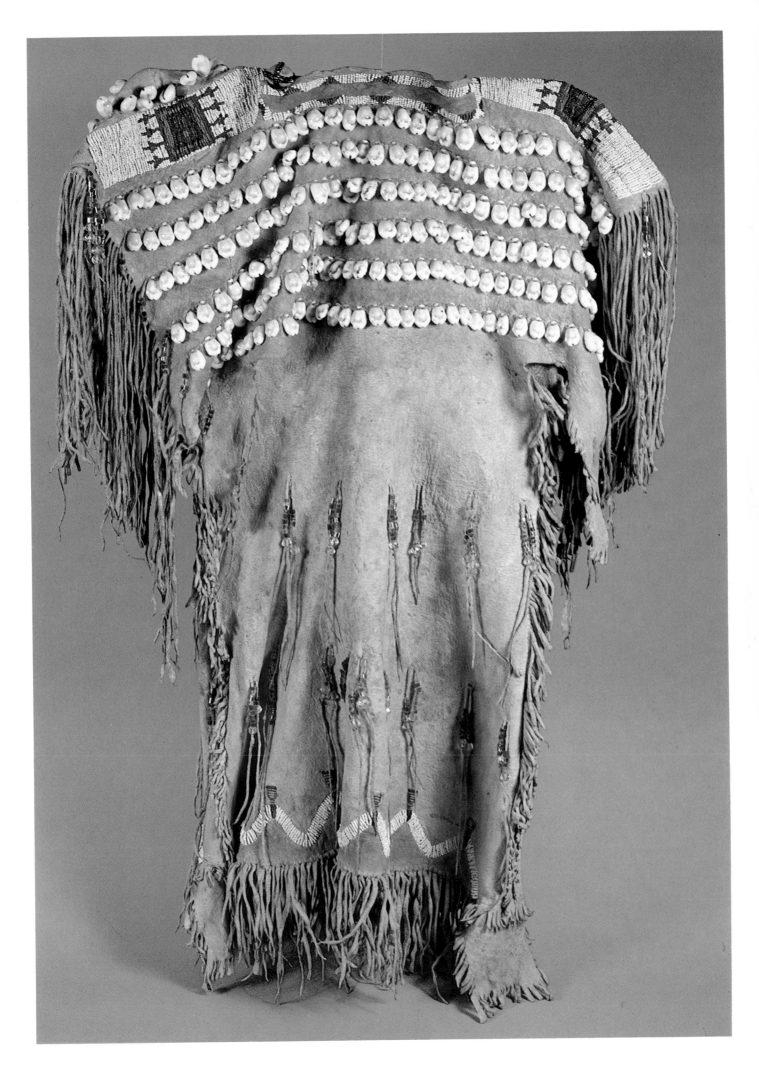

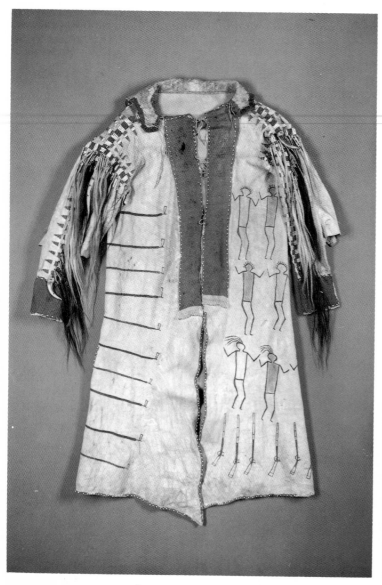

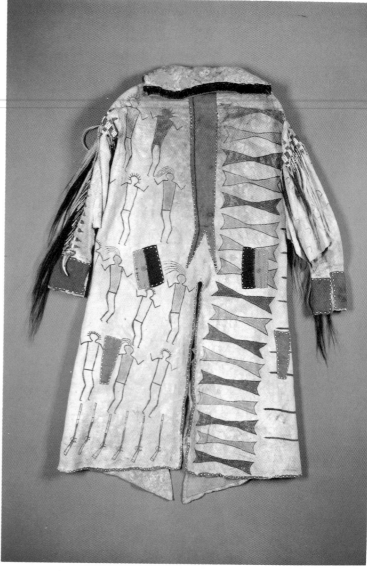

Plates 164 & 165. The German scholar-explorer Maximilian Prince zu Wied, a contemporary of the painter George Catlin, who traveled among the Indians of the Missouri from 1832 to 1834, collected this strikingly autobiographical buckskin coat of a Dakota Sioux warrior. Although its cut is loosely patterned after American Army officers' uniform coats of the time, it is otherwise strictly Indian. Decorated with beadwork embroidery, scalp locks, horsehair, bear claws, and pictographs, it details the owner's exploits in war and generosity in peace. Numerous horse tracks on the sleeves indicate the number of horses captured. Sixteen human figures with raised arms and the rifles on the left side of the coat stand for enemies he has killed in battle; the 10 ceremonial tobacco pipes and 17 horizontal black or red hourglass motifs, for the number of important gifts he has distributed. (50" long. Ca. 1825. Museum für Völkerkunde, Berlin.)

Plate 166 (opposite top). This spectacular buckskin dress, a recital gown made in about 1890 by a Sioux pianist from the Fort Peck Reservation, Mrs. Minnie Sky Arrow, is considered to be the greatest single example of Plains Indian beadwork of its kind. The dress is fully beaded on both sides, and the beadwork alone weighs seven pounds. (Smithsonian Institution.)

Plate 167 (opposite bottom). A Blackfoot made this boy's shirt of tanned buckskin with painted and beaded decoration in Alberta, Canada, about 1870. (35" long. Collection William E. Channing.)

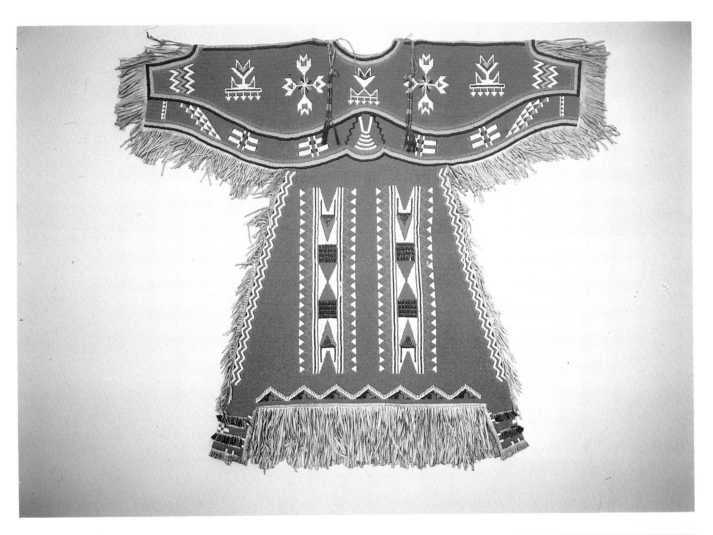

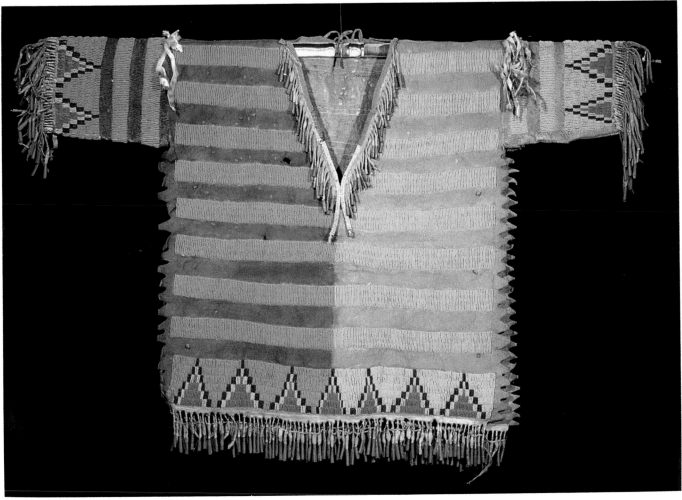

*Plate 168. Pad saddles of elk or moose hide, stuffed with plant materials and embroidered with porcupine quills or beads, were common among a number of eastern and northeastern Plains peoples. This one, from about 1880, is Plains Cree, from Manitoba, Canada, decorated in the typical Woodlands floral style that also spread into the Plains. (17" long. Collection William E. Channing.)*

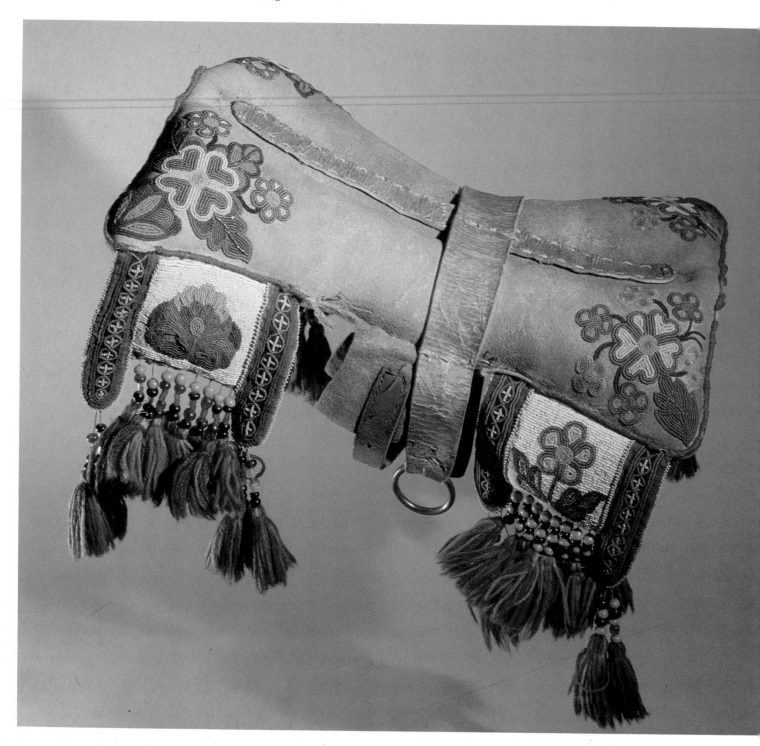

*Plate 169 (opposite). Strikingly decorated with dyed porcupine quills, seed beads, and eagle feathers, this large rawhide medallion once adorned the buffalo robe of Red Cloud, an Oglala Sioux and one of the greatest of the Sioux fighting chiefs. It was his uncompromising leadership of Indian resistance against the Bozeman Trail through Indian hunting grounds along the Powder River to the gold fields in Montana that led to the Army's abandonment of its string·*

*of forts and the 1868 treaty, in which Red Cloud pledged never again to fight the white man. The government, in turn, reserved the Powder River country and the Black Hills "forever" to the Indians. Red Cloud kept his word; the government's "forever" lasted exactly six years. (25" long, 12¼" diameter. Natural History Museum of Los Angeles County.)*

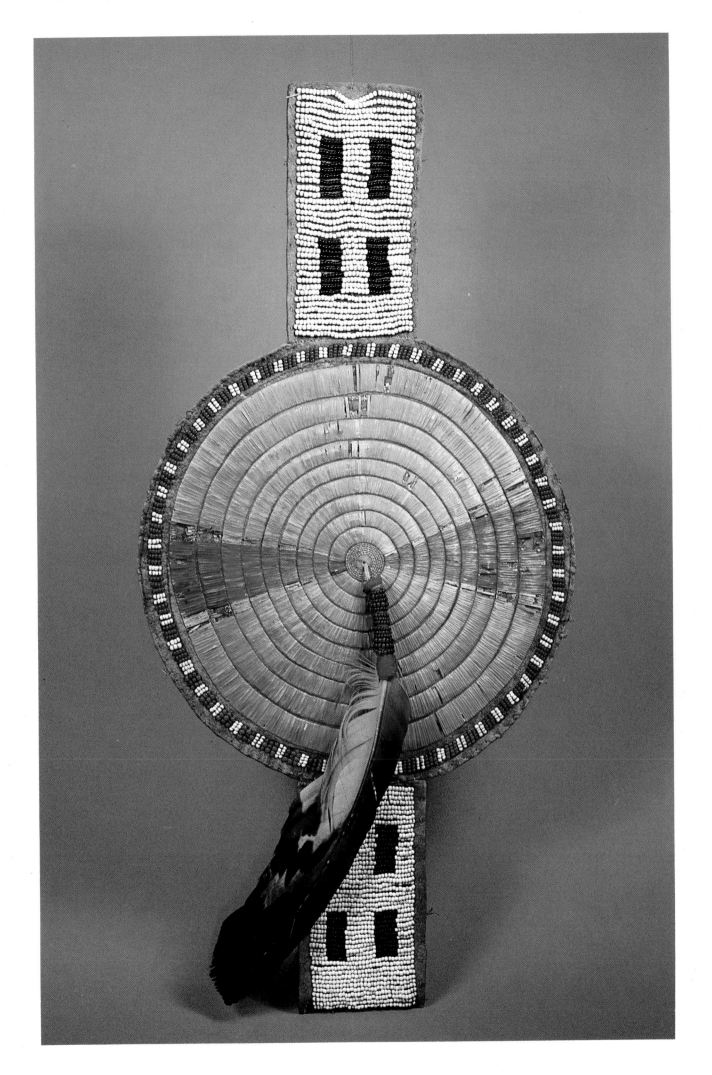

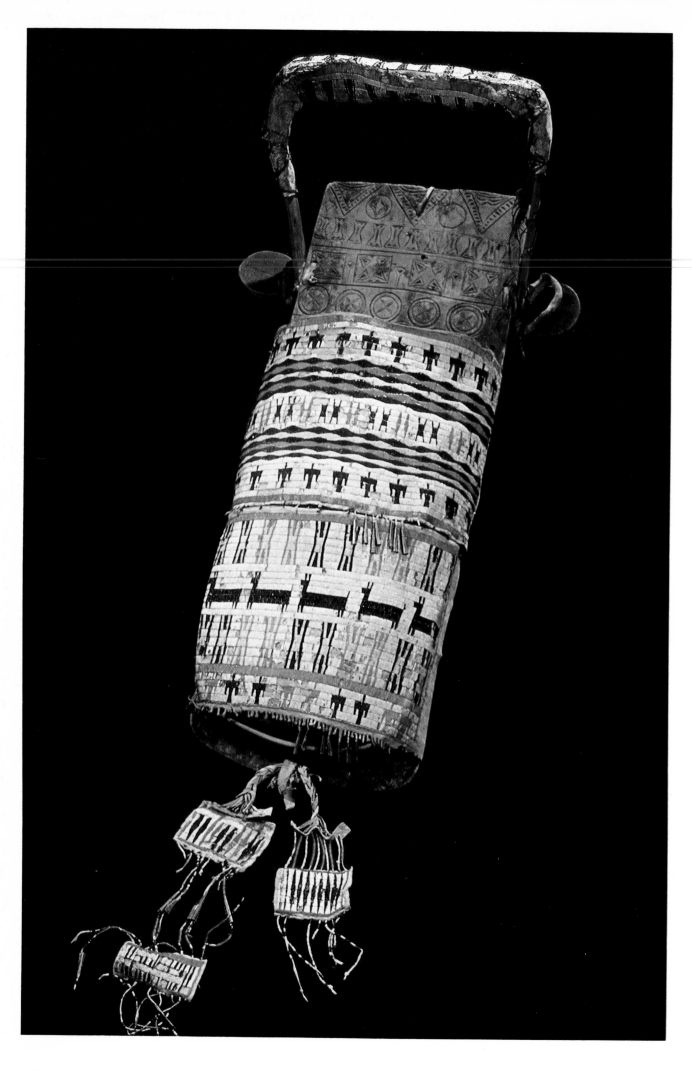

Plate 170 (opposite). Eastern Sioux cradleboard, with a buckskin cover decorated with porcupine quill embroidery depicting, among other motifs, antelope and thunderbirds, was collected by George Catlin on the upper Missouri in 1835. (31" long. Smithsonian Institution.)

Plate 172. Comanche cradleboard with beaded buckskin cover and painted parfleche backing. (45" total length; cover 32" long. Arrowsmith Collection.)

Plate 171. Photograph of an Apache baby in its carrier, taken by Edward Curtis in 1903 in Arizona, illustrates the basic similarity of cradleboards all over North America and the special care taken everywhere to protect the infant's head. (For an Iroquois example, see Plate 217.)

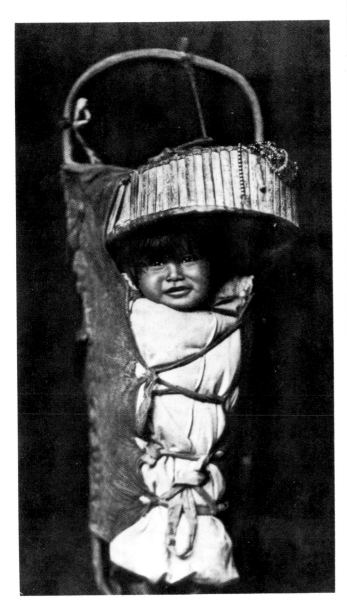

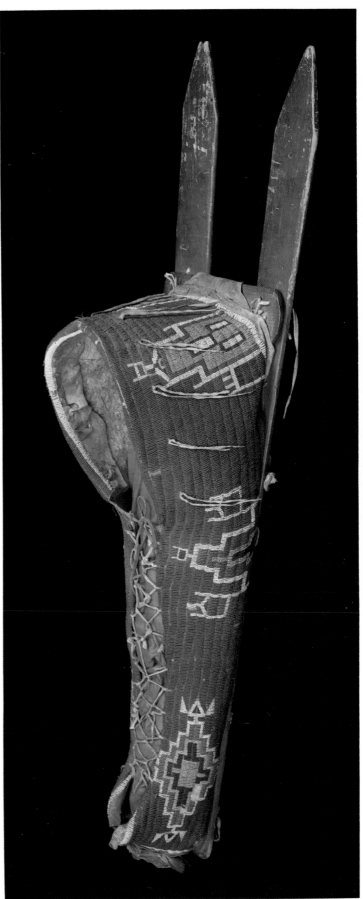

*Plate 173. Sam Kills Two, also known as Beads, photographed on the Rosebud Reservation around 1920 while painting his Winter Count. (John A. Anderson Collection, Nebraska State Historical Society.)*

*Plates 174 & 175. Two pages from the Winter Count of High Hawk (Plate 196), which takes the Sioux from mythic times to the early twentieth century and which the Brulé tribal historian copied on paper for Edward Curtis in 1908. At right is the year 1540, when the holy White Buffalo Woman, shown in her animal form, appeared in a circle of tipis to give the Sioux their sacred pipe (above the animal) and the great ceremonies. Plate 174 depicts the year 1680, when horses were first used for riding. (This was not the first time a horse had been seen, an event that High Hawk placed in 1624.) Before taking her leave, White Buffalo Woman predicted the coming of the horse, depicted in the lower left of Plate 175, and told the hunters to look out for a white buffalo cow in a herd of black animals, kill it, and preserve its hide as a holy relic. The numbers on these and other pages of the Winter Count were added by one of High Hawk's educated sons, supposedly for the numbers of buffalo killed, although the figure of 6,000 for 1540, a year of terrible hardship and hunger for the Sioux migrating westward from the Great Lakes, hardly seems possible. High Hawk himself was one of those who fled with Short Bull into the Dakota Badlands during the Ghost Dance troubles and surrendered with him just before the Wounded Knee disaster.*

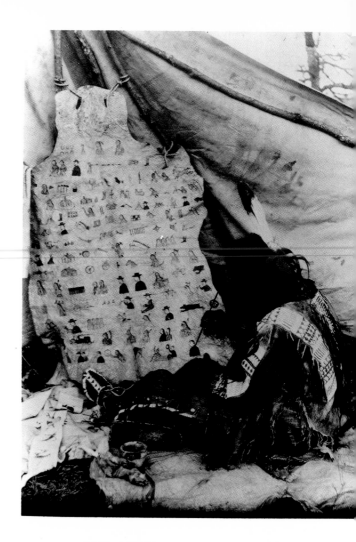

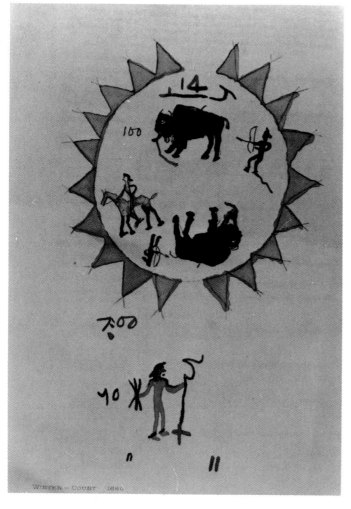

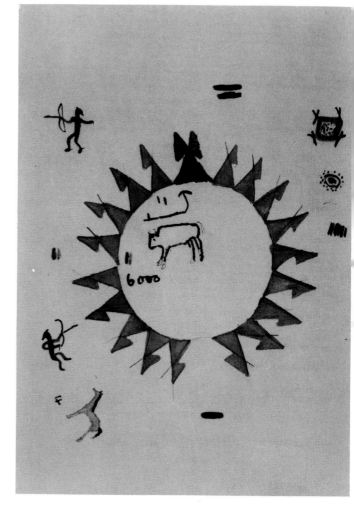

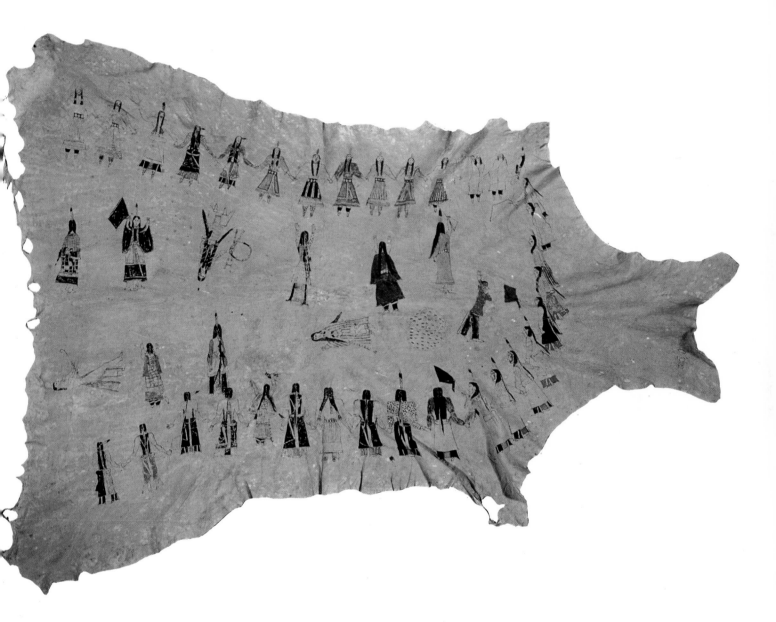

Plate 176. In 1891, a few months after the tragedy at Wounded Knee that effectively ended the millenarian Ghost Dance among the Sioux, a Ute captive among the Cheyenne, Yellow Nose, painted on buffalo hide this picture of the dream dance as it was still being performed by Cheyenne and Arapaho in the desperate hope of divine salvation. Smithsonian ethnologist James Mooney was then traveling through the West gathering material for the classic history of the Ghost Dance movement he published in 1896. It is to him that we owe the explanation of this buckskin painting: "The dancers are in full costume, with paint and feathers. The women of the two tribes are plainly distinguished by the arrangement of their hair, the Cheyenne women having the hair braided at the side, while the Arapaho women wear it hanging loosely. Two of the women carry children on their backs. One of the men carries the bäqati (gaming) wheel, another a shinny stick, and a woman holds out the sacred crow, while several wave handkerchiefs which aid in producing the hypnotic effect. In the center are several persons with arms outstretched and rigid, while at one side is seen the medicine-man hypnotizing a subject who stretches out toward him a blue handkerchief. The spotted object on the ground behind the medicine-man is a shawl which has fallen from the shoulders of the woman standing near." (50" long. Smithsonian Institution.)

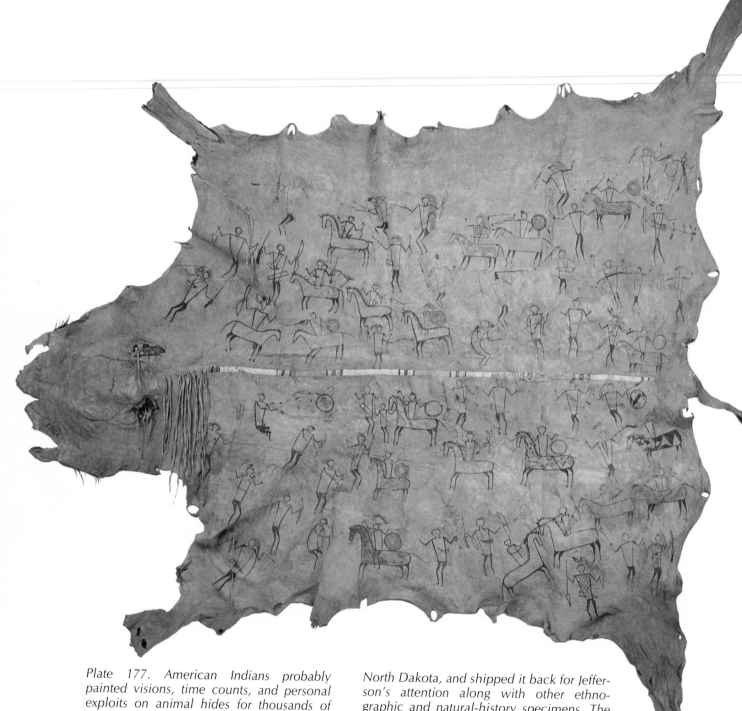

Plate 177. American Indians probably painted visions, time counts, and personal exploits on animal hides for thousands of years. Although the Spanish explorers who penetrated all the way to present-day To-peka, Kansas, in 1540–41 made brief mention of seeing painted skins, the oldest surviving hide paintings unfortunately go back only to the beginning of the nineteenth century. The first white Americans to pay attention to the art and bother to preserve it were Meriwether Lewis and William Clark, and through them, President Thomas Jefferson. Lewis and Clark purchased this painted buffalo robe in 1805, while wintering in North Dakota, and shipped it back for Jefferson's attention along with other ethnographic and natural-history specimens. The work of a Mandan warrior, the robe depicts a battle fought by his people and their allies against Sioux and Arikara around 1797. The pictographic style, with its conventionalized human stick figures and gestures, is very much like that found in Plains and Great Lakes rock art, some of it prehistoric, and was employed on skins throughout the nineteenth century. (74" long. Mandan, 1797–1804. Peabody Museum of Archaeology and Ethnology, Harvard University.)

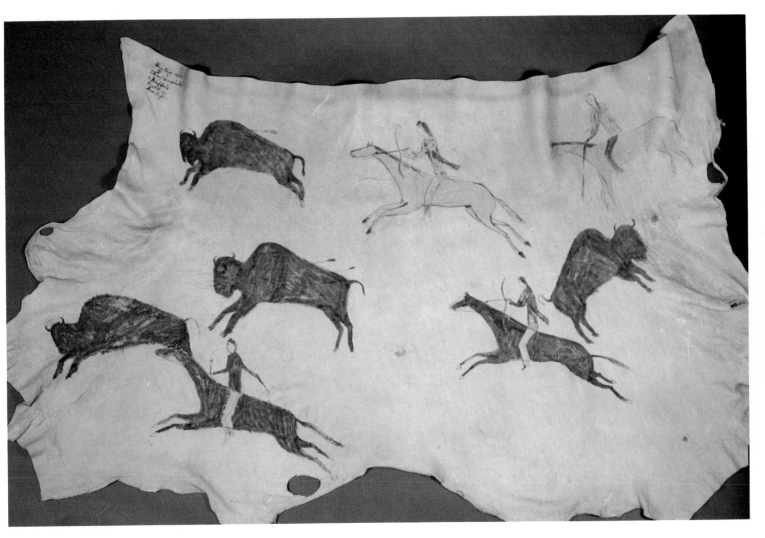

Plate 178. Two centuries ago, perhaps 60 million buffalo roamed over much of North America. By 1830, not one was left east of the Missouri. By 1898, when the Shoshone artist Chief Washakie depicted himself from memory in this skin painting, chasing buffalo as a youth in his native Wyoming, the great shaggy ruminant, "blood brother" to the Plains Indians and physical and spiritual mainstay of their existence, was, for all practical purposes, gone from the West as well. Between 1820 and 1870, a million buffalo a year were slaughtered by white hunters; from 1872 to 1874, an estimated seven and a half million were killed, most of them left to rot where they dropped while Indians starved on their reservations. Along a 100-mile stretch of Union Pacific track, travelers reported the ground could not be seen on either side for buffalo bones, remains of tens of thousands of animals slaughtered from the comfort of railroad cars. And so it went until, between 1887 and 1889, white hunters vying for the dubious distinction of having killed the last buffalo left alive could find just 56 stragglers in Texas, where Spanish explorers had once been awed by herds so vast they seemed like an endless black sea. In Colorado, the final western refuge of buffalo in the wild, the last were shot in 1897. If the buffalo (more correctly, American bison) did not go the way of the passenger pigeon, it was because at the turn of the century a few ranchers from Texas to Montana re-established small herds with captive calves; today the total number in public and private hands stands around 25,000. (32" long. Natural History Museum of Los Angeles County.)

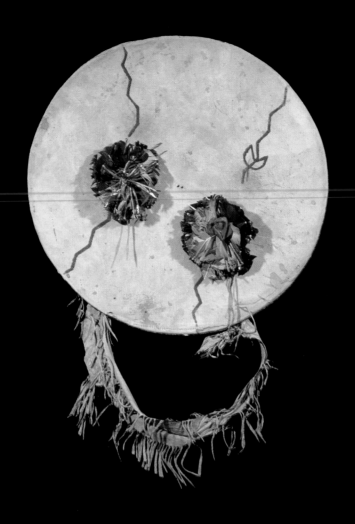

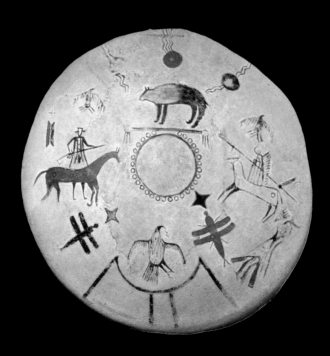

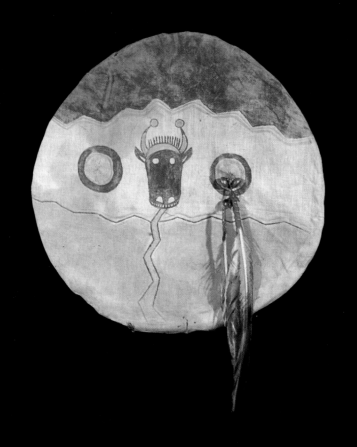

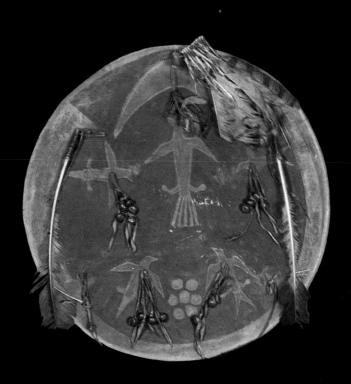

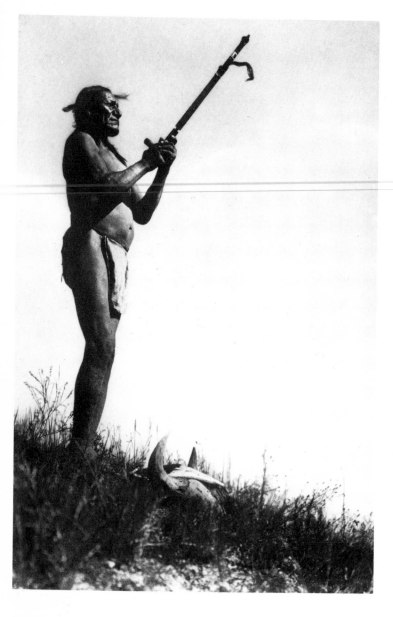

Plate 183. *A Sioux Sun Dance participant offering the sacred pipe to the Great Mystery is the subject of this 1907 photograph by Edward Curtis. In his photographs Curtis tried to recreate the free-roaming past on the Plains, just as the Indians themselves were reliving it over and over in their narratives. There was no need to recreate such solemn ceremonies as the Sun Dance, however. The Sioux were continuing to observe them then, as they do to this day, with the same pipe offering to the Mysteries and the same prayers heard by Curtis or, three quarters of a century earlier, by Catlin.*

Plate 184. *The sacred red pipestone quarry in southwestern Minnesota, as George Catlin painted it in 1836. "The Great Spirit," he wrote while sitting on the edge of the two-mile-long cliffside, "at an ancient period, here called the Indian nations together, and standing on the precipice of the red pipestone rock, broke from its wall a piece, and made a huge pipe by turning it in his hand, which he smoked over them, to the North, the South, the East, and the West; and told them that this stone was red—that it was their flesh. . . ." (Oil on canvas. Smithsonian Institution.)*

Plate 185. *Catlin's portrait of the Blackfoot chief Stu-mick-o-sucks, The Buffalo's Back Fat, holding his quilled sacred pipe, painted at Fort Union, at the mouth of the Yellowstone, in 1832. While sitting for his portrait, Catlin wrote, the chief was surrounded by his own warriors and distinguished personages of other tribes, their weapons laid aside, "peaceably and calmly recounting the deeds of their lives, and smoking their pipes upon it. . . ." (Oil on canvas. Smithsonian Institution.)*

Plate 186 (opposite). *A Sioux pipe with a quill-wrapped open-work wooden stem decorated with the heads of mountain sheep, deer, turtle, and buffalo. (25¼" long. Ca. 1885. Private Collection.)*

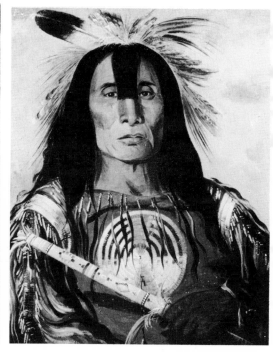

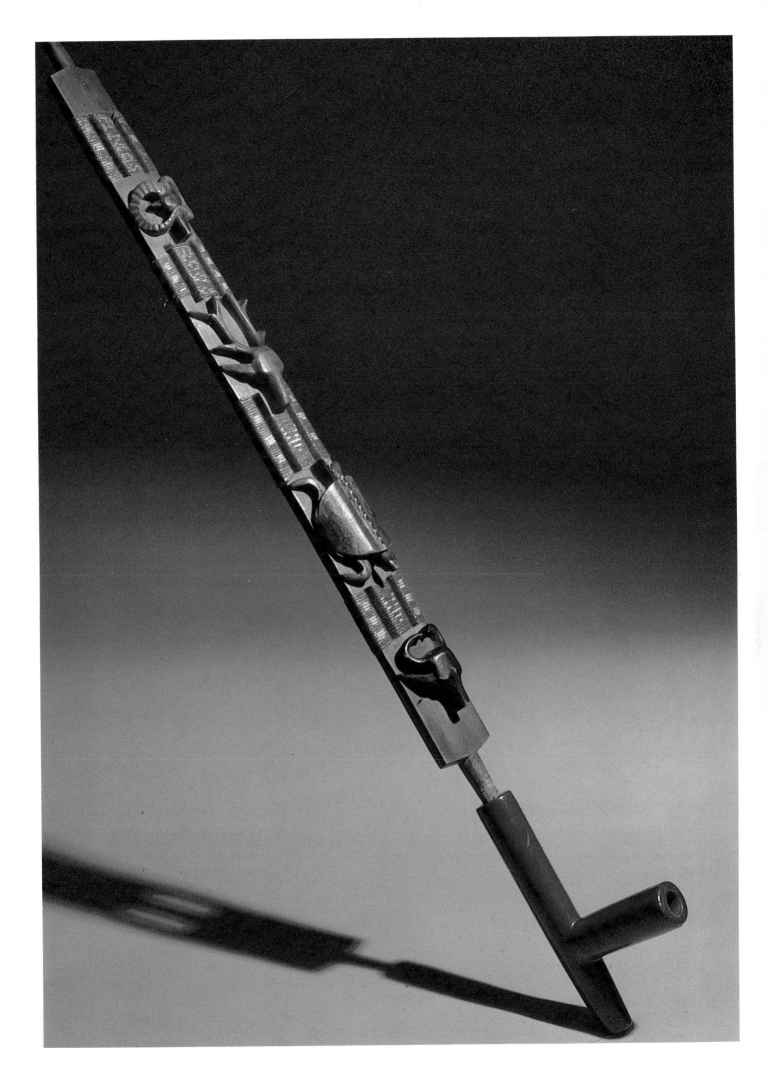

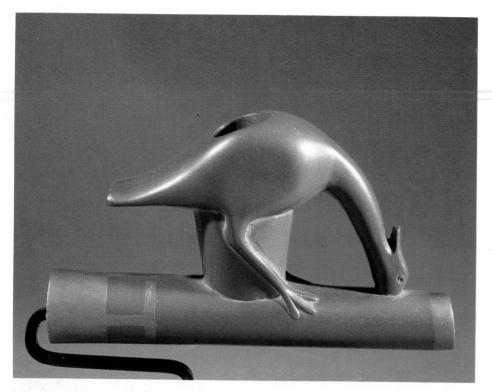

Plates 187 & 188. Catlinite pipe bowls with decorative or symbolic lead inlays were made by the Sioux as early as the first half of the nineteenth century, and even earlier by Great Lakes Algonquians such as the Ojibway. But effigy pipe sculptures as elegant and fragile as those shown here would not have been practical for frequent ceremonial use under the old conditions of almost constant movement. Most such pipes were made in the last decade or two of the nineteenth century under the enforced idleness of the reservations, more as works of art to demonstrate the carver's skill and taste than for personal use. Still, the subject matter was often traditional and spiritual, inspired by myth and the vision quest. Birds were messengers of the superior powers or themselves embodied the Mysteries. If the bear astride a leaping horse seems whimsical, one need only recall the overwhelming economic and metaphysical importance of the horse in Plains culture and the great potency ascribed to bear medicine to realize that mystery power more than humor must have been on the artist's mind. (Crane pipe: 4¾" long. Ca. 1880. Collection William E. Channing. Bear and horse pipe: 5⅞" long. Ca. 1880. Private Collection.)

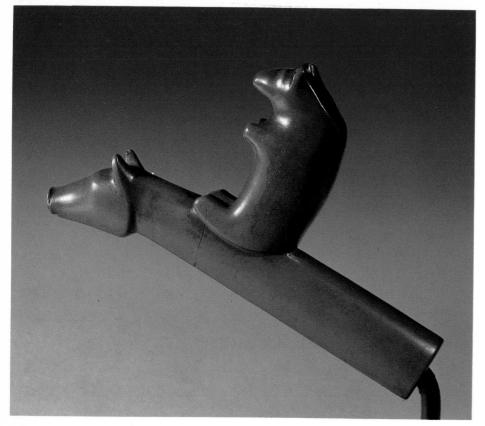

Plate 189 (opposite). Catlinite pipe (possibly a specialized medicine pipe or one for women's use) representing a fanged and crested water spirit, with fish effigy stem. This was carved in Minnesota in 1850–60. Several very similar eastern Sioux bowls have been found, all apparently by the same carver, but complete pipes including bowl and fish stem are rare. (8⅝" long. Private Collection.)

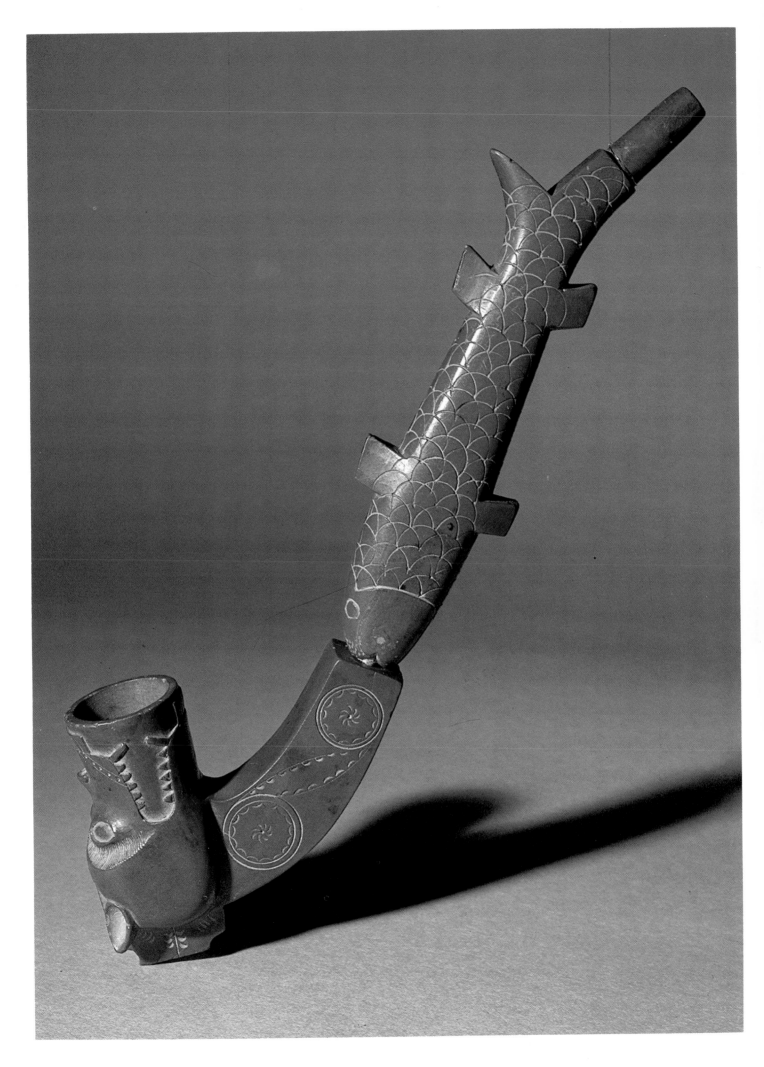

Plate 190. Spiralling in nature, as in vines and snailshells, was a powerful symbol of new life and growth to eastern Plains and Great Lakes Indians. In this eastern Sioux pipe, dating from about 1840, the catlinite head, heavily decorated with lead inlay, is fitted with a long hardwood stem carved into a double spiral, ending on opposite sides near the mouthpiece in two streamlined heads of a long-beaked water bird, presumably the owner's guardian spirit. (30¼" long. Private Collection.)

Plate 191. This complex open-work "puzzle stem," so-called because only the carver knew the exact route by which the smoke traveled from bowl to mouthpiece, was collected by English missionaries among Great Lakes Algonquians in the late eighteenth century. (35⅛" long. Private Collection.)

Plate 192. The massive proportions and great weight—almost two pounds—of the old northern Plains catlinite pipe bowl at left and its equally unusual bulky wooden stem almost certainly mark it as a powerful medicine bundle that would have been unwrapped and smoked only on extraordinary occasions. The smaller pipe more nearly represents the average, for not only practicality but the thickness of the catlinite seams at the sacred quarry and the great spiritual and economic value of the mineral ordinarily limited the proportions of bowls. (Left: 30" long. Northern Plains, probably Crow. Ca. 1840. Right: 20½" long. Sioux. Ca. 1880. Private Collection.)

Plate 193. What makes this early nineteenth-century human-effigy pipe bowl unusual is not its form, which is typical of some Great Lakes pipes of the period, but its material. Rather than steatite, this one was carved in one piece from a rough casting of metal, an alloy of lead and a small amount of tin. Marks on the pipe indicate that the artist worked the soft metal with knife and file, and polished it just as though it had been stone. That the Indian faces toward the smoker probably means that he was the owner's guardian spirit. Metallurgy is not often counted among Native American skills, but in fact some eastern Iroquois and Algonquians were making pipes of lead, pewter, and brass as early as the mid-seventeenth century. Lead and pewter inlay in channels cut into catlinite or steatite is a very sophisticated craft, of which the eastern Sioux and the Ojibway, among others, were outstanding masters in the early nineteenth century. But lead smelting and casting by Indians in this region actually began much earlier.

The most important lead deposits in the United States are located in Illinois and Wisconsin. The Sauk and Fox, who lived here when French traders and artisans first entered the region, learned to mine and smelt lead into pigs from French visitors before the end of the seventeenth century, and thereafter carried on a lively trade in lead castings with other Indians and with whites. (5³/₁₆″ long. Great Lakes, Sauk and Fox or Ojibway. 1800–20. Private Collection.)

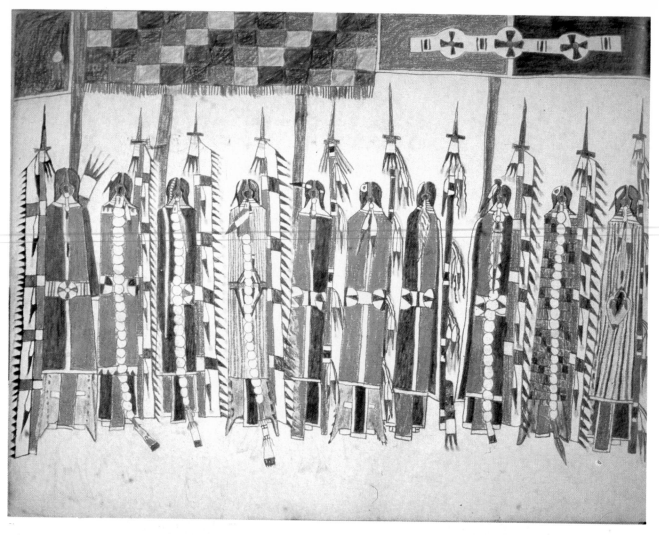

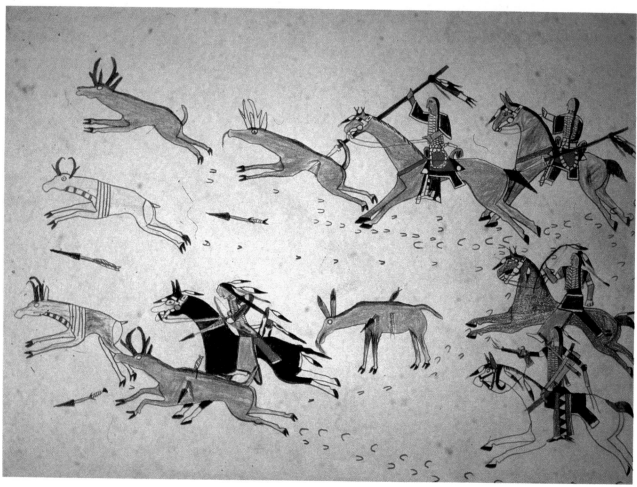

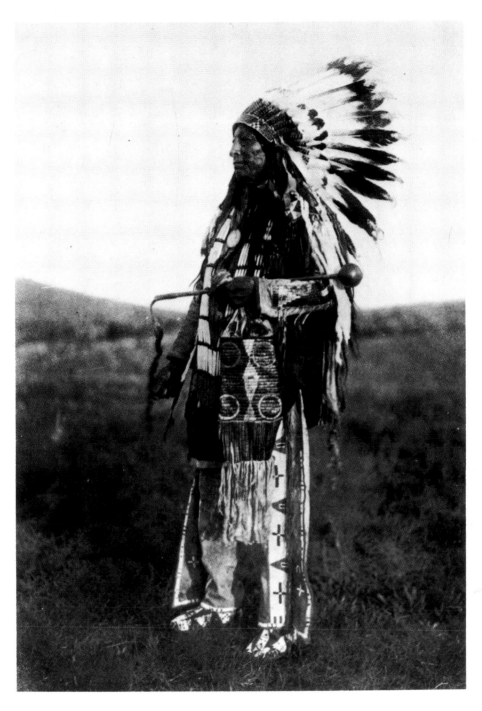

Plates 194 & 195 (opposite). The traditional art of Plains Indian narrative painting on hides survived the end of the free-roaming life in other forms, above all in ledger-book drawings, such as those of Indian hostages taken on the southern Plains in 1875 and shipped to distant imprisonment at Fort Marion, Florida. Among them was Howling Wolf, son of Eagle Head, one of the principal chiefs of the southern Cheyennes. Howling Wolf made many drawings in his three years at Fort Marion, but the earliest sketchbook, dated 1876 and previously unknown, was rediscovered only in 1981. Pages from this sketchbook, stressing above all the dignity of his people and the rewards of their free, pre-reservation life, are reproduced here and on the next several pages for the first time. Top: The artist has captured the grave formality of a gathering of splendidly attired members of his dance society, seen from the rear

beneath sunshades of colored strouding supported on poles. The men's lances are decorated with eagle feathers, horsehair, and the shriveled gut of buffalo. Bottom: Men and women pursue mule deer on horseback, the men with bows and arrows, the women with lances. (New York State Library.)

Plate 196. High Hawk, keeper of the historical record, or Winter Count, of the Brulé Sioux on the Rosebud Reservation, posed for Curtis in 1907, in all his ceremonial finery. Winter Counts—so-called because they marked the year from the first snowfall of one winter to that of the next— were true histories that placed important events in a specific time. But by marking the passage of time between memorable events, they also served as calendars.

197

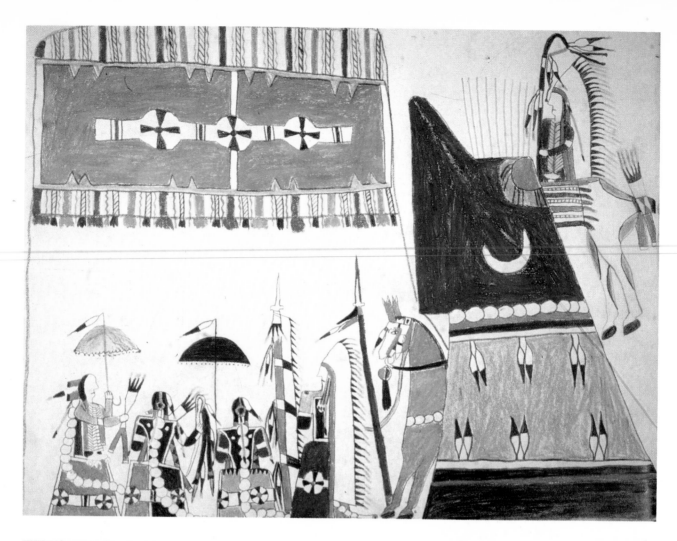

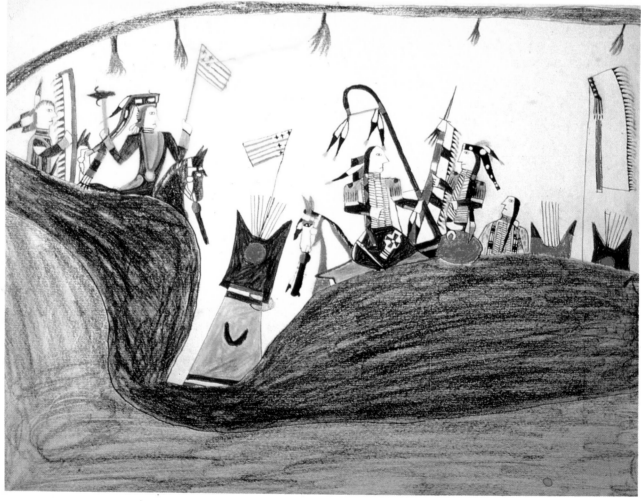

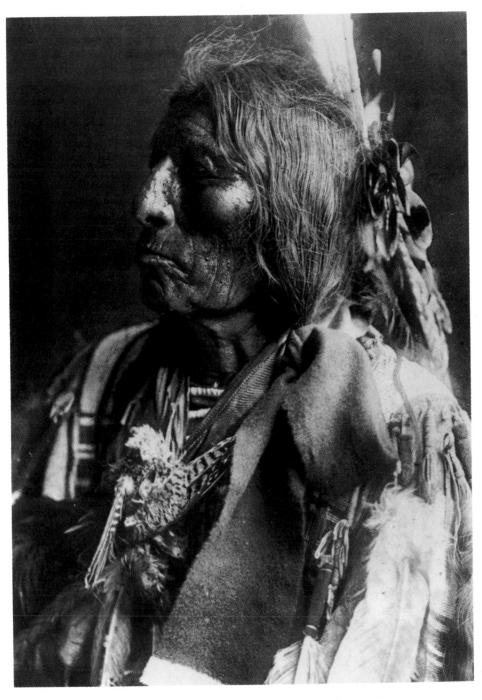

Plate 197 & 198 (opposite). A splendidly painted tipi dominates the drawing (above) of a ceremonial gathering of members of the Bowstring Society, with its dance director, Howling Wolf himself, at upper right, holding a crooked lance. The notched ears of the horse beside the tipi and the stretched scalp dangling from its bit identify it as a war or hunting mount. Note, at upper left, a sunshade with a beaded blanket strip, made of two pieces of strouding. Howling Wolf's drawing (below) of a meeting of Osage and Cheyenne warriors, the latter identified by their emblem as members of the Crooked Lance Society. Note, at right, a long, flowing eagle-feather war bonnet atop a pole. (New York State Library.)

Plate 199. The 73-year-old Slow Bull had been a sub-chief of the Oglala Sioux for nearly thirty years when Curtis took this portrait of him in 1907. Born in 1844, he had participated in 55 battles, the first at age 14 under the famous Red Cloud; three years later, at 17, he captured 170 horses from the Apsaroke and established his reputation as a brave warrior.

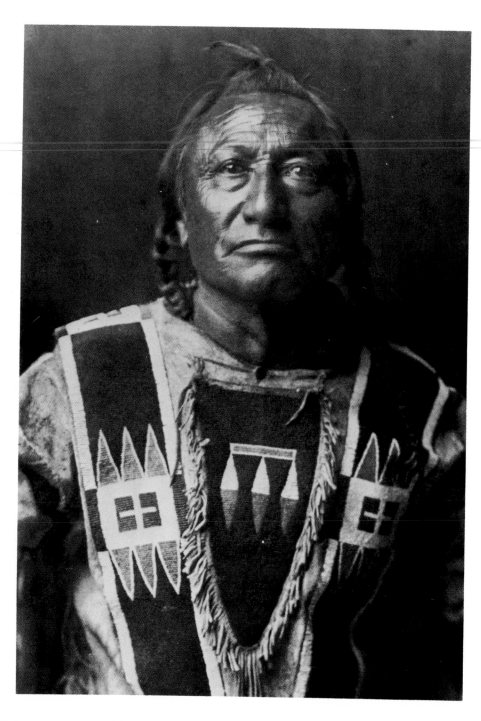

Plate 200. Otter Robe, photographed by Curtis in 1908, was a noted Atsina warrior who received his name and his guardian spirit in a vision after a long fast, in which a tree transformed itself before his eyes into a warrior. The warrior told him he was to receive many honors; that when he went to war, he was to paint himself exactly like the spirit, yellow on the temples and with a red streak across the forehead; and that to honor the otter he was to wear a strip of its fur—the otter's robe—around his scalplock.

Plates 201 & 202 (opposite). Howling Wolf's drawing (above), apparently showing the communal beading of a large stretched skin by Cheyenne women and, curiously, by two men (wearing breastplates, center rear) as well, is unusual because it depicts half the participants in frontal view, in a marked departure from the usual convention in Plains Indian narrative art of showing faces in profile. A visit by a white party of traders to a Cheyenne tipi encampment at the confluence of two rivers (below). As was customary in Plains Indian narrative paintings, the whites are clearly distinguished from Indians by the heels on their shoes; Indian moccasins being heelless, anyone, whatever his or her other clothing, can thus be recognized immediately as Indian or white. The parts in the women's hair are painted red, which men did for women whom they especially cherished. There are several Navajo blankets in this drawing, perhaps purchased from white traders: the second woman at lower right wears a "chief's blanket," while two other women are dressed in Navajo striped women's blankets. (New York State Library.)

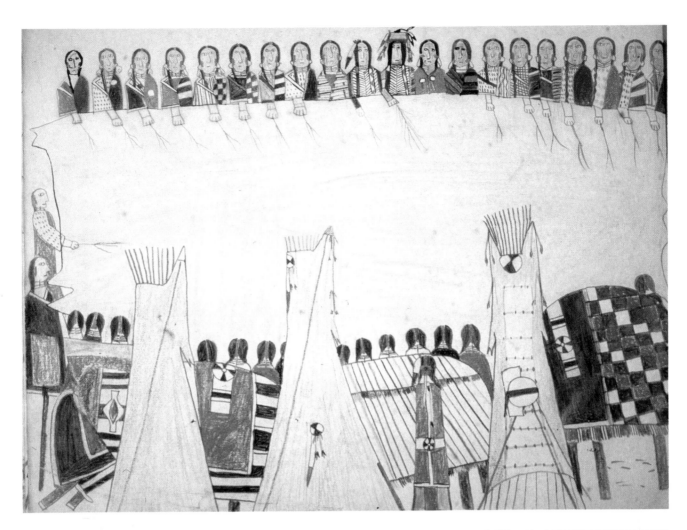

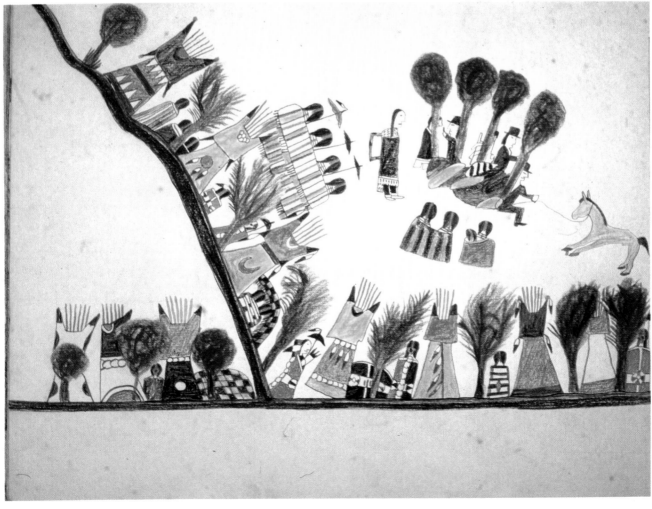

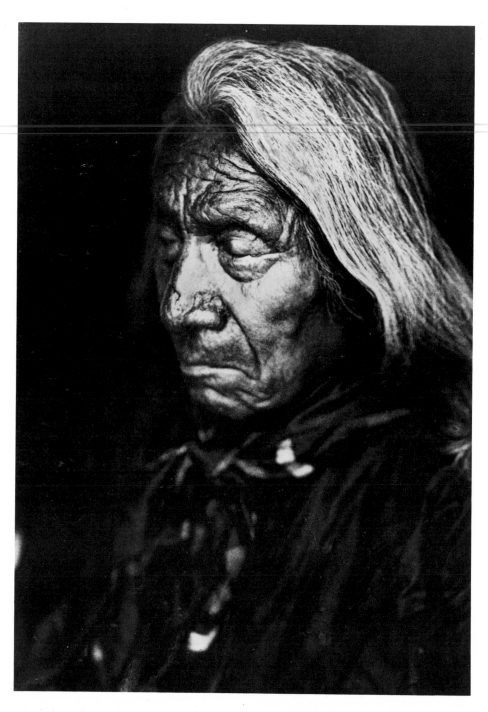

Plate 203. The Oglala warrior chief Red Cloud at age eighty-three, in a 1905 photograph by Edward S. Curtis. It was Red Cloud who in 1866 led his own Sioux and their Cheyenne allies in their total victory over Captain William J. Fetterman, who had boasted that with no more than eighty men he could "ride through the whole Sioux nation."

Plates 204 & 205 (opposite). Until sympathetic whites paid to send him to Boston for eye surgery, Howling Wolf was gradually losing his sight during his Fort Marion imprisonment. Perhaps failing vision made his memories of the colorful ceremonies and formal social events all the brighter; certainly they dominate his subject matter. At top, a tripod at right supports a warrior society lance, bridle, and hair ornaments while men and women sit in ceremonial splendor beneath sunshades and umbrellas topped with eagle feathers, watching the presentation of a holy pipe. Below, an Osage village, identified by its round grass lodges, receives southern Cheyenne visitors at right, perhaps including the artist himself. Before the lodge at lower left stands a pole surmounted by a horned-buffalo war bonnet, kept outside during the day to expose it to the sacred power of the sun. The halters of the Cheyenne horses are of classic Spanish design and probably of Navajo manufacture. The Fort Marion imprisonment was to have set Howling Wolf and his fellow Indians on the "white man's road," and for a few years following his return to the Cheyenne Agency in Oklahoma, he tried just that, farming, interpreting, woodcutting, butchering. It didn't work for him. By 1882 he was back on the Indian road, and along it he traveled until his death in 1927, at age seventy-seven. (New York State Library.)

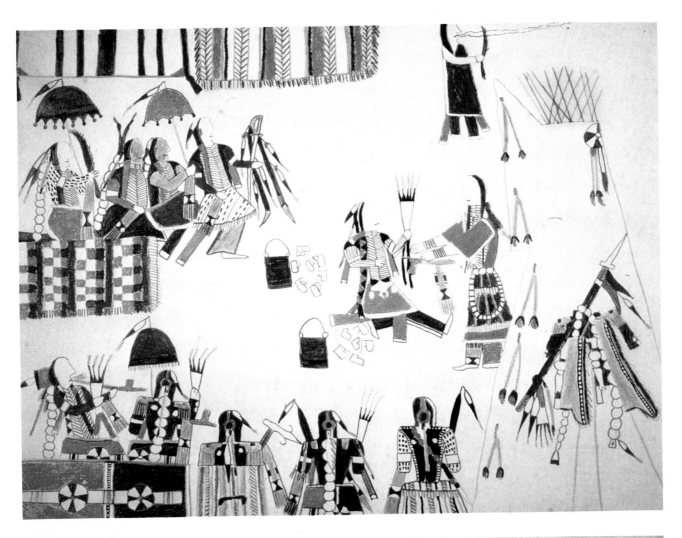

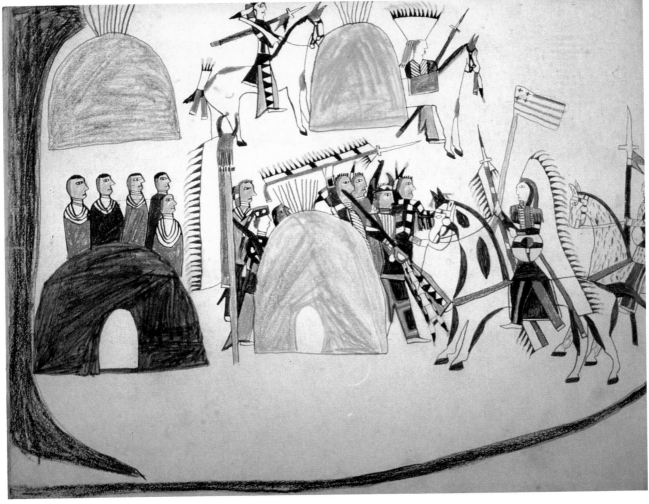

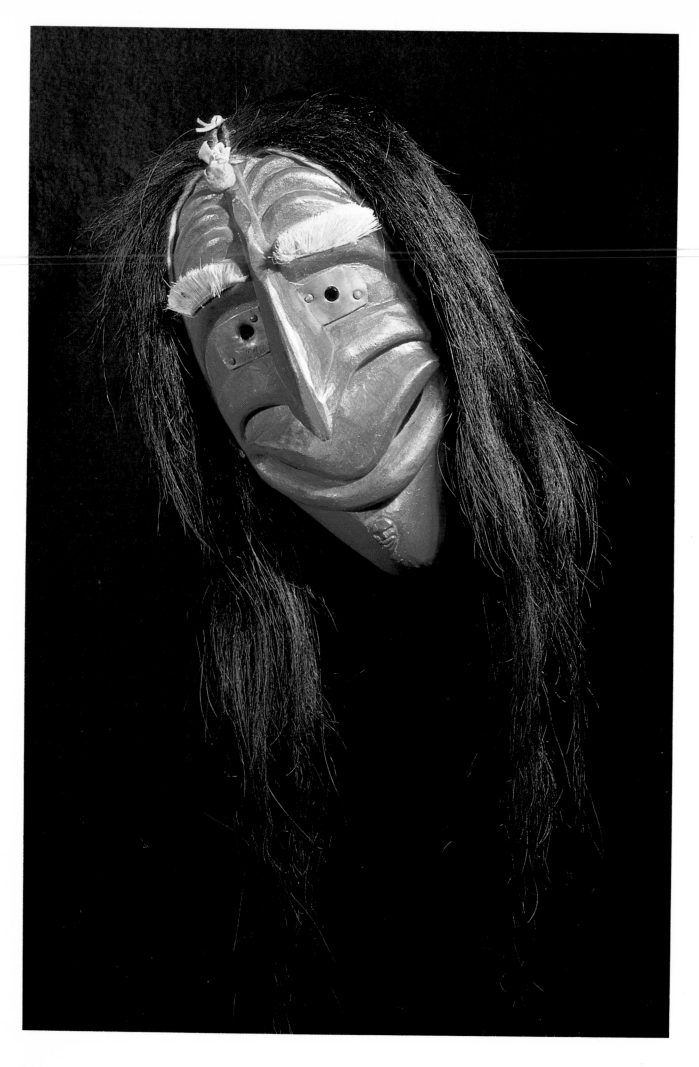

# Arts of the Eastern Woodlands

The magnificent shamanistic spirit masks of Northwest Coast Indians and Alaskan Eskimos are today museum specimens, admired as art and valued as cultural monuments to a time and to lifeways that can never be again. But at the opposite end of the continent, within a day's drive of New York City, masks are still as much a part of a living religious and artistic heritage as they are among the Hopis, still used in the old ways —not something nostalgically recreated, as the nineteenth-century Kwakiutl were in Curtis' twentieth-century photographs, or recently revived by Native American artists in a splendid cultural renaissance, as in British Columbia. Iroquois masks—the wooden "faces" (Plates 13, 206–208, 210–212) of restricted shamanistic medicine societies, and the Husk Faces (Plate 209) associated with them—belong to an old tradition that was never put to death or died of its own accord, not in the 450 years since Jacques Cartier met his first Huron while exploring the waterways of Canada.

The Huron Iroquois, in fact, may have been the very ones from whom the shamanistic use of masks spread to the rest of the Iroquois some hundreds of years ago; the Huron language is no more, but the masks remain. To this day, conservative Iroquois communities maintain themselves in western New York State and the Canadian province of Ontario, where medicine Faces continue to be carved by men, cornhusk masks are braided by women, and the Longhouse religion, a blend of older Iroquois belief and the reformist message of the Seneca prophet Handsome Lake,

*Plate 206. With its bushy deerskin eyebrows, horsehair mane, and grinning mouth, this Onondaga Iroquois beggar mask represents one of the forest spirits that appeared to hunters, flitting from tree to tree, rummaging in campfires, and begging for cornmeal mush. Their wooden images, carved from basswood, are among the curing Faces that play a part in the Midwinter Ceremony to rid the houses of evil, cold, and illness. This mask has its own protector or guardian, carved as a tiny face on the chin. (11⅞" high. Ca. 1930. Private Collection.)*

remains strong. It is in these communities that members of the Society of Faces gather on festive occasions and dance with their masks and their turtle rattles in dramatic performances intended to drive disease from the houses and cure and purify their occupants (Plate 214). Lest it be thought that the dancing of the Faces during the great midwinter rites and other seasonal festivities has become little more than theater, there are few Iroquois with any connection to their culture who would make light of the spirit of the mask or fail to turn to its psychotherapeutic powers in times of personal crisis. The Faces, in fact, come into play not only in the seasonal rites. Anyone who feels their need, at any time of the year, may dream of a mask and request that a member of the Society of Faces perform a cure. When a cure has been effected, the patient, in turn, may join the company of shamanistic curers. In fact, to dream of a Face and be healed by it is the most common form of induction.

Yet ownership of a mask is not a prerequisite of membership in the curing society, and, indeed, many people have to borrow masks for ceremonial occasions. Essentially, membership is open to anyone who has been cured by the Society, has dreamed of joining it, or has had membership prescribed by a diviner in the interpretation of a dream. The only way of resigning from the Society is likewise through a dream that says one should depart; in that event the dreamer organizes a final feast for the Company of Faces and takes his leave.

With their bold and sometimes grotesquely distorted features, their staring eyes encased in shiny metal, and their long, flowing horsehair manes, the Faces are quintessentially Iroquois, the most distinctive and exclusive manifestation of Iroquois religious art, even if, as the late Frank G. Speck, pioneer ethnographer of northeastern Indians, believed, they and their ritual context belonged to an ancient and wider Woodlands tradition. It is to Speck and William N. Fenton,

the most experienced modern student of the Society of Faces and its masks, that we owe most of what is known of the art of the mask and its functions in Iroquois belief and ritual, Speck having devoted his attention to the Cayuga and Fenton to the Seneca.

Although some masks portray animals, most are likenesses of human-like mythic beings, portraits of spirits encountered by people in dreams or while hunting in the forest. "False Face" is thus a misnomer, for the mask is in no way intended to disguise or hide its wearer, any more than is the kachina mask of the Pueblos. Rather, the Face is worn to transform the wearer into the spirit embodied in the wooden image—one of the Common Faces, perhaps, like those hunters might once have seen flitting from tree to tree, or those thought to live beneath rocks and waterfalls. The masks are objects not of worship but of reverence, for they contain a great spiritual force for good, akin in beneficial power to the medicinal plants that grow on earth, which the Iroquois still number in the hundreds.

Plate 13 depicts the likeness of a supernatural being that had the greatest power of all and that rarely, if ever, appeared to ordinary people. Its broken nose and twisted mouth immediately identify it as the mighty spirit the Seneca call "Great Defender" and the Onondaga "Great Humpback." He is also known as "Rim-Dweller," for before the spirit was tamed and turned to the benefit of human beings, he was thought to have lived on the very edge of the world, causing whirlwinds and other misfortune. How he came to be a mask spirit, founder and supernatural patron of the Society of Faces, is the subject of several Iroquois myths that differ in detail but agree on the main story:

In the days when the earth was still incomplete, the Creator-Culture Hero, Sky Holder, or Sapling, was wandering about inspecting his handiwork when he encountered a giant on the rim of the world who was carrying a great rattle made from the body of a mud turtle in one hand and a staff cut from a towering pine tree in the other. The giant demanded to know who he was and what he was doing. Informed by Sky Holder that he was the Creator, the giant roared, "It is I who is master of the world!" They challenged each other to a contest to see who was the more powerful, and the Creator suggested that each try to move a mountain. The giant tried but the mountain moved only a little way toward them. They turned their backs and now the Creator bade the mountain to come close. Hearing a great rush of wind at his back, the giant turned and smashed his face against the mountain,

which now stood right behind him. So the Great Defender was compelled to acknowledge the Creator's greater power. Nevertheless, he, too, had power, and the Creator asked him henceforth to use it not to harm but to help human beings. The giant agreed, requesting that people offer tobacco to him and carve his likeness from living trees. Then, he said, he would cause his power to enter the wooden images and help drive away disease and misfortune.

Thus the first mask with twisted features came into being. The Iroquois call it "Grandfather," a ritual kinship term that is also applied to other Faces. In Seneca tradition, to obtain the first curing power in the world, the Great Defender rubbed his turtle rattle against the World Tree, which stands in the center of the earth as cosmic axis linking the Sky Dome with the earth and the Underworld. This is why members of the Society of Faces make medicine rattles for themselves from the body of the turtle—the animal that in the Iroquois creation myth brought up the mud with which the earth was formed as an island floating in the primordial sea. Plate 226 depicts two of these turtle rattles. Rattles as large as the bigger one, made from a mature animal, have become rare because the mud-turtle population has been dwindling.

Many masks depict forest beings and dreamed Faces that, like Great Defender himself, may at one time have been malevolent, or at least capricious, but came to serve human beings with their medicine power through gifts of food and, most important, burnt tobacco offerings. Throughout Native North America (and in South America as well) the spirits crave tobacco, and indeed require it as their most precious sustenance.

Most of this class of Faces seem to have had their origin as spirits of trees and plants, rocks and waterfalls, and other features of the natural environment. Again, different myths account for their origin. In one, they first appeared to a pair of hunters who set out from their village to find game deep inside the forest, carrying among their provisions parched corn for mush and tobacco with which to feed and appease whatever spirits they might encounter. As they walked, they were constantly harassed by shy, long-haired forest beings which flitted from tree to tree but disappeared from sight when approached. When the hunters returned to their camp they found dirty handprints and the ashes of their fire scattered around the hearth. To solve the mystery, one hunter stayed behind in the camp and hid. A spirit approached, slithering along on one hip and then standing up to look about before continuing on. He reached the fire and rummaged in

the coals. Not finding what he wanted, he left. That night the hunter dreamed about the Faces, which requested tobacco and cornmeal mush. In order to fulfill the dream the hunter set out some native tobacco and a kettle of food. The Faces came and in gratitude taught him songs and the method of curing patients with hot ashes. In a subsequent dream the Faces enjoined him to remember them each year with a feast and told him that they were everywhere in the forest and would bring luck to those who remembered to give them tobacco and mush.

The Canadian Cayuga of the Sour Springs Longhouse have a different story to account for the origin of the Society of Faces. According to this myth, long ago the daughter of a chief was set adrift in a canoe on the Niagara River to appease a spirit who was causing disease. She went over the falls but miraculously survived. After a long time she reappeared among her people, saying that she had been living with some little folk in the caves under the falls. Soon she gave birth to a male child who had extraordinary powers. If he quarreled with one of his playmates and touched him, the other child would instantly die. Soon the people would no longer allow him to play with other children. Left alone, the boy began to carve little Faces—some red, some black, some with crooked mouths, some with big noses, some smiling. He told the people that these were the images of his relatives who lived under Niagara Falls. The boy also made rattles of turtles, for these turtles also lived with his people. The noise of the rattles was like the thunder and would frighten away disease.

The boy gave these powers to some of his mother's people, telling them that the masks he had carved were medicine and that the differences among them reflected the fact that some of his relatives living under the falls had black skin, others red, with long flowing hair and gleaming eyes.

In religious esteem, the red masks and the black are partners—they "both go together where they are called, together," as the Cayuga say. In former times, pokeberry juice was used for red, charcoal for black, and chalk or the natural color of the wood for white, but for a century or more commercial paints have been in general use. As primary colors for the Faces, red and black are accounted for differently in Iroquois legends. The Cayuga believe the red Face, or "Laughing Mask," like the one depicted in Plate 206, to be the original kind, while black masks represent the Grandfather Face, or Great Defender, after the Creator had put him to shame. But there are other explanations. It is said that

masks carved in the morning or from trees chosen before midday were supposed to be colored red, and those carved in the afternoon black. Red is the color of east and dawn, black of west and sunset, the directions in which the Great Defender faced while traversing the earth. Perhaps so, but the complementarity of black and red in the context of the sacred is virtually universal throughout Native North America and elsewhere in the world, and so probably had more profound meanings than the modern explanations would suggest.

Plate 211 depicts a rarer type than the all-red or all-black Faces, being black on the left side and red on the right. Supposedly, the splitting of colors represents the Great Defender at dead center, the exact midway point between dawn and dusk. Such masks seem to have spiritual potency considerably beyond the expulsion of disease, although that is certainly their principal function. Properly used and accompanied by song and burnt tobacco offerings, they could turn aside the fiercest tornado. In the old days, masks of this type were suspended in trees in the face of an approaching storm, or even flung in the teeth of the storm to split the clouds asunder. The power of the masks derived from the Whirlwind Spirit, a dangerous adversary of human beings who is generally too fast to be properly seen as he hides on the far side of trees but who is capable also of harming one who inadvertently catches a glimpse of him. Thunder and Lightning, themselves powerful spirits, try to strike him down, but he is too swift even for them. An old Cayuga tale accounting for the origin of the first divided red and black Whirlwind mask is reminiscent of the familiar pattern of shamanistic recruitment through sickness vocation; that is, the chosen neophyte falls ill with a mysterious ailment that can be cured only through his agreement to become a shaman.

The first man to see the Whirlwind Face deep inside a forest was struck dead by it when his nose began to bleed and the flow would not stop. The second man had better luck, barely escaping with his life when the spirit suddenly peered out at him from behind a tree. He asked a shaman to divine what was happening to him and was told that he must go and find a Whirlwind Face and offer it tobacco, thereby becoming a curer himself. Try as he might, the man failed to find the desired mask, until at last he fell into a dream in which he saw a man carving such a mask for him. He found the man and got his mask. Soon thereafter his wife dreamed that a terrible storm was approaching and that only by hanging the black and red mask in a tree and burning a to-

bacco offering to it would they escape death. The storm was duly turned aside. When it had passed, they carved the mask in three different sizes, one to be worn, a second one in smaller size, and the third in miniature.

A Face manifesting itself to a human being by means of nosebleed is not merely a matter of myth, as Speck discovered when several Cayugas recounted similar experiences. One man told him that as a small child his brother was suddenly struck down by a severe nosebleed while picking berries in the forest with his mother and another woman. He had wandered off by himself, and the women went looking for him when they heard him crying. They found him lying with blood flowing from his nose beneath a great pine that had been struck by lightning. When he could speak, he told them that he had seen a Face looking at him from behind a tree. The women carried him home and called in the members of the Society of Faces, who placed ashes on him (a crucial aspect of Iroquois curing) and performed their healing ceremony. In return he had to call for a Face Dance ceremony every year.

Miniatures serve important functions (some positive, some negative) that are less well known than those of their full-size prototypes. Like the so-called "passport masks" of West Africa, they can serve as substitutes for the larger masks; they also protect their owners, or their masks, against disease and other harm. Some full-sized masks have miniature masks attached to them (Plate 13) or, like the red smiling-mouth mask in Plate 206, have minuscule guardian masks carved on the chin or forehead. The small masks are considered especially efficacious in the curing of dream persecution by a Mask Spirit. Such cures are effected within the Dream Guessing Rite, held during the midwinter ceremony to help someone plagued by persistent dreams of evil omen or trouble. First described by seventeenth-century French Jesuit missionaries, who were astonished by such sophisticated understanding of the causes and cures of emotional ills, Iroquois dream guessing is a form of psychotherapy that, anticipating Freud by many centuries, recognizes that dreams have both latent and manifest content and that nonfulfillment of unconscious desires may have serious psychological consequences that can translate themselves into physical ills. The nature of the troubling dream is divined by members of one half of the society for those of the other half, just as the two moieties perform curing rites, the Condolence Ceremony, and other social duties for each other. Dreams are divined by guessing, with only slight hints from the troubled dreamer. The cure for dream persecution is effected by correct

guessing of the dream, which may be done with only three or four guesses or may require many questions over several days. Whoever gave the solution is then required to carve a mask in miniature, to be presented to the relieved patient as a medicine charm against further troubling dreams. As the Jesuits described these rites, it was incumbent upon the society to fulfill whatever desires, conscious or unconscious, emerged from the guessing ritual as the real meaning of the dream. The other side of this coin is that miniature masks could also be employed in witchcraft and love magic, for they would carry out whatever wishes their owners expressed while burning tobacco as an offering.

Individual taste or dream experience may determine precisely how a Face is to be carved and decorated, but all masks fall into certain traditional patterns. Fenton has distinguished the major types of wooden Faces as follows: (1) crooked mouth (Plate 13), (2) straight-lipped mouth, (3) spoon-lipped mouth (Plate 210), (4) hanging mouth, (5) mouth with protruding tongue (Plate 207 depicts such a mask, collected by the pioneer ethnographer Lewis Henry Morgan in 1850 and published by him in 1852 as the first Face to be depicted in print), (6) smiling mouth, a very common type (Plate 206), (7) whistlers (Plate 212), and (8) divided mask, either black and red (Plate 211) or black and white, the latter depicting the spirit of one "cleft in half," in the sense of dualistic or two-sided. There are masks for specific illnesses, such as venereal disease and smallpox, serious problems for the Iroquois after contact with the Europeans. The mask represented in Plate 212, an old red-faced Seneca "Whistler" or "Wind-Maker" from Tonawanda, New York, has a pockmarked forehead, suggesting that the curing or prevention of smallpox may have been one of its functions. This mask has also been called "Stone-Faced Giant," but Fenton suggests that giving masks names beyond those for which there is a basis in the old traditions may be more the preoccupation of whites than of the Indians themselves. As Indians have said, there can be as many different kinds of Faces as there are Indians to dream them.

In fact, not even such distinctive features as the broken nose and twisted mouth always define the meaning of the mask in a particular ritual. One might think that this Face, at least, would always and everywhere represent Defender, or that masks with "spoon lips," symbolizing the prophylactic blowing of ashes over the patient, were always the curing spirits of the forest. Actually, custom, the age of the mask, and even the importance of its owner determine its interpretation

as much as do its features. Thus, if a Face with twisted features is inherited by a relatively new recruit to the medicine society, it may initially be relegated to the category of tree spirits or Common Faces. Conversely, a mask that lacks the twisted mouth and nose and is otherwise apparently unconnected with the Great Defender may have accumulated so much sacred power through long use that it may come to represent him in the ceremonies. An individual may infuse a common mask with so much of his own power and prestige that it may be treated as the Grandfather Mask regardless of its features. Plate 208 illustrates an old mask that appears to be a Common Face but takes on quite a different aura when one learns that its owner was reputedly the great Chief Cornplanter, half-brother to the prophet Handsome Lake and a leading Iroquois figure two centuries ago. Of course, uncertainty in identifying the many types of Faces today may be only a consequence of gradual erosion over time of distinctions that formerly were more crucial.

If owning a mask is not absolutely essential, it is nevertheless highly desirable. Indeed, it is possession of one's mask (which may accompany its owner at death, being interred with him if he is buried or burned if he is cremated) that enables a man to participate fully in the rituals of the masked medicine society. To this day there are carvers whose work is especially esteemed and whose cash income is augmented or almost wholly derived from this craft, for they also carve masks for sale to non-Indians. Although a purchaser is admonished to treat the masks with respect, and not to let his children, for example, use them as toys or as Halloween disguise, replica masks have not been ceremonially fed with tobacco and consecrated through the proper ritual and are thus not considered to have comparable power.

The preferred material for masks is basswood, but pine, maple, willow, and poplar are also employed. There was once considerably more ritual attached to the process of carving than there is today. A generation or so ago, the carver began with the living tree, not, as nowadays, at home with a block of wood. In the old way, the selection of a suitable tree for a mask was the common task of a group of men who accompanied the carver into an untraveled part of the forest. After the tree had been found, the carver built a fire at its base and prayed to the tree and to the Mask Spirits, while throwing pinches of tobacco into the fire. This was one of the two principal ways in which tobacco was used by the Iroquois, the other being the smoking ritual, usually with an

effigy pipe that represented one's guardian spirit or an animal or supernatural being associated with one's clan. Tobacco was often mixed with other plant materials, but the tobacco itself was always the native species, *Nicotiana rustica*, not the commercial variety, a distinction that is still generally observed. The carver then cut the features of the mask directly onto the living wood and split the block with the outlines of the mask away from the tree. If the tree survived, this was taken as a sign that the power of the tree would transfer itself to the mask.

The carver then took the roughly shaped mask to his house for finishing with chisel and crooked knife. These are still the carver's principal tools, having replaced the older cutting tools of flint and bone soon after European contact. The remarkable crooked knife, an all-purpose cutting tool found over much of the continent, deserves attention, for although its steel blade is obviously an innovation, it is truly a product of Indian genius. Besides, in the eastern Woodlands, the handles of these knives were often elaborated into real works of art, those of the Algonquian Passamaquoddy and Penobscot of Maine being among the finest. Skill, imagination, and even humor were lavished on practical, everyday tools (Plates 227–228, 230). It might be noted, however, that notwithstanding the opinion of some whites, the new availability of steel to the colonial Indians of New England did not improve their workmanship. Quite the contrary, the straight steel blades and hatchets of the Europeans were actually inferior for delicate woodcarving to such indigenous cutting instruments as chipped flint or the sharp, curving incisor of the beaver set into a wooden handle. Only the advent of the crooked knife brought Indian woodcraft back to its former glory.

Several accounts from the early 1600s comment admiringly on the skill and taste the Indians lavished on wooden utensils, including bowls, dishes, platters, and ladles. A splendid example of this art among the northeastern Algonquians is the small hardwood bowl with mythical animals at either end dating from the early 1600s (Plate 215). It may have been made by the Massachusett or the Wampanoag, whose famous seventeenth-century war chief Massasoit was the father of the Indian warrior known to history as "King Philip" (Plate 216). However, bowls of similar shape were made by all the northeastern Woodlands Indians. A young man about to marry was expected to provide his bride with all the wooden bowls, dishes, and ladles she needed for housekeeping, and everywhere men spent much of their leisure time carving utensils from various

hardwoods for their wives. One reason why so few bowls have survived is that during the smallpox epidemics that ravaged the northeastern Woodlands Indians in the early 1600s, in some villages the survivors, too weak to collect firewood, were reduced to burning their wooden utensils to ward off the cold.

That the Iroquois were no less adept at crafting hardwood utensils into works of art than the Algonquians is evident from elegant feast ladles (Plates 224–225) and other small wood sculptures found in prehistoric or early historic archaeological sites, or that were collected in the eighteenth and nineteenth centuries. Remarkable, too, is the small number of elegant effigy war clubs from the late 1600s (Plate 231) which found their way to Europe in the early colonial period. Another admirable prehistoric miniature Iroquois art form were ceremonial antler combs decorated with clan and longhouse symbolism (Plate 223). Such combs may have been used by clan matrons who customarily signalled the end of mourning in the Condolence Ceremony by ritually combing their hair.

# Husk Faces

If the wooden masks are the most visual and dramatic expression of Iroquois ritual art, this is not to underrate their companions, the *gad-jeesa*, or Corn Husk Faces (Plate 209), or to slight the social, ceremonial, and political role of women in this matrilineal clan-based society. It is they who braid the Husk Faces, while the men are the exclusive carvers of the wooden masks. Husk and Wooden Faces belong together in the seasonal rites, and both express in their own way the beneficial influence of vegetation on human affairs that underlies the predominance of floral and plant motifs in Iroquois and Woodlands art (Plates 217, 220, 222, 229). The Corn Husk Mask Society is open to men and women, but women have the closest spiritual and practical connection with corn, corn products, and agricultural fertility, for they own the fields and do most of the essential work in agriculture, from sowing and weeding to harvesting and processing the foodstuffs. Like the wooden Faces, the Husk Faces function as doctors, perhaps even more frequently, for they treat patients in their own homes for almost any form of illness. In the company of the Wooden Faces they also play an important role in the seasonal communal rites of curing and purification, and they join with the members of the Society of Faces in the social longhouse dances, although, because these festivities are informal, without their masks.

The origin myths that account for the first appearance of the Husk Faces and their Society are not too different from those of the wooden Faces themselves. The Husk Faces were first seen by hunters, either as messengers sent by the chief of the wooden Faces and the Creator, or without any reference to wooden Faces and their patron. Thus, in a Cayuga story a hunter surprises a Husk Face near his campsite who tells him that in return for cornbread with blueberries, a favorite food of his people, he will drive a deer toward him in the morning. The hunter complies, gets his deer, and adopts the mask of the Husk Face and his sacred songs. But another story actually credits the Husk Faces with the first gift of corn:

In ancient times, a hunter saw a deer at the bottom of a valley and killed it. After he had dressed the carcass, he turned around and saw a male Husk Face. He asked him, "Where do you come from?" and was told, "From the place where the uprooted tree trunk is" (that is, from the center of the other world). The hunter inquired about his mission, and the Husk Face answered that he brought corn for human beings from "the farther side of the bushes," where the Creator had planted it for them. He instructed the hunter to mix it with the meat of game because these were the proper foods for people.

The Husk Face revealed that he had been sent by the Creator and by Crooked Face, chief of the Faces, to accompany the Twisted Face (mask) where he went from house to house to drive out malevolent spirits and to cure the people. He lived, he said, where the berries grow and picked up his provisions, unseen and unheard, from people who went about gathering the berries when they ripened. He also told the hunter that he had lived on the earth from the very beginning, as a "wild creature," but that now he would bring to the people the seeds of corn, beans, and squash from the Creator's fields. However, he warned, let none complain about the quantity of seeds brought to maturity each season. Instead, he said, the people were to make his likeness with the husk of corn, so that he might appear and help them. Having spoken, the spirit sent the hunter home with his precious seeds.

Thus, the Husk Faces are agricultural fertility spirits, comparable to those of other Native American agricultural societies. The myth suggests their abode as the fertile soil or the underworld ("the place where the uprooted tree trunk is"), precisely where one would expect to find such germinator beings. Fenton describes the arrival of the Husk Faces at the midwinter ceremony as follows:

Preceded by runners, they arrive amid a great din of beating the building with staves, stop the dances, and kidnap a chief as their interpreter. They are mute but are believed to have the gift of prophecy. They are led by an "old woman," actually a man dressed in woman's clothing, as indeed the others in the group of Husk Faces are dressed as women. The Husk Faces have a ritualized message for the people, predicting fertility and good crops, but, as they are mute, their words have to be relayed through the "interpreter." They say that, having come from the east, they are hurrying home toward the west to tend their crops of corn, beans, and squash, which grow to gigantic sizes in their magical gardens, and to see their wives, who have remained at home to tend the babies. This information is enthusiastically received. Then the Husk Faces request the honor of dancing with the people, most of whom then join a joyous social dance with their supernatural partners. As a parting gift, the Husk Faces receive a variety of popcorn developed early by Mexican Indians and diffused northward.

The Husk Faces also appear on other occasions, particularly in spring and fall, as heralds and companions of the False Faces. Spring and fall are times for clearing the villages and houses of disease spirits and other malevolent influences. In some communities two groups of Faces, preceded by the Husk Faces, set out from opposite sides of the settlement, and members of the Society put on their masks, take their mud-turtle rattles, and join the growing procession as it passes their houses. An unmasked leader sings, "It might happen, it might happen, from the mighty Shagodyoweh (Defending Face) I shall derive good luck." He sings to ask the Great Face to grant his power to the assembled members of the masked medicine society and to prevent devastating high winds. The company enters one house after another in a crouching walk, chanting with nasal voices. They visit each room and with pine boughs search out and expel any concealed disease spirits. Fenton notes that as they go about their sacred business they also "commit indignities"—that is, publically insult and shame lazy people and drag the sick out of bed. If someone asks to be healed and proper offerings of mush are made to the company, the leader will burn native tobacco, their only fee for their services, and blow hot ashes on the patient to effect a cure. Thus the living Faces are offered the gifts mandated in primordial times by the spirits of the forest, and in return the spirits, represented by the masks, commence the cure.

It goes without saying that the sudden invasion of the house by crawling, chanting masked beings is a fearful experience, particularly for children. For, like the Kachinas, the Masks are seen not as men disguised as spirits but as the living spirits themselves. However, despite the gravity of the occasion, there are moments of levity which greatly relieve the tension.

While the houses are being cleansed, two women brew a purgative at the village cookhouse; this may be made of parched white sunflower seeds to which is added a "manroot" (Ipomoea pandurata) that was found growing erect, like a person. When all the houses have been cleansed the community gathers at the longhouse, and a speaker gives thanks to the spirits. The Husk Faces may come singing to announce the False Faces, who burst into the room and crawl toward the fire. The two women give a pail of the medicine to two of the Faces, and a priest of the Longhouse religion invokes the protection of the Great Defender against epidemics and tornadoes, burning the tobacco the Faces have collected in the village. All who wish to be cured are asked to stand by the fire, and the two Faces pass the medicine infusion to the sick, who drink as much as they can hold. Two Husk Faces guard the doors, to make certain that no one enters or leaves. Then the dancing begins, to the accompaniment of a singer and the turtle rattles. The forest-spirit Faces dance and blow hot ashes toward anyone who has either dreamed that this would be the proper cure or had it prescribed for them by a diviner. A woman gives gifts of native tobacco to the forest-spirit Faces, who then take their leave with their kettles of cornmeal mush. The Husk Faces take up the dance, receive their gifts of popcorn, and with great bounding leaps exit from the house.

Now two masked men, one from each moiety and each representing the Dweller on the Rim of the World, begin the Dance of the Doorkeepers with the two women who prepared the medicine. Each man faces the woman of the other moiety, and they dance in unison, sparring with each other with their left hands, turtle rattles suspended from their thumbs. The two women pair off the other men and women, who also dance, sparring and moving in imitation of the Faces. Finally, a Doorkeeper who has guarded the entrance to the Longhouse compels everyone present to dance. The dance continues until, in the sequence of songs, the two Great Rim-Dwellers are requested to blow hot ashes on the women's heads. The Faces receive gifts of native tobacco for their efforts and depart.

If these rituals and the Faces as shamanic curing spirits are strictly Iroquois, Plates 7 & 213

illustrate masks from another place, North Carolina, and another society, Cherokee, that touch on at least some of the prophylactic purposes of the Iroquois masking complex. They may even be distantly related to it. Plate 213 depicts the mask of a warrior with a rattlesnake coiled on his head, Plate 7, a character usually called "Angry —or Apprehensive—Indian." Both function in the Booger or Bugah Dance, held in midwinter, although the warrior mask is used also in other masked dance rituals that survive among the eastern remnants of the Cherokee Nation—those whose ancestors evaded westward deportation, the "Trail of Tears," in the early nineteenth century. Cherokee dances generally celebrate the equilibrium between the people and their environment, but in the Booger Dance the balance is clearly precarious. Its subjects are not corn or game but strangers, the Europeans, whose coming the Indians could not resist and who brought displacement, sickness, and the sense and reality of oppression. Strictly speaking, although the dance has its sacred components—a calumet or peace-pipe smoking ritual, for example, and a Bear or an Eagle Dance held halfway through it —it is not itself religious in the sense of the Iroquois ceremonials. Nor do the masks hold spirit power comparable to that of the Iroquois Faces. Still, the Booger Dance functions, through ridicule and satire, as protective medicine, and it is sometimes prescribed by medicine men as part of the cure for a sick person, or to drive evil spirits away from the community. The basic idea is to neutralize by ridicule that which is beyond the people's control, which is why, although the masks are not caricatures, the Booger dancers wear exaggerated and ridiculous costumes that parody those of whites. There are thus some parallels with the performances of the Society of Faces. The Cherokee, of course, are themselves distant relatives of the northeastern Iroquois, from whom they became separated, linguists tell us, some four thousand years ago. ("Booger," however, is not a Cherokee word but came into the Cherokee culture by way of escaped black slaves from the Mandingo *baga* and the Wolof *bugal,* meaning to annoy, worry, or harm. Bogey, bug, and boogie-woogie, among other terms, derive from the same African roots.)

Presumably the Booger masks were once as sacred to the Cherokee as the Faces were, and are, to their Iroquoian cousins. To this day, however deeply he may be involved in American life in other respects, for the Iroquois still connected to his own cultural traditions the great power, the validity, and the sentient nature of the mask are beyond question. It is as alive as any human

being, and it must be treated with respect. When the mask is not in use it may not be stored face up, for that is the position of the laid-out dead. Instead it must be carefully wrapped and preserved face down in a trunk or other special container. If for some reason it cannot be so stored, its face has to be turned to the wall or covered with a cloth, for not only would the mask resent being exposed outside its proper ritual context but the human beholder must be protected from its power.

Some masks are thought to have notoriously bad tempers and must be fed often with the proper ritual foods. Tobacco is tied in small bundles and attached to the crown, and cornmeal is regularly placed on the lips. The mask may be rubbed periodically with oil from the sunflower, the plant that gave light to the earth in primordial times, and whose extract has medicinal as well as nutritional properties. But much of the bad temper that may be inherent in a mask comes from its eagerness to be used as it was intended to be used by the Creator-Culture Hero and the Great Rim-Dweller: for the prevention and curing of illness and misfortune and, by extension, for the preservation and protection of the Iroquois people.

Plate 207. Carved in the style of the Grand River Reservation, this Onondaga Iroquois medicine mask was already old when Lewis Henry Morgan collected it in 1850. Morgan, a wealthy upstate New York lawyer, became the first serious student of Iroquois social organization and culture and in 1847 was formally adopted into the Hawk Clan of the Senecas. (10½" high. New York State Museum.)

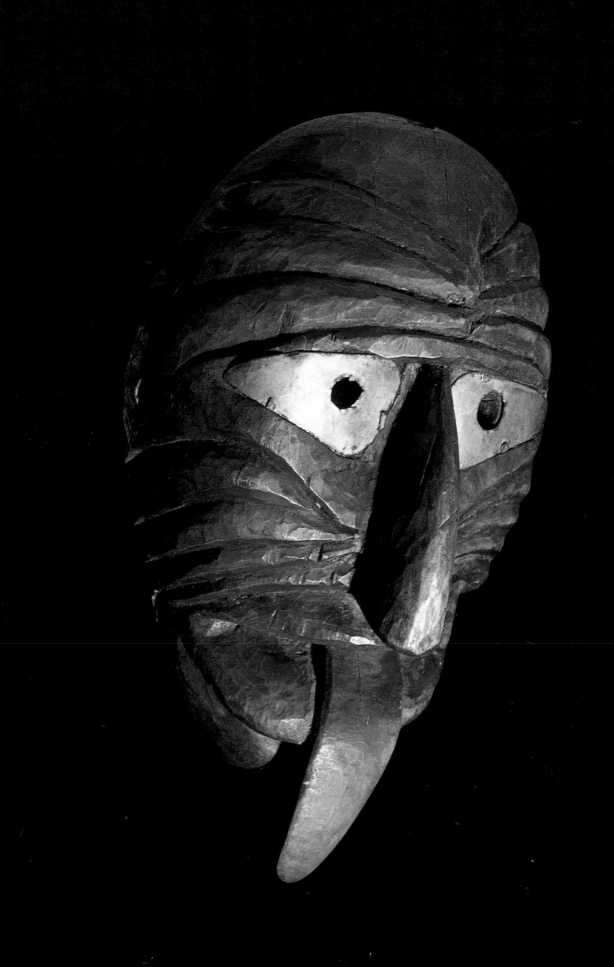

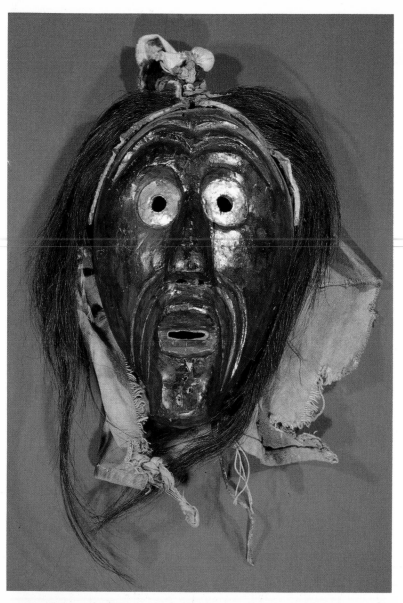

Plate 208. According to Seneca tradition, this old False Face curing mask is supposed to have belonged to the Seneca Iroquois Chief Cornplanter at the time of his death, in 1836, at age 104. Cornplanter was a major figure in the military and political history of the New York Seneca, first in the war between the French and British, in which he participated on the side of the French, and later in the American Revolution, in which he and most Iroquois, except for the Oneida and half of the Tuscarora, sided with the British. (12" high. Smithsonian Institution.)

Plate 209. Braided of cornhusk by Iroquois women, the Husk Faces are vegetation spirits that, like the wooden masks, function as doctors, treating people in their own homes for almost any kind of illness. They also help the wooden Faces drive evil spirits, disease, and misfortune from the community in the seasonal rites. Wooden masks are made and worn only by men, but the Husk Face society is open to both sexes. (Left to right: 14" high; 11½" high; 11" high; 17" high. Private Collection.)

Plate 210 (opposite). Enormous lips and the knobbed "turtle tail" motif carved on the forehead indicate a classic Cattaraugus Seneca Doorkeeper mask, made in about 1900. Although the False Faces have become somewhat plastic in recent years, with different types serving diverse functions, the function of the Doorkeeper is very specific. During the Midwinter rites, it is the duty of the Doorkeeper to guard the doors to the longhouse, allowing no one to enter or leave while the Faces are performing. Exceptions may be made for emergencies, but only if the Doorkeeper is appeased with gifts of sacred tobacco. (11" high. New York State Museum.)

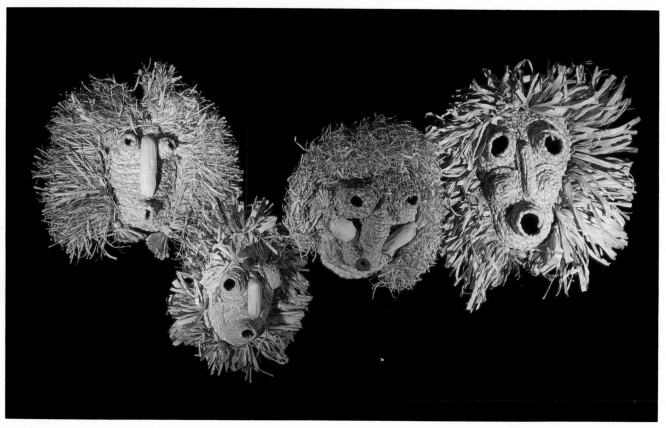

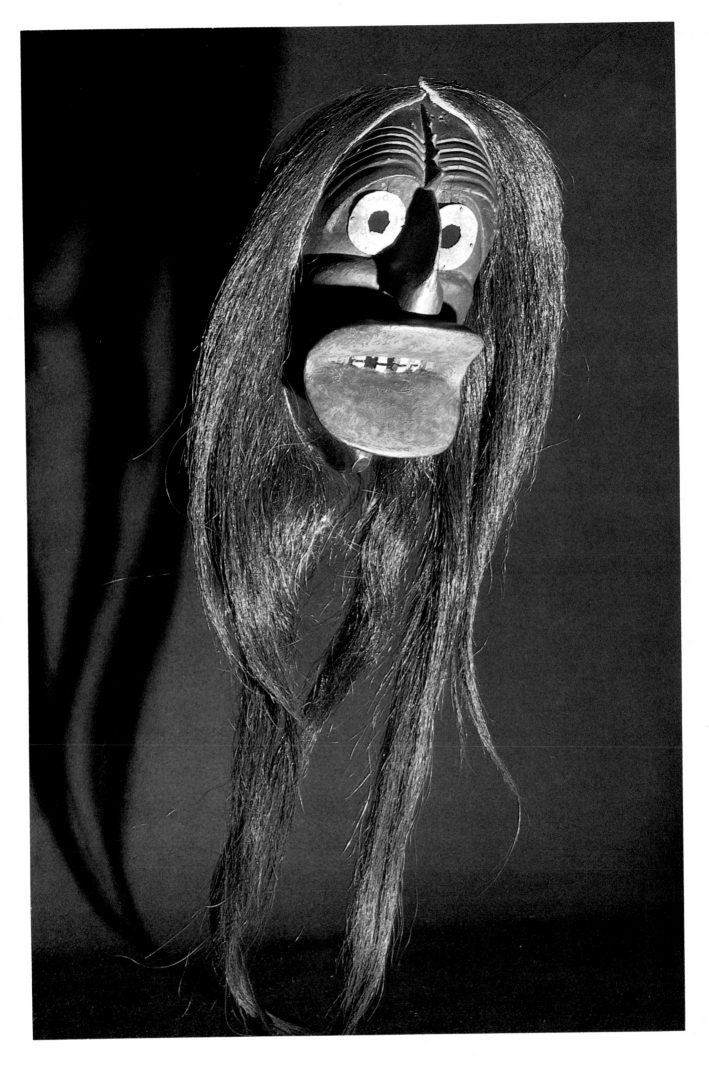

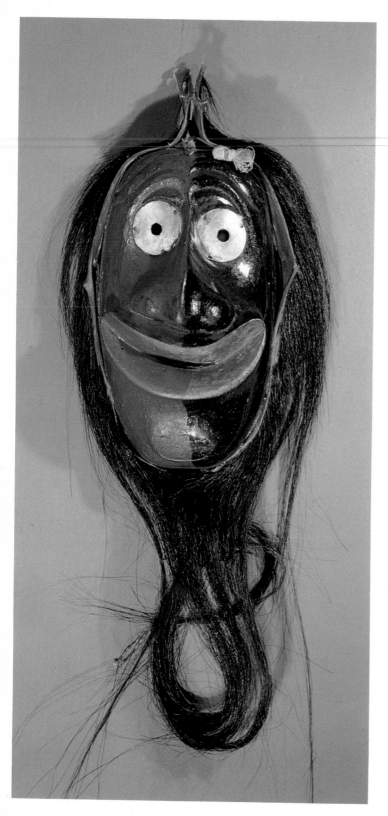

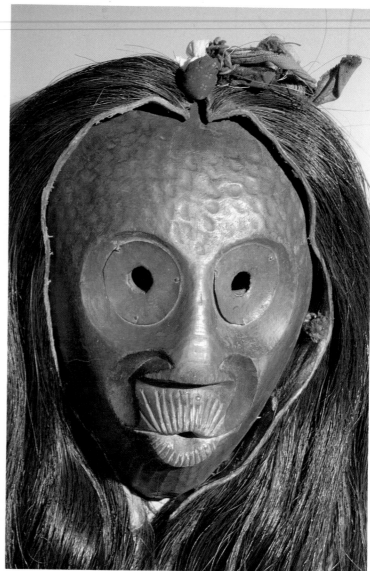

Plate 211. The juxtaposition of red and black in the context of the sacred is found all over Native North America, and in many other parts of the world as well. There are various explanations for the origin of Iroquois False Face masks painted half black, half red, but there is no question that these split masks have spiritual powers beyond those of doctoring and the expulsion of evil spirits. According to the Cayuga, for example, the terrible Whirlwind Spirit first appeared to hunters in this way, and masks painted thus have the power of turning away the fiercest storms. (11" high. 1880–1900. Smithsonian Institution.)

Plate 212. The pitted face of this old Whistler mask suggests that he might have had the function of curing small-pox. (10" high. New York State Museum.)

Plate 213. The Cherokees are distant linguistic cousins of the Iroquois, and though their masks no longer are as powerful and sacred as the Iroquois Faces, there are some similarities in use. This buckeye-wood mask of a warrior with a coiled rattlesnake on his head, from Big Cove, North Carolina, is used in the Cherokee Booger Dance, held in midwinter to neutralize through ridicule the negative influences attributed to whites and other strangers, to drive out disease and purify the community for spring, and to commemorate past glories in the hunt and war. In former times, a warrior mask such as this probably identified the wearer with the powerful medicine of the rattlesnake. (11½" high. 1935–40. Private Collection.)

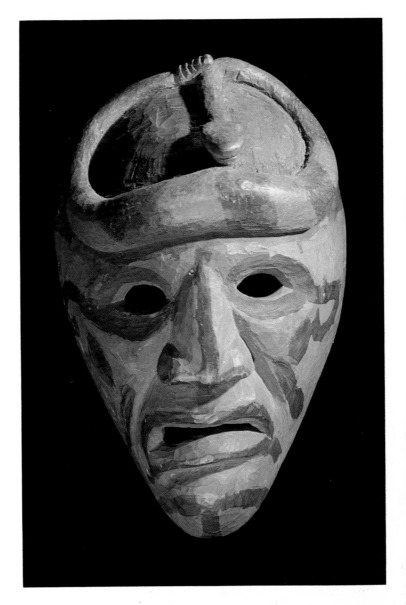

Plate 214. This diorama, in the Milwaukee Public Museum, recreates the appearance of the False Faces in the Midwinter rite in its old setting in the Iroquois longhouse.

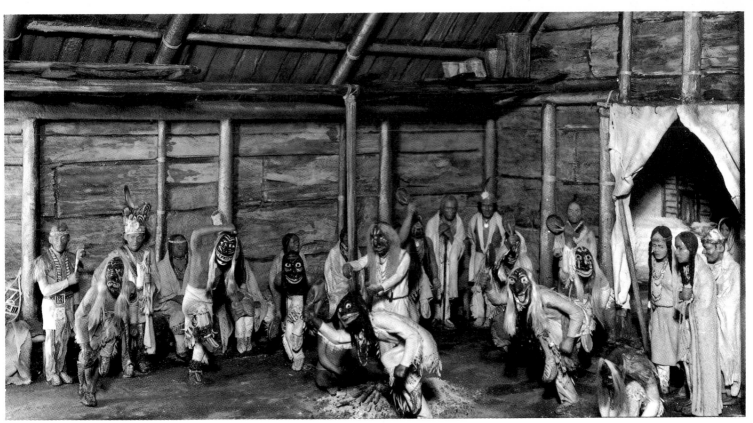

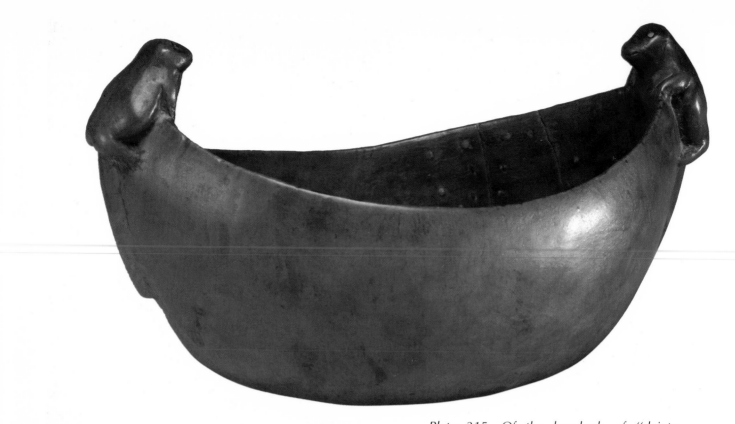

Plate 215. Of the hundreds of "dainty wooden bowls" early English colonists saw in use among seventeenth-century New England Algonquians and praised for their elegance and durability, a mere handful exist today. Rarer still are true masterpieces of utilitarian art like this little stone-carved burlwood Wampanoag or Massachuset ceremonial or eating dish, thought to date no later than 1630. The two animals serving as handles are mythic creatures. How precious the bowl must have been to its owner is suggested by the careful repair, with lead inlay, of a split in the far rim. Young men customarily made such bowls for their intended wives and carved wooden utensils for most of their lives to keep the household supplied. Thousands of these utensils were destroyed when villages were laid waste in fighting with the colonists; according to English eyewitnesses, thousands more were burned during the smallpox epidemics of 1633–35, when people were too ill or weak to gather firewood. (6¼" long. Private Collection.)

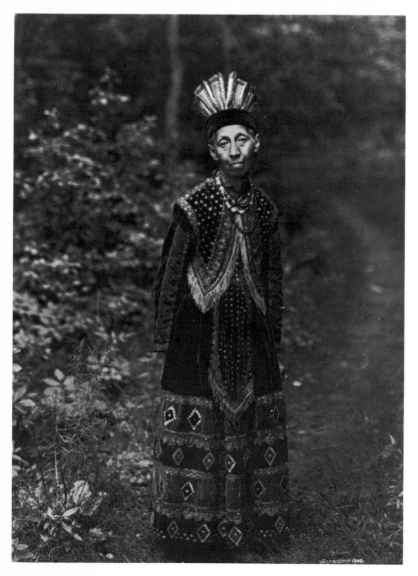

Plate 216. Mrs. Emma Mitchell Safford, a direct descendent of the famous Wampanoag Chief Massasoit, photographed by a Massachusetts photographer, F. W. Glasier, in 1904. It was Massasoit who in 1621 visited the then barely surviving Plymouth colony and concluded a treaty of friendship and peace. Nominally, the treaty lasted more than fifty years, although it did not prevent the colonists from conducting frequent armed assaults against Indian communities, virtually exterminating such peoples as the Pequot, or fomenting internecine warfare among New England Indians. One of Massasoit's sons was "King Philip," who led the New England Indians against the English in the tragic uprising of 1675–76 known to history as King Philip's War.

Plate 217. Iroquois cradleboard with dyed moosehair embroidery, collected by Lewis Henry Morgan in 1849–50. (25½" long. New York State Museum.)

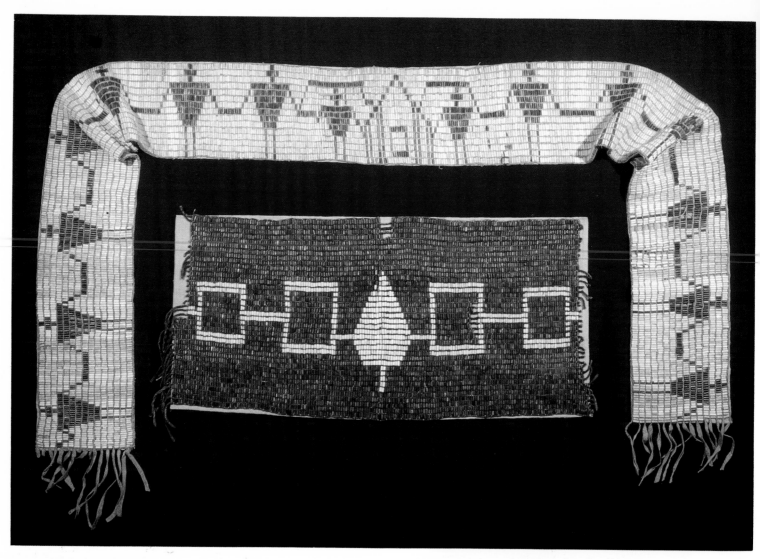

Plate 218. Two of the most famous Iroquois wampum belts —the long Washington Covenant Belt, so-called because it is associated with a treaty between the Iroquois and George Washington, and the shorter Hiawatha Belt, named after one of the two founders of the great League of the Iroquois. Dating between 1775 and 1789, measuring over six feet, and containing more than 10,000 tubular white and purple shell beads, the Washington Covenant Belt is the longest belt known. The Hiawatha Belt, thought by some Iroquois to date to the founding of the League, contains nearly 7,000 beads. (Washington Covenant Belt: 75½" long, 5¼" wide; Hiawatha Belt: 21½" long, 10½" wide. New York State Museum.)

Plate 219. Tee Yee Neen Ho Ga Row, or Hendrick, was painted from life by John Verelst in 1710 during a visit by this noted Mohawk chief to Queen Anne. Except for the wampum belt with porcupine or moosehair embroidery, the chief's accoutrements including the red cloak, are European. (Public Archives of Canada, Ottawa.)

Plate 220 (opposite above left). Buckskin knife sheath and tobacco and pipe bag belonging to Red Jacket, one of the most famous Iroquois chiefs at the end of the eighteenth century. (Sheath: 11½" long. Pouch: 20½" long. New York State Museum.)

Plate 221 (opposite above right). Eighteenth-century pouch and cloak of porcupine-quill-embroidered dyed buckskin, probably from the Hudson Valley or Connecticut. (Pouch: 9" high. New York State Museum.)

Plate 222 (opposite below). Iroquois buckskin moccasins with dyed moosehair embroidery. (10" long. Ca. 1800. New York State Museum.)

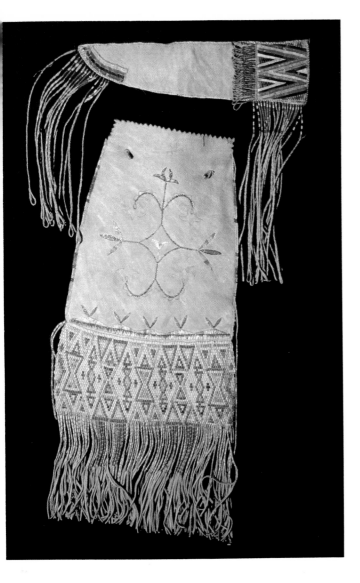

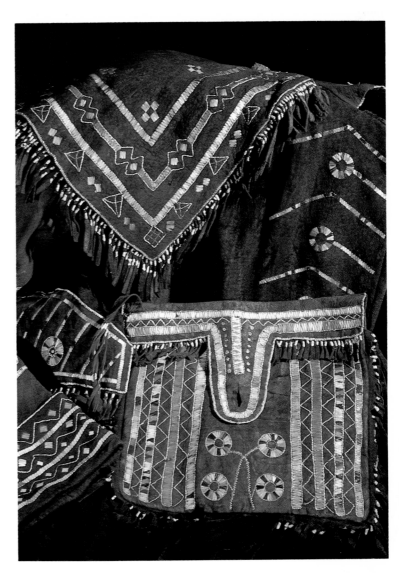

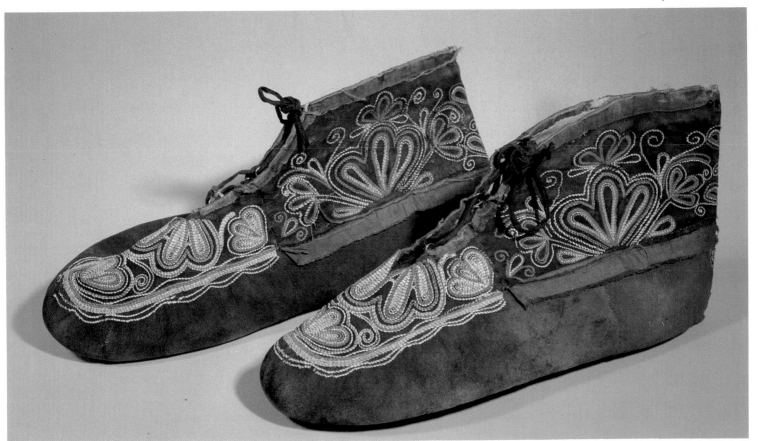

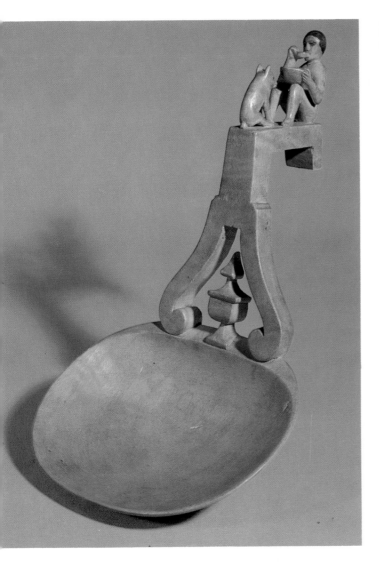

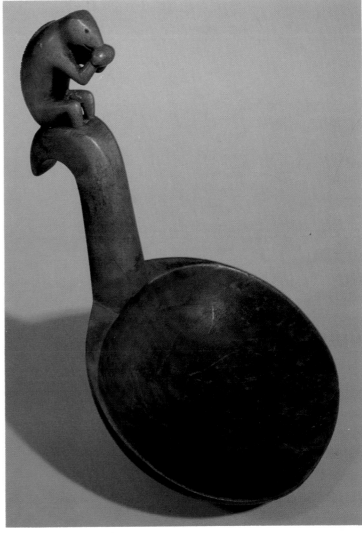

*Plate 223 (opposite). For the Iroquois, as for many other peoples, human hair had magical, life-giving powers. So it is not surprising that many Iroquois combs were embellished with animal, human, and plant elements that symbolized a whole range of cosmological, genealogical, and political concepts. The symbolic meaning of this beautifully carved and incised antler comb from a late-seventeenth-century Seneca archaeological site in upstate New York has been analyzed as follows: The two animals at the top are wolves, clan symbols of the Wolf Clan. They stand on the roof of the cosmic longhouse that symbolizes the political structure of the Iroquois Confederacy. Within the longhouse three human figures squat in the well-known hocker position, the ancient and near-universal motif derived from the position many women in traditional societies assume when giving birth. On Seneca combs such figures occur singly or in threes; in threes they almost certainly represent the Seneca, Onondaga, and Mohawk as*

*the three "Eldest Brothers" of the Iroquois Confederacy, in which the Cayuga and Oneida, later joined by the Tuscarora, were the "Younger Brothers." The Mohawk Wolf Clan served as "Keepers of the Eastern Door" of the metaphorical longhouse under whose common roof the member nations gathered from the Hudson in the east to the Genesee in the west. The Seneca Wolves were the "Keepers of the Western Door." As the central nation, the Onondagas were "Keepers of the Wampum," the shell-bead belts with which peace and other treaties were confirmed. (4½" high. Rochester Museum and Science Center.)*

*Plates 224 & 225. Two Iroquois feast ladles, used in seasonal ceremonies of thanksgiving to the food plants. The one at right was collected in 1850 by Lewis Henry Morgan from the Seneca reservation at Tonawanda, New York. (Left: 6½" high. Right: 7" high. New York State Museum.)*

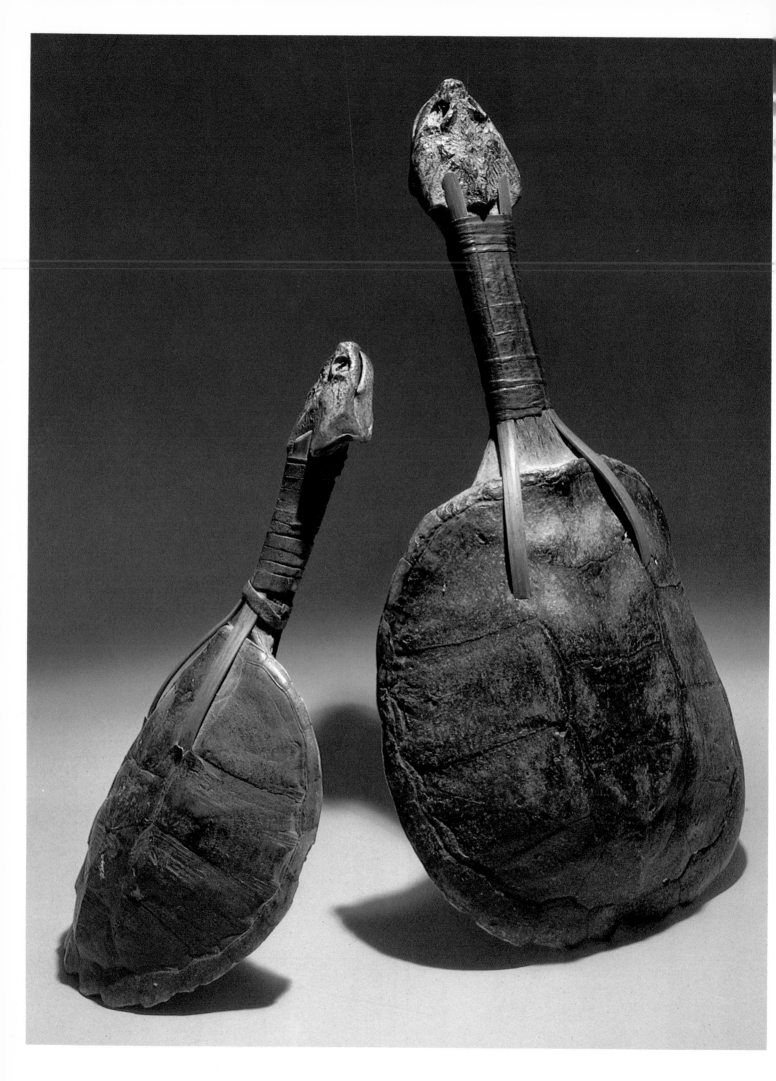

*Plate 226 (opposite). In the Iroquois story of creation, the daughter of the chief of the Sky World tumbled down toward an empty ocean through a hole rent in the heavenly vault by the uprooting of the celestial Tree of Life and Light. Birds and water animals watched in alarm as she fell, but Mud Turtle dove to the bottom of the cosmic sea to bring up mud with which to make a place for her to land. Resting on Mud Turtle's back, the little earth island grew larger and larger, a new Tree of Life and Light was planted, and eventually the earth became populated with plants, animals, and people. It is the turtle's cosmic function as earth bearer that accounts for its adoption as a magic rattle by the Great Defender, or Crooked Face, patron spirit of the curing Faces. He, in turn, decreed that the members of the Society of Faces make sacred rattles from the body of the mud turtle and use them in curing ceremonies. Women, too, use turtle rattles in their dances, but they are generally smaller. The turtle as earth bearer is not limited to the Iroquois but is found in the cosmologies of many Native North Americans. (Left: 17½" high; 1890–1910. Right: 21¾" high; 1930. Six Nations Reserve, Ontario. Private Collection.)*

*Plates 227 & 228. Popular opinion notwithstanding, Indian woodcarving did not necessarily improve with the adoption of steel blades. The straight edges of steel knives were less suited to the supple curves preferred by New England Algonquian carvers than their old flint tools. Not until the general adoption of the curved, or "crooked," knife in the eighteenth and nineteenth centuries did Eastern woodcarving approach its former glory. Especially among the Passamaquoddy and the Penobscots of Maine, the knife itself was soon transformed into a work of art, with effigy handles that, like the hand and the torso in the early nineteenth-century knives shown here, compete with the best small-scale aboriginal wood sculpture. Hands and horses were popular subjects, and so was the human body, occasionally, as in Plate 230, treated with considerable humor. With time, the carved handles became more sophisticated and elaborate. Blades, made from old files, knives, and, in the nineteenth and early twentieth centuries, even straight-edged razors, were replaced as they wore out, so that a 200-year-old handle might be fitted with a modern blade.*

*For the Indians, the crooked knife was an all-purpose tool that performed every task for which whites might require a whole set of specialized tools; indeed, some carvers—the Kwakiutl Charlie James, for example—almost never used anything else. (Left: 9" long. Collection William E. Channing. Right: 10" long. Private Collection.)*

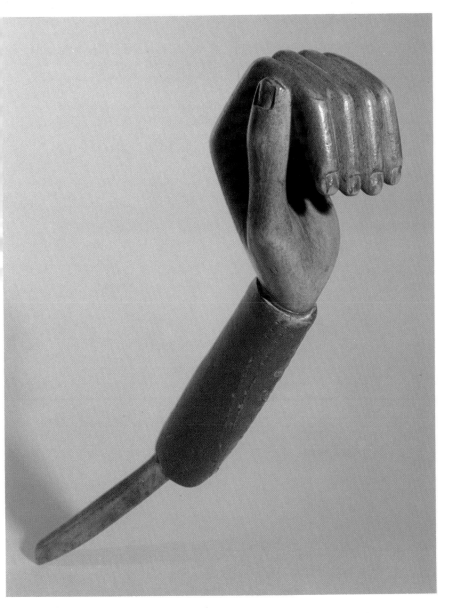

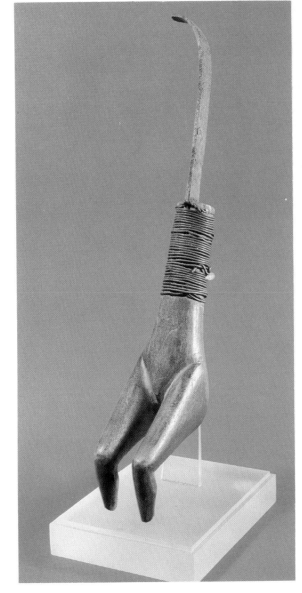

Plate 229. Hojiage 'de, or He Bears a Fish by the Forehead Strap, also known as William Henry Fishcarrier, a Cayuga from the Six Nations Reserve in Ontario, Canada, photographed by DeLancey Gill on a visit to the Smithsonia Institution in Washington, D.C., in 1901.

Plate 230. An early nineteenth-century Passamaquoddy Penobscot crooked knife with lead inlay and nude huma figure incorporated into the wooden handle. (9" tot length. Private Collection.)

Plate 231 (opposite). Iroquois ball-headed human effig club, probably Seneca, almost certainly dates from th early part of the seventeenth century, and thus belong among the handful of wooden utensils to have survive from early colonial times. The eyes are lead inlays, pr sumably fashioned from musket balls or shot. Bar lead an bullets first appear in Seneca sites in the first half of th seventeenth century, when the Seneca also began castin their own musket balls, effigy pendants, medallions, an geometrical inlays, as well as whole pipes. The mouth the effigy head on this club may once have been set wit teeth made of bone. Except for the face, which bears trace of red paint, the whole club was painted black, both pig ments apparently of Native rather than European origir Early clubs of this type may be effigies of shaman-warrio or Rattlesnake-Man beings, a common motif in Iroquo mythology. (24¼" long. Private Collection.)

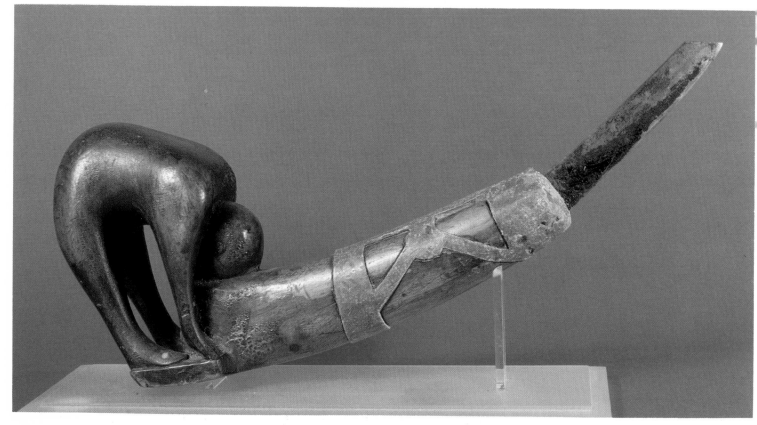

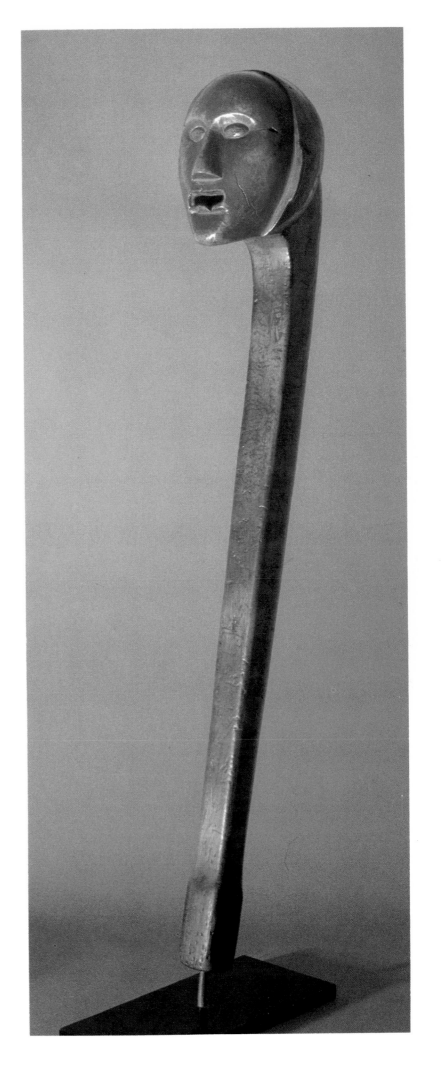

*Plates 232 & 233. Even before the American Revolution, the Iroquois were under heavy pressure from missionaries to conform to the white man's ways. These efforts intensified with the loss of most of their former lands and much of the old political, economic, and ethical order. In style and subject matter, these drawings from 1821 by Dennis Cusick, son of a Tuscarora chief, Nicholas Cusick, show some attempts at acculturation: James Young's classroom at the Seneca Mission School on the Buffalo Creek Reservation in upstate New York (top), and Mrs. James Young in another classroom instructing Iroquois girls in carding, spinning, and knitting (bottom). The Iroquois learned and adapted. But they remained Indian. (Private Collection.)*

# Acknowledgments

This book would not have been possible without the generosity of many individuals and institutions in sharing information or photographs and allowing us access to their collections. The staffs of the museums represented in the illustrations were unfailingly sympathetic to our goals and helpful. Not one of the private collectors whom we contacted for permission to photograph in their homes and publish their pieces refused. We respect their almost unanimous desire to remain anonymous but take this opportunity to thank them again for their public-spirited generosity.

John Krumdieck, of the New York State Museum in Albany, and David Kiphuth, Peabody Museum of Natural History, Yale University, went out of their way to provide space, specimens, and information. Patrick T. Houlihan, formerly in charge of the New York State Museum and now director of the Southwest Museum in Los Angeles, has our deep gratitude for making available the previously unknown sketchbook of the nineteenth-century Cheyenne artist Howling Wolf (Plates 194–195, 197–198, 201–202, & 204–205), which he discovered in the New York State Library. Karen Daniels Petersen, author of Howling Wolf's biography and foremost student of the art of the Fort Marion prisoners, and Jean Afton, in turn, helped interpret the new additions to this Cheyenne warrior-artist's considerable legacy. Horst Hartmann generously provided photographs of major pieces of early nineteenth-century Plains Indian art in the Museum für Völkerkunde, Berlin-Dahlem (Plates 4 & 164–165). For photographs of one of the finest copper daggers from the Northwest Coast (Plate 3) and a rare seventeenth-century New England Algonquian bowl (Plate 215), the latter almost as this book was going to press, we thank Ellen Napiura of Sotheby Parke Bernet. Roderick Blackburn of the Albany Institute of History and Art kindly provided the photograph of the historic Iroquois painting in Plate 219, Kathryn Bardwell that of the prehistoric Pueblo blanket in Plate 32, and Michael Kan of the Detroit Institute of Arts that of the Cheyenne shield in Plate 182.

We also wish to express our appreciation to the numerous individuals who found time to share their special expertise and offer counsel or interpretation on particular objects or on questions of Native American symbolism and technology. First and foremost, our thanks go to Edmund Carpenter, who, incidentally, also gave one of the authors (P.T.F.) his first full-time teaching job in anthropology. The threads of his intellectual stimulation run through this book but are especially evident in the chapters on the Northwest Coast and the Eskimos. We have also benefited from conversations with, among others, Rex and Bonnie Arrowsmith, the late David Bartholomew, Jack Campisi, William E. Channing, Adelaide de Menil, William N. Fenton, Skip Holbrook, André Nasser, Alfonso Ortiz, Robert Manchester, Randy Lee White Horse, and Joe Ben Wheat. George Hamell of the New York State Museum helped unlock the meaning of the Seneca antler comb (Plate 223) and the Iroquois war club (Plate 231). William A. Lanford, Department of Physics, State University of New York, Albany, used his computerized X-ray-induced X-ray fluorescence analyzer to determine the composition of the effigy pipe in Plate 193. Marianne Mithun, our colleague in the Department of Anthropology at SUNY, Albany, pointed to the African origins of the Cherokee term "booger" and clarified other questions of American Indian linguistics, and Nancy Parezo shared her special expertise in Navajo sandpaintings on board. Gladys Topkis read and made many helpful suggestions about the manuscript.

Finally, it is not often that authors have the privilege of working closely with the publisher and designer in the production of their work. More rarely still are authors' wishes and opinions accommodated with as little argument as ours have been by our publisher, John L. Hochmann. We are grateful also to Ray F. Patient for his work in producing this volume. That the designer of this book, Kornelia Kurbjuhn, is herself also an anthropologist familiar with Native American art was our special good fortune.

To all these, to the authors of the numerous published works and unpublished papers we consulted, and to Joann Somich, with whose nimble fingers the fastest typewriter has difficulty keeping up, our profound appreciation.

Peter T. Furst      Jill Leslie Furst

# Bibliography

## General

Arts Council of Great Britain. *Sacred Circles: Two Thousand Years of North American Indian Art.* London, 1977.

Campbell, Lyle, and Marianne Mithun, eds. *The Languages of Native America: Historical and Comparative Assessment.* Austin: University of Texas Press, 1979.

Conn, Richard. *Native American Art in the Denver Art Museum.* Denver, Colo.: Denver Art Museum, 1979.

Dockstader, Frederick J. *Indian Art in America.* Greenwich, Conn.: New York Graphic Society, n.d.

Feder, Norman. *American Indian Art.* New York: Harry N. Abrams, 1969.

Haberland, Wolfgang. *The Art of North America.* New York: Crown, 1964.

Hultkrantz, Ake. *Conceptions of the Soul among North American Indians.* Monograph Series 1. Stockholm: The Ethnological Museum of Sweden, 1953.

Lindig, Wolfgang. *Die Kulturen der Eskimo und Indianer Nordamerikas.* Handbuch der Kulturgeschichte. Frankfurt am Main: Eugen Thurnher, 1972.

Mason, Otis Tufton. *Aboriginal American Indian Basketry.* Facsimile reprint of 1904 edition. Santa Barbara, Calif.: Peregrine Smith, 1976.

Radin, Paul. *The Trickster: A Study in American Indian Mythology.* New York: Philosophical Library, 1956.

Roosevelt, Anna Curtenius, and James G. E. Smith, eds. *The Ancestors: Native Artisans of the Americas.* New York: Museum of the American Indian, 1979.

Snow, Dean. *The Archaeology of North America.* Photographs by Werner G. Forman. New York: Viking, 1976.

Walker Art Center and the Minneapolis Institute of Arts. *American Indian Art: Form and Tradition.* Minneapolis, Minn., 1972.

## "To Beautify the World . . ."

Benedict, Ruth F. *The Concept of the Guardian Spirit in North America.* Memoirs of the American Anthropological Association, No. 29, 1923.

———. "The Vision in Plains Culture." *American Anthropologist,* n.s., Vol. 24: 1–13, 1922.

Brody, J. J. *Between Traditions: Navajo Weaving Toward the End of the Nineteenth Century.* Iowa City: University of Iowa Museum of Art, 1976.

Capps, W. H., ed. *Seeing with a Native Eye.* New York: Harper and Row, 1976.

Carpenter, Edmund. "Introduction." In: Bill Holm and William Reid, *Form and Freedom: A Dialogue on Northwest Coast Indian Art,* pp.9–24. Houston, Tex.: Institute for the Arts, Rice University, 1975.

Cushing, Frank Hamilton. *Zuni Breadstuff.* New York: Museum of the American Indian, 1974.

Dittert, Alfred E., Jr. and Fred Plog. *Generations in Clay: Pueblo Pottery of the American Southwest.* Introduction by Patrick T. Houlihan. Flagstaff, Ariz.: Northland Press, 1980.

Eliade, Mircea. *Shamanism: Archaic Techniques of Ecstasy.* New York: Pantheon, 1964.

Furst, Peter T. "The Roots and Continuities of Shamanism." In: *Stones, Bones and Skin: Ritual and Shamanic Art,* pp. 1–28. Reprinted from *Artscanada,* Vol. XXX, Nos. 5–6, 1973. Toronto: Society for Art Publications, 1977.

Hatcher, Evelyn Payne. *Visual Metaphors: A Formal Analysis of Navajo Art.* American Ethnological Society Monograph 58. St. Paul, Minn.: West, 1974.

Hultkrantz, Ake. *The Religions of the American Indians.* Berkeley: University of California Press, 1979.

Lame Deer (John Fire) and Richard Erdoes. *Lame Deer: Seeker of Visions.* New York: Simon and Schuster, 1972.

Society for Art Publications. *Stones, Bones and Skin: Ritual and Shamanic Art.* Toronto, 1977.

Vastokas, Joan M. "The Shamanic Tree of Life." In: *Stones, Bones and Skin: Ritual and Shamanic Art,* pp. 93–117. Reprinted from *Artscanada,* Vol. XXX, Nos. 5–6, 1973, 1977.

Witherspoon, Gary. *Language and Art in the Navajo Universe.* Ann Arbor: University of Michigan Press, 1977.

## Arts of the Southwest

Adair, John. *The Navajo and Pueblo Silversmiths.* Norman: University of Oklahoma Press, 1944.

Amsden, Charles Avery. *Navaho Weaving.* Facsimile reprint of 1934 edition. Santa Barbara, Calif.: Peregrine Smith, 1975.

Bedinger, Margery. *Indian Silver: Navajo and Pueblo Jewelers.* Albuquerque: University of New Mexico Press, 1973.

Bunzel, Ruth. *Zuñi Katcinas. Forty-seventh Annual Report of the Bureau of American Ethnology,* pp. 839–1086. Washington, D.C.: U.S. Government Printing Office, 1932.

Colton, Harold S. *Hopi Kachina Dolls with a Key to their Identification.* Albuquerque: University of New Mexico Press, 1959.

Curtis, Edward S. *The North American Indian,* Vol. XII. Cambridge, Mass.: The University Press, 1922.

Dockstader, Frederick J. *The Kachina and the White Man.* Bloomfield Hills, Mich.: Cranbrook Institute of Science, 1954.

Dutton, Bertha F. *Indians of the American Southwest.* Englewood Cliffs, N.J.: Prentice-Hall, 1975.

Erickson, Jon T. *Kachinas: An Evolving Hopi Art Form?* Foreword by Patrick T. Houlihan. Phoenix, Ariz.: The Heard Museum, 1977.

Fewkes, Jesse Walter. *Hopi Katcinas, Drawn by Native Artists. Twenty-first Annual Report of the Bureau of American Ethnology.* Washington, D.C.: U.S. Government Printing Office, 1903.

———. "Tusayan Katcinas," *Fifteenth Annual Report of the Bureau of American Ethnology,* pp. 247–313. Washington, D.C.: U.S. Government Printing Office, 1897.

Frank, Larry, and Francis H. Harlow. *Historic Pottery of the Pueblo Indians, 1600–1880.* Boston: New York Graphic Society, 1974.

Green, Jesse, ed. *Selected Writings of Frank Hamilton Cushing.* Lincoln: University of Nebraska Press, 1979.

Haberland, Wolfgang. *Kachina-Figuren der Pueblo-Indianer-Nordamerikas aus der Studiensammlung Horst Antes.* Karlsruhe: Badisches Landesmuseum, 1981.

Harlow, Francis H. *Matte-Paint Pottery of the Tewa, Keres and Zuni Pueblos.* Albuquerque: Museum of New

Mexico, 1973.

Hartmann, Horst. *Kachina-Figuren der Hopi-Indianer*. Berlin: Museum für Völkerkunde, 1978.

James, George W. *Indian Blankets and Their Makers*. Reprint of 1920 edition. New York: Dover, 1974.

James, Harry C. *Pages from Hopi History*. Tucson: University of Arizona Press, 1974.

Kent, Kate Peck. *The Cultivation and Weaving of Cotton in the Prehistoric Southwestern United States*. Transactions of the American Philosophical Society, n.s., Vol. 47, Part 3, 1957.

Kissell, Mary Lois. *Basketry of the Papago and Pima Indians*. Reprint of 1912 edition. Glorieta, N.M.: Rio Grande Press, 1972.

Kluckhohn, Clyde, and Dorothea Leighton. *The Navaho*. New York: The Natural History Library, 1962.

Maxwell Museum of Anthropology. *Seven Families in Pueblo Pottery*. Albuquerque: University of New Mexico Press, 1974.

McGreevy, Susan. "Navajo Sandpainting Textiles at the Wheelwright Museum." *American Indian Art*, Vol. 7, No. 1: 55–61, 1981.

Newcomb, Franc J., and Gladys A. Reichard. *Sandpaintings of the Navajo Shooting Chant*. Reprint of 1937 edition. New York: Dover, 1975.

Olin, Caroline Bower. *Navajo Indian Sandpainting: The Construction of Symbols*. Ph.D. dissertation. Stockholm: Faculty of Humanities, University of Stockholm, 1972.

Ortiz, Alfonso. *The Tewa World: Space, Time, Being and Becoming in a Pueblo Society*. Chicago: University of Chicago Press, 1969.

———., ed. *Handbook of North American Indians*, Vol. 9: *Southwest*. Washington, D.C.: Smithsonian Institution, 1979.

Parsons, Elsie Clews. *Pueblo Indian Religion*. 2 vols. Chicago: University of Chicago Press, 1939.

Reichard, Gladys A. *Navajo Medicine Man Sandpaintings*. Reprint of 1939 edition. New York: Dover, 1977.

Rodee, Marian E. *Southwestern Weaving*. Albuquerque: University of New Mexico Press, 1977.

Schaafsma, Polly. *Indian Rock Art of the Southwest*. Santa Fe and Albuquerque: School of American Research and University of New Mexico Press, 1980.

Stephens, Alexander M. *Hopi Journal*. Edited by Elsie Clews Parsons. New York: Columbia University Contributions to Anthropology, Vol. XXIII, 1936.

Stevenson, Matilda Coxe. "Ethnobotany of the Zuni Indians." *Thirtieth Annual Report of the Bureau of American Ethnology*, pp. 31–116. Washington, D.C.: U.S. Government Printing Office, 1915.

———. *The Zuni Indians*. Twenty-third Annual Report of the Bureau of American Ethnology. Washington, D.C.: U.S. Government Printing Office, 1904.

Tanner, Clara Lee. *Prehistoric Southwestern Craft Art*. Tucson: University of Arizona Press, 1976.

———. *Southwest Indian Craft Arts*. Tucson: University of Arizona Press, 1968.

———. *Southwest Indian Painting*. Tucson: University of Arizona Press, 1973.

Tyler, Hamilton A. *Pueblo Gods and Myths*. Norman: University of Oklahoma Press, 1964.

Voth, H. R. "Brief Miscellaneous Hopi Papers." *Field Columbian Museum Publications, Anthropological Series*, Vol. XI: 89–149, 1912.

Washburn, Dorthy K. *Hopi Kachina: Spirit of Life*. San Francisco: California Academy of Sciences, 1980.

Witherspoon, Gary. *Language and Art in the Navajo Universe*. Ann Arbor: University of Michigan Press, 1977.

Wright, Barton. *Hopi Kachinas*. Flagstaff, Ariz.: Northland Press, 1977.

———. *Hopi Material Culture*. Flagstaff, Ariz.: Northland Press, 1979

Wyman, Leland C. *Sandpaintings of the Navaho Shootingway and the Walcott Collection*. Washington, D.C.: Smithsonian Contributions to Anthropology 13, 1970.

## Arts of California

Applegate, Richard B. "The *Datura* Cult among the Chumash." *Journal of California Anthroplogy*, Vol. 2, No. 1: 7–17, 1975.

Barnett, Homer G. *The Coast Salish of British Columbia*. Eugene: University of Oregon Press, 1955.

Barrett, S. A. *Pomo Indian Basketry*. Facsimile reprint of 1908 monograph. Glorieta, N.M.: Rio Grande Press, 1976.

Blackburn, Thomas C. *December's Child: A Book of Chumash Oral Narratives*. Berkeley: University of California Press, 1975.

Clark, Cora, and Texa Bowen Williams. *Pomo Indian Myths*. New York: Vantage, 1954.

Furst, Peter T. *Hallucinogens and Culture*. San Francisco: Chandler and Sharp, 1976.

Grant, Campbell. *The Rock Paintings of the Chumash*. Berkeley: University of California Press, 1965.

Heizer, Robert F., ed. *Handbook of North American Indians*, Vol. 8: *California*. Washington, D.C.: Smithsonian Institution, 1978.

Kroeber, A. L. "Basket Designs of the Indians of Northwestern California." University of California Publications in American Archaeology and Ethnology, Vol. 2, No. 4: 105–64, 1905.

———. *Handbook of the Indians of California*. Reprint of 1925 edition. Berkeley: California Book Company, 1953.

———. *The Religion of the Indians of California*. Berkeley: University of California Publications in American Archaeology and Ethnology, Vol. 4, No. 6, 1907.

Landberg, Leif C. W. *The Chumash Indians of Southern California*. Los Angeles, Calif.: Southwest Museum Papers No. 19, 1965.

Mason, Otis Tufts. *Aboriginal American Indian Basketry*. Facsimile reprint of 1904 edition. Santa Barbara, Calif.: Peregrine Smith, 1976.

Oster, G. "Phosphenes." *Scientific American*, Vol. 222, No. 2: 82–87, 1970.

Reichel-Dolmatoff, Gerardo. *Beyond the Milky Way: Hallucinatory Imagery of the Tukano Indians*. Los Angeles, Calif.: UCLA Latin American Center Publications, 1978.

Rozaire, Charles E. *Indian Basketry of Western North America*. Santa Ana, Calif.: Charles W. Bowers Memorial Museum, 1977.

Silva, Arthur M., and William C. Cain. *California Indian Basketry*. Cypress, Calif.: Cypress College Fine Arts Gallery, 1976.

## Arts of the Northwest Coast

Bancroft-Hunt, Norman, and Werner Forman. *People of the Totem*. New York: G. P. Putnam, 1979.

Barbeau, Marius. *Haida Carvers in Argillite*. Facsimile reprint of 1957 edition. Ottawa: National Museum of

Man, 1974.

———. *Totem Poles*. Bulletin 119, Anthropological Series. Ottawa: National Museum of Canada, 1950.

———. *Totem Poles of the Gitksan, Upper Skeena River, British Columbia*. Facsimile reprint of 1929 edition. Bulletin 61. Ottawa: National Museum of Canada, 1973.

Boas, Franz. *Ethnology of the Kwakiutl*. Thirty-fifth Annual Report of the Bureau of American Ethnology. Washington, D.C.: U.S. Government Printing Office, 1921.

———. *Kwakiutl Ethnography*. Helen Codere, ed. Chicago: University of Chicago Press, 1966.

———. *Kwakiutl Tales*. Columbia University Contributions to Anthropology, Vol. 2. New York: Columbia University Press, 1910.

———. *The Mythology of the Bella Coola Indians*. New York: Memoirs of the American Museum of Natural History, Vol. 2, Anthropology I, 1898.

———. *Religion of the Kwakiutl Indians*. Columbia University Contributions to Anthro-pology, Vol. 10. New York: Columbia University Press, 1930.

———. *Social Organization and Secret Societies of the Kwakiutl Indians*. Report of the U.S. National Museum for 1895. Washington, D.C.: U.S. Government Printing Office, 1897.

Bogoras, Waldemar. "The Folklore of North-eastern Asia as Compared with That of Northwestern America." *American Anthropologist*, n.s., Vol. 4, No. 4: 577–673, 1902.

Carpenter, Edmund. "Introduction." In: Bill Holm and William Reid, *Form and Freedom: A Dialogue on Northwest Coast Indian Art*, pp. 9–24. Houston, Tex.: Institute for the Arts, Rice University, 1975.

Curtis, Edward S. *The North American Indian*. Vol. 10: *Kwakiutl*. Norwood, Mass.: Plimpton, 1915.

Dall, William H. "Masks, Labrets and Certain Aboriginal Customs, with an Inquiry into the Bearing of Their Geographical Distribution." *Third Annual Report of the Bureau of American Ethnology*, pp. 67–203. Washington, D.C.: U.S. Government Printing Office, 1884.

de Laguna, Frederica. "Mungo Martin: 1879–1962." *American Anthropologist*, Vol. 65: 894–96, 1963.

———. *Under Mount Saint Elias: The History and Culture of the Yakutat Tlingit*. 4 vols. Washington, D.C.: Smithsonian Contributions to Anthropology, Vol. 7, 1972.

de Menil, Adelaide, and William Reid. *Out of the Silence*. Fort Worth, Tex.: Amon Carter Museum of Western Art, 1971.

Drucker, Philip. *Indians of the Northwest Coast*. New York: McGraw-Hill, 1955.

Emmons, George T. *The Basketry of the Tlingit*. New York: Memoirs of the American Museum of Natural History, Vol. 3, Anthropology, Vol. 2, 1903.

———. *The Chilkat Blanket*. New York: Memoirs of the American Museum of Natural History, Vol. 3, 1907.

Garfield, Viola A., and Paul S. Wingert. *The Tsimshian Indians and their Arts*. Seattle: University of Washington Press, 1966.

Goldman, Irving. *The Mouth of Heaven: An Introduction to Kwakiutl Religious Thought*. New York: Wiley, 1975.

Gunther, Erna. *Art in the Life of the Northwest Coast Indians*. Portland, Ore.: Portland Art Museum, 1966.

Haberland, Wolfgang. *Donnervogel und Raubwal: Indianische Kunst der Nordwestküste Nordamerikas*. Hamburg: Hamburgisches Museum für Völkerkunde, 1979.

Hawthorn, Audrey. *Art of the Kwakiutl Indians and Other Northwest Coast Tribes*. Seattle: University of Washington Press, 1967.

———. *Kwakiutl Art*. Seattle: University of Washington Press, 1969.

Holm, Bill. *Crooked Beak of Heaven: Masks and Other Ceremonial Art in the Pacific Northwest*. Seattle: University of Washington Press, 1972.

———. *Northwest Coast Indian Art: An Analysis of Form*. Seattle: University of Washington Press, 1965.

———, and George Irving Quimby. *Edward S. Curtis in the Land of the War Canoes: A Pioneer Cinematographer in the Pacific Northwest*. Seattle: Thomas Burke Memorial Washington State Museum, Monograph 2, 1980.

———, and William Reid. *Form and Freedom: A Dialogue on Northwest Coast Indian Art*. Houston, Tex.: Institute for the Arts, Rice University, 1975.

Inverarity, Robert Bruce. *Art of the Northwest Coast Indians*. Berkeley and Los Angeles: University of California Press, 1950.

King, J. C. H. *Portrait Masks from the Northwest Coast of North America*. London: Thames and Hudson, 1979.

Krause, Arel. *The Tlingit Indians*. Translated from the German by Erna Gunther. Seattle: University of Washington Press, 1956.

Malin, Edward. *A World of Faces*. Portland, Ore.: Timber Press, 1978.

National Gallery of Art. *The Far North: 2000 Years of American Eskimo and Indian Art*. Washington, D.C., 1973.

Siebert, Erna, and Werner Forman. *North American Indian Art*. London: Paul Hamlyn, 1967.

Stewart, Hilary. *Looking at Indian Art of the Northwest Coast*. Vancouver: Douglas and McIntyre, 1979.

Stone, Peter. "Tlingit Art." In: *The Far North*, pp. 165–69. Washington, D.C.: National Gallery of Art, 1973.

Swanton, John R. *The Haida of the Queen Charlotte Islands*. New York: Memoirs of the American Museum of Natural History, Vol. 5, 1905a.

———. *Haida Texts and Myths*. Bureau of American Ethnology, Bulletin 29. Smithsonian Institution, Washington, D.C.: U.S. Government Printing Office, 1905b.

———. *Tlingit Myths and Texts*. Bureau of American Ethnology, Bulletin 39. Smithsonian Institution. Washington, D.C.: U.S. Government Printing Office, 1909.

Vogel, Virgil J. *American Indian Medicine*. Norman: University of Oklahoma Press, 1970.

Wardwell, Allen. *Objects of Bright Pride*. New York: American Museum of Natural History, 1978.

———. *Yakutat South: Indian Art of the Northwest Coast*. Chicago: The Art Institute of Chicago, 1964.

William, Richard. *The Northwest Coast*. New York: Time-Life Books, 1973.

Witthoft, John, and Frances Eyman. "Metallurgy of the Tlingit, Dene, and Eskimo." *Expedition*, Vol. 11, No. 3: 12–23, 1969.

Woodcock, George. *Peoples of the Coast: The Indians of the Pacific Northwest*. Bloomington: Indiana University Press, 1977.

## Arts of the Eskimos

Artscanada. *The Eskimo World.* Dec. 1971/Jan. 1972, Nos. 162–63. Toronto: Society for Art Publications, 1972.

Bandi, Hans. *Eskimo Prehistory.* Fairbanks: University of Alaska Press, 1972.

Birket-Smith, Kaj. *Eskimos.* New York: Crown, 1971.

Bogoras, Vladimir. *The Chukchee.* Memoirs of the American Museum of Natural History, Vol. 11. Part 1: *Material Culture,* 1904–09.

Carpenter, Edmund. "The Eskimo Artist." In: *Anthropology and Art,* Charlotte M. Owen, ed., p. 171. Garden City, N.Y. Natural History Press, 1971.

———. *Eskimo Realities.* New York: Holt, Rinehart and Winston, 1973a.

———. "Some Notes on the Separate Realities of Eskimo and Indian Art." In: *The Far North.* Washington, D.C.: National Gallery of Art, 1973b.

Collins, Henry B. "Eskimo Art." In: *The Far North,* pp. 1–24. Washington, D.C.: National Gallery of Art, 1973.

———. "The Origin and Antiquity of the Eskimo." *Annual Report of the Smithsonian Institution for 1950,* pp. 423–67, 1951.

———. *Prehistoric Art of the Alaskan Eskimo.* Washington, D.C.: Smithsonian Miscellaneous Collections, Vol. 81, No. 4, 1929.

Curtis, Edward S. *The North American Indian.* Vol. 20: *Eskimo.* Norwood, Mass.: Plimpton, 1930.

Graburn, Nelson H., and Stephen B. Strong. *Circumpolar Peoples: An Anthropological Perspective.* Pacific Palisades, Calif.: Goodyear, 1973.

Hawkes, Ernest W. *The Dance Festivals of the Alaskan Eskimos.* Philadelphia: University of Pennsylvania Museum, Anthropological Publications, Vol. 6, No. 2, 1914.

Himmelheber, Hans. *Eskimokünstler.* Eisenach: Erich Röth-Verlag, 1953.

Hoffman, Walter James. "The Graphic Art of the Eskimos." *United States National Museum Report for 1895.* pp. 739–968. Washington, D.C.: U.S. Government Printing Office, 1897.

Hultkrantz, Ake. "Die Religion der amerikanischen Arktis." In: *Die Religionen Nordeurasiens und der amerikanischen Arktis,* by Ivar Paulsen, Ake Hultkrantz, and Karl Jettmar. *Die Religionen der Menschheit,* Vol. 3. Stuttgart: W. Kohlhammer, 1962.

Lantis, Margaret. *Alaskan Eskimo Ceremonialism.* American Ethnological Society Monographs 11. New York: J. J. Augustin, 1947.

———. "The Alaskan Whale Cult and Its Affinities." *American Anthropologist,* Vol. 40: 438–64, 1938.

Mason, J. Alden. "Eskimo Pictorial Art." *The Museum Journal,* Vol. 18, No. 3: 248–83, 1927.

National Gallery of Art. *The Far North: 2000 Years of American Eskimo and Indian Art.* Washington, D.C., 1973.

Nelson, Edward William. *The Eskimo about Bering Strait.* Eighteenth Annual Report of the Bureau of American Ethnology, Part I. Washington, D.C.: U.S. Government Printing Office, 1899.

The Newark Museum. *Survival: Life and Art of the Alaskan Eskimos,* 1977.

Oswalt, Wendell H. *Alaskan Eskimos.* San Francisco, Calif.: Chandler, 1967.

Rainey, Froelich G. *Eskimo Prehistory: The Okvik Site on the Punuk Islands.* New York: Anthropological Papers of the American Museum of Natural History, Vol. 37, Part 4, 1941.

Rasmussen, Knud. *Intellectual Culture of the Iglulik Eskimos.* Report of the Fifth Thule Expedition, 1921–24. Copenhagen: Glydendalske Boghandel, Nordisk Verlag, 1929.

Ray, Dorothy Jean. *Artists of the Tundra and the Sea.* Seattle: University of Washington Press, 1961.

———. *Eskimo Art: Tradition and Innovation in North Alaska.* Seattle: University of Washington Press, 1977.

———. *The Eskimos of Bering Strait, 1650–1898.* Seattle: University of Washington Press, 1975.

———, and Alfred A. Blaker. *Eskimo Masks: Art and Ceremony.* Seattle: University of Washington Press, 1967.

Schuster, Carl. "A Survival of the Eurasiatic Animal Style in Modern Alaskan Eskimo Art." In: *Indian Tribes of Aboriginal America,* Sol Tax, ed. Selected Papers of the 29th International Congress of Americanists. Chicago: University of Chicago Press, 1949.

Smith, J. G. E. *Arctic Art: Eskimo Ivory.* New York: Museum of the American Indian, 1980.

Spencer, Robert F. *The North Alaskan Eskimo: A Study in Ecology and Society.* Washington, D.C.: Bureau of American Ethnology Bulletin 171, Smithsonian Institution, 1959.

Van Stone, James W. "Masks of the Point Hope Eskimos." *Anthropos,* Vols. 63–64: 828–40, 1969.

Weyer, Edward M. *The Eskimos: Their Environment and Folkways.* New Haven: Yale University Press, 1932.

## Arts of the Plains

Barsness, Larry. *The Bison in Art.* Flagstaff, Ariz.: Northland Press, 1977.

Benedict, Ruth. *The Concept of the Guardian Spirit in North America.* Memoirs of the American Anthropological Association, 29, 1923.

Brown, Joseph Eppes. *The Sacred Pipe: Black Elk's Account of the Seven Rites of the Oglala Sioux.* Norman: University of Oklahoma Press, 1953.

Catlin, George. *Letters and Notes on the Manners, Customs, and Conditions of North American Indians.* 2 vols. Reprint of work first published in London in 1844. New York: Dover, 1973.

Curtis, Edward S. *The North American Indian,* Vol. III. Reprint of 1908 edition. New York: Johnson, 1970.

Deutsches Ledermuseum. *Indianer Nordamerikas 1760–1860: Aus der Sammlung Speyer.* Offenbach, 1978.

Dyck, Paul. *Brulé: The Sioux People of the Rosebud.* Flagstaff, Ariz.: Northland Press, 1971.

Ewers, John C. *Plains Indian Painting.* Palo Alto: Stanford University Press, 1939.

———. "Plains Indian Painting: The History and Development of an American Art Form." In Karen Daniels Petersen, *Howling Wolf, A Cheyenne Warrior's Graphic Interpretation of His People.* Palo Alto: Stanford University Press, 1968.

———, ed. *Indian Art in Pipestone: George Catlin's Portfolio in the British Museum.* Washington, D.C.: Smithsonian Institution, 1979.

Hartmann, Horst. *Die Plains- und Prairieindianer.* Berlin: Museum für Völkerkunde, 1973.

Hoebel, E. Adamson, and Karen Daniels Petersen. *Cohoe: A Cheyenne Sketchbook.* Norman: University of Oklahoma Press, 1964.

Howard, James H. *The British Museum Winter Count.* Lon-

don: British Museum Occasional Paper No. 4, 1979.

———. *Yanktonai Ethnohistory and the John K. Bear Winter Count.* Plains Anthropologist Memoir 11, 1976.

Hultkrantz, Ake. *Prairie and Plains Indians.* Iconography of Religions, Vol. 10, No. 2. Institute of Religious Iconography, State University at Groningen. Leiden: E. J. Brill, 1973.

Josephy, Alvin M. Jr., ed. *The American Heritage Book of Indians.* New York: American Heritage, 1961.

King, J. C. H. *Smoking Pipes of the North American Indian.* London: British Museum Publications, 1977.

Lame Deer (John Fire) and Richard Erdoes. *Lame Deer, Seeker of Visions.* New York: Simon and Schuster, 1972.

Lewis, Meriwether, and William Clark. *The History of the Lewis and Clark Expedition.* Elliott Coues, ed. Reprint of the 1893 edition. 3 vols. New York: Dover, 1964.

Lowie, Robert. *Crow Indian Art.* New York: Anthropological Papers of the American Museum of Natural History, Vol. 21, No. 4, 1922a.

———. *The Religion of the Crow Indians.* New York: Anthropological Papers of the American Museum of Natural History, Vol. 25, No. 2, 1922b.

———. *The Tobacco Society of the Crow Indians.* New York: Anthropological Papers of the American Museum of Natural History, Vol. 21, No. 2, 1919.

Mails, Tomas E. *Dog Soldiers, Bear Men and Buffalo Women.* Englewood Cliffs, N.J.: Prentice-Hall, 1973.

———. *The Mystic Warriors of the Plains.* Garden City, N.Y.: Doubleday, 1971.

Mallery, Garrick. *Picture-Writing of the American Indians.* Tenth Annual Report of the Bureau of American Ethnology. Washington, D.C.: U.S. Government Printing Office, 1893.

Maurer, Evan M. *The Native American Heritage.* Chicago: The Art Institute of Chicago, 1973.

Mooney, James. *Calendar History of the Kiowa Indians.* Introduction by John C. Ewers. Reprint of 1898 edition. Washington, D.C.: Smithsonian Institution, 1979.

———. *The Ghost Dance Religion and the Sioux Outbreak of 1890.* Fourteenth Annual Report of the Bureau of American Ethnology, Washington, D.C.: U.S. Government Printing Office, 1896.

Neilhardt, John G. *Black Elk Speaks: Being the Life Story of a Holy Man of the Oglala Sioux.* New York: William Morrow, 1932.

Orchard, William C. *Beads and Beadwork of the American Indians.* New York: Museum of the American Indian, Heye Foundation, 1975.

Petersen, Karen Daniels. *Howling Wolf: A Cheyenne Warrior's Graphic Interpretation of his People.* Palo Alto, Calif.: Stanford University Press, 1968.

———. *Plains Indian Art from Fort Marion.* Norman: University of Oklahoma Press, 1971.

Powell, Peter J. *Sweet Medicine.* 2 vols. Norman: University of Oklahoma Press, 1969.

Powers, William K. *Oglala Religion.* Lincoln: University of Nebraska Press, 1977.

Schneider, Richard C. *Crafts of the North American Indians: A Craftsman's Manual.* New York: Van Nostrand, 1972.

Underhill, Ruth. *Red Man's Religion.* Chicago: University of Chicago Press, 1965.

Walker, James R. *Lakota Belief and Ritual,* Raymond J. de Maillie and Elainer A. Jahner, eds. Lincoln: University of Nebraska Press, 1980.

West, George A. *Tobacco, Pipes and Smoking Customs of the American Indians.* Facsimile reprint of 1934 edition. 2 vols. Westport, Conn.: Greenwood, 1970.

## Arts of the Eastern Woodlands

Beauchamp, William M. "Aboriginal Use of Wood in New York." *New York State Museum Bulletin,* No. 89: 184–92, 1905.

Converse, Harriet. *Myths and Legends of the New York State Iroquois.* Arthur C. Parker, ed. New York State Museum Bulletin 125, 1908.

Cornplanter, Jesse. *Legends of the Longhouse.* Philadelphia: J. B. Lippincott, 1938.

Fenton, William N. "The Hiawatha Wampum Belt of the Iroquois League for Peace: A Symbol for the International Congress of Anthropology." *Selected Papers of the Fifth International Congress of Anthropological and Ethnological Sciences,* Anthony F. C. Wallace, ed. Reprint, pp. 1–7. Philadelphia: University of Pennsylvania Press, 1960.

———. "Iroquois Masks: A Living Tradition in the Northeast." In *American Indian Art: Form and Tradition.* The Minneapolis Institute of Art, New York: E. P. Dutton, 1972.

———. "Masked Medicine Societies of the Iroquois." *Annual Report of the Smithsonian Institution for 1940:* 397–430. Washington, D.C.: U.S. Government Printing Office, 1940.

———. "The New York State Wampum Collection: The Case for the Integrity of Cultural Treasures." *Proceedings of the American Philosophical Society,* Vol. 115, No. 6: 437–61, 1971.

———. *Parker on the Iroquois.* Syracuse, N.Y.: Syracuse University Press, 1968.

———. "Some Questions of Classification, Typology and Style Raised by Iroquois Masks." *Transactions of the New York Academy of Sciences 18,* ser. 2: 346–57, 1965.

Flint Institute of Arts. *The Art of the Great Lakes Indians.* Detroit, Mich., 1973.

Gillette, Charles E. *Wampum Beads and Belts.* Albany: New York State Museum, 1970.

Herrick, James W. *Iroquois Medical Botany.* Unpublished doctoral dissertation, Department of Anthropology, State University of New York at Albany, 1977.

Hewitt, John N. B. "Iroquoian Cosmology: Second Part." *Forty-third Annual Report of the Bureau of American Ethnology:* 449–819. Washington, D.C.: U.S. Government Printing Office, 1928.

———. "Iroquois Cosmology: First Part." *Twenty-first Annual Report of the Bureau of American Ethnology:* 127–339. Washington, D.C.: U.S. Government Printing Office, 1903.

Krusche, Rolf. "Zur Genese des Maskenwesens im östlichen Waldland Nordamerikas." *Jahrbuch des Museums für Völkerkunde zu Leipzig.* Berlin: Akademie Verlag, 1975.

Mathews, Zena Pearlstone. *The Relation of Seneca False Face Masks to Seneca and Ontario Archaeology.* New York: Garland, 1978.

Morgan, Lewis H. "The Fabrics, Inventions, Implements and Utensils of the Iroquois." *Report of the New York State Museum, Part 5, for 1851,* pp. 67–117. Albany, 1852.

———. *League of the Ho-dé-no-sau-nee or Iroquois.* New York: M. H. Newman, 1851. Reprinted in 1962 as

*League of the Iroquois*, New York: Corinth Books.

Parker, Arthur C. "Certain Iroquois Tree Myths and Symbols." *American Anthropologist*, n.s., Vol. 14: 608–20, 1912.

————. "Iroquois Uses of Maize and Other Food Plants." *New York State Museum Bulletin*, Vol. 144: 5–113, 1910.

————. "Secret Medicine Societies of the Iroquois," *American Anthropologist*, Vol. 11: 161–85, 1909a.

————. "Secret Medicine Societies of the Seneca." *American Anthropologist*, n.s., Vol. 11, No. 2: 161–85, 1909b.

Ritzenthaler, Robert. *Iroquois False Face Masks*. Milwaukee Public Museum Publications in Primitive Art 3, 1969.

Speck, Frank G. "Concerning Iconology and the Masking Complex in Eastern North America." *University of Pennsylvania Bulletin 15*: 7–57, 1950.

————. *The Double-Curve Motif in Northeastern Algonquian Art*. Geological Survey of Canada Memoir 42, 1914.

————. *Functions of Wampum among the Eastern Algonkians*. Washington, D.C.: Memoirs of the American Anthropological Association, Vol. 25, 1964.

————. "Huron Moose Hair Embroidery." *American Anthropologist*, n.s., Vol. 13, No. 1:1–14, 1911.

————. *Midwinter Rites of the Cayuga Longhouse*. Philadelphia: University of Pennsylvania Press, 1949.

————. *Penobscot Man*. New York: Octagon Books, 1970.

————. *Symbolism in Penobscot Art*. New York: Anthropological Papers of the American Museum of Natural History, Vol. 29, 1927.

————. *Territorial Subdivisions and Boundaries of the Wampanoag, Massachuset, and Nauset Indians*. Indian Notes and Monographs No. 44. New York: Museum of the American Indian, Heye Foundation, 1928.

————, and Leonard Broom. *Cherokee Dance and Drama*. Berkeley and Los Angeles: University of California Press, 1951.

Thwaites, Reuben Gold. *The Jesuit Relations and Allied Documents*. 73 vols. Reprint edition. First published 1896–1901. New York: Pageant, 1959.

Trigger, Bruce G. *Handbook of North American Indians*. Vol. 15: *Northeast*. Washington, D.C.: Smithsonian Institution, 1978.

Wallace, Anthony F. C. *The Death and Rebirth of the Seneca*. New York: Vintage, 1972.

————. "Dreams and Wishes of the Soul: A Type of Psychoanalytic Theory among the Seventeenth-Century Iroquois." *American Anthropologist*, Vol. 60: 234–48, 1958.

Willoughby, Charles C. "Wooden Bowls of the Algonquian Indians." *American Anthropologist*, n.s., Vol. 10: 423–34, 1908.

Wray, Charles F. "Ornamental Hair Combs of the Seneca Iroquois." *Pennsylvania Archaeologist, Vol. 33: 35–50, 1963.*

————. *Seneca Tobacco Pipes*. New York State Archaeological Association Bulletin 6: 15–16, 1956.

# Photo Credits

All photographs in this book are by Peter T. Furst except as noted below.

Plate 3: Sotheby Parke Bernet, Inc.
Plate 4: Museum für Völkerkunde, Berlin
Plate 6: Wheelwright Museum of the American Indian
Plates 16–17: Edward S. Curtis
Plate 32: Kathryn Bardwell
Plate 35: Joe Ben Wheat
Plate 36: Edward S. Curtis
Plates 40–41: Wheelwright Museum of the American Indian
Plate 42: Laura Gilpin, courtesy Wheelwright Museum of the American Indian
Plate 43: Edward S. Curtis
Plate 52: Edward S. Curtis
Plate 58: Smithsonian Institution Photo
Plate 64: A. W. Ericson, Smithsonian Institution, National Anthropological Archives
Plate 69: Smithsonian Institution, National Anthropological Archives
Plate 70: Edward S. Curtis
Plate 77: Lowie Museum of Anthropology
Plate 79: Campbell Grant
Plates 81–85: Campbell Grant
Plate 93: Edward S. Curtis
Plate 99: Edward S. Curtis
Plate 100: Gideon Lewin
Plates 103–104: Gideon Lewin
Plate 105: Edward S. Curtis
Plate 106: Donald Baird
Plate 111: Edward S. Curtis
Plates 152–153: Edward S. Curtis
Plate 157: Murray Arrowsmith
Plates 164–165: Museum für Völkerkunde, Berlin
Plate 166: Smithsonian Institution Photo
Plate 170: Smithsonian Institution Photo
Plate 171: Edward S. Curtis
Plate 172: Murray Arrowsmith
Plate 173: John A. Anderson Collection, Nebraska State Historical Society
Plate 176: Smithsonian Institution Photo
Plate 177: Peabody Museum of Archaeology and Ethnology, Harvard University
Plate 182: Detroit Institute of Arts
Plate 183: Edward S. Curtis
Plates 184–185: Smithsonian Institution Photos
Plate 196: Edward S. Curtis
Plates 199–200: Edward S. Curtis
Plate 203: Edward S. Curtis
Plate 214: Milwaukee Public Museum
Plate 215: Sotheby Parke Bernet, Inc.
Plate 216: F. W. Glasier
Plate 219: Roderick Blackburn, Albany Institute of History and Art
Plate 223: Rochester Museum and Science Center; Photo by John Griebsch
Plate 229: DeLancy Gill, Bureau of American Ethnology, Smithsonian Institution